D1196187

The Fate of the Object

The Fate of the Object

From Modern Object to Postmodern Sign in
Performance, Art, and Poetry

Jon Erickson

Ann Arbor

The University of Michigan Press

NX
456.5
.P66
E74
1995

Copyright © by the University of Michigan 1995
All rights reserved
Published in the United States of America by
The University of Michigan Press
Manufactured in the United States of America
⊗ Printed on acid-free paper

1998 1997 1996 1995 4 3 2 1

A CIP catalogue record for this book is available from the British Library.

Library of Congress Cataloging-in-Publication Data

Erickson, Jon, 1951–
 The fate of the object : from modern object to postmodern sign in
performance, art, and poetry / Jon Erickson.
 p. cm.
 Includes bibliographical references and index.
 ISBN 0-472-10613-9 (hardcover : acid-free paper)
 1. Postmodernism. 2. Arts, Modern—20th century. 3. Symbolism in
art. 4. Ut pictura poesis. I. Title.
 NX456.5.P66E74 1995
 700'.1—dc20 95-16743
 CIP

LONGWOOD COLLEGE LIBRARY
FARMVILLE, VIRGINIA 23901

For my mother

Contents

Preface

In March of 1990, I constructed a performance event at a small Catholic college in Milwaukee. It was called *The Answer Man* and was set up in a room, otherwise empty, with one table against a wall, a mirror on the wall above the table, and two chairs on the same side of the table facing the mirror. I sat in one chair, and participants entered one at a time and sat in the other chair, facing me only through the mirror. Each person was asked to pose one question to me for which they had no answer; I would try to answer to the best of my ability. One stipulation I made, even though I sat in front of a mirror for four hours, was that I never look myself in the eyes, forcing myself to look only at the questioners.

I was amazed to find that everyone I talked to was sincere and displayed great faith in my ability to answer their questions, some of them quite personal. But of all the questions that were asked me, one affected me the most, leaving me wondering about the nature of what I was doing. A troubled teenage girl asked: "Why am I so easy to read?" If I gave her a more or less accurate answer, I don't recall. But the question itself stayed with me, since it was painfully obvious that her social life suffered; not only could she not be intriguing to other people through retaining some quality of personal mystery, she could also be easily taken advantage of because easy to read. It occurred to me that, despite so many confirmations every day within mass culture that people in all sorts of circumstances desperately want others to understand them, there is as strong a desire *not* to be understood—at least not easily understood. This is clear from the level of the individual sufferer, who certainly doesn't want to hear someone pityingly say, "I know what you're going through," to the level of identity politics, where T-shirts proclaim, "It's a Black Thing, You Wouldn't Understand," or "It's a Gay Thing, You Wouldn't Understand."

Why am I so easy to read? may stand as the emblematic question

of people who not only have to deal with a fragile sense of self con-fronted by Foucault's society of disciplinary surveillance but with a consumer culture that manipulates desire and makes us easy prey for advertisers and politicians who capitalize on our fears.

I see the art object's position in our culture as parallel to, and as a reflection of, the condition of the human subject. It is continually responding to or resisting that state of objecthood which is created and coded to be "easily read": the commodity. The speed of turnover in fashion, in lifestyle, in technological innovation is facilitated by the production of items of instant gratification, "easy reading" that is discarded once consumed. Desire for the new depends upon a quick death of the previously new and the easy fulfillment of the desire it provoked. This rapid cycling gives people concerned with their eval-uation by others a continual sense of anxiety about how they are being read.

Art in this century—under which term I include the performing and literary arts as well as the visual—has had to consider and recon-sider its relation to this sense of the commodity, especially as art competes with the works of the past that have withstood the test of time. Art objects contain or reveal the hopes and anxieties of individ-ual artists, as well as movements, which confront rapid death within a culture of continual consumption. Art objects reflect the desire for the subject's survival of identity—which, paradoxically, means resisting simple identification by others: being "easily read." Within the mod-ern ethos, *objectification* as I describe it in this book means establishing resistance to the tide of continual change that overwhelms any sense of self, as well as the defining mechanisms of hegemonic ideologies. The modern approach was to create abstract, enigmatic objects that defeat easy reading, yet whose resistance is not so drastic as to repel interest or desire on other levels. While it might seem that this resis-tance to commodification has broken down in the postmodern era, it has only shifted its ground from trying to create resistant objects to problematizing the ideological systems of "easy reading" within com-modity culture itself—developing or revealing contradictory stances within the defining codes of culture at large, thereby operating primar-ily on a semiotic, not an affective, material basis.

This shift from modern to postmodern forms of evasion of easy reading might be seen as a shift in attention from object to audience, as Henry Sayre has so aptly described it in *The Object of Performance*

(xiv). In the socioeconomic sphere, this seems to mark a parallel shift in attention from production to consumption. But the notion of a clear separation between production and consumption is problematic within postmodern, or (the very infelicitously termed) "postindustrial," culture.[1] Local popular cultures and fashions are often created through recombining various mass-cultural items aimed at distinct, if not conflicting, markets, effecting an ironic shock value. These recombined styles are then appropriated and commodified by mass culture itself, forming what seems to be a perpetual-motion machine of consumption as production and production as consumption. It is this form of ironic consumption-as-production, continual shifts of identity, that many critics involved in cultural studies see as a way the subject resists commodification from within its own logical structure. Some critics, such as Philip Auslander, maintain that there is no choice *but* to operate within the structure of commodification as the all-determining basis of our culture in general, just as deconstructionists may claim there is no "outside the text" (Auslander, *Presence and Resistance*).

In this sense, resisting commodification from within posits no viable alternative to it, only a slowdown or momentary evasion in the inevitable process of its consumption of one's identity: Duchamp's use of the term "delay" in describing his art demonstrates this approach. Both modernist and postmodernist forms of resistance appear as questions of interpretation: the modernist object enigmatically delaying its consumption by interpretive methods and postmodernist art entering discourse head on, acting out the role of theorist, revealing the contradictions in the interpretation of its own socially defined condition. And yet, critical resistance within the system of commodification is useful only for a short while, before it too becomes a refined and integral, noncritical part of that very system. Resistance, after all, is a motivating aspect of desire, and capitalism is nothing if not based on the continual creation of desire. It would seem that any resistance to the complete commodification of all aspects of existence (including oneself) requires first of all an understanding of the nature of desire that such systems promote and of other forms of desire that pose problems for such systems.

As a teacher of literature, I have learned that one of the most essential, and at times the most difficult, lessons to impart to students is not how to analyze a text in order to master its difficulties and

extract a clear meaning, but rather how to get them to develop a relatively unanxious relation to a text's uncertainties, contradictions, and recalcitrance to interpretation. Further, it is to inculcate an actual love of encountering a text that resists one's advances, that at times one only begins to understand when one doesn't try too hard to impose a singular meaning on it, but lets the text be multiple, irascible, and resistant. This kind of encounter strikes me as the opposite of the encounter with the commodity, where immediate gratification is imperative and exhaustion of the product demands more of the same; or where one switches to another product if the first is found wanting. In contrast, the difficult text remains an object of desire, whose shifting planes reveal different things at different times. In this way the object, like the commodity, can take on the characteristics of the human subject. With the object, as I believe with an ethical relation to another human being, acceptance cannot depend upon complete understanding, the satisfactions of mental consumption, which discards the person or commodified object when it is used up or demonstrates resistance to one's predispositions.

Following from this, I think it is clear that the tensions and irresolutions attendant upon the resistance of the object of art to commodification are similar to those one encounters today in issues of multiculturalism: the relation of subaltern groups to any system of cultural hegemony. The development of mutual understanding, on the one hand, is correctly reckoned to be the appropriate weapon against fear and hatred; on the other hand, understanding cannot be the sole *basis* of the acceptance of the other's right to exist: acceptance of the other, whether we understand them or not, is the beginning of understanding.[2] The problem of understanding cultural difference is made more difficult when it becomes a question of representation within mass culture; then, for the sake of entertainment values more than critical knowledge—often despite the best intentions—that representation removes the complexities of cultural identity and results in new stereotypes. Thus, made "easy to read," one is made subject again to the prejudicial actions of others. Peggy Phelan has convincingly spoken to the necessity of not being wholly visible as an identity and resisting discursive appropriation within cultural politics (*Unmarked*). While a comparison of the politics of the avant-garde with the politics of multiculturalism is something that still needs further theoretical attention, this is not the purpose of the present book.

Nor should this book be read as yet another theory of the avant-garde, even though issues raised by Poggioli and Bürger remain in the background.³ I am not concerned here with defining the avant-garde per se, or distinguishing it clearly from high modernism, since most distinctions along those lines tend to be tenuous at best, conflicted between intentions and methods; many of the figures we now revere as high modernist were thought of at the time as part of the avant-garde. Resistance to commodification is something generally shared, even if for different reasons, by artists considered high modernist or avant-garde.

It should also be stressed that any method of resistance to commodification *in itself* is no guarantee of rectitude, since for many modernists the seemingly implacable monumentality of fascism offered an attractive escape. From an entirely different perspective, one result of the "It's a———Thing, You Wouldn't Understand" phenomena—a parallel to some avant-garde provocations—is that while as an excluded group's taking on the power of exclusion it builds a resistant group solidarity, it also helps provoke intolerance on the part of those it excludes. Again, this revolves around the issue of understanding—which is commodified and reduced to a binary: either you understand or you don't, either you belong or you don't.

Despite my desire not to exclude anyone, if I could imagine an ideal reader for this book, it would be an artist who is aware of contemporary theory and how it affects both the reception and production of art. I think artists, writers, and performers who understand their own practice as an intuitive discovery procedure and not just as an illustration of a theory will recognize what I say here more readily than academics who are too caught up in the competitive field of critical interpretation to experience art on anything but an immediately argumentative, discursive level. I say this fully aware of this book's implication in that scene. But I think that no critical practice is worth its while unless it can offer encouragement to the further production of art; much of criticism seems to consist of telling us what is no longer possible, even as it is insisting that it is opening things up. The artist-reader I imagine knows that sometimes it is the critic/theorist who is to be resisted almost as much as the commodity system (if the distinction between them really holds) but also knows that avoiding theory means blinding oneself to the critical conditions of one's own time and their inevitable effect on one's work.

A number of people have helped in this writing in various ways, aiding and sustaining my efforts on material as well as intellectual levels. My deepest gratitude goes to Kimm Marks, who, through this writing, has borne my moods and methods with great equanimity, and who has helped me keep my center. I thank Herbert Blau for his confidence and critical input in this work, someone who has convinced me that thought must be blooded, that it is as much a matter of performance as performance is a way of thinking. Thanks must also go to my earliest readers, Kathleen Woodward, Gregory Jay, Bernard Gendron, Patrice Petro, and Jamie Daniel, for their constructive criticism. Likewise I thank Walter Davis for his insights and caveats as the book reached its later stages. In a spiritually material sense I want to thank Dan Grego and Deb Loewen for the use of Wild Space Farm, a place conducive to reflection and warmed by friendship. Not least, I want to thank my editor at the University of Michigan Press, LeAnn Fields, for her critical support, patience, and encouragement.

I wish to thank the College of Humanities and the School for Arts and Sciences at the Ohio State University for a grant-in-aid that allowed me to complete this book.

A portion of this book has appeared in *Psychiatry and the Humanities* 12: *The World of Samuel Beckett* (1991), edited by Joseph H. Smith, 181–94, and is reprinted by permission of the Johns Hopkins University Press. Other portions have appeared in *Boundary 2* 14, nos. 1, 2 (1985–86): 279–90, and *Journal of Dramatic Theory and Criticism* 5, no. 1 (1990): 231–43.

Chapter 1

The Fate of the Object in the Modern World

In 1920, in the second number of Francis Picabia's Dada publication *Cannibale*, there appeared a poem by Louis Aragon entitled "Suicide" (Sanouillet, *Francis Picabia*). It consists of the letters of the alphabet written in five rows; it is constructed in the familiar sequence that every schoolchild learns by heart. What is most striking about the poem is the innocence of the alphabetic form contrasted with the sinister and despairing title:

SUICIDE
A b c d e f
g h i j k l
m n o p q r
s t u v w
x y z

What does the poem suggest? *Who* is committing suicide? The reader, by submitting to the machinations of language? Or language itself, in its rationalized form, exemplified by the arbitrary, yet mechanical, structure of the alphabet? Is the alphabet the *cause* of the suicide, or the *form* the suicide takes?

How is the poem read? On the one hand, its meaning is glimpsed in a moment since its nature is primarily visual, static, and all of a piece. On the other hand, an attempt to recite the poem would result in the reader assuming the role of a child: an aspect of the regressive impulse in Dada.

Is "Suicide" really a poem, or is it a work of visual art? Though the potential for all possible language sounds and units for meaning lies within it (the letters of the title itself are drawn from it, that is, the alphabet), the "poem" itself is dumb. The more you stare at it, the

more it seems to stare back at you, but without real revelation of its character. "Suicide" as a work of meaning seems impregnable. The only way to enter it as a poem is between the title and its body (and given the title, "body" is quite an appropriate term). Yet, despite this split and the atomized condition of the body, it still appears to us as a unified object. The overdetermination of the poem seems overwhelming. It cannot be further condensed, and it has displaced all speech. Through language we commit ourselves to the destruction of ourselves by giving ourselves away, for, after all, our identities are constructed through language. The implication is that once we commit ourselves to a rationalized communicability, we condemn our (secret, unified) selves to death. It is as if our essential beings could exist only prior to the absenting power of signification, before we enter the realm of the Symbolic.

Because of the unbreachable and enigmatic unity of the poem, the real poetic act here is but the *naming* of the alphabet "Suicide." It is a commonplace in therapy or analysis that the naming of a state of mind is the first step toward dealing with it constructively (as in the exorcisms of yore, the naming of the demon is necessary to cast it out). Naming takes on a certain power, through definition, of inclusion or exclusion (it actually involves both, in the same movement). What we perhaps fail to recognize is that ever-more-exact names, and therefore refined definitions, can also serve as a source of anxiety, as a bombardment of "information that does not inform" (Baudrillard), but that may in fact *de*form. This brings us back to the point that the self (as it is understood as something unified and essential) risks its diminution (a form of death) by being reduced to an element of the world of information and language, the world of naming.

Despite all of these possible interpretations or extrapolations of this poem, I find that they do little to alter my primary experience of it, which remains as enigmatic as ever. It could be that it is because the poem itself resists its title, or maybe the title resists the poem. This may be because the alphabet does not exist in the sense that a sentient being exists, so that it cannot commit suicide; its "nonbeing" also prevents one from viewing it as a means of suicide. But even these interpretations are in themselves "rationalizations" for a response that can only be at best unclear when it tries to verbalize itself. So perhaps one's response commits "suicide" in trying to explicate its

own nature. This kind of reaction and rationalization can go on and on, but the poem still sits there in its ineluctable objecthood.

What I intend to examine in the following work is the question of objecthood and the process of objectification in the production and reception of modern works of art, performance, and literature. I wish to examine theory's interaction with objectification in art as well, especially theory that either devalues or dematerializes art, the artwork, and the value of aesthetic experience. I chose Aragon's poem to begin with because it is exemplary of modern works that resist total consumption by systems of interpretive theory. It is also revelatory of an attitude toward rationalized language that makes such consumption possible, and perhaps inevitable. Dada was a highly subjective, freedom-seeking movement, concerned with the ideal of an autonomous self, unrestricted by the institutional authority of history, bourgeois ideology, and rationalized systems of thought and production. Although what I said above about a "secret, unified" self that resists language may seem specious to us now, after the poststructuralist analysis of language and the subject, it was nonetheless a strong motivating force for those resisting the more oppressive aspects of modernity that coincided with the traditional values and disciplines of home, country, and law, institutions involved in the creation of subjects.

It must be made clear that Dada was not the only movement in art or literature that was concerned with resisting the rapidly developing forces of rationalization. The "difficulty" that T. S. Eliot, as well as Walter Benjamin, maintained was necessary in the modern work of literature kept its artistic energy from being dissipated in a too-easy reception; it is what produced the longevity of the work. This attempt to resist consumption can be seen in almost every modern work of art, literature, and theater. The primary form of resistance is the creation of an object that proclaims and draws attention to its objecthood, that is, that resists rationalized language's tendency to reduce it to a sign to be consumed. I will call this process one of *material* objectification. In this chapter, as I move between allusions to objectifying tendencies in art and an exposition of theories applied to art, it will become more apparent that theory itself has a tendency toward self-objectification in this way.

There is another sense of objectification, which I will designate as

referential objectification, which has a more problematic relation to an ethos of resistance to rationalization. For example: in poetry it began as a reaction against the reification of poetic language by the worn-out practice of nineteenth-century symbolism, itself a weak form of subjective resistance to the forces of modernity. Ezra Pound, T. E. Hulme, and other *imagistes* attempted to come to terms with this impoverishment of language by "returning to the things themselves," as both William Carlos Williams and Edmund Husserl proposed, and by allowing the energy of material objects to reinvigorate a language become effete through abstraction. The poem itself became, in the process, an object separate from the personality of the poet, a crafted work with the implacable qualities of cut stone, and that burned with a "gem-like flame," as Pater put it. Cut stone became a primary metaphor for Pound, inasmuch as it indicated an object that resisted the forces of time as well as fashion. Although Pound indicated that the image was always the most "adequate symbol," which precluded it from being taken only as literal reference, later forms of referentially objectifying poetry had an uneasy affinity with more positivistic, hence rationalistic, uses of language.

Objectification serves two purposes: that of the creation or depiction of an object that cannot be further reduced to the state of a "name," and that of the *process* of naming itself, that would *identify* the object for the subject. There are objects that can be reduced to a name and objects that resist that reduction. If we could never imagine the world as comprised of objects without names (or even as nameless experience), we would never be able to examine language as we do, as an "object" separate from other objects. Nevertheless, the first questions we are asked as human beings are "What's that?" and "Who's that?" This is the specificity of the household, the earliest environment where certain objects are valued and used in certain ways and others are not. It is the beginning of the personal investment of value and language into things and other people. It is also where one learns to objectify oneself in a world of others.

It must be made clear that I will not be emphasizing *objects* as static "things-in-themselves" so much as the *process of objectification* itself, which is never entirely completed. It is in fact an aspect of ongoing *consciousness* that it needs to objectify things in order to re-cognize them in the first place; this is a function of memory.

The project of objectification is necessarily an incomplete one. An

"art object," a "literary object," even a "theoretical object" is not something static; rather, it is something that is always being objectified as long as attention is paid to it. An objectified human being is not merely an object but is rather someone who exists and experiences the objectification of her- or himself in daily life, as Sartre has pointed out (*Being and Nothingness*, 229). The big question in art or in an artful life is whether to allow others to objectify you or to try to take control of your own objectification. Perhaps this is a postmodern analogue to Marx's saying that workers should take control of the means of production: trying to designate how others should consume your meaning as an individual. This is a performance problem, a kind of self-objectification as self-fashioning, whether the intention is to display one's self, to be found in the bohemianism of the dandy, or to hide oneself, as Eliot disguised himself as a bank clerk.

The limit of self-objectification is the empty space, the blind umbilicus, the hermeneutic circle in which the determining (and always being determined) consciousness exists, inaccessible to any final self-reflection. In this sense the self is unfinishable, and at best can only become other than what it is. The objectification of self is always done in terms established by others. Hence, the true situation of objectification is a social and not merely an individual one. This is yet another reason why objectification is an ongoing process and not a fait accompli.

The question of the object itself depends upon designating it against the ground of the subject. Even these terms are reversible according to perspective, as Sartre has indicated in *Being and Nothingness*. In order to realize that you are acting or thinking subjectively in the first place, you have to objectify yourself. If one thinks of the artist as subject and artwork as object, we can see how nowadays art is most often introduced as the ground upon which the figure of the artist is displayed as cultural hero or figure of fashion, and not the other way around.

"To be an object" is conventionally construed as negative. "To be objective" about things, social conditions, and so on, is generally construed as positive, although it is really an act of subjective will. Yet to "objectify others" is a necessary step in being "objective" about the social. The real question is not about objectifying others, or even one's self, but *how* others are objectified. If your objectification of them matches their self-objectification, they will be satisfied; if not, it will be

construed as dismissal or the desire to control them. This tendency is most evident in issues of gender and "the gaze." Since Laura Mulvey's influential essay, "Visual Pleasure and Narrative Cinema," there have been tendencies among some feminists to hypostasize the male gaze as a predominant force in culture and any gaze that objectifies as inherently a "male gaze"; some have even attempted to envision an operation of desire without a tendency to objectify, which, I hope to demonstrate, is not possible. Ultimately it is a different kind of question of power: self-fashioning versus having a particular self-image culturally imposed as the true one upon the individual or group. In this regard one can find conditions where criticism of the male gaze is eminently applicable and necessary. There can be, however, a certain pleasure in being an object, if one feels capable of any efficacious and recognizable self-fashioning: in the self-objectifying revelations of one's own unconscious, in making oneself an object in everyday life performance—an object of respect, of affection, of desire, even of dread—a force in women's performance art, from Rachel Rosenthal's ritual work to Karen Finley's violence of the abject. The question might be further broken down into the idea of being a *human* object versus being an *inhuman* object. But this already presupposes varying ideas of humanness, and of manhood or womanhood.

How are we made aware of the material and ideological construction of our personality or consciousness? Through the objectification of the contradictions of that construction. Those contradictions free us, through estrangement, from that construction to the extent that we can objectify it for our own consciousness. By objectifying reality around and outside us we learn to objectify ourselves. Yet we wouldn't know how to do this if reality were not already objectified for us.

For the rest of this chapter I want to set out the terms and conditions through which in later chapters I will examine the shift from modern to postmodern artistic practice—from the purified object to a field of signs. I use the heuristic of a slowly shifting figure-ground to show how art production has defined itself in relation to or against capitalist mass production, while as an autonomous sphere it shares a similar mode of development—Weber's notion of rationalization. A critical reading of Lukács's definition of reification provides the ground against which I will posit my contrasting figure of objectification as a

goal of modern art. I see as parallel to these terms within discourse the functions of literality and metaphoricity; the drive toward literality in art as we approach the postmodern, even if initially a resistance to discursive appropriation, will eventually help dissolve the enigmatic object into its signifying and commodifying ground. In terms of production, I designate the shift in artistic practice concomitant with the shift from modern object to postmodern sign as moving from "expressive labor"—parallel with a capitalist production economy—to "conceptual investment"—cognate with the shift to fiscal capitalism and a so-called postindustrial information society.[1] On the level of reception I distinguish between nonpossessive contemplation of an artwork and the possession and/or consumption of a commodity, also looking at art's tensions with and resistances to the reifying interpretive methods of aesthetics and the ethos it establishes. Finally, I look at how the hegemony of conceptual investment—through the objectification of linguistic and semiotic systems as our ground of experience, and the shift in privilege from art production to theory—has altered our relation to the materiality of the world.

THE SHIFT FROM FIGURE TO GROUND

In the course of this work I wish to propose various heuristic methods by which one can reexamine modern artworks as objectified. I say heuristic because, although I might employ the methodologies of various analyses—historical materialist, phenomenological, deconstructive— I do not do so for the sake of legitimating their *mythologies* as definitive explanation. I am concerned, rather, with how artworks rub up against the limits of these theories, even while corroborating them to a certain extent.

One such heuristic approach is that of the well-known gestalt, the figure-ground model, exemplified by such conundrums as the duck-rabbit picture or the two profiles–one vase configuration. One cannot see both figures at once, although the discernment of figure in both cases depends upon seeing the other element as ground. The shift in focus can be seen as a sort of deconstructive "hinge." A poetic example of this is Wallace Stevens's "Anecdote of the Jar," in which the jar placed on the hill in Tennessee "made the slovenly wilderness / Surround that hill," the wilderness that "sprawled around, no longer wild," while the jar "took dominion everywhere."

While the wilderness sprawled around and "rose up" to the jar, seeming to return the hill and jar to its natural state, it is the *jar*—the apparent object dispersed as object—that took dominion. This goes to the heart of the assumed nature/culture division.

In calling my method a figure-ground system, I mean to oppose the sense of dialectics as a way of reconciling opposites; it is close in sense to Theodor Adorno's negative dialectics. Thus the meaning of both figure and ground is obtained through the dialectic of its complementary tension, without resolving that tension. The process of changing focus is the same as the process of contradiction. Contradiction as a space of freedom is also a source of energy, inasmuch as energy, in a real physical sense, is produced by a gap, a resistance, that creates a difference in potential. That gap is created in individual consciousness by that particular form of freedom which can be read as the tension between the particular and the universal. This is why desire cannot exist without an object: desire needs a potential that is separation, the resistance of the object to the subject. One should not forget the gap in potential that seems to obtain as well between the conscious mind and the unconscious (the repressed): the manifestation of the preconscious as the energy flow of the Imaginary.

The attempt at overcoming dichotomies (theory and practice, subject and object) through a linguistically based consciousness of totality will always be doomed to failure as long as we are bodies, particulars in a generalized world. The alternative would be to acknowledge and develop what would be the most *productive* tension between these things and to stop worrying about overcoming any split; rather, by operating creatively *within* it, it is already overcome.

A figure-ground relation typifies the workings of metaphor: the relation of a formal similarity between two different takes on reality, each of which can be taken literally or used metaphorically according to which constitutes the figure and which the ground in any context. The most literalist of poems, which may try to eliminate metaphysical tension, can still be read allegorically—that is, the *entire content* becomes metaphorical within an implicit "literal" ground of the context of reception that is provided by the reader. Ambiguity can provide a multiplicity of relations, as New Critics were quick to point out, but these relations can be effectively observed only as a multiplicity of

dialectical relations and acknowledged one at a time, again with each allusion seen against the literal content.

Both poetic symbolism and objectivism, despite their supposed antithesis, eventually meet in their respective reductions to the ground of signification. Both demonstrate an emergence of self-consciousness in different ways—through the objectification of the spiritual (the internal) and the other through the objectification of the material (the external). Inasmuch as we are comprised of both inner and outer (even if our identities can be read as temporal "folds," as Foucault said), if either side chooses to completely claim hegemony over human consciousness, a balanced sense of being is lost. It is the objectified contradictions and fragmentations of both the spiritual and material that give rise to self-consciousness in the first place. But these contradictions are only initially apprehended through a language. By language, I do not mean only verbal discourse; I mean it in a larger semiotic and affective sense, as one can claim to "read" a painting, say, or bodily gesture.

Perhaps one can say that any objectification, idealistic or realistic, that attempts to achieve formal perfection has a tendency to turn into its opposite. Thus in the meeting place of language, symbolism finds its processes objectified in both semantic and syntactic systems (Mallarmé: one does not make poetry with ideas but with words), while imagism and objectivism find their limitations in the mediations of the symbolic, clearly seen in Pound's attempt to adapt poetry in English to Chinese forms.

The reversal of figure and ground in modernism is incremental in its development. It begins with the figure of idealized individual aspirations grounded in nineteenth-century bourgeois ideology, which sees itself as a universal norm. Gradually an awareness of the very materiality of that ground begins to call into question the idealized figure, because the ground slips away from universality through the contradictory changes produced by material progress. Temporality becomes an issue, whether through the depiction of changes in light by Monet or the inability to maintain a cohesive sense of self through memory, as described by Proust. This threatens the sense of stability of the figure as relatively static and predominantly spatial.

The concentration on the object in early modernism was a way of trying to fix the figure spatially against the ravages of time. But the

object that proceeds from expressive labor out of the personal immedi-
acy of perception, newly emergent from the subjective depths of ro-
manticism, finds only a tenuous existence as a thing-in-itself before it
must encounter its ground in the social and in history. Pound under-
stood this as he transformed the image into the vortex: the inward rush
of ideas within particular historical events, sites, and biographies.
Among his followers this resulted in the opening up of the object into
the larger ground of myth as sociohistorical topology, culminating in
the field poetics of both Charles Olson and Robert Duncan. In a more
radical vein, experiments in concrete poetry display as its figure the
conventional ground of visuality, as we have seen with Aragon's
poem, just as experiments with Sound poetry, from dadaists Hugo Ball
and Kurt Schwitters and the Russian futurist "transrational" language
of *zaum*, to John Cage and the ethnopoetics of Jerome Rothenberg,
make a figure of the material ground of orality. Similar figure-ground
shifts can be seen in music, in the work of John Cage; in art, within
minimal and conceptual art; and in dance, from Merce Cunningham to
Judson Church and Grand Union.

The question may be raised as to whether an actual reversal of
figure and ground is taking place, or if it is simply a movement of
the figure trying to *consume* its ground, growing larger and larger in
scale. This question might be asked of obsessively self-reflexive
theater and literature, in which the ground of appearance and lan-
guage tries to wholly consume the figure. Neither consumption can
actually take place, given the objectifying differential basis of con-
sciousness, whether perceptual or conceptual. Actual consumption
of either figure or ground would result in blindness or the loss of
consciousness altogether. One can say that in both theater and dance
the body in itself posits a figure-ground relation: that of body as sign
and that of body as body, a mortal *thing*. No matter what the space
of performance or type of movement or language employed, this
relationship permeates the scene. In the long run, the attempt to
reverse figure and ground can only do so by calling attention to the
ground instead of the figure, but its actual accomplishment can only
take place in the audience's receptive attitude.

A great many modern artists and writers began their work as a consoli-
dation of, or investment in, an object, predominantly static objects.
The static is seen as the start of the development of each art. It defines

itself through difference and resistance to forces of change or alteration, including the altering power of interpretive forces: the object strives "to alter not when it alteration finds."

But then the artist finds that the static object, while resisting change in some inertial way, has no energy of its own and is swept over by the tides of change. To compete with the forces of modern life, and to prevent the object status from quickly being reified, the artist must incorporate a systematic structure that maintains self-conscious, constant, and dynamic tension between the work's objecthood and the possibility of its dissolution (consumption). It is its shifting character in each new context of reception that prevents it from being "naturalized" (reified), rather than its static muteness that relegates it to a hermetic, asocial realm. The tension that creates the dynamism of the artwork is between its criticality as resistant structure or idea, and its palpability, or "suchness." Between these two poles the seductive nature of the object operates. Works that are only critical quickly become dated or subsumed by an ideological system and no longer function as art. Works that rely only upon their palpability suffer the fate mentioned above, that of the static, hermetic object. The real question lies in determining *where* the palpability and criticality encounter each other in the work. In some cases, perhaps in all, it can't be found *in* the work, but rather in that work's relation to both its particular ground of production and reception.

What has to be taken into account is how the "form and content" of the work correspond to the "form and content" of a particular social milieu and epoch. Wallace Stevens understood the role of imagination as one that relieves the strain of reality: "It is the imagination pressing back against the pressure of reality" (*Necessary Angel*, 36). It is possible to view how the imagination operates formally over against any particular reality.[2] If one sees the operations of art or imagination as a strategy to resist the strain of necessity within reality, one has to observe how that strain manifests itself. There can be the strain of the real that is chaotic, unstable, and unsure, which older forms of art are no longer able to resist and have perhaps cynically accommodated themselves to. There is also the strain of the real, in which reality has become all too compartmentalized, ordered, defined, and restrictive for any vital existence to develop within its forms. In a time of social upheaval, when the world seems or is in chaos, a new ordering of form within works of art will not seem authoritarian but will provide

much needed relief, if not inspiration, to those seeking direction. This can be seen in the poetry of Pound, Eliot, and Stevens, and in the visual art and architecture of constructivism, for instance. If that form takes root and imposes itself for too long after things have become relatively stable, it can indeed become authoritarian, either resisting change or subsuming all change unto itself. At that moment, forms that provide personal resistance to this regime, that disrupt its self-satisfied grip on reality, are called for, usually seen in this age as forms of "willful indeterminacy" and anarchic interpretations of reality. We can see this in the literature and performance of Dada, James Joyce, John Cage, William Burroughs. When *those* regimes last too long, and the social ground becomes chaotic, then anxiety, impotence, and the desire for substance, the dissatisfaction with subjective relativity that flattens out all values, gives way once again to a "rage for order." So in one case art puts a halt to the chaotic and insecure strains of reality through the imposition of form; in the other case art attempts to disrupt and transgress the boundaries set for individuals and art by an oppressive society. This should not be taken to mean necessarily that these two forms of reality are always sequential according to particular ages, although there can be a generalized ethos involved. Both responses can be contemporaneous, which is the case within the conflicting fields of modernism. Once that is established, one must consider the figure to which the particular ground, or interpretation of reality, is opposed; that is, one must examine the ideological and biographical particulars of the artist's vision of things. Yet in the *reception* of past works of art, this figure-ground relation operates in the same way: depending upon the nature of one's position within any era, past works that are either orderly and masterful or indeterminate and disruptive will take personal precedence. As a "word's meaning is its use," so is a particular form's meaning its use.

In every age where a major shift in consciousness takes place, the agents of change tend to react to the more decadent trends of their age, the ones that have hung on too long after social change has occurred. At the same time this reaction is but a culmination of the logical development of those decadent trends, which usually end in self-contradiction. If the reaction tends to be only a nostalgia, a desire for earlier, clearer values, it is bound to fail. If it negotiates that desire with the inevitable change wrought by the exhaustion of a system of thought, it is prophetic.

RATIONALIZATION

Max Weber has described the progress, since the Renaissance, of what he called the "rationalization" of the modern world. Its development involves the gradual "disenchantment of the world," with the replacement of magical thinking by reflective reason (*From Max Weber*, 51). Collective myth, which for so long acted as the unifying element in culture, is displaced by a reason that compartmentalizes reality through what Michel Foucault calls its "will to knowledge." This compartmentalization results in what Weber designates as autonomous "cultural spheres of value," namely three: science-technology, art-literature, and law-morality. The separation of the artistic sphere from its relation to the culturally unifying agencies of religious and centralized political power has resulted, through the ongoing process of rationalization, in art's search for its own "essence." Jürgen Habermas has noted that art becomes rationalized when, first, it becomes autonomous, second, it divests and purifies itself of "theoretical and moral admixtures," and third, in reflecting upon its own formal processes, it makes those processes transparent (*Theory of Communicative Action*, 1: 178). In part, the rationalization of art, its will to self-knowledge and the attempt to eliminate all but its most absolutely essential features, can be seen as the will to autonomy from other, "exterior" forces that would define it for their own purposes.

Each particular form of art within modernism has engaged in this process—literature, painting, sculpture, music, dance, theater—and in each, the relentless pursuit for understanding the essence of its formal properties has resulted in one or another kind of minimalism. Each has reduced itself to its most basic form of objecthood—sound, color, plastic form, and so on, but each has also drawn attention to what gives that form its shape—silence, emptiness, stillness. This movement has even resulted in certain reversals of work that end up encroaching on the territory of other arts or disciplines: conceptual art's reliance on language, minimalism becoming body art then performance art, which slides into the theoretical purview of theater.

The process of rationalization in art is then one that becomes increasingly self-conscious about how meaning is produced or constructed through any particular material form (verbal, visual, aural) until that "how" becomes the meaning itself, the "what." The problem

is that the "how" within a social context becomes an ever-changing if not continually receding horizon of possibility, or horizon of expectation, at least, when one attempts to objectify finally its "whatness."

In reaction to a society in which, as Marx put it by invoking Shakespeare, "all that is solid melts into air," many artists in their minimalizing self-reflection have eschewed what is human as too ephemeral, in order to create works whose objecthood and survival value largely depend upon the elimination of representation, of the human or anything else. Paradoxically, the nonhuman object becomes a refuge for the self—a materialized projection of inner creative consciousness. Wilhelm Worringer, an aesthetic philosopher championed by T. E. Hulme and Wassily Kandinsky, described the attraction of the "hieratic" and the modern preference for the "abstract" Egyptian style over the "empathetic" Greek naturalistic style. Although originally speaking about primitive man's development of geometric art, Worringer's ideas seemed to some, like Hulme, to be transposable to modern existence. The modern preference for the hieratic over the organic exemplifies the desire for the tranquility of pure geometric form that provides refuge from the chaotic vicissitudes of modern urban life. Worringer describes the primitive relation to art this way:

> The simple line and its development in purely geometrical regularity was bound to offer the greatest possibility of happiness to the man disquieted by the obscurity and entanglement of phenomena. For here the last trace of connection with, and dependence on, life has been effaced, here the highest absolute form, the purest abstraction has been achieved; here is law, here is necessity, while everywhere else the caprice of the organic prevails. (*Abstraction and Empathy*, 20)

The modern desire for the abstract objectification of self that this reflects emerges from the existential dread of a loss of self, inspired by the vertiginous positioning of the human being at the edge of the abyss of history and mass society; the caprice of history and progress has replaced the caprice of the organic.[3]

To contemplate this artistic relation of subject to its object, it may be necessary to examine the subject's resistance to death, not merely

physical death, but many other types of death that are the by-products of rationalization: the demise of the human element in life, or mechanization; the death of the individual in the mass; the death of the importance of the particular moment within world, or even cosmic, history (evolution); the death of qualitative value within the equivalences of a monetary system; the death of solidity within particle physics; the death of unitary time within the theory of relativity; the death of the conscious will with the discovery of determining unconscious desires. The concentration on the object itself belies a hidden doubt about its stability. The concentration on subjective perception is a way of seeking a self that can traverse the ephemeral phenomena of events and remain "whole," which means "pure." The notion of hygiene, whether applied to the Great War by the futurists, Dada's "sweeping clean," or Mallarmé's "purifying the dialect of the tribe," is a primary motivating force in modernism that wishes to preserve a unified subjective will, even through a stoic emphasis on "impersonality."

Yet rationalization in its socioeconomic role is itself a purifying process, seen most clearly in the development of the division of labor to enhance production. Primary technique becomes an end in itself, separating the consciousness of its operations from a consciousness of how it fits into the overall scheme of things. "Technique" as the primary agent of rationalization still operates at the forefront of society, but instead of being sustained by legislative fiat, as in the Enlightenment, it has become a self-perpetuating, cybernetic system. It has fractured into ever tinier self-conscious bits every aspect of experience. Technique, as described by Jacques Ellul in *The Technological Society*, becomes a kind of independent "demonic" force in modernity, something akin to a virus.[4]

Artistic modernism had utilized self-conscious technique originally as a kind of negotiation between the reason of classicism and the natural intuitive values of romanticism, between mind and heart, fact and value. Some either ask if modernism has failed, or openly aver the failure of modernism.[5] But perhaps what's really the case is that modernism has succeeded: resulting in the entire *sublimation* of the conflict of classicism and romanticism, realism and idealism, subject and object—in other words, the emergence of postmodernism, in which concern with neither fact nor value obtains.

These qualities are replaced by technique, by cybernetics, or what Lyotard calls "performativity," a kind of pragmatic nihilism (*Postmodern Condition*, 62–63).

The task at hand is to examine where and how artworks advance the process of rationalization within society, and where and how they resist it. The problem is one of reception and its context. For example, the compulsion in modern art toward nonobjective, abstract forms might ultimately be seen as a desire to make the human separation from nature complete. On the other hand, this separation may have been seen as necessary in order to bring forth the "higher" truth of nature that is *within* the human, as Kandinsky attempted to express it. The alteration of reality by mechanization carried with it a weight of inevitability, and the delight with which futurists, for instance, hurled themselves into a new symbiosis with machines can be viewed as a form of species adaptation. Perhaps one shouldn't think of the question of dehumanization as if we know exactly what that means (except in its broader sense as the extinguishing of life or vitality), since the question of what is human is always historically retrogressive—we're never as human as we used to be. It ignores the adaptive capacity of the organism. Even so, where it *should* be addressed is to the points of the organism's *in*capacity to adapt, where excessive and gratuitous measures (as a result of this assumed incapacity, or as Peter Sloterdijk calls it, "self-preservation gone wild" [*Critique of Cynical Reason*, 324]) result in massive pain and death. The rub is figuring out the point where things become excessive and gratuitous.

REIFICATION

A term that I will be using as a kind of ground for the figure of what I designate as objectification is *reification*. I ask the reader to bear with me in this section, as I will depart from more specific references to art to engage in a more extended analysis of this term, in order to demonstrate the necessary ground against which the process of objectification in art must be understood. Reification is a term widely used by sociologists and cultural critics, and it has been used in positive, negative, and indifferent senses. The variance in its use often results in the vagueness of its meaning, which is generally not explained very clearly. I intend to use it in a particular way that, depending upon circumstances, can be

seen as either neutral or negative. Inasmuch as it has a connection within modernity to the forces of rationalization, I will examine the most complete articulation of its meaning in this regard, to be found in the work of Georg Lukács, specifically in his book *History and Class Consciousness*. Lukács draws specifically from Weber's notion of rationalization and Marx's notion of commodity fetishism in order to define the term for his own position.

Reify is generally defined by various dictionaries as "regarding or treating an abstraction or idea as if it had concrete or material existence." Lukács introduces the concept by speaking of a social relation that takes on the character of a thing, a "phantom objectivity," and whose "objecthood" hides that relation from our sight (83). He also speaks of man's labor as becoming "something objective and independent of him, something that controls him by virtue of an autonomy alien to man" (87). In both cases he is speaking about a relation, or a force, that, ideally, should not be objectified, that is, separated from its "owner" or "owners." For the moment man's labor becomes objectified, it becomes subject to forces of commodification and man himself becomes a commodity.

Lukács speaks of reification as separating the worker from his labor or the fruits of his labor, so that he is left in a state of contemplation toward these objects, while contemplation itself "reduces space and time to a common denominator and degrades time to the dimension of space" (89). It does this by ignoring the "qualitative, variable, flowing" nature of time, making it space through quantifying it (90).

We can observe from the above that these early ideas of Lukács, against the impersonal world of (manufactured) objects and "objectified" relations, are formulated in the name of subjectivity and process. His "realism" is in fact an idealism that is the reverse of Hegel's, desiring the overcoming of the dialectic of subject and object by the *subject*. He appeals to the Romantic concept of "nature" as "authentic humanity" whose inward organic nature overcomes dichotomies:

"Nature" here refers to authentic humanity, the true essence of man liberated from the false, mechanising forms of society; man as a perfected whole who has inwardly overcome, or is in the process of overcoming, the dichotomies of theory and practice, reason and the senses, form and content; man whose tendency to

create his own forms does not imply an abstract rationalism which ignores concrete content; man for whom freedom and necessity are identical. (137)

This idea of man as a "perfected whole" seems quite monadically individualistic for a Marxist like Lukács to posit. Yet in his overcomings, he seems to also be overcoming the dichotomy of self and other, while being complete unto himself. This describes neither a social being nor a user of language.

Although Lukács uses both the terms reification (*Verdinglichung*) and objectification (*Versachlichung*), he does not draw a very clear distinction between them, and often they appear as interchangeable. It is sometimes hard to tell whether *any* form of objectification is not tantamount to becoming a commodity. Thus, when he speaks of the "self-objectification" of the worker, he indicates that this is the same as the transformation of one's self into a commodity (92). Perhaps I should clarify this point by saying it is not a *freely* chosen self-objectification, in the sense of one assuming a role one enjoys, but rather a socially *coerced* self-objectification. Yet, later on, to accentuate the possibility of the proletariat's becoming self-conscious, he speaks of the worker in this way:

> He is able therefore to objectify himself completely against his existence while the man reified in the bureaucracy, for instance, is turned into a commodity, mechanised and reified in the only faculties that might enable him to rebel against reification. Even his thoughts and feelings become reified. As Hegel says: "It is much harder to bring movement into fixed ideas than into sensuous existence." (172)

In other words, since the laborer doesn't use his mental faculties while working, those faculties are freer to recognize his situation than the reified mental faculties of the bureaucrat. This implies that true self-consciousness depends upon the freedom created by a mind-body split.[6] But we can see here too that Lukács uses "objectify" in a positive sense: the worker can objectify himself *against* his existence because his "humanity and soul" have not changed into commodities. But this kind of self-objectification (which is self-consciousness) in-

volved in proletarian dialectics paradoxically functions to *overthrow* the self as object: "[S]ince consciousness here is not the knowledge of an opposed object but is the self-consciousness of the object, *the act of consciousness overthrows the objective form of its object*" (178). That is, the worker realizes "subjectively" his former status as object and is therefore no longer bound to it. But it is my contention that *subjectivity* is only known to us *as it is and remains objectified for us*, whether it is through *self*-objectification or through the critical gaze of others. A change in our general consciousness can occur only through objectification of it for us and/or by us. The main problem here seems to be the confusion of the ideas of commodity and object, of self as "objective" use-value defined by others, and self as self-defined object resistant to this, which Lukács calls "subjectivity."

The question of reification as rendering an abstraction or idea as a *thing* is important, for in fact it comes close to Foucault's notion of a "positivity" or "the production of truth." That Lukács believes self-consciousness enacts the overthrow of the objective state of the worker demonstrates that an idea or mental state generates material effects, and in a certain way, *materializes itself*. This might be made clearer if one realizes that in German *dinglich* can also mean *real;* so reification is a realizing process, close to the sense of the French verb *réaliser*. Lukács himself states that "Only by conceiving of thought as a form of reality, as a factor in the total process[,] can philosophy overcome its own rigidity dialectically and take on the quality of Becoming" (203). According to the definition, he is here reifying *thought*, just as elsewhere he will reify *history*. Part of the reason Lukács privileges time over its "degraded condition" as space is that consciousness of history turns objects into processes that can be altered to provide utopian hope. Yet even in *conceptualizing* time to speak about it one *necessarily* "degrades" it into a spatial metaphor.

Lukács seems to be saying that only through reification of self-consciousness, otherwise known as subjectivity or subjective will, can social reification be overcome. In a certain sense, this is a project of *de*realization:

Reification is, then, the necessary, immediate reality of every person living in capitalist society. It can be overcome only by *constant and constantly renewed efforts to disrupt the reified structure of existence*

by concretely relating to the concretely manifested contradictions of the
total development, by becoming conscious of the immanent meanings of
these contradictions for the total development. (197)

Who is to say whether "concretely manifested contradictions"
and the response of "concretely relating" to them is not simply a less
obvious way of talking about "subjective" action in relation to "objec-
tive" conditions? Notice that reification is the "necessary, immediate
reality of every person living in capitalist society." Isn't it possible that
it may be the necessary immediate reality of people in any society?
What would a utopian society be like whose everyday reality was not
reified? It would be a society where all "immanent" social processes
would be transparent to everyone, which would mean that each indi-
vidual's thought would be transparent to itself as process. It would be
a society *mise en abîme*, a society of subjects without objects, and one
as fantastic as the "man as a perfected whole." Even though I concur
with the idea of finding freedom in contradiction, the very attempt to
completely overthrow the reality of reification through the "constant
and constantly renewed efforts to disrupt the reified structure" by
concretely relating to contradictions of the *total* development (assum-
ing you knew what that was) of reality, especially in this day and age,
could only result in paranoid ineffectuality.

The question to be asked at this point is whether reification is a
realizing or a derealizing process, or can it be both? If it conceals the
actual processual nature of reality through objectifying it, then it
should be read as derealizing and mystifying. If it is a "necessary,
immediate reality" (ignoring for the moment the question of whether
reality is ever unmediated) of people in capitalist society and that
produces real effects, then it can only be seen as a realizing process,
the making real of an ideological approach to reality. In either case the
actual effects of a certain mental attitude, through practice, alters the
nature of material reality and conforms it to that attitude, even if not
without contradiction.

The idea of reification has to be considered in its relation to
both things and ideas. In a sense, reified ideas become "things-in-
themselves," just as fetishized commodities conceal their natures as
the products of labor and are seen as things-in-themselves. But is
this entirely true? Terms or material items that have use value to us
as commodities *cannot* be seen as merely things-in-themselves, for

they would then resist our use or consumption of them. So although I might admit that reification, especially as it applies to terms or ideas, begins as a *kind* of objectification, for it to have any value it can not be seen only in its objecthood. It is first objectified in order to distinguish it from the general flux of reality, and then personal value is projected into it (it becomes "fetishized," cathected) for it to be utilized or consumed. In other words, it becomes subjectified. For any term to have use value it must become reified; that is, the multiplicity of meanings within its "natural history" must be repressed or ignored if it is to have any value for any particular task at hand. While it is necessary—and this has been the task of poet as well as philologist—to constantly remind ourselves of the history and diverse applications of words, to prevent them from being used unreflectively as universally applicable and always true, we cannot help but at least provisionally accept their reified status for them to be of use in interpretation or communication. To call into question consistently and constantly the nature of the words we use can in the end only reduce our tasks to silence. At best, in a particular interpretive situation, we accept the use of certain terms as provisional transcendental signifiers in order to use them at all. Paradoxically, the reified as "ordinary meaning" is understood here as transcendent, even if its status as such is provisional. What is it in the nature of language that, creating the notion of reification in the first place, can really resist it? Where does the search for the sources of reification in language end? Traces of mythology, universalism, "human nature," in contemporary society have been seen as elements of a reified consciousness. But what is to prevent *any* accepted categories or notions (that is, notions agreed upon through some form of tacit consensus) from being "reified consciousness"? This is the same kind of development as the attempt to rid language entirely of transcendental traces, a self-defeating project.

Although reification might have begun with the semblance of "object" status, it is not objectification at all, but subjectification. It refers to what Sartre, in the context of the theater, called the image rather than the object (*Sartre on Theatre*, 87; see chap. 2). It is what is made constant, therefore familiar, instantly recognizable and comprehensible, "eternal" for all intents and purposes. It is what is *literal* (I will return to this later). At base, all that reification refers to is what

has become habitual in perception and therefore takes on the semblance of something that has always been true. This is common to most cultures, but in Western modernity it specifically refers to the rapidity of this habituation through the leveling power of money (capital) as the standard of all value. So at best, at least within this system, in order to keep a relatively demystified, balanced, and healthy positioning of ourselves within the material world, all one can hope for is the ability to slow down this process of rapid habituation through the creation of objects that confound for a while this final leveling power in the social production of meaning.

In its benign form, reification simply operates as a literal ground against which we can view the uniqueness and vitality of the particulars of life "in themselves," and so restore our faith in life. In its more malignant form, reification, as the runaway production side of the creation of commodities for us to consume, must consume the material world itself, reducing *all* of its resistant and enigmatic qualities to that of mere sign, leaving no material alone to confront us in its objecthood and to remind us that we are objects in the world as well, and not just the masters and consumers of material.

To eliminate reification altogether is a specious aim. It can only be seen and maintained in a complementary figure-ground relation to what I have called objectification. The practice of objectification is a way of resisting the hegemony of reification and an attempt to balance the equation. Objectification as I use it is similar to what the Russian formalists have called "defamiliarization" (*ostranenie*), only my concern is to see how it operates in the service of both subject and material reality within society. Neither reification nor objectification when first applied to material is a matter of essence—nothing is "inherently" reified; it is a matter of focus, of socially directed or enforced perception.[7] There is nothing wholly objectified or reified; elements are always mixed in varying degrees according to context. The wholly objectified would be past rationalization, enigmatic, utterly private, entirely idiolectic, that is, dumb: the silence that a dadaist such as Hugo Ball was reduced to in his search for a private language. The wholly reified would be the totally rationalized, totally public, vernacular, generic, mythic. The fact that our perception of objects can contain a mixture of the objectified and the reified explains why Duchamp could take a reified object and "express" it as newly objectified by shifting its ground of reception. Reification is a background

created by attitudes or states of mind against which we see objects that have more or less importance to us at a certain moment. When an object that is reified is seen by us in a new way, it rises out of its background status and becomes a figure in its own right. Yet it can perhaps more easily work the other way as well. Elin Diamond, in speaking of Mother Courage's snapping shut of her purse, says that "This gest has become something of a reification" (89). So the two perceptions, as defamiliarized and reified, can be just a hair's breadth apart, but what this also indicates is that reification occurs through repetition. Yet defamiliarization does too, as any child who repeats a word over and over again knows well.

Repetition as it operates in the service of reification can be seen as a form of "truth production," a literalizing process. A commonplace in political rhetoric is that if you repeat something long enough it takes on the semblance of truth; if people then act on it, it *becomes* true. Objectification shares with metaphor an ambiguous edge, a reserve of indeterminacy that defies simple repetition, a possible self-contradiction as pure sign inasmuch as it is not a tautology. Literalization attempts to defeat this ambiguity that contains within itself an enigmatic lacuna that resists discursive consumption.

LITERALITY

> What then is truth? A movable host of metaphors, metonymies, and
> anthropomorphisms: in short, a sum of human relations which have
> been poetically and rhetorically intensified, transferred, and
> embellished, and which, after long usage, seem to a people to be
> fixed, canonical, and binding. Truths are illusions which we have
> forgotten are illusions; they are metaphors that have become worn
> out and have been drained of sensuous force, coins which have lost
> their embossing and are now considered as metal and no longer as
> coins.
> —Friedrich Nietzsche, "On Truth and Lies in a Nonmoral Sense"

What then is the literal? Although often mistaken for a direct perception of "how things really are" or "what is right there before you," it is in fact a largely unquestioned, totally conventionalized approach to reality, that through social habituation seems to be an unmediated perception expressed by transparent terms. It is not quite the word

taken for the thing, but almost; in this sense, it appears to be synonymous with reification. The word *literal* itself demonstrates that it cannot really apply itself to things, only to the self-conscious mediation of language in its effort to do just that. So the literal is a medium's attempt to efface itself before reality, but in the process it becomes only more of what it is, forgetting its metaphorical roots. In fact, it is the *unconventional* nature of metaphors that makes the literal seem more direct in its treatment of reality.

I have found the theory of philosophers George Lakoff and Mark Johnson, as developed in their book *Metaphors We Live By*, to be particularly congruent with my figure-ground gestalt approach to meaning. In it they refute what they call the "objectivist" (positivist) myth of meaning in language that attempts to find in words objective reference to reality that can be observed as ultimately truthful regardless of context. They do this by showing that metaphor is the basis of all communication, and that even objectivists operate according to the "conduit" metaphor: "The meaning is right there in the words" (200). Their approach is close to Nietzsche's in that they postulate that metaphor arises out of bodily experience; it is an extension of physical, spatial, and temporal experience into the figures of language. Lakoff and Johnson demonstrate that the supposed "literality" of objectivist statements is indeed nothing but *conventionalized* or "dead" metaphors, as opposed to living, nonconventionalized metaphors otherwise employed "rhetorically."

Just as there is a spectrum of perception between the nondiscursive properties of objectification and the univocal signifying of reification, so there is a spectrum of understanding between nonconventional metaphor and literalism (conventionalized metaphor). What we designate popularly as *symbol* often falls in the middle, although it too has a tendency to be reified and literalized: one example is the all-too-obvious psychoanalytic symbols representing phallus and vagina. Part of the task of modern art and literature has been to prevent the process of literalization from happening as fast as it does. Magritte said that he rejected the term symbols for the objects he put in his paintings and preferred "enigmas," simply because symbols can be interpreted and easily passed over. Perhaps the true stigma of the hyperreal (or rather, the hypersymbolic)[8] is the speed with which it transforms the resistant symbol into the literal for easy consumption and forgetting.

And yet there is something that prevents us from ever attaining the truly literal, which is the ideal of positivism. The constant attempt to translate or transform the mediated into the unmediated always ends up concentrating on the medium itself. Any attempt to render a medium transparent, as in Brecht's alienation effect or in the gestures of painterly abstraction, actually accomplishes its opposite, and the medium is rendered opaque: it becomes a trademark.

This opacity has the opposite danger of making one think that the surface is all there is. The problem with those who condemn artists still concerned with substance as essentializing, out-of-it metaphysicians is that they cannot see in their own fetishization of signifying form another kind of essentializing. We have to ask ourselves, what does it mean to affirm the "mere surface" of things? How can "surface reality" be all there is, when it can only be discernible against other surfaces? There can be no such thing as pure surface. It may eventually even have to be admitted that we cannot imagine anything without attributing substance to what we see or think; nor should this propensity be seen as negative. In this Wallace Stevens can offer, in his own subjective way, a caution to the sometimes naive "direct" treatment of the objectivist poets: "Disillusion as the last illusion" ("An Ordinary Evening in New Haven").

In modernism one can observe a cross-pollination that can be described as the "artifactualization of language" and the "literalization of art." Literature becomes artifactual through the self-reflective concentration placed upon how language operates, how it is perceived, received, and preconceived. Fiction that displays its fictiveness, poetry that displays its visual-syntactic structure (in post-objectivist and Language poetry) create objects seeking autonomy and is therefore alienated from the noncritical or habitual receptivity of its readers. Art, on the other hand, in that it is an object reflecting upon its own processes, rids itself of its own conventional iconographic language that serves other purposes than the "purely" visual ones, to replace it with a language that defies strict analysis, maintaining the enigmatic power of the unconscious (surrealism), or trying to get rid of referentiality altogether, to replace it with sweeping traces of inarticulate, resistant feeling. But it can only do this effectively against an interpretive ground of language, and by becoming a language unto itself.[9]

The eschewal of perspectival representation in art for the first

time, in its movement toward the disintegration, introspective distortion, and dissolution of the referential object, necessitated an accompanying textual structure, so that we find Apollinaire an apologist for the cubists, and every other avant-garde move in these directions supplemented by manifestos: Italian and Russian futurism, *Die Brücke, Der Blaue Reiter*, Dada, surrealism, suprematism, constructivism, among others. The movement toward pure form that is nonreferential is deceiving, for a great deal of weight was shifted to language, creating a discourse to give the art a context, or a position, from which a new type of perception was to be gained. One can even say, despite the fierce animus that fills these manifestos, that it is even a reasoned discourse, although containing within it the usual conflict between expressivism and scientism. With the advent of a conceptually based art, such as followed on the heels of Dada and Duchamp, one can even say that *seeing* was displaced by *saying*. But while Duchamp's saying operated denegatively or enigmatically through slippery metaphors and puns, later conceptualism would succumb to the very literalism he evaded or mocked.

Expressive Labor and Conceptual Investment

The transition from labor in art to that of simple choice, random or selective, parallels an alteration of the ethos of capitalism in general from the Protestant work ethic to that of speculative or fiscal capitalism. Labor in art follows a humanist course, best exemplified by various types of expressionism. Speculation, consumption, chance, "choice" in art tend to negate the humanist tradition and bet on perpetual future progress based upon manipulating trends rather than creating objects to last. In part, this is a simple matter of recategorization, a speech act. I wish to designate the first category as *expressive labor*, or the *productive* tradition in modern art; the other I wish to call the tradition of *conceptual investment*. This latter, speculative art is exemplified by the Duchamp-Dada-pop-conceptual axis, in the 1980s seen also in the "pictures" or "simulations" artists, some of whose works attempted a critique of mass media and mass commodification by adopting their forms as cultural reflection. In none of these modes of speculative art is personal production (that is, psychic and/or physical labor) a primary factor, and sometimes it is not a factor at all. There have been crossover cases in this tradition, such as Jasper Johns and Robert Rauschenberg, where elements of both expressionism and conceptual investment play a role.

The difference between the two modes can also be read as a difference in attitude toward the self. Expressive labor has a tangible connection between self and material, a physical one. The conceptual artist correlates self to information or language, an eidetic system, especially as the economic basis of society becomes more information oriented. Perhaps this has even facilitated the reification of art, if one recalls Lukács's bureaucrat who is reified body and soul, lacking a sensuous existence with which to resist. Even so, the body bounces back, even out of the core of conceptualization, in the form of performance art. Yet the emergence of the bodily self reflects the shift from an economy of production to that of a service economy.

What we find in the expressive labor side of modern art is the split in the artistic process exacerbated by romanticism's rebellion against classical practices. The two sides of this split can be read as expressionism and constructivism, that is, art derived from the Romantic "labor of the spirit" and art derived from what may seem to be an essentially classical "labor of external form" (what Eliot called the "Inner Voice" versus "Outer Authority"). I say "seem" in the latter case simply because it cannot be proved that classicism denied the inner workings of the spirit (usually referred to as nature, reason, or inner light) but was concerned rather with adjudicating between those workings and social constructions to make them compatible. The Bauhaus is most clearly seen as the constructivist foundation for the modern creation of external social forms, but it should be remembered that the school was founded by predominantly expressionist artists, who gave vent to the internal workings of what they saw as the universal human spirit, only to later produce constructivist forms that it was hoped would be internalized to promote social harmony.

When drawing a distinction between art that is "worked through" and art that is "conceptually invested," one must see that these two sides represent the two major sides of modern alienated consciousness, with one side a resistance to, and compensation for, the other: namely, work and play. There is much that can be, and has been, said about the relation of artistic creation and play. Schiller said that man is only man when he is at play. This is most obvious in the conceptual-investment ethic of art, a form of play that is at bottom a game of chance, with the definition of art riding on the outcome. Chance as a major factor in avant-garde art operates in basically two ways, yet in both, its use is an attempt to operate outside of the conscious will, that

is, the subjectivity, of the artist. First, chance is designed to draw out elements of the unconscious, as in automatism in writing and painting (e.g., surrealism and Jackson Pollock). Second, chance is utilized in such a way that it can bear no relation to even unconscious choice but seems to stand outside the subjectivity of the artist altogether (Marcel Duchamp, John Cage). Yet how easily separated are these two uses? In number two, how far can the artist remove himself or herself from the process, and in number one, what role do external conditions play on the outcome?

The artist's denial of labor, yet claim to the fruits of chance as his or her art, represents a major subversion of the expressive ethic in art. What appears transgressive in our culture, but at the same time reveals a hidden, long sought after ideal, is production without labor, getting something for nothing, becoming rich without working for it. In art this is reflected in the cult of genius, the idea man (*sic*) who seems to come up with ideas almost without mental labor. This indicates that far from being the outcast mode of resistance to capitalism, the avant-garde of conceptual investment is actually a reflection of its hidden desires.[10]

The object status of the work of art within modernity always operates against its original or potential state of being a commodity. How the relationship of object and commodity has changed is reflected in the difference between Duchamp's and Warhol's appropriation from mass culture. Duchamp chose mass-produced objects that were generic and recognized for their use value, which is then disrupted. Warhol chose names, trademarks; their visual, representational object value is completely bound up with their names. Even the visual images he uses are so grounded in a widespread knowledge that a face and its name are inextricably bound and interchangeable: Elvis Presley, Marilyn Monroe, Jackie Onassis. This displays a shift within modernism that indeed confirms Baudrillard's idea of a historical shift from use or exchange value to sign value within the world's general economy.

The concept of naming, depicted by Walter Benjamin as a divine ability imparted to Adam (what Adorno called Benjamin's "mixture of magic and positivism"), can be connected to a *speech act* that has power only legalistically or contractually, mediated by a higher power such as tradition or law. What happens when, in a democratic milieu, naming becomes a principle of investment, the bid at an auction, the

naming of a stock? Here the name must be backed by the most standardizing power of intellectual *and* monetary investment before it can gain attention or credence in the world of business or art.

CONTEMPLATION

Although in the course of this work I concentrate on the value of objectification for the artist in the production of works, I also wish to analyze the reception of works of art in relation to their objecthood. This must begin with the notion of the separateness, in perceptual process and cognitive and sensual understanding, of subject and object. Kant's idea that aesthetic pleasure rests on a "disinterested" relation to the object (*Critique of Judgement*, 162), repeated by Joyce in *Portrait of the Artist as a Young Man*, has much to say about the value of this division. Although a certain late Romantic sensibility rebelled against this attitude because it wished to preserve the sensual vitality of the human spirit in an increasingly rationalized and objectified environment, modern art and literature were learning to adapt and find useful a strategy of objectification as a way of maintaining the potential for meaningful life and a way of resisting the *absolute* instrumentalization and commodification of existence.

Nietzsche reacted against Kant's notion of disinterested pleasure by counterposing Stendhal's idea of art as the *promesse de bonheur*, a more sensually direct engagement with the material of art (*Genealogy of Morals*, 238). Yet Nietzsche himself was wary of the inebriation that Romantic music induced in its audience, clouding its cognitive faculties. The engagement he foresaw was not one of passive ecstasy, but of a stimulus and sustenance for the will to power, or life. This reaction to Kant was shared by Lukács, who decried the contemplative stance of Kantian aesthetics. He connected the notion of contemplation with the contemplative attitude of the worker to his material (hence his detachment from the whole process of production) and the static contemplation of the bourgeois to his surroundings that denies history and process. Art should rather serve as an unmasking of this false consciousness and act as a stimulus for collective social action to alter these relations by taking hold of the process of production.

Although this is understandable as a late Romantic response to a rationalized universe, it misses the value of a notion of disinterested pleasure in that it interprets it as a passive attitude toward things,

which is not true of aesthetic discrimination (as the way one lives one's life). Nor can it be entirely true that the relation of the consumer to a commodity is merely one of disinterested contemplation. A consumer's relation to commodities is one of consumption—sometimes in the passive way indicated by Nietzsche's audience for Romantic music, sometimes in an anxious, self-conscious way—rather than as an "active" engagement, which would involve a more artistic, critical, and productive attitude on the part of the consumer, seen at some levels of popular culture. I believe that there is a misuse of the term *contemplative* here, in that, although it involves detachment, it doesn't necessarily imply *passivity*.

Contemplation involves thought, and thought of this sort needs detachment from merely sensual involvement. Thinking as an activity in this sense is a necessary prelude to physical action. If not, then action is simply a response to the stimulus of an ideology that orders the world for you, while purporting to demonstrate that your former ideological ordering is false. Marxists themselves use history as a contemplative device in order to distance themselves from the "natural" world constructed by bourgeois ideology. Contemplation is a distancing that allows one to see the relation of figure and ground; if it were not involved, one would be left immersed in either figure or ground.

Autonomous art, through its defamiliarizing process, places us in a contemplative attitude that calls into question the conventional ordering of reality in which we are immersed.[11] It turns the figure of the object, conventionally defined by our social ground, into a new ground upon which we must construct new figures of meaning. This becomes anathema to critics such as Lukács because it establishes a situation in which we must learn to create a sense of meaning subjectively and individually, which is then interpreted as simply another form of Romantic, powerless alienation, when it could alternatively be seen as creative space of individual freedom in a homogenized reality. For Lukács it is much easier to assimilate bourgeois realism, which by his time had already established itself as a collective mentality, and adapt it to a different collective mentality—that of the proletariat. The contemplation of art as a stimulus to the individual's decision to alter his or her conception of reality and therefore life is then seen as having no effect on the alteration of material conditions as a whole.

What possible use does the contemplative stance of disinterested

pleasure have for our lives? Determining its value involves, first of all, distinguishing between objects as works of art and objects as commodities, and secondly, distinguishing between the notions of contemplation, consumption, and possession.

It must be admitted at the outset that works of art *are* commodities inasmuch as they are bought and sold and assigned a price tag within a market system. This becomes the problematic situation of any kind of work produced within a capitalist system. Even, for instance, work that exists only at the level of receiving federal or state grants is assigned a "market" value by boards that demonstrate in their own structures the indistinct division between the private and public sectors. Be that as it may, the work of art attempts *in its very structure* to resist its *total* commodification, a primary impulse in modern art that has been pointed out by Theodor Adorno and others.[12] This entails a different sense of the notion of commodity than simply something that becomes bought and sold. This is where the notions of contemplation, consumption, and possession come in.

A "pure" commodity would be an article that can be possessed and then consumed, and usually consumed with no residue of possible meaning to elicit desire left over. The contemplation of a work of art *as* a work of art and not a financial investment demands a sensibility of nonpossession, or the demands for immediately assimilable meaning will be utterly frustrated. Art theory provides guidelines for the partial possession of meaning in any significant work, but the work's truest value, in its objecthood, is its resistance to total possession of meaning, while this resistance itself is productive of meaning. This resistance creates the distance required for disinterested pleasure: concerned more with a relationship to *being* than with *having*. In such contemplation, one hopefully sees reflected the value of a certain acceptance of being, even in relation to one's self, inasmuch as one cannot possess the meaning of one's life entirely, the obsession with which prevents the ongoing process of living; to adapt Baudelaire to a different context: "He who does not accept the conditions of life sells his soul." This doesn't mean that one merely accepts the muteness of the work as unattainable meaning; rather one allows the process of meaning to unfold itself in its own time without anxious and compulsive desire for possession, or as Keats put it, "without any irritable reaching after fact and reason." In other words, the work's *esse* is its *posse*. Paradoxically then, it is the work's *objecthood* that by resisting

reduction to easily consumed sign value gives rise to a process of unfolding meaning through the act of contemplation.

In human terms this principle applies as well. The people that one finds most valuable and engaging are those who resist one's total interpretation as personality types. They are the ones who provide a meaning for one's life by retaining a hidden potential for further interactions. It is often said that love thrives on mystery—but usually when mystery isn't calculated, a discovery of which gives the whole game away. One can be surprised to learn as well that what one conceived of as mystery turns out to be vacuity, but that usually results from not paying attention to what is available to one. Jean Baudrillard has said that it is only the object that seduces; its self-contained resistance to possession is what drives desire, its muteness (*Strategies fatales*, 174). But of course, as in a work of art, there cannot be total muteness, for that would eliminate the potential for the least possession of understanding or even partial fulfillment of desire.

In art this potential is created by the sensuous form of an idea that indicates but does not reveal completely its meaning to be possessed. What then, one might ask, has happened to contemplative distance, if one is being seduced by sensuous form? This involves being compelled, by the implacable resistance of the object, to learn to experience and enjoy one's desire for meaning for what it is: it is living fully in the space of the potential, rather than immediately seeking self-gratification, the complete fulfillment of desire—the total possession of which results in death: "Consumed with that which it was nourished by," instead of life, a desiring of desire, a nongrasping, yet gradually unfolding engagement with reality.[13]

AESTHETICS AND ART

Given that it is the artist who exemplifies the resistance to a rationalized world of alienated labor, it is easy to see why Nietzsche would want to conceive of art as a basis for a truly vital philosophy. It must be made clear, however, that this is not simply the same thing as an aesthetic philosophy. Aesthetics as a discipline was born from the rationalized conceptions of the Enlightenment.[14] It can be isolated, in this light, as solely a system of judgments and not a process of creation. This doesn't mean it doesn't have an effect in a social sense, for even the taste that Kant speaks of refers to a commonality of judg-

ment. But the art produced within modernism seeks to subvert that commonality, in the same way it tries to resist the homogenizing propensities of mass culture and production. The will to art tries to defy aesthetics at every turn, yet it ends up consistently revising our conception of aesthetics after the fact. Reception always tries to keep up with production, while production of art, inasmuch as it attempts to maintain a freedom of vision over against its reification, tries to defy a too easy reception that would result in its being absorbed by the social and rationalized forces of aesthetics.

Wittgenstein, in his *Tractatus-Logico-Philosophicus*, referred to aesthetics and ethics as being "one and the same" (6.421), something he maintained even in his later work, as factors of human experience, an understanding of whose basis cannot adequately be put into language. In a non-Wittgensteinian sense, they can both be seen as generalized guides for the understanding of artistic or social action. Accentuation can be placed on a formal sense of balance and harmony, related to justice and the understanding of moderation and the mean in relation to virtue, as had been postulated by Aristotle in his *Ethics*, or as physical health or vitality, as understood by Nietzsche and Foucault. We are much more likely to conceive of the practice of ethics as a positive, socially effective practice, than the "practice" of aesthetics, which often appears as not a practice at all, but merely a passive form of reception. Yet the fact that judgment through the act of contemplation is involved makes aesthetics a practice indeed. Judgments of taste and judgments of correct action find their bases intermingling within their social context, an atmosphere whose various aesthetic manifestations (at any and all levels) create continually a "sense" of what's right, even while the diversity of these forms of information undermine their certainty at the same time.

So art first becomes expressly positioned against any form of ethics or moral judgment, and second, inasmuch as the aesthetic conforms to the predominant mode of ethical judgment isomorphically, it finds itself at war with aesthetics as well. Art as a vital force, whose force depends upon a free practice, will posit itself against the standard ethos of its age, attempting to either avoid categorization, and so stand outside of judgment, or to create a new category that defies the judgments of its age, as a willful negation. Art as such can only effectively exist in protean form. Aesthetics becomes the Hercules to art's Proteus.

The so-called antiart movements are but a further extension of

the desire for an art autonomous from aesthetic, thereby social, control. Antiart movements are not anti*art* at all, but anti*aesthetic*. They build their radicality on their identification of all current art with the current aesthetic. An antiart movement arises when it becomes obvious that art has become indentured to systems of meaning congruent with, if not dependent upon, systems of cultural repression. Thus antiart is a desire for the preservation of the force of art as autonomous from corrupt and determining powers, which use art by incorporating formerly effective autonomous art into their own meaning systems. When antiartists want to break down the distinction between art and life, this is at bottom a political act, but one in the service of art, not in the service of a more just political system, which if it took "antiart" seriously, would only prove to threaten more radically once again the autonomy of art. Art in the service of the revolution finds that it must change its figure and ground so that revolution operates also in the service of art, if it wants to survive as art. This is a hard lesson learned from the experience of the Russian futurists, among others.

A further question must be asked: if antiart wants to break down the division between art and life, one must be more specific and ask, What art? What life? Obviously, any artist must face the fact that the destruction of art also means being even more fully assimilated into the kitsch of a consumerist culture.[15] The general rationale has been that what needs to be produced is a life that is a work of art, which can hardly do away with art as a category if one recognizes that most lives are not works of art. Secondly one would have to ask, what *is* a life that *is* a work of art? This is basically a question of performance, which has been asked from the time of Baudelaire's reflections on *dandyisme* to contemporary performance art like that of the two British middle-class "poseurs" teetering on the brink of kitsch, Gilbert and George, as well as countercultural confrontational lifestyles, such as punk.

Antiart's battle with aesthetics only demonstrates the hegemony of reception—which easily becomes mere consumption—over production in a growing consumerist culture, of production's uncomfortable foundation in social reception. One aporia of the avant-garde is that to a certain extent the reception of art relies upon the short memories of its audience, so that the struggle is not simply with

contemporary systems of meaning, but with history itself. Once the autonomy of art has been pushed to the wall by its gradual assimilation into the rationales of systems of power, it attempts, through its objecthood, to be a class unto itself, a class of which it is its own member, defying Gödel. Art for art's sake may turn out to be impotent in itself for the creation of meaning, but it is always instructive as a desperate bid for freedom when viewed against the conditions that create it.

The meaning of a work of art, even its "suchness," depends upon the system of meaning it is part of, generally construed as deriving from a bourgeois illusion of autonomy. At a certain level the idea that autonomy is an illusion is unimportant, for illusions are nevertheless effective in producing reality, as history has shown us time and again. Where systems of meaning are most easily criticized as illusory is when and where their effectiveness is in decline and becoming inoperative. It is then that the status quo systems of power (in a Foucauldian, not necessarily hierarchical, sense) do their best to promote these illusions as the truth. But it is also when the critical opposition is the most involved in decrying those illusions as false consciousness in order to replace them with illusions of their own, hoping they will be more effective.

But we have to ask what is at stake in maintaining even the illusion of autonomy in a work of art. This may be the same question as what is at stake in the illusion of autonomy for productive human beings. Can we say that the word is meaningless for us? What does Lyotard's idea of a world of incommensurable spheres of discourse reflect but the desire for the possibility for autonomous human action, despite his dismissal of the grand narrative of liberation? The illusion of autonomous art is a positivity (in Foucault's sense) resistant to the positivity of the illusions of determining theories, whether political, psychoanalytic, or philosophical. This is not to say that the work of art can really eliminate any of these determining factors, especially in interpretation. It is just that that is not the whole story. As it is, one can only resist or appropriate what one can postulate, and usually, in art, resist it through the attempt to create what is unpostulatable within the current dispensation of meaning. Even the use of determining theories in art (when it is not a simplistic illustration of theory) can end up at the same time as resistance to them. The use the surrealists

made of the unconscious is not the use intended by Freud, for instance. What for Freud was a ground for the determination of behavior was for the surrealists a ground for the possibility of freedom.

Despite what I've said about aesthetics and theory over against the vitality of the artwork, it will no doubt be argued that I am developing an aesthetic theory. It's hard to avoid this when one attempts to analyze the situation discursively, even in analyzing nondiscursive effects. I would like to be able simply to show certain limits of theory as it is currently operative. As I've said, my aim is at best a heuristic, not a totalizing one. The principle of a figure-ground mode of reception is not designed to tell anyone what specifically and once and for all what a certain figure means against a certain ground—I chose this structure simply because it is so easily subject to change. Something as difficult to describe as an *attitude* (such as sympathetic or antipathetic) is what can completely alter one's reception of a particular work. Most overly intellectualized attitudes toward art are predisposed by the acceptance of certain theories in perceiving works, often glossing over the affective nature of their forms that may contradict and resist theoretical consumption—and theory is all too often simply that: another form of consumption to feed a single voracious ideological appetite, rather than a willingness to let the art work on other levels. Part of the "blame" may be put on the development of various modern forms themselves, since they all come accompanied by apologists in order to confirm some reception or audience at all; the heuristic of the emerging art theory then becomes codified into an aesthetic that determines *the* way of receiving the work. (This has usually been of strategic value in competing with other art at any crucial historical moment.) My use of theory here is designed not to simply enhance any particular theoretical end; it is simply a tool in an investigation that is endless, but not hopeless, for it is the vitality of the investigation that counts, just as it is, for the artist, the creation of the work that seems to matter most. The problem in taking any particular methodological approach too far in the interpretation of art is that it may tell us in the process about the truth of Marxist or Freudian analysis, for instance, but not much about the truth of art. This is because at base the truth of art can only be nondiscursive; this is even true of literature. As Gertrude Stein said, it is at best a "method of pointing," pointing beyond its own structure, even to demonstrate its own enig-

matic "objectivity," and not taking its finger for the moon, as the old Zen proverb has it.

When I say nondiscursive, I am not simply using it as another way of speaking of the basic silence read as meaninglessness in an absurdist sense, although that may be one kind of reception. There is not one form of silence, there are many—each with their own particular affective natures, and these natures are to a large extent shaped by those formal elements of the work that *are* interpretable discursively.

THE MATERIAL WORLD

> The attempt to deduce the world in words from a principle is the behavior of someone who would like to usurp power instead of resisting it.
>
> —T. W. Adorno, *Minima Moralia*

If one were to consider the etymological character of the word *object* (*ob-jactare*) as a thing that is "thrown against" one, then its identification with alienation makes sense. That is, it is a thing not assimilated to the self or not yet placed under its control (*sub-jactare*). We often consider the idea of alienation as the rejection of the self by the social, that is, we are objects "thrown against," but not assimilated by, the social. We should also consider it in terms of the desire, yet inability, of the subject to possess something that would "complete the self," in such a way that at some point it would be complete in itself (the myth of rugged individualism). It is a frustration with two facts, that the self is not completed by the social, but also that the social is not completed by the self. Tyrants and rebels share this frustration. At the farthest stage of this alienation is the envious desire not to be what one is, but to be someone else; this is what Kierkegaard designated as a limit of despair. Alienation really lies in the unacceptability of self to self due to its seemingly incomplete nature in comparison to others. It is a confusion of the notions of being and having. The stage of primary narcissism is often tenuously retained within the contractual universe of the social. Once any sense of *being* is removed from social existence, and then from personal experience, the only way of dealing with this lack is by depending upon *having*—taking material reality (which includes social relations) as something to be

consumed and assimilated to the self; Freud speaks of this as a form of "cannibalism." But consumption of a fundamentally impersonal universe to maintain one's sense of self renders one's self as something just as impersonal. What is produced by the self becomes secondary, yet it is in the productions of the self that the personal and the social sense of being is maintained. "The death of the author" would deny even this, and so displace the moment back onto consumption again: intertextuality as digestion of some impersonal linguistic organism, cognate to an Hegelian Absolute Spirit. The disappearance of the material world has truly begun with the disappearance, first, of God(s) and then of self, to be replaced by an uroboric appetite that consumes itself as it empties itself.

The idea of autonomy, however, is willingly giving up the primacy of this desire as inessential to being. Autonomy is a relation to objects, confirmed in the ongoing production of objects (material or not) that does not attempt to wholly possess them but does not reject them either. They are seen as comprising elements of meaning (discursive or not) within a whole reciprocating system of being in general, often exemplifying in microcosm this very system. The intelligent artist or writer produces work with the general understanding of never completely finishing it, for the work is coterminous with the ongoing process of life itself. It is a poor artist who insists on possessing every work she makes or seeks to create a work that contains every aspect of her being at once. In fact, the work will never progress until work that is "done," "objectified," is given up. Picasso, when asked when he knew a painting was finished, replied that he never finished paintings, he abandoned them.

This notion that the work is finally not a possession of the artist brings up the question of the artist's responsibility for the meaning attached to the work by its audience. The artist has a few choices: she can ignore the interpretation, at the risk of being misunderstood and possibly condemned for the wrong reasons; she can go to great lengths to defend the work verbally, to the point of reducing the meaning to a particular intention, which may or may not be accepted; or she can continue working on new projects, altering production to "make the meaning clear," thereby entering more fully into a communicative relation with her audience, often at the risk of losing semantic richness and the art object's capacity for resistance. But the artist's first audience is herself, and the objectification of the self shouldn't

necessarily be construed as a fixation in time of a unitary personality, but as the exemplification of a particular "self" (combination of elements) that can be continuously altered through the production of new work.

One cannot completely separate the notions of autonomy and alienation, as they are to be discerned in a figure-ground relation to one another. One finds elements of one's freedom within experiential and ideological contradiction, and the first effect of this contradiction is alienation. But through the distancing process of objectifying the contradiction one can turn alienation into a feeling of autonomy. American expatriate writers in Paris during the twenties were alienated from their homeland's cultural vulgarity and found a space in which to create their own private universes. New York abstract expressionists in the forties, frozen out by the conventional representational taste of the time and forced to make the best of the situation, with communal yet individualistic spirits established a new American art. At the same time what can be found in many modernist works is a contradiction between the rejection of bourgeois comfort and the nostalgic desire for it. The further objectification of this contradiction is yet another way of retaining autonomous distance from it, even while living it. It also admits the necessity of myth while rejecting its more obvious operations.

Conversely, the drive to autonomy can also result in alienation, as the autonomization of language and sign systems can tend toward the subject's alienation from material realities. While I hope to demonstrate in the following chapters how concern with objectification shifts from materiality to sign value as cultural production shifts from expressive labor to conceptual investment, I will briefly indicate how this shift has also influenced developments in interpretive theory, moving toward the reduction of all affective experience to semiotic or linguistic determinations.

Both the formalist critics in art and the New Critics in literature reflected upon the material and formal wholeness of works of art as separate from ideological investments of meaning. In this way they viewed the object as the expressive *labor* of the artist's spirit, as separate from and resistant to the proliferating reduction of meaning to univocal sign, to commodity status; this is clearly seen in the literary formalists' attempt to establish "literariness" as a special kind of language. Although they established heuristic theories for the approach to works of

art, blind as they might have been to social causes, these critics always allowed art and literature to offer their resistances to total theorization and so let them lead the way, in a relatively nonpossessive manner. The values of ambiguity and irony in literature and the silence of pure form in painting exemplified these resistances. In fact, the final ambiguity of William Empson's seven types resists as aporia, close to Freud's "antithetical sense of primal words." This approach worked well as long as the values of labor and the work ethic still maintained their tentative holds on society. But this had already begun to be challenged in the art world by the conceptual-investment ethic of Dada and Duchamp. By the fifties and sixties, pop art and socially invested Beat poetry displayed the new conceptual-investment ethic in all its glory.[16]

Structuralist critics observed how structures of art and literature reflect the structures of cultural linguistic norms in general; in other words, the conceptual investment of socially determined meaning in any work of art. As a transitional phase in interpretative history, structuralism first had to objectify the structure of meaning in the work of art, through what might have seemed at the time the objective science of linguistics, participating in the older ethic of labor in art. Yet its interpretive "products" proved to be incomplete and ineffectual until *utilized* by already developed social theories, such as Marxism and psychoanalysis (feminism would come later). This utilization can then be seen as the real beginning of theory's conceptual-investment ethic, cognate to that of avant-garde art. This is not to say there were no attempts at this all along in the search for scientific models; it is just that structuralism made the job easier and more effective.

What becomes problematic in all this is in how one views language. The deobjectifying work of deconstruction would have been impossible without structuralism's objectification of language, just as one might say that the development of the conceptual-investment ethic would have been impossible without the prior productive work ethic in relation to material. Derrida, in his use of terms such as *différance*, hinge, trace, and so on, tried to demonstrate that language is not an object to be possessed, or an instrument to effect possession of the "real" meaning of a work of art or literature. In his forays outside of philosophy and into literary interpretation (although he would deny the distinction), he chose works that in their own "structures" already demonstrate this attitude to language (the work of

Bataille and Artaud, for instance, in what Foucault would call their "non-discursive language" [*Language, Counter-Memory,* 39]). Where the difficulty arises is in elements within language itself (whether through the accretions of history or in its "inherent nature" is undecided) that posits a being for itself and its speaker. This may explain one reason why Derrida had to place the term *being* under erasure, as it cannot truly be eliminated from our means of communication. The very grammatical structures of Indo-European languages posit a subject-object distinction. If it is there in one's language, how does one use that language to eliminate it? The question then can be raised if some forms of deconstruction in this sense can ever truly be a force of demystification or simply a more sophisticated form of repression.

But the repressed always returns. The American development of deconstruction as an interpretive theory (or industry) only demonstrates its *own* objectification (if not reification). I wish to make it clear that I consider the work of deconstruction to be a valuable way of undermining the authority of unself-critical essentializing theories, with the caveat that to follow uncritically the relentless logic of deconstruction in any instrumental or political application may lead one to a powerless position of indeterminacy. Despite this, some deconstructors of literary texts end up utilizing deconstructive techniques (for whatever ideological purpose) that instead of admitting the difficulty of viewing language as an object, as Derrida did, end up positing it as the *only* object—an instance of the figure trying to consume its ground (or vice-versa)—in order to consume the work through the elimination of nondiscursive elements that prove resistant to such consumption. These nondiscursive elements are then designated as a type of metaphysical "false consciousness" and are used to pry open the text so it can be deconstructed. Deconstruction can be liberating in the sense that it compels us to think through and beyond unquestioned assumptions within rhetoric, not based on "nature," but on ideological and cultural enforcements in the language we use. Deconstruction can be disabling in that, depending upon the extent to which it is deployed, it can create a restrictive atmosphere in which any term that can be designated as metaphysical or as reference to transcendental or simply nondiscursive states is proscribed from interpretative or critical use, which includes terms that may be politically efficacious. There have been many "problematizers" whose careers depend upon utilizing deconstruction to void the world and its texts of any meaning that cannot

be reduced to linguistic difference: these are paths that have been cleared in advance. Deconstructors who feel compelled to constantly shift their terms to prevent them from being reified as transcendental signifiers, in order to be operative interpretatively, find that this reification is inevitable. This constant defensive shifting, far from opening up a liberating space of discourse, where people are free to express their desires and concerns and even sometimes be understood, evokes a paranoia of any linguistic system and actually closes down possibilities, despite all the talk of free play. Those who distrust language the most can hardly be said to have much trust in anything else, especially if language is "all there is." Perhaps what we may find most liberating in the long run would be a certain kind of trust in the material, metaphysical framework of language, and an understanding of its adequacy or inadequacy *relative to our needs* and not a fear of it. To invoke Adorno again, the principle that deconstruction can easily become for some critics—that deduces the world in words (or reduces it to words)—may indeed reflect the desire to usurp power rather than resist it.

Insofar as deconstruction as a reified perspective has participated in the conceptual-investment ethic in this way, it has helped in transforming artworks into commodities to be consumed by its own operations. Some artists who have observed this have established a self-deconstructive appropriation of social iconography as their work, carefully playing to the critical self-images of the interpretive community of the market and/or academy. They may not realize that, were it possible, the complete deconstruction of the ideological context would also be the disintegration of the work itself, unless it could somehow resist the interpretation of the very audience for whom it is playing.

But the objectification, and subsequent reification, of deconstruction as a tool of interpretive power operates against a real ground of institutional structures and a political economy of bodies engaged in "productive consumption." This ground cannot simply and without contradiction be reduced to the discursive structure of any theory, nor should it be, any more than one would want to constantly possess and consume friends and lovers through a strategy of reducing them to a level of signs.[17] If both art and theory are consuming themselves in this way, it should serve as an exemplary warning as to what we are doing materially on a global scale. The proliferation of signs and the concomitant false notion that our existence is *only* one of signs contributes to the

material demise of the planet. The conceptual-investment ethic—as it presently operates—has to be replaced in order to at least attempt to prevent this. In other words a new attitude toward material reality must be developed. The will to knowledge that with increasing force inundates our environment with information—information "about" the environment, about our perceptions of it, about our own microphysics, biology, and so on—has in some sense replaced *experience* of that environment, thereby giving rise to what has been deemed the "hyperreal." The exponential increase of the eternally regressing quest for knowledge may reduce all matter to mere sign, and although we see this in terms of attitude, it becomes so in fact: the destruction of matter is the prerequisite for consumption, and the earth becomes a "self-consuming artifact." Art that operates in a merely parasitical relationship to mass media, mass information systems, is in fact another program imbued with the same will to knowledge and is therefore complicitous with what it would critique (not arrest, alter or slow down, but critique). Such is the contemporary art of Warhol's children, who utilize photographs and commodity forms in a highly self-conscious way that parodies film and television media, advertising, news, and conspicuous commodity display.[18] While some of the works purport to critique these forms—often actually critiquing the content and not the form—in the long run they also accept the idea of the art object as merely another commodity, denying it any other value: a prescriptive act that disguises itself as general description.[19]

What is needed in response to all this is a new approach to the inarticulated and the enigmatic that would give pause to the unthinking and compulsive "uncovering," rationalizing process. A sense of wonder needs to balance the overwhelming power of doubt in our philosophical view of the world.[20] The progress of rationalization or technique has effectively reduced our relation to material reality to one simply of consumption, and therefore its role in commodification has been one of *derealization*, in a real sense of the world as self-consuming artifact. We have been so busy demystifying our perceptions of matter in seeing it only as a medium of social exchange that we have neglected our real situation to it as *matter*. I don't simply mean dead matter with a particular use value, either. The so-called materialist supposedly looks for causes of social forms within material conditions but does not value material as such. Material is only valued in its use value for the development of social relations: making its

intrinsic value immaterial. Joseph Beuys has spoken of the link between the idea of material and *mater*, the mother of us all (Tisdall, *Joseph Beuys*, 105). One does not simply consider one's mother for the use one can make of her in enhancing one's social existence. The advantage of older animistic cultural beliefs about nature over our own is that they *situated* the human symbiotically within the environment, maintaining what has always been a rather delicate balance, maintaining a respect for life. We have interpreted this as a false relation to matter, a naive projection of human consciousness into inert things, fetishism, instead of seeing this "projection" as a survival technique basic to human beings who do not exteriorize their consciousness in machines that consume reality as a "survival" technique. I am not suggesting that somehow we return to animistic beliefs, whether we could at this point or not, only that we understand their operations in a way that would be useful for our situation, instead of rationalizing them away. Pound understood this when he said, "Learn of the green world what can be thy place / In scaled invention or true artistry" (Canto 81). We cannot simply go on fetishizing *technique*, linguistic or otherwise, without paying the price.[21] Following Williams, we should become more familiar with the "poetry / of the movement of cost, known or unknown" (*Paterson*, 109).

What I wish to do then, is to examine our inevitable recourse to metaphysics in the production of art or theory, in particular as it applies to matter, whether through the materially or referentially objectifying tendencies of our consciousness. Metaphysics will be with us as long as we have language, and the attempt to entirely repress it (which often appears as circumvention) only helps to sever our symbolic link to the material world. Wittgenstein, not predominantly known as a metaphysician, said, "It is not *how* things are in the world that is mystical, but *that* it exists" (*Tractatus*, 6.44)—and he wasn't speaking of the mystical disparagingly. We have become so entranced by the how that we have ceased to believe in the that. We have become so powerful through our use of the how that our one hope now is to refocus our relation to the that, or it won't be there for long.

All this means is a basic respect for life, which has to start with basic matter; this means fostering a sympathetic, affective, but nonpossessive relation to it. What I am trying to show in examining works of art and literature within modernism and modernity is that while art has not only participated in, but helped advance, the

derealizing process of rationalization, it has also resisted it in its objecthood, tempting us to view the constituents of our reality as things that are not merely signs to affirm our own status or to consume for immediate pleasure, but as objects that tell us that we are objects too, no matter how willful or powerful we become. One can say it is a nonhumanist, antiself-centered temptation that would deliver us to the world, rather than the world to us. It problematizes and resists our demystifying pride, without necessarily delivering us over blindly to the forces of ideology. After all, we should recall that it was the demystifying operations of rationalization, leading to the "disenchantment of the world" (Weber) that produced the totalizing mystification of reification. Of course this means we have to situate ourselves intellectually relative to this resistant objecthood, but emotionally as well. I do not privilege either the work ethic in expressive art or the conceptual investment of experimental art but desire to find in each how the question of objecthood and our relation to it can aid in balancing our attitudes toward the material world.

Chapter 2

The Sign of the Body and the Body of the Sign: Objectification in Modern Theater

Plays have traditionally led double lives, both in and out of the theater. In the theater, they have existed as potential grounds for performative action: objects that are made real only when they have become materialized within the performance. On the other hand, in the hands of the literary establishment, they can also be read as written artifacts, just as novels, short stories, and narrative poems are read—for their thematic content. In their purely literary form it is usual for them to be read for the "what" of the content, as a linguistic object, without considering the "how" of the object's relationship to actual production.[1] This is especially true of naturalist plays, in which all the cues for action are spelled out in detail. In contrast, in plays of earlier ages, such as the Elizabethan era, cues for action must often be taken from indications within the dialogue itself, rather than from stage directions. While premodern playwrights worked with and around the unities of time, place, and action, they also worked to keep the dialogue integrated with the action, as expressive of emotion and motivated to action out of that expression.

Peter Szondi, in his *Theory of Modern Drama*, has examined what he called the crisis in drama in the modern age, beginning with Ibsen, Strindberg, and Chekhov. Following a stringent definition of the drama as a form absolute unto itself, a form that "arose in Elizabethan England and above all, as it came into being in seventeenth-century France and was perpetuated in the German classical period" (4), he states: "The crisis experienced by the Drama at the end of the nineteenth century (as the literary form embodying the (1) [always] present, (2) interpersonal, (3) event) arose from a thematic transformation that replaced the members of this triad with their conceptual

opposites" (45). This crisis corresponds to the development of psychological drama, which tends to be more static than eventful (in the sense of physical action); its language tends to replace action rather than being a part of the action, while the illumination of memory replaces actions decided by present conditions. This is evident in Ibsen, where the revelation of the past, which takes up a good portion of each play, is the basis for the dialogue, and such memories establish all the behavioral conditions of the present. In Ibsen, as Szondi says, "[T]he interpersonal is displaced by the intrapersonal" (45). In Chekhov, it is not only the past but the hoped-for future that takes the action out of the present. In Strindberg's late plays, the highly subjective projection of the mise-en-scène reduces all the elements to aspects of a single consciousness, not only eliminating interpersonal contact, but establishing an internal time-sense in which past, present, and future intermingle, negating a more objective sense of the present.

Szondi considers that the unities of classical drama can absorb the audience in a flow of action that is not divided into subjects and objects, but where every movement is reciprocal within the play. "In Ibsen's 'analytical drama,' " however, "present and past, revealer and revealed, confront each another as subject and object. In Strindberg's 'station drama,' the isolated subject becomes its own object. . . . Maeterlinck's fatalism damns humankind to passive objectivity; the people in Hauptmann's 'social drama' appear in the same objective light" (46). The three factors of dramatic form—as present, interpersonal event—are relativized by the subject-object split. This paves the way for the epic form to take precedence over the dramatic, something of which Brecht was quite conscious as necessary for the active critical engagement of the spectator, the form standing as paradigm and parallel for action in the world outside the theater.

For all of its intended immediacy, Szondi's absolute drama of the present event still operates as representation, and as such is the framing of a past event within the real space-time of the audience. While giving the audience the illusion of being elsewhere, it reinforces an illusion of events happening contemporaneously. In other words, because still operating as representation, the space-time of the performance is "in synch" with but is not the same as the space-time of the audience. Overt theatricality, insofar as it draws attention to the context of reception and acknowledges the audience, appears to break

down this differential. There are degrees here too, in that while direct address can begin to integrate these separate space-times, the actor (inevitably?) fictionalizes the audience in the process, since working from a script sustains a temporal distinction between performer and audience. In any event, the immediacy that Szondi's idea of the drama proposes, while still separated from the audience by the abyss of representation, can be seen as formally closer to the *material* objectification of the real-time situation of performance art and theater, in their self-analytic of reception (which dates from Brecht's alienation effect), than to the *referential* objectification of modern realist drama, which in its attempt at the most direct reflection of reality must conceal from itself denegatively the presence of the spectator and her judgment, and the *means* of this reflection. In effect, this shows the desires of modern realist drama to be closer to the private conditions for reception of a literary text than the more self-conscious public space of an event or work of visual art.²

If we glance back at theatrical practice in the nineteenth century, prior to these changes wrought by naturalistic drama, we can already see signs of a subject-object split that challenges classical dramatic form. Martin Meisel, in *Realizations*, his study of popular theater in nineteenth-century England, reveals two underlying sources for dramatic presentation: the novel and painting. Both of these forms defy one or another of Szondi's three terms for absolute drama—the novel, both in its ability to shift its temporal location, and in its intrapersonal descriptions of psychological states; and painting, in that its objecthood defies interpersonal discursivity. While its frozen state may allude to or evoke action, it is not an action itself. Painting and the novel represent the external and internal limits of the personal space of apprehension. The difficulty arises in unifying them in action.

The influence of painting on theatrical art in the nineteenth century is clearly seen in the tableaux vivants that interrupt the action at peak moments within many popular plays. These pauses, these static images, draw together all the lines of action into a particular "situation" that is held for the viewer's visual pleasure. The analogue of viewing painting is thus objectified by living figures on the stage. Plays in the nineteenth century tended to become series of frozen climaxes strung together. The paintings that influenced this practice at the beginning of the century depicted great historical moments, understandable in a somewhat self-satisfied postrevolutionary age.

Meisel refers specifically to Napoleon's career as the focus of a series of heroic tableaus, derived from works of painters such as Horace Vernet and Carl von Steuben (Meisel, *Realizations*, 217–20). As time went on, and popular consciousness moved from external heroic fervor to more of a self-absorbed psychological state, the staging moved as well from spectacular effects to a heightened verisimilitude of everyday life. It should be noted that Brecht's "gestus," as a dramatic act that draws together in its simple symbolic movement the intentions and consequences of social action in a self-conscious way, can be seen in a new light if one connects it with the earlier feature of the tableau in popular theater as a moment of history.[3]

The novel, a form relatively new in a popular sense, presented a challenge to dramatic presentation, given the internal relationship to time and motivations that are not easily presented as actions. The "explanation" of behavior and personal history that is more easily rendered in the novel seems highly artificial on the stage, requiring a narrative break from the dramatic action that takes on a more theatrical stance, directed outward to the audience, even if it seems to be directed to the actor himself, as in a soliloquy. It was Ibsen's genius to contain the necessary narrative within dramatic dialogue, often revealing it piecemeal. The motivation required to bring this information to light comes through a sudden alteration in the present situation, a situation that most of the characters have become used to, if not comfortable with. This alteration most often comes in the return of a character who has not been seen for a long time, but who—like Lövborg in *Hedda Gabler* or Oswald in *Ghosts*—bears painful reminders of what once was and what might have been. In any case, the focus of the drama shifts from physical actions and their consequences to a narrative of past events and its consequences for the present; through various means the story is told rather than shown.

We can see, therefore, that Szondi's subject-object split is already predicated upon the split between the visual properties of physical action and the more displaced use of language through narrative, whether its form is dialogical or monological. Coextensive with this split is the split between the "purely" dramatic and the "purely" theatrical; that is, the dramatic presents itself as the fourth-wall phenomenon, complete unto itself, oblivious to audience members who are in the position of voyeurs. The theatrical directs all action and language at the audience in a self-conscious manner; the tableau is

thus theatrical rather than dramatic; that is, it is exhibitionistic. It must be made clear, however, that the theatrical function cannot be completely separated from drama. While within a naturalist drama the characters may be speaking to each other as if no one is observing, they must theatrically *accentuate* this "as if" in their acting. Even the minutely detailed sets of drawing rooms strike one as absurdly theatrical if one's attention takes in the context of the whole theater, and the audience's relation to the stage. But the verisimilitude of set details and the "naturalness" of the acting are what is supposed to draw our attention wholly away from theatricality. The signifying processes of realism's referential objectification can only work by concealing the material basis of its theatricality. In other words, it is theatricality working against theatricality. In classical plays, drama and theatricality worked in a more balanced way, as asides and soliloquies seemed to function more organically within action produced by figures that are larger in presence than the psychological types encountered in naturalist drama.

The dramatic element of theater, inasmuch as it has accommodated itself almost entirely to a narrative function, even if dialogical, finds itself easily reduced to literary form, in which, as I've said before, the *how* of the play's action may never impinge upon the reader's consciousness. What the literary consciousness cannot accommodate to the degree it would hope to is the theatrical element of theater inasmuch as it falls within the purview of performance itself. This split in the consciousness of the theater may be commensurate with Eliot's notion of the dissociation of sensibility in postmetaphysical poetry.[4]

The healing of this split was Antonin Artaud's primary concern when he desired "to put an end to the subjugation of the theater to the text, and to recover the notion of a kind of unique language halfway between gesture and thought" (*Theater and Its Double*, 89). Artaud saw that balance must be recovered by accentuating the theatrical over the "psychological" elements of theater, but he adds: "It is not a question of suppressing the spoken language, but of giving words approximately the importance they have in dreams" (94). This in itself is a movement toward the visual end of theater, following Freud's notion that "generally speaking, words are often treated in dreams as things, and therefore undergo the same combinations as the ideas of things" (*Interpretation of Dreams*, 330).

While Artaud wanted to materially objectify language in this way in order to reconcile its power with the power of visual spectacle in the creation of a whole and unique work, Bertolt Brecht objectified language in order to exacerbate the split between intentions and action. He rendered the action ironic in order to distance the spectator from the fascination of conventional dramatic movement. His use of placards that explain the action before it even starts is an example of this kind of objectification. Rather than attempt to unite the dramatic and the theatrical, he uses both dialectically: at times we watch the action with a degree of absorption until something or someone disrupts the action and calls attention to it in a theatrical manner; and so it moves back and forth between the two fields.

After the crisis that Szondi speaks of, and after Brecht's creative use of the dramatic-theatrical dissociation, the most powerful theater of the avant-garde, even while residing in the dramatic mode, will at some point or other cast a sidelong leer at the artificiality of the dramatic situation. Thus in *Waiting for Godot*, Didi signifies consciousness of the audience's presence when gazing out into the house by crying "A charnel-house! A charnel-house!" Or in *Krapp's Last Tape*, despite the solipsistic play Krapp involves himself in, the tiny gesture of toeing the banana peel over into the orchestra pit indicates a consciousness of the theatrical space. In Genet's *The Balcony*, the stage directions indicate an obvious illusion when they specify that "on the right wall, a mirror, with a carved gilt frame, reflects an unmade bed which, if the room were arranged logically, would be in the first rows of the orchestra" (7). And at the end of the play, Madame Irma speaks directly to the audience about the artificiality of their own lives: a grand theatrical gesture. In all these cases and more, not forgetting the seminal experiments of Pirandello, we are confronted with a figure-ground conundrum, in which each of the two components continually threaten to fall into the ch(i)asm of the other. A *mise-en-abîme* need not only project itself in one direction.

In this chapter, I examine both sides of theater: performance, whose fundamental ground is the body of the actor; and text, inasmuch as the text points back to the theatrical objectification of both scene and character. The texts I examine are the above-mentioned *Krapp's Last Tape* and *The Balcony*, as they are exemplary, in seemingly opposed ways, of self-objectification as a mode of both production and reception, articulated across both sides of the proscenium that

defines consciousness; they are also of interest because they appear on the cusp of modernist and postmodernist theatrical history, between the ideal of a unified self-as-object and the self as an abyss of insubstantial signifying reflections. Since the theater can serve as a reflection of social reality, these objectifications point to the artifice of our own social roles and the emptiness of our own self-constructions as far as we devote ourselves to the truth of appearance. They also point to a desire to eliminate artifice and find a ground of being within ourselves that defies simple characterization. While it can be said that the idea of the theatricality of the social world is at least as old as Shakespeare and Calderón, the hidden existence of a soul was not then widely doubted, as when Hamlet speaks of "that within which passeth show." Even the highly artificial constructions of Restoration theater contained an underlying moral tone that militated against artifice, or at least understood the folly of taking things at face value. It is in our own age that artifice takes on an overweening importance, when the technology of knowledge, previously only operating upon external nature, turns its full attention to human nature and discovers levels of appearances rather than substantive being. At the same time, the reality of the effects of these appearances has led sociologists and anthropologists such as Erving Goffman, Richard Sennett, and Victor Turner to use performance as a paradigm for understanding the social construction of self.

THE BODY AS OBJECT IN MODERN THEATER

I mentioned in chapter 1 that many modernist artists in their striving to locate and abstract the essence of their art evaded human representation as too fragile and ephemeral to sustain itself objectively within the rapid changes induced by a new machine age. Since the theater ultimately depends upon what is human, this nonhuman objectifying poses something of a problem for it. The famous actress Eleanora Duse was quoted by Gordon Craig as saying that in order to save the theater all the actors would have to die of the plague, so that it could start over with a clean slate (Kirby, *Total Theater*, 33). This clean slate seemed to have been accomplished in at least two instances of empty stage performances. One was an Italian futurist performance whose "performer" was a bullet shot from a gun offstage. The other was Samuel Beckett's "Breath," a thirty-second performance consisting of

the sound of an inhalation and an exhalation. But in both cases a human agency is made present by its absence.

The theater finds itself in the position of having to objectify what it is that can be construed as human, while trying at the same time to either radically reduce or eliminate the distance between the human being and its representation, or else radically increase the distance so that, as with Brecht, representation stands apart from the human being as a transparent process. There is on the spectrum of possible representation a dehumanizing limit and a humanizing limit. On one extreme there is Gordon Craig's solution: replace the actor with the Übermarionette, whose nonhuman character and whose two virtues of "silence and obedience" provide the only adequate basis for a "symbol of man," since no particular actor with his or her eccentricities can really be such a symbol, with the twin intention of purity and universality. On the other extreme, there is Jerzy Grotowski's work, in which what is essentially human can only be accomplished in the full embodiment of the *particular* human being, so that, following Artaud, not only the split between representation and the human being is reduced, if not eliminated, but the rift between mind and body, or as Grotowski puts it, "soul and body," is healed. In this process layers of personality are stripped away until one reaches an "inexplicable unity" (Grotowski, *Towards a Poor Theatre*, 131). We can see that the dehumanization of theater and the radical humanization of theater follow a parallel course—toward the establishment of a pure and unified object for contemplation.

Of course the problem is that what is "essentially" human is what is not unified in the first place. The very nature of human consciousness is its split character, in which the source of consciousness can never be located, and therefore never objectified. As Jacques Lacan put it, "I am not wherever I am the plaything of my thought; I think of what I am where I do not think to think" (*Ecrits*, 166). But when Grotowski puts so much emphasis, in his early work, on *impulse* as a unifying force, he is not really talking about reflection but action, although the equally emphasized ideal of the actor's self-revelation already belies this. Even his reduction of theater to its essential relationship of actor to spectator demonstrates in that very relationship a materialization of the structure of consciousness that must be split.

If we are to draw away from Grotowski's ascetic enclave that postulates an essential humanity into the much larger realm of social

and historical forces, the unified self becomes even more unfeasible, as Bertolt Brecht argues: "The continuity of the ego is a myth. A man is an atom that perpetually breaks up and forms anew. We have to show things as they are" (*Brecht on Theatre*, 15). For Brecht it is not the responsibility of the actor to objectify what is human as self at all. What is objectified are the relations between human beings, made manifest in the gestus. One should not even conceive of the gestus as a unified or pure act, however, in that Brecht desires as well that every act contain the condition of possibility for alternative action.

I am mainly interested in examining a particular form of objectification that takes place in modern experimental theater whose focus is on the body.[5] One can view here the distinction between, to borrow terms from R. D. Laing, the "disembodied self" and the "embodied self." Although the continuity of the ego may be a myth, and consciousness may be split and its source unlocatable, the body appears to be substantial, irreducible, and solid, so that the focus of any theatrical search for its essential object locates itself there.

Before I begin, I would like to make some brief comments on a type of theater that sets itself in opposition to the phenomenological reduction of actor as the central feature of theater, either as sign or body. "Total theater" resists the ongoing rationalization of theater, that is, its inexorably reductive process of self-reflection, in that it tries to mobilize other forces outside of its minimal generic boundaries: dance, music, visual spectacle, advanced technology. Yet what is still posited is a basis in an essential and unquestioned theatricality. Total theater tries to claim hegemony over the other arts in that it puts to theatrical use elements from the other arts, trying to draw out the *theatrical* aspects of dance, music, visual art, etc. This is reflected in Nietzsche's demand, after his break with Wagner, that "The theatre shall not lord it over the other arts" (*Basic Writings*, 636). Total theater would maintain that the only synthesis can be a theatrical one. Yet it is resisting its own essentializing reduction by expanding its horizons in a desire for a larger cultural unity, a unity that defies the compartmentalization of modern life.

Brecht recognized in this process a real lack of self-reflection, the positing of a cultural unity that is the promotion of a bourgeois myth, and he was suspicious of the power of theater to "theatre it all down" (*Brecht on Theatre*, 43). His own work is a meeting place of diverse arts,

yet it is not a synthesis. As he put it: "So let us invite all the sister arts of the drama, not in order to create an 'integrated work of art' in which they all offer themselves up and are lost, but so that together with the drama they may further the common task in different ways; and their relations with one another consist in this: that they lead to mutual alienation" (204). Brecht's aim in this is to maintain a true reflection of the divided and alienated nature of social and cultural spheres.

Insofar as Brecht's theater was operating critically at the time within capitalist society, his criticism of total theater seemed justified. But if we turn to Russian constructivist theater, also operating along the lines of total theater, we see that its primary function in a newly revolutionary society was a unifying, propagandistic one, where at least in its earliest stages, critical self-reflection would have seemed out of place and counterrevolutionary. Perhaps because of this, in this theater's later stages, critical self-reflection became impossible, especially in the turn to socialist realism.

It is important to note that total theater, for its synthesis to be complete, depends upon a certain dehumanization of the actor, for the human presence is too strong to allow everything to be viewed with equal attention. Recognition and identification with the human always draws us away from other sensory elements and relegates them to mere backdrop. Thus we see the incredibly stylized acting, designed as a complementary plastic and not psychological element, in both constructivist and Bauhaus theater and even today in the performance theater of Robert Wilson and Richard Foreman (despite the ruthless "ontological" self-reflection of the latter).

Brecht's form of schizoid acting, designed to separate in performance the actor from the role, is meant to draw attention to the role, its socially constructed nature, and not so much to the actor himself. In that the disembodied style of the role is to be maintained throughout, the actor must maintain a critical attitude toward his role, even acknowledging dislike for the character he plays. In effect, Brecht accepts the actor's attitude to the role and wants to use that to reveal the possibility of other social constructions through the independent decision-making ability and will of the spectator as "actor" in real life. Grotowski takes that back further in getting the *actor* to question his

own real socially constructed layers of personality in order to strip those away as well.

What are we finally left with in the end? The body of the actor. Although it can be noted, as Brecht did, that the idea of the universality of human nature is a bourgeois illusion, when it is actually a social and historical construction, it can be argued that what human beings all have in common are bodies: this seems incontrovertible and irreducible. And our bodies feel pleasure and feel pain. Our common humanity constituted by bodies operates as the first level of sympathy: "If you prick us do we not bleed? If you tickle us, do we not laugh? If you poison us, do we not die?" What strikes us as so shocking about certain types of body art, such as that of Chris Burden, who has himself shot in the shoulder, or crucified on a Volkswagen, or Stelarc, who suspends himself by hooks piercing his flesh, is this seemingly inhuman or superhuman disregard for that which we hold most primordially in common. The identification with these acts strikes too close to home and must be denied. But the denial of the flesh does not necessarily have to be so drastic, as a good portion of the mythos of both East and West affirms a self separate from the body. But can the self we "know" really be a self separate from the body? Brecht's denial of the "continuity of the ego" disregards the seeming continuity of the body. Freud connects body and ego this way: "[T]he ego is first and foremost a bodily ego," and in a footnote remarks, "I.e. the ego is ultimately derived from bodily sensations, chiefly those springing from the surface of the body" (*Ego and Id*, 16). We construct our sense of the continuity of self on the apparent continuity of the body. It is, as Michel Foucault writes, "the locus of a dissociated self (adopting the illusion of a substantial unity)" (*Language, Counter-Memory*, 148). It is on this "illusion of a substantial unity" that the stability of the personality rests. We cannot *observe* it in the process of changing or being acted upon subtly by social forces, watching it continuously be "the inscribed surface of events." We are always surprised that we are physically not what we once were.

In the long run Brecht's view is vindicated by Foucault. An actor taking on a role must observe the comportment of a particular body acted upon by the dynamics of a social role—the hunched shoulders of the scholar or accountant, the ramrod spine of a military man, and so on. But what is the bodily comportment of the actor who is trained

to take on these roles? On must take into account not only the body as the site of social inscription, but as the materialization of the individual will that resists these forces. A training of the body to deal with a variety of situations is a strong tradition in the theater. The development of flexibility can be observed from Meyerhold's biomechanics and acrobatic training to the work of Grotowski. To alter the body's comportment is to alter one's relation to oneself. This was a factor in Meyerhold's reversal of Stanislavsky's working from the inside out to working from the outside in. As he put it, "All psychological states are determined by specific physiological processes" (*Meyerhold on Theatre*, 199).

Gordon Craig's extreme view of absolute physical control caused him to reject the ability of human actors in this regard in favor of the completely controllable Übermarionette. In this Craig never theoretically dissolved the split between the actor and the role inasmuch as he knew that every puppet needs a puppeteer, even if the wires that ran from the poet's soul were "not material." Still, the puppeteer remains invisible to the audience. In order for the actor to be an artist, "[H]is body would have to be the slave of his mind, which healthy bodies refuse to do. Therefore the body of man . . . is *by nature* utterly useless as a material for art" (*Craig on Theatre*, 37). In other words, the body always at some level thinks for itself, disrupting the absolute physical and formal control of the mind. Despite this, Craig eventually abandoned the idea of replacing the human actor by the Übermarionette but instead held up the latter as an ideal for the former. The marionette as body, the body as exteriorized, disciplined ego.

Heinrich von Kleist, a hundred years earlier, had expressed nearly the same criticism as Craig, in his essay "On the Puppet Theatre." He had observed that the real advantage of the puppet over living performers was that it was "incapable of affectation." This was due to the fact that the inanimate puppet contained an implacable center of gravity, unlike the human being, and that the human attribute of affectation is created when the soul is located anywhere else than in "the center of gravity of a movement" (213). The puppet's center of gravity is in eternal homeostasis, and when the puppet is moved by the puppeteer, the limbs describe the inevitable lines of inertial force. If the actor were to follow Craig's advice, he would internalize the puppeteer, find his center of gravity, and move with

the whole movement of the emotion. One must find the body's center in order to discover its limits.

Craig traced the marionette back to its religious origins as statue in the temple. Can we create our gods, even unavoidably in our own image? The very impulse to escape the body drives us to create it ever anew. The pain of living as a body conscious of itself drives us to create bodies without consciousness. Lack of self-consciousness is the hieratic, noble, godlike, and cruel ideal, to avoid sympathy, and pity that stinks of mortality. As Kleist put it, grace can only reappear in the theater in "bodily form that has either no consciousness at all or an infinite one, which is to say, either in the puppet or a god" (216). It is left up to us to determine which is the puppet and which the god.

If we are to examine the role of the body in the theater, we should pay close attention to its most animate feature: the face. The face draws our attention, says Sartre, because of its essential *futurity*: "[W]e discover among objects certain things we call faces. They have not, however, the same kind of existence as objects. Objects have no future, while the future surrounds faces like a muff" ("Face," 162). This futurity of the face, inasmuch as it defies reduction to static objecthood, also reflects the movements of the mind's ability to transcend situations: "If we call transcendence that ability of the mind to pass beyond itself and all other things as well, to escape from itself that it may lose itself elsewhere, anywhere; then to be a visible transcendence is the meaning of a face" (163).

If we were to look at Craig's idea that desiring the human face, "the realest of things," to take us beyond reality is "too much to ask" (*Craig on Theatre*, 21), it is clear that he denies the visible transcendence that Sartre grants the human face. The value of the mask, or the face of the idol, the proto-Übermarionette, is that it should seem to look without looking. Perpetually gazing into Eternity, or eternally gazing at Nothing? If the mask remains the same it contains in itself no futurity; therefore, can it be said to indicate transcendence? In words that echo Kleist's, Sartre says of the face of a statue that it is "Concerned only with obedience to the laws of equilibrium and of motion" ("Face," 159). If, as Sartre says of his friend's face, "his face is everywhere; it exists as far as his look can carry" (162), then in a context of total theater in which all parts have equal weight, the human face will always attract attention

even while guiding it: *it* will be the center of attention and the animating force, even without language.

The mask, in that it contains no futurity, implies no transcendence, for it is eternally fixed. One could possibly say that it *is* transcendent, in that it is free of human vicissitudes, but in that its spirit is fixed, spectator identification is more difficult, since it contains no *possibility* of transcendence, since it does not change. The spectator cannot identify himself or herself with anything eternal or divine. The purpose of the mask (or the marionette) is to inspire awe, which requires a level of estrangement. That estrangement depends upon the spectator's reaction to the ambiguous state of the mask as human in appearance, yet also as an object that is not alive—giving it the quality of something or someone beyond life and death, the embodiment of a principle or perpetual attitude. Still, if this ambiguous state is not maintained by supplementary actions, gestures, actions, or words, the estrangement ceases, and the mask is simply reduced to the state of an object without effect or affect.

It should be noted in this regard that Grotowski's desire to reveal the essentially human in the actor depends upon the stripping away of masks. In this sense, the mask can be seen as a form of repression, a blockage that must be removed before transcendence can be achieved. What is remarkable, however, is that the actor is also called upon to mold his own face as a mask. It is a commonplace that masks actually allow more to be revealed, in that they protect the identity of the actor while he engages freely in activity he might normally not if his person was identified with that activity. The mask operates as a form of denegation, which draws attention to a certain reality while denying it at the same time. Of course, if Grotowski's aim is to demonstrate the possibility of transcendence through the stripping away of masks, through confessional enactment, it is necessary to begin with the mask as a concentration, a gestus, if you will, of that element of personality to be stripped away. Once the mask has been removed, we then see the actor in his vulnerable state. Yet this vulnerability may be yet another mask, what Meyerhold called the "inner mask," problematizing the end point of Grotowski's project, inasmuch as the soul of the actor has as many masks as Peer Gynt's onion has layers.

Brecht attempted to defeat spectator identification with both the corporeal and representational being of the actor. "Spectator and actor

ought not to approach one another but to move apart. Each ought to move away from himself. Otherwise the element of terror necessary to recognition is lacking" (*Brecht on Theatre*, 26). Although Brecht is clearly using, in words like "terror" and "recognition," Aristotelian language, the identification of spectator with actor purely on the level of characterization is denied. So the terms are used in a very different sense. Identification with the critical method of the actor *is* implied, however, in the hope that if the actor can demonstrate his own objective attitude to his theatrical role, the spectator can correspondingly split off from himself his own social identity in the terror of recognition that this role is *not his* identity, but a socially imposed sense of self. The actor objectifies the role in a critical distance from himself, in the hope that the spectator should follow suit. The actor recognizes that he is both subject and object at once. As subject, the audience or the other performers are the object of his attention. He is the object of the audience's attention. Brecht wished us to perceive the objects of our attention as subjects like ourselves, or like we could be.

To what extent can self-objectification in the consciousness of performer or spectator actually take place? Sartre apparently denies this process: "One cannot judge oneself. . . . [My reflection] is something I can't lay hold of; it is not an object, but an image. . . . In other words the reflection passes into the state of object when it is not recognized and of image when it is" (*Sartre on Theater*, 87). Here we must distinguish the possible differences between Sartre's and Brecht's use of the word *recognition*. In the first place Sartre is talking about recognition of one's own physical appearance, which cannot be estranged or objectified. So what he means by "recognize" is acknowledgment and acceptance of a certain state of things as they are. What Brecht means by it is the ability to recognize that things are not as they should be, that one is objectifying a part of one's self that, upon reflection, becomes strange and in contradiction to the true needs of one's self. But this alienation of object from self-accepting image that Brecht hopes to accomplish is a difficult task in the theater, where image always becomes the dominant factor, and where even his own alienation effects in time become conventionalized images. Alienation of object from image—which in this sense is also to distinguish between perceptual processes of objectification and reification—is difficult enough to be accomplished on stage, much less in the passive spectator, who is more concerned with what is going to happen next before him, than what should be happening now

inside of him. Bert States, in using an extreme example of observing a dog onstage, denies the split by saying that "in the theatre there is no ontological difference between the image and the object" (*Great Reckonings*, 35). Though there may be no ontological difference, there will always be a phenomenological difference, as anyone who attends the theater knows. Identification is never strong enough for one to continuously merge image and object in perceiving the actor, even in the best of performances. But for that split to be consistently carried into the spectator's perception of herself outside of her role as spectator may be asking too much.

In fact, the tension between the image and object, between the actor and the role, is what gives performance in the theater its measure of power in the first place. But that power is also sufficient to prevent it from being carried to the next level of rational self-reflection. To go in the opposite direction, the tension between the *body as object* and the *body as sign* gives birth to an awareness of *presence* as the tension between basic corporeal being and the becoming of signification. The inevitable figuration that is at the center of theater practices challenges a literalizing consciousness through the incorrigible frisson of sign and body.

"Presence" in the theater is a physicality in the present that at the same time is grounded in a form of absence. It is something that has unfolded, is read against what has been seen, and presently observed in expectation as to what will be seen. It means that the performer is presenting herself to the audience, but at the same time holding something back, creating expectation. The most frightening people are those of whom it is said, at least in mental terms, "They are not all there."[6] What this means is that you don't know what they are going to do next; you are put on edge expecting the unexpectable, at every point knowing that words may turn into physical actions—daring, embarrassing, violent. In other words, not only does the notion of presence in performance imply an absence, but that absence itself is the possibility of future movement; so paradoxically, presence is based not only in the present, but in our expectation of the future.[7] Ironically, if Gertrude Stein could actually achieve her ideal of the "continuous present" in the theater, in which no expectation existed, the presence of the performer would be lost. Even if the spectator is familiar with a play and knows what will come next, the how of what will come next is still missing in the present perception, and the actor

with presence will know how to keep that how indeterminate. One might also say that the expectation of a response finds its most exact and focused form in facial movement, hence Sartre's emphasis of the futurity of the face.

This is not all. Presence has an inverse relationship to language. Presence seems to be most evident in silence, since it resists the disembodying proclivities of discourse. One is holding back the articulate meaning that the audience is expecting. Presence of the body is stronger when linguistic desublimation is absent; more precisely, not absent, but not yet manifested. Presence becomes most acute at the moment of its possibility of dispersion into language, the moment of working into speech, at the edge of articulation. Demonstrations of uncertainty, stuttering, Artaud's cries that lapse back into silence draw the audience into the space of the performer's lack of articulation. Cries and stuttering draw attention not so much, or not only, to what is to be articulated, but to the physical origins of speech in the body of the performer. This has been made even clearer to me in watching a performance by Karen Finley. Known for her excessively abject, personally political, pornographic, and vitriolic monologues that seem to issue from a state of possession, the most unnerving moments of the performance are when she stops speaking. Her ranting, which is what is upsetting at first, becomes almost a zone of security after a while (despite its content), since one gets the sense she is not *there* to really threaten one.

This all might seem to place the idea of presence at only an extreme level of embodiment, when in fact people who are effective speakers fully engaged in discourse can have presence as well. But even here, we acknowledge their presence only when we cease to simply acknowledge the meaning of their words, or at least become aware of their body's relationship to their words. We acknowledge the physical property of the voice, we acknowledge the timing of their words—which draws attention to the physical action of the voice, and again the relation of expectation to silence. So in fact the words almost become supplements to the meaning displayed by the body's physical attitude. At times, presence is made even more acute when the body displays an attitude contradictory to the words. At that point we always believe the truth of the body over the truth of the words—which is articulated in psychoanalysis as the "acting out" of a repressed subtext.

Brecht's distrust of theater's reliance on presence is reflected in the dependence of his work on discourse, for pure presence (were it possible) would allow for no dialectical understanding. It would erase the discursive self-consciousness of the spectator. Even Brecht's use of the physical gesture is designed as a supplement to discourse—its value as sign is more important than its physicality. In this sense, physical presence has no meaning in itself except that of a pure investment of one human being's (the spectator's) interest in the performer as a human being, although within the theater's tyrannical framework of representation, this humanity-capable-of-eliciting-identification most often requires a physical comportment that is larger than life.

Since presence operates in opposition to discourse, the use of voice as utterer of a text is literally a "becoming disembodied." Artaud's *cry*, however, has a signature. It is identified with a particular body, while at the same time resisting inevitable symbolic difference *from* the body. Spoken words belong to everyone. One can repeat what someone said, but try to repeat his cry. The distrust of text in certain post-Artaudian theatrical experiments was a distrust of its power to diminish the presence of the actor in his embodied state. Language that is uttered belongs to all. It dissipates in the mind, it draws the mind away from the present to possibilities, probabilities, dissimulations, memories, promises, and so on, and it ceases to belong solely to the act, the event, the being before you. This reminds us of Szondi's critique of the discursivity of modern drama. In other contexts, this "givenness" of language (constantly giving itself up) obviates the notion of "an appropriation of discourse," for "discourse" in its very meaning contradicts the idea of it as a possession. Wittgenstein had argued that there is no private language. Artaud's fear of someone stealing his words is founded on his mistaken belief in a unified consciousness, not accepting the fact that language is social, and hence based in the Other.

But the body has also been seen in the past as a unified "body of knowledge." This is exemplified in the earliest forms of drama. Anagnorisis as the denouement or turning point of the play is the point of *recognition* (Oedipus recognizes his crime, Agave recognizes she has killed her son Pentheus). Things, facts, histories are drawn together again. The hero's body is rent so that the body of the state can be made whole. There is another Greek word that, although not identical in meaning to anagnorisis, bears in its use a similar dynamic.

Anamnesis is the Platonic basis for the revelation of knowledge; that is, all knowledge is known prior to bodily existence, and anamnesis is the process of recollection of that ideal knowledge. Socrates used the maieutic method to facilitate anamnesis. The maieutic method is metaphorically related to midwifery, birthing. Yet perhaps it is not so metaphorical after all, if all our knowledge is forgotten (repressed) when we are first embodied and enter this world. Amnesia is very often a physically produced state, in this case produced by the trauma of birth. Thus is anamnesia a *re*birthing process, a *dis*embodiment of knowledge through language.

Brecht, a dialectician like Socrates, was engaged in a particular type of maieutic method. Catharsis comes after the moment of recognition. Timothy Wiles has shown that the term *catharsis* has varying interpretations after being translated from the Greek. The work of Else, Golden, and Hardison reads it as "clarification of incident" rather than "purgation of emotion," clarification preceding purgation (*Theater Event*, 126–27). Wiles has also pointed out that in conventional Aristotelian dramaturgy "actor and audience achieve catharsis at the same time during the apprehension of the play; Brecht is really 'non-Aristotelian' in that, according to his scheme, his actor would have to have achieved catharsis before the play or the performance began, while his audience cannot experience it until after the play has ended" (82). Inasmuch as recognition for the actor is prior to the play and maintained throughout, knowledge is *never* embodied in the Platonic amnesiac sense. It is disembodied throughout, remaining separate from the actor who "delivers" it as he consciously "enacts" his part.

Finally we have to ask ourselves: the body "itself," *is* there such a thing? The thing that experiences libidinal pulsions, joy, anger, hate, lust, pain—inasmuch as it viewed in a certain way, can it be considered the body proper? Even identification with someone else's pain involves an image that is interpreted (grimaces, tears, cries, etc.). This entails the philosophical "problem of other minds." One "knows" that one has a mind, feels pain, and so on, but how does one know this is true for others? One answer is that we assume the mind and feelings of others by using ourselves as models that we then project on others *as if* they had minds and felt pain.

Both the physical sensations that the body experiences and its incorrigible visibility have led certain performance and body artists to

preserve the fragile status of the subject that has been under attack by deconstructing philosophies, as well as social forces—not to mention film and television—by rendering it visible as bodily object. This is roughly analogous to Samuel Johnson's material act of kicking the stone to refute Bishop Berkeley's dematerializing idealism. The avoidance by these artists of theatrical spaces can be seen as a way of defying the distancing and disembodying propensities of the relentless signifying structure of the stage, which as we have seen, threatens the unified notion of the self. Of course most of these artists emerged from the art world and so displayed themselves in galleries and museums. Art galleries, in that they are ostensibly places where objects, not social selves, are on display, provide an appropriate structure for viewing the body as object. Other social spaces—especially if the artist is involved in some experientially based interventionary practice—position the embodied subject in its natural habitat. Such is Vito Acconci's *Following Piece*, where he chose random pedestrians to follow through the streets of New York, or the year-long performances of Tehching Hsieh—one spent living outdoors in New York, one spent silently in a prison cell built in his loft—which operate on a conceptual level, where the "problem of other minds" truly poses itself, since the performance is not based so much on the external action of the performer's body as it is on the performer's internal experience of the action, or *nonaction*.

A perfect example of this "nonaction" is the work of the performance couple Marina Abramović and Ulay (Uwe Laysiepen). The work *Night Sea Crossing* consisted of their sitting across a long table from each other for seven hours a day, and at each location doing this for a week (fig. 1). Over the course of years they did this until they reached the total time of ninety days. They simply sat and stared into each other's eyes for the duration of the work. Not averse to having themselves perceived as symbols, they could be seen as the exemplification of duality, as male and female principles. But while one could perhaps grasp this signification quite easily, what is more enigmatic is their own internal experience as it is displayed to us. In this opacity we find that despite all our theories the body still retains an air of mystery.

So the problem of the body in performance remains twofold: when the intention is to present the body itself as flesh, as corporeality, as living organism itself free of signs, it remains a sign nonetheless—at

the very least the sign of "the body," "mortality," "sensuality." It is not *enough* of a pure corpus. When the intention is to present the performer's body as primarily a sign, idea, or representation, corporeality always intervenes, and it is *too much* of a body. This creates the basic tension in the suppression of the actor/role dichotomy within the spectator's suspension of disbelief. We need to recognize this body/sign differential in terms of a shifting figure-ground relation that, despite numerous attempts, cannot for very long exact a simple resolution, in either utopian (modernist "authenticity") or critical (postmodernist "theatricality") terms. On the one hand, it is the "problem of other minds" that posits the "as if" of projection but finds its identification always incomplete. On the other hand, it is a lack of distance, a reflection of human vicissitudes that makes the sign less than full for the spectator. The body can be seen, then, both as instrument *for* the sign and something inexplicably Other.

SELF-KNOWLEDGE AND THE OBJECTIFICATION OF THE
BODY: GENET'S *THE BALCONY* AND
BECKETT'S *KRAPP'S LAST TAPE*

Although I have considered the actor's body—as sign and corpus, and mirror for the spectator's sense of being—as the object of modern performance, the illusion of the continuity of self that it provides points to another central question: that of time, or more exactly, duration. What we consider as an artwork's objecthood is actually its ability to endure. The ability of a play to endure can be read in two ways: in the larger sense of literature that endures historically, the meanings entailed by its language always having the potential to mean something to whatever generation encounters it. But there is another sense that has less to do with meaning than with being—that of the play's performance in time, which means the ability of the audience to remember not only what was represented, but how it was materialized on stage. Highly differentiated bits of information, complex systems of meaning that come thick and fast, may produce an emotional effect on the audience (usually one of distress), but the meaning of the performance, or the memory of the figure of its becoming, will be lost on the audience.[8] So signs, whether verbal or physical, objects or actions, must be repeated in order to ensure their impression on the audience's mind and memory. What this means for

the actors is that their representation of human behavior is repetitive. This repetition not only defines "character" but demonstrates change in character as well, through the modification of repeated behavior. In sum, we identify ourselves and others through the forms our repetitions take.

The repetitiveness of human behavior takes many forms. I can list a variety of repetitions (although by no means all-inclusive) that demonstrate the varying degrees of intensity or indifference, self-consciousness or instinctiveness, of human interactions with either the social environment or the self. The scale runs from *ritual* to *routine* to *habit* to *addiction*. They all represent attempts at survival, or endurance, whether physical or psychic. Before I turn to Genet and Beckett, I want to examine these terms in a way that I believe will be useful for interpreting the predicament of the characters in their plays.

Elizabeth Burns maintains that "Ritual . . . consists of a series of actions, considered appropriate to certain situations and capable of generating appropriate reactions from others. They are . . . characterised by instrumentality and expressiveness" (*Theatricality*, 217). While this seems to exclude private rituals, the "other" might be read as one's own self-objectification in a system of self-discipline that private rituals often serve. The other in religious terms may be gods or natural spirits. Ritual involves a self-conscious act, concerned with maintaining a faith in a course of personal action or in a social system. As a self-conscious act, it tends to be aware of, or remind the performer of, the symbolic or metaphorical nature of its repetitions. It can, of course, become empty ritual, when through repetition it tends to become reified or literal; the larger picture of what the symbols point to is lost in the attention paid to externals. This indicates a certain loss of desire or will to repeat, allowing one to slip into routine or habit. Only the *will* to repeat finds its expression in ritual.[9]

Routine, which Burns posits in distinction to ritual, "is a formalised way of dealing with recurrent actions and events which a person regards as necessary (i.e., has learned to regard as socially incumbent) but with which he does not feel deeply involved" (216). Most of society's existence depends upon routine. The effectiveness of the operations of routine depends upon a somewhat detached attitude in their performance. Too much psychic investment in simple routines can throw the system or oneself off balance. Routine requires

half-conscious behavior. It is, says Burns, "inexpressive." I think it can be expressive within the limitations of the behavior it requires. It is certainly less expressive than ritual behavior, but in its most expressive performance, routine will often try to disguise itself as ritual.

"Habit is a compromise effected between the individual and his environment, or between the individual and his own organic eccentricities, the guarantee of a dull inviolability, the lightning-conductor of his existence. Habit is the ballast that chains the dog to his vomit" (Beckett, *Proust*, 7–8). Habit is also what defines us as having a predictable character, either for ourselves or others. Habit is compulsive behavior, dependent on external things. Habit is unself-conscious and operates instinctively. It is an established compromise between two adamant forces, and the possessor of a habit feels threatened the moment its operations are questioned. The level of emotional investment is higher in habit than in routine. But it is more grounded as well, the "lightning-conductor of his existence."

Addiction is not expressive but ingestive. It is self-consuming as well as substance consuming. It is unconscious behavior; even though one can become conscious of it, continued addictive behavior always defeats that consciousness. What may begin as the enhancement of the senses ends as anaesthetization against any life not covered by the repetition of addiction.

As we move from ritual to addiction, the level of self-consciousness decreases, as does the ability to alter the conditions of the form of repetition. Does the center of investment move from a more disembodied zone to a more embodied one, in the path from ritual to addiction, or does it move in the opposite direction? The sensitized self-consciousness of ritual may be more "embodied" than the desensitizing repetitions of addiction. Yet both ritual and addiction use the body in certain ways in order to try to transcend the body.

To try and understand in more detail how ritual and addiction are involved in transcending the body's hold on us, I will examine two relatively late works of modern drama (both appeared in 1958) that exemplify objectification of self through repetition that tries to resist, or escape from, not only changes wrought by social circumstances, but time's tendency to undermine, if not dissolve, a personal sense of being: Jean Genet's *The Balcony* and Samuel Beckett's *Krapp's Last Tape*.

The former play portrays a ritualistic consciousness that seems to

operate at the service of personal desire rather than for any higher purpose, even if it wears its guise. These personal desires, however, are at the same time those that preserve worldly power, and the rituals serve to sacralize the secular functions of the state. But since, as Genet himself has noted, the play is basically about the power of *illusion*, political ritual is revealed as sustainable only by the continual desire to believe, even on the part of those who erect such illusory structures. In the end, however, it is the actual belief in the reality of such structures that condemns us to serve them, even to the point of death, the apparent end of illusion.

Krapp's Last Tape is predicated upon another illusion, that of true self-knowledge. Its focus on repetition is that of an addiction to self-consciousness, an addiction to the illusion of self-possession. What may have begun as a truly self-conscious ritual action of affirming the self through the recording of its experience, and the subsequent contemplation of that experience, ends up through repetition compulsion as the continual frustration of a narcissistic desire. Despite this frustration, the force of habit, rather than any real self-conscious reflection, is what keeps Krapp going. While the unexamined life may not be worth living, the *method* of this overly examined life takes the place of living, negating its worth in the long run.

The place of ritual, for Genet, is essential to the theater. It delineates a deeper understanding of the nature of reality itself, through the power of illusion it provokes. The rituals of theatrical illusion call into question the reality of our roles as social beings, or even as individual selves, and attempt to summon forth a sense of poetic truth that points beyond the shallow tricks of realism. Marvin Carlson has drawn attention to Genet's use of ritual:

> In a 1954 preface to *Les bonnes* (1947), Genet calls the celebration of the Mass the greatest drama available to modern Western man, whose theatre has lost, perhaps irrevocably, the element of the numinous. Theatre should be "a profound web of active symbols capable of speaking to the audience in a language in which nothing is said but everything portended." Genet, like Artaud, feels that Eastern theatre still offers this, while in the West the actor "does not seek to become a sign charged with signs. He merely wishes to identify himself with a character." (*Theories of the Theater*, 413)

Each of the characters of *The Balcony* wants first and foremost to become a "sign charged with signs," performing within their own "profound web of active symbols." They understand that denying the illusions and contradictions of their own humanity is the only way possible to partake of the numinous nature of immortality, the only reality, existing on the other side of death.

The Balcony

At the center of a capital city is a brothel known as the Grand Balcony. It is famous for being a "house of illusion"—that is, the clientele can work out "scripts" for a symbolic role they wish to play and it will be enacted, complete with props, sets, and costumes. The three major roles in the play are those of the Bishop, the Judge, and the General, performed by mediocre little men with large fantasy lives (fig. 2). Matters are complicated by the fact that the brothel is at the epicenter of a revolution and circumstances confound the three roles in the brothel with their real functions in the state under siege. At the same time the "real" Chief of Police, in love with Irma, the Balcony's madam, wants above all that his identity as Chief become the grandest role, to be eternally instated within a tomb in her house of illusion. Death and destruction surround an environment of fantasies, projections of majestic and eternal virtues into the cheap and gaudy fetishes provided by the house.

The desire for death operates at the core of the enactments of the Bishop, Judge, and General. But it is not so much death as an immortal equilibrium that each seeks. Each seeks to rid himself of his frail and fallible mortality in order to take on, and merge himself with, the universal symbol of an eternal principle—the Judge with justice, the Bishop with piety, the General with courage. It is in this allegorical image that the power of immortality is sought. It is a merging of the organic with the inorganic, the body with the costume, the face with the mask, in order to attain an adamantine "final immobility," as the Bishop says, as he stands face to face with his "death." His description of his vestments are that of inorganic longevity: "rigid cope," "carapace," "rock," into which his hand disappears like the head of a turtle, to masturbate, "to dream" (13). Likewise the Judge seeks the total freedom of his power in death: "If every judgment were delivered seriously, each one would cost me my life. That's why I'm dead. I

inhabit that region of exact freedom. I, King of Hell, weigh those who are dead, like me" (17). He is safe in his judgments, for what worse punishment can he give to the dead? The General, when told by his female "horse" that though he is a dead general he is an eloquent one, he replies, "Because I am dead, prating horse. What is now speaking, and so beautifully, is Example. I am now only the image of my former self" (26). This recalls Walter Benjamin's "Death is the sanction of everything that the storyteller can tell. He has borrowed his authority from death" (*Illuminations*, 94). The illusion of each role takes its authority from death as well, because unlike life, it is only of death that it can be said, it is not an illusion. Even this, however, is challenged in the play by the deaths of Chantal, the whore turned revolutionary, and Arthur, the pimp.¹⁰ Please note that the Judge speaks of *exact* freedom, and the General of the eloquence of Example, which is his perfected image. We are in the realm of Platonic ideals, unknown to humans in their mortal state. Death delivers us to that pure eternal world (whether of Heaven or Hell) that has no part in materiality. Paradoxically, the rock and marble hardness of the Bishop's vestments and the Chief of Police's tomb partake of the same eternity as the purely immaterial image instilled in the minds of men. The mask and the role outlive the man, only to be assumed by others in line behind him.

The Chief of Police's perspective is just the opposite of that of the Bishop, Judge, and General. Rather than seeking to merge with an eternal image, say of law and order, he states: "I'll make my image detach itself from me. I'll make it penetrate into your studios, force its way in, reflect and multiply itself. Irma, my function weighs me down. Here, it will appear to me in the blazing light of pleasure and death" (48). In this way the Chief of Police's image will bore its way into the mentalities of all who behold him. The force of order will become internalized by those who wish to partake in his glory. Even Roger the revolutionary, his supposed enemy, is his first emulator, ending up castrating himself in the "inadequacy" of his emulation. The Chief of Police wants to build an empire, he says, so that "the empire will, in exchange, build *me* . . ." with the phrase completed by Irma: "a tomb" (49). That slight pause and completion of the thought by Irma reflects clearly the Chief's identification with death: the empire builds him by building his tomb. His dream is that "I shall not be the hundred thousandth reflection-within-a-reflection in a mirror, but the One and Only, into whom a hundred thousand want to merge"

(80). He is the eponymic *generator* of reflection, which places him in a greater position of power than that of the Bishop, Judge, or General, for it is his real function that is to be detached and idealized, for others to unite with and behind. In a sense, the role he already plays does not become "real" until this is accomplished.

The Envoy presents the most mysterious of characters, one who is to solidify the three clients into the "real" roles of Archbishop, General, and Judge, and transform Madame Irma into the Queen. He does this as bombs are dropping around the brothel, and two large explosions seem to indicate that the royal palace has been blown up; in fact the Envoy defines the palace as a "continuous explosion" (65). The Chief of Police, who demands to know of the condition of the Queen, receives only gnomic and contradictory answers from the aloof Envoy. He maintains that the Queen is embroidering and not embroidering an invisible handkerchief, that she picks her nose and examines the pickings, that she lies snoring in a rosewood chest. Ultimately, she is carrying "to an extreme the Royal prerogatives," including "Absence" (61–62). The Envoy explains his elusive position by stating that "though it is my duty to describe her, it is also my duty to conceal her" (62), which seems clear to us today to be the role of press secretary to any head of state. The most powerful figure of the state, or kingdom, who confers power on all others, derives and preserves her power through her own inaccessibility, her own invisibility. Through her representative she can be made to seem as common and human as someone who picks her nose, or someone as ethereal as an embroiderer of invisible handkerchiefs. It is the Envoy who thus becomes the one capable of conferring power, deriving his authority from Absence itself, the most inaccessible source of reality as well as illusion. Power is based in secrecy, no matter what it is that is being concealed. Paradoxically, this Absence can change "illusory," temporary, impalpable roles into "real," permanent, and palpable ones. It forms the ground for Presence.

Even the most self-acknowledged illusions carry within them the truth on which their figurations are based. While it becomes obvious in the course of the play that the three clients find their particular roles to be conducive to the feelings of power that suit their own natures, there is one moment when Madame Irma addresses the sources of those feelings, which at the source are not as purely narcissistic as they appear.

THE QUEEN *(very blandly)*: Excuse him, if he gets carried away. I'm quite aware of what you used to come here for: *(to the Bishop)* you, my Lord, to seek by quick, decisive ways a manifest saintliness. No, no, I'm not being ironic. The gold of my chasubles had little to do with it, I'm sure. It wasn't mere gross ambition that brought you behind my closed shutters. Love of God was hidden there. I realize that. You, my Lord, were indeed guided by a concern for justice, since it was the image of a magistrate that you wished to see reflected a thousand times in my mirrors. And you, General, it was bravery and military glory and the heroic deed that haunted you. So let yourselves go, relax, without too many scruples. . . .

(One after the other, the three men heave a deep sigh)

THE CHIEF OF POLICE *(continuing)*: That's a relief to you, isn't it? You never really wanted to get out of yourselves and communicate, if only by acts of meanness, with the world. I understand you. (83–84)

It is a relief to them, because they cannot admit to virtue in a place of vice without appearing foolish. But it is still a virtue that remains locked within their own self-images, since they lack the courage required to communicate nobler feelings to a world founded purely on self-interest, or because those nobler feelings are inextricably entwined with baser motivations. The result of this inability is an obsession with the manifestations of these positions that can be "witnessed" by one of Irma's girls. The three men cannot "lay their hands on" the ineffable sources from which come the intangible qualities known as true piety, justice, or bravery and so must substitute for those invisible powers the visibility of their ornaments, which become fetishes, in both the Freudian and religious sense. They are metaphorical objectifications of power that are eventually taken literally as the source of power (or the feeling of power). But they only retain their attraction in contrast to the banality of uncertain and fluid social life. In that sense these roles give pleasure only when one is not compelled to identify completely with them. The question "Were they real?" (meaning the tears of penitence, the screams, the stripes on the back) is asked only half in earnest, since it is the uncertainty of the answer that provides the excitement. The attempts at the transcendence of the body and its limitations that feeds the egos of these men also

denies them the acknowledgment of the humanity of others—who are as much the objectified victims of their roles as the three "masters" are (we see this in the girl Carmen's devotion to the role of the vision of the Holy Virgin). The very instability of a sense of individuality within society seems to demand an objectification of *role* that is accomplished by the projection of its essential attributes into its outward manifestations: clothing, costume, ornamentation. What is *ornamental*, which is normally seen as supplemental, superfluous (the framing device that Derrida calls the "parergon"), becomes foregrounded as the essential. The fixing of individual need within a supreme role that has the character of a universal *symbol* overthrows the notion of the particular individual altogether. To attain the supreme immobility and power that death imparts means to give up one's distinctions as a mortal, which include one's contradictions.

One can approach this objectification of self, immortalized in its allegorical role, from various angles, two of which, one political, the other psychological, may shed light on the "inner" forces and drives of the play.

The first perspective concerns the manipulation of time. We watch the three clients in the act of repeating an endless nocturnal ritual, in the seemingly timeless rooms of the brothel, in what might be the timeless realm of dream, and in the dark of the theater itself, in which the passage of time has always been manipulated and confounded. Each client seeks the timelessness of death, an eternity in which the tensions of desire created and released approximate a point of stasis. Political ideology has some bearing on the nature of these particular desires.

Charles S. Maier, in an essay entitled "The Politics of Time," posits three different political dispensations of time in the modern era: "bourgeois time served time; fascist regimes . . . denied time; and postliberal communities tend to decouple collective and individual, public and private, time" (152). While I believe the distinctions made here are not necessarily so hard and fast as they seem, since there is an ahistorical consciousness implicit in each one of these times, what is obvious is the connection between an ideology that wishes to eternalize itself and its resistance to progress, which means not just change, but also inevitable corruption and decay. A thousand-year Reich, or "existing socialism," depends upon an absolute belief in the present state coupled with an absolute sense of history, but it can only do this by valorizing

the unchangeability found only in death. As Maier puts it, "The thematic of fascist or Nazi time consisted precisely of its juxtaposition of permanency with its transfiguration of death" (162). The purity of the image that each of the brothel's clients sought can be read in this light as well: "[T]he dead hero never decayed, he remained immune to the universal entropy that afflicted the living" (162).[11] Genet himself has pointed out that the Spanish Civil War and the success of Franco was the inspiration for the play (Coe, *Theater of Jean Genet*, 91).

Maier contrasted fascist time with liberal bourgeois time, in that the latter class served time and subordinated all activities to it, inasmuch as "time is money"; the fascist did not want to be at the service of time but sought to *master* it for his own glory. The fascist regulation of time was a "pervasive effort to reverse liberal concepts and to decommodify time once again. . . . [F]ascist initiative sought to remove from the marketplace the principles of individual and collective time" (163). Thus the Chief of Police attempts to appropriate and stretch the commodified two-hour limit of the Grand Balcony into his own two-thousand-year Reich.

Aside from the political ideal implicit in the veneration of death, what might be the personal pleasure to be sought there? What is the *desire* that drives these men into the rigid codes of their petrifying roles? Freud has spoken to this. While the reality principle operates to stave off death, "[T]he pleasure principle seems actually to serve the death instincts" (*Beyond the Pleasure Principle*, 56). More exactly, "[T]he pleasure principle . . . is a tendency operating in the service of a function whose business it is to free the mental apparatus entirely from excitation or to keep the amount of excitation in it constant or to keep it as low as possible. . . . [I]t is clear that the function thus described would be concerned with the most universal endeavor of all living substance— namely to return to the quiescence of the inorganic world" (56). Prior to this Freud states that we may be compelled to say that the " '*aim of all life is death*' and, looking backwards, that '*inanimate things existed before living ones*' " (32). And *after* as well: the longing for immortality is the desire to merge with the inanimate. This may seem strange to find in a brothel, where excitation is the main business. But we see in *The Balcony* the attempt of a function to "keep the amount of excitation in it constant." What is significantly missing in the play is any sexual activity that results in orgasm. The desire of the Chief of Police to be represented by a gigantic phallus is the desire to keep that excitation forever

constant and hard. Which means his image remains in a state of potential: while others may come and suffer detumescence, he will not.

The clients objectify themselves for themselves, they objectify themselves for their "witnesses,"[12] they objectify themselves for Irma and the Chief of Police, they are forced to objectify themselves for a fictional populace, and finally they objectify themselves for us, the audience. In this figure swallowing its ground, this radiation outward from an illusory center, all those for whom they objectify themselves become objectified in the process. Finally the audience is objectified the moment Irma speaks to it in the last lines: "You must go home now, where everything—you can be quite sure—will be falser than here" (96). The audience has been placed in the position of the voyeur that has been discovered and is immobilized in this act of recognition. At the same time, the direct address of Irma fictionalizes the audience by including it within the discursive space of the play. Its return to "real life" is prefaced by the statement that it is falser than all the levels of falsity we have observed in the play. That might be in part because of our lack of reflection upon the constructed nature of the political illusions we maintain through our unquestioning faith, and in part because we do not care enough about our deepest desires to objectify them and see them for what they are but are willing to carry on a masquerade that actually conceals our desires from ourselves.

Our desires seem less real, less attention (even in a purely self-indulgent way) is paid to them as human value, because of the lack of objectification. In fact, we must come to the theater to see them enacted for us at a safe remove, free from having to acknowledge any real identification. We assume the truth of our normal, socially imposed roles, while denying the truth of our desires, which we can only, if even that, state to our mirrors. These Sartrean mirror "images" are difficult to truly discern in their overfamiliarity, however, and we need them to become materialized as "objects" to see them clearly.[13] We would like to affirm the unity of our own selves or characters while ignoring their real nature as being themselves reflections of others over whom we have power or who have power over us, just as the Judge is a reflection of the thief, the Bishop of the penitent, the General of his horse. Still, there is something of our selves reflected in the play. Our identities can become rigidly, even turgidly, bound up in the petrification of our roles and ideals, which, while only symbolic constructions, are capable of either being dissolved, taking us with

them, or unexpectedly bound to us, like the shirt of Nessus, by painful circumstance.

Krapp's Last Tape

Krapp's Last Tape takes place at a desk bathed in light from an overhead lamp. Krapp, one of Beckett's ridiculous old men, sits there caught in a cycle begun in his twenties, of recording events of his life on a reel-to-reel tape recorder. What once had begun as a ritual event of self-examination has taken on an obsessive narcissistic cast that prevents Krapp from living for anything else but recording, not only events in the present, but responses to his audition of old tapes, which take on even more importance than present life experiences. Krapp's degenerated physical state shows the effects of his obsession with the ungraspable object of his life. His condition is exacerbated by alcoholism—demonstrated in his movements to the outer darkness to drink before coming back to the light to listen to his past once again—as well as a steady diet of bananas, inducing constipation, a physical symptom of the fear of losing any part of the self to the inevitability of time and decay. As in many of Beckett's plays, it is repetitive behavior that convinces one of one's existence. Conversely, repetitive behavior diverts consciousness from the thought of death, which is the cessation of repetition.

> Repetition and recollection are the same movement, only in opposite directions; for what is recollected has been, is repeated backwards, whereas repetition properly so called is recollected forwards. Therefore repetition, if it is possible, makes a man happy, whereas recollection makes him unhappy. . . . When one says that life is a repetition one affirms that existence which has been now becomes. When one does not possess the categories of recollection or of repetition the whole of life is resolved into a void and empty noise. (Kierkegaard, *Repetition*, 3–4, 34)

Is *Krapp's Last Tape* the repetition of recollection, or the recollection of repetition? Or does the confluence of the two result in their negation, becoming a "void and empty noise"? Does Krapp affirm "that existence which has been now becomes"? Or has becoming ceased altogether because of the absolute privileging of the past?

When we consider the two forms of recollection, what Proust called "voluntary" and "involuntary" memory, we see that Krapp's method of self-objectification involves them both. The voluntary approach creates a mathesis of self, superimposing a grid over temporality to facilitate an impeccable "self-knowledge" and control over Krapp's own image, experience, and history. There is, on the other hand, the content of the tapes, which although created by the will of voluntary memory, drifts into the ramblings of involuntary memory, punctuated by such Proustian tactilities as the feel of a hard rubber ball in his hand.[14]

Krapp's method is a battle against time, a desire, if not for pure self-presence, then for repeated moments of happiness. It is an attempt at the complete mastery of past experience. It is the desire, expressed through the yearly rundown of peak moments, to have *all* of his temporal existence before him at any moment: in other words, the total spatialization of his personality in time.

But this attempt only works against itself. While Krapp thinks he is articulating his life, that is, joining elements of it coherently, he only disarticulates himself into separate spools. At the same time the past takes on a greater sense of presence than the present itself. While his voice and certain memories retain their sensuous strength on the old tape, the present Krapp becomes ever more a ghost of what has been recorded: a strange reversal, since the disembodied voice would seem more the ghost. This material degradation is also reflected in the contrast between the "Farewell to love" idyll on the old tape and the current travesties of Fanny, "better than a kick in the crutch," and his secondhand romance through Effi Briest (62).

Krapp exists in a paradoxical state: is he "being" or "remaining"? It is a question occasioned by an earlier description of his mother's "viduity," which the dictionary he consults describes as "State—or condition—of being—or remaining—a widow—or widower" (59). It is more likely that he is but the "remains" of his former life on tape, evidenced by his condition. While he has developed a complex system to retain the vibrancy of his past, he is at the same time an outrageous drunk, and after all, one drinks to forget. And it would seem he wants to forget what might have been the purpose of his system. The part of spool 5 that Krapp represses is the part that would promise to "make sense" of his preoccupation with memory. He cannot now face what might be a meaningless ground for his actions.

"The vision at last," the fire, the clarity, the blazing sun, seem to have become anathema to Krapp. He can only drink in the darkness of self-forgetting but is invariably pulled back to "me . . . Krapp" in the circle of light. It is difficult to say which, the light or darkness, has more power over him. This is common to most of Beckett's characters, a kind of absolute ambivalence that keeps them in perpetual but undecided motion. Words drain from minds that are never made up, and words are what provide the escape from the necessity to decide or act. It is the inability to remember the past, except as fragments, that stimulates repetitive action, more than the Nietzschean will to repeat, which is fully conscious and affirmative. But it is at the same time the experience of unexpected memories that creates the despair of repetition. After the repeated attempts to get outside of habit, which requires another habit, that of drinking, the old habit of remembering again takes over to evoke the reality of the past. It is like the situation in which a distracted person wanders into a room where he must ask himself, what did I come in here for? So he retraces his steps to provoke the mind back into the memory of his original intention.

"Habit is the ballast that chains the dog to his vomit" (Beckett, *Proust*, 8). Although vomit might not be the appropriate metaphor for this play, there is something comparable demonstrated in the hero's own name. Through his habit Krapp continually attempts to give birth to himself. But as is the case with his father, this birth can only be parodied as an "unattainable laxation," something even Freud's Little Hans understood. All of his spools can be read as hard ("iron") stools—echoed in the solidity of the black rubber ball, the feel of which he will "always remember"—or as the spoor left on the trail of his life. As such, instead of that which will inspire and shed light on his present state of being, and be a completed work one day, the recordings become the waste products of experience, just as his own present degradation can be seen as the waste product of his obsessive relation to the memory of those experiences.

Something that Krapp's attempted self-objectification has in common with the clients of *The Balcony* is the desire for complete self-possession through the materialization of self-knowledge. Arnold Gehlen wrote that "The tendency which characterizes the progress of technique, from the substitution of organs to the replacement of the organic as a whole, is ultimately rooted in a mysterious law pertaining to the realm of the mind. Briefly put, this law is: Nonorganic nature is

more knowable than organic nature" (*Man*, 6). Therefore the organic nature of memory and life experience is transferred to a nonorganic solid, whether in the form of costume or a reel of magnetic tape: the materialization of speech. Gehlen credits Bergson for this insight and continues: "According to Bergson, intellect can only be judged in relation to action, and its primary aim is the production of artifacts: 'Therefore . . . we may expect to find that whatever is fluid in the real world will escape [the intellect] in part. Our intelligence, as it leaves the hands of nature, has for its chief object the unorganized solid' " (*Man*, 7). What is this "unorganized solid" but Krapp himself?

Beckett accentuates the fetish character of both banana and tape reel, which are kept in the same drawer, under lock and key. Krapp uses each reel of tape to bind himself to himself, and the image of the banana in his mouth goes beyond the masturbatory nature of his enterprise to self-fellatio. This in itself is a ludicrous travesty of the uroboric world consuming itself. The tapes begin as a supplement to Krapp's life, but in their very superfluity replace that life itself. Krapp wants the ground to swallow the figure, and his reel-to-reel to become real, too real. But these fetishes cannot overcome as a unity Krapp's multiplicity of selves; he has as many bananas as reels of tape, that is, former selves. This proliferation of irreconcilable units contributes to time's ineluctable process of dematerialization. As Beckett speaks of it in his book on Proust: "No object prolonged in this temporal dimension tolerates possession, meaning by possession total possession, only to be achieved by the complete identification of object and subject. . . . All that is active, all that is enveloped in time and space, is endowed with what might be described as an abstract, ideal and absolute impermeability" (*Proust*, 41). Despite the ability to rescue the past through its recordability, the past as object remains impermeable by the present subject. True self-possession remains an impossibility.

While I have claimed objectification to be a positive aspect of art making and enjoyment, Krapp and the clients of Genet's brothel illustrate the result of trying to retain absolute possession of what is created. Both have the inability to distance themselves from what they have objectified, even while at the same time they suffer absolute frustration at not being able to truly bridge the distance that is inevitably manifested. Krapp himself finds it impossible to look at, or hear, his life in an "objective" light, for he wants always to be able to possess and live those past moments, to "Be again, be again" (62). Yet

he is forever unconscious of the fact that he has his being *now*, in the present, the one dimension he can't recognize since it is but fodder for the mill of memory, which seems more real.

This disparity, this inability to possess his life completely, is what wastes him, as it is an endless process that is never complete despite his former hopes, when "Suddenly I saw the whole thing. The vision at last. This I fancy is what I have chiefly to record this evening, against the day when my work will be done and perhaps no place left in my memory" (60). But will this self-generating work ever be done, any more than any interminable psychoanalytical process? Krapp is indeed *afraid* of having no place left in his memory, which stimulates his "work": the attempt at a complete reconstruction of his own consciousness, a representation that is the "equal of life," to put it in Artaud's terms. But this still creates an irreconcilable split between lived experience and consciousness of that experience. A chasm yawns between the present moment and the words just spoken, recorded or not, that attempt to preserve and maintain every present moment. That chasm is Krapp's own "viduity" as the widow (or widower) of himself; "remaining" is always the widow of "being." Viduity of course, is an echo of the void, the void between the present moment and the past.

In Ibsen, the revelation of memory always serves to alter conditions dramatically and irrevocably, usually ending in someone's death or downfall. In Beckett, the narration of memory repetitively and compulsively maintains conditions that are intolerable, a living death, tragedy dragging its feet. The metaphysical structure of *Krapp's Last Tape* is committed to the spoken word, the conveyor of memory, as the sole arbiter of reality and the sole creator of a self as a continuous entity. This can be seen elsewhere in Beckett in the bodiless voice of *The Unnamable* and the mouth in *Not I*, as well as in his radio works. One or two memories repeated by this voice often enough constitute a "self." Paradoxically, the more disembodied the voice in performance, the more "objectified" it seems. Its authority comes from its very disembodied state. This is part of the appeal of the voice-over in much contemporary performance.

Although one might consider that the play is performed in "real time" to the audience, the voice on the tape and the voice being taped (the moment words are spoken) are both in the past. That is what puts this play "in the future," as the stage directions indicate. This point

foregrounds the taped voice as the standard by which to experience and temporalize the rest of the play. There's a sense we get after a while that everything material that we see is to be dematerialized into the sound of one voice, which is itself only an echo. This winding in of the present into the past in order to become the future's present is always delayed at the most minimal level by the time it takes to listen to the past.[15] A work of conceptual art by Christine Kozlov, called *Information: No Theory* (1970), radically framed this problem by running a continuous loop on a tape recorder, with the recorder in "Tape" mode. The loop, which is continuously taping the present, is forever erasing what it just taped (Meyer, *Conceptual Art*, 172). It is the clearest performance of Gertrude Stein's continuous present, but it can only exist in the void, in silence. It creates an impermeable privacy.

Krapp's Last Tape can be read allegorically, depicting our own obsessions with preserving the present, with the retention of history in its "original form" ("original voice" in this case). It can be read as a continual recycling of self and continual consumption of self, a repetitive reification of personality that is the replacement for an eternal soul. It also demonstrates the internalization of formerly external processes of surveillance and control by authorities. In a Foucauldian sense, it is a kind of "technology of the self" that, rather than resisting social technologies that create the self, simply recapitulate them in private. It is what Václav Havel (to whom Beckett's play *Catastrophe* is dedicated) has described as the internalization of the police state, which he calls "post-totalitarian," since formerly totalitarian states had to rely mainly upon brute force and external threat (27). All these miniobjectifications, which through habit become reifications, literalized desires, lead to their own demise, and to ours as individuals, our self-image systems near to drowning in a sea of inconclusive signs.

Beckett disarticulates the body through hypostasizing speech-as-memory within the space of the dread of silence. Perhaps, as in Pinter's work, this speech is created by the dread of silence. Is it this dread that disarticulates the body, or is it language that breaks up the dread unity (monotony) of silence and therefore atomizes the body into separate functions? We have seen that Krapp's attempts at re-membering actually constitute a dis-memberment of experience. Beckett's early work is filled with cripples, the deaf, dumb, and blind (Lucky and Pozzo, Hamm and Clov). His late work emphasizes separate body

parts: the feet in *Footfalls*, the Mouth in *Not I*, the face in *Catastrophe*, *Play*, and *That Time*.

The disembodied nature of Beckett's voices seems to emphasize a poststructural obsession with difference that privileges language over materiality—or at least demonstrates the radical discontinuity of mind and matter. But what is evident in Beckett's work that is not in the dematerialization processes of poststructural discourse is the recognition of a *silence* that is at the foundation of all linguistic expression. The dread of silence is not simply the dread of the silence of the vacuum, but the pained silence of the body, of "dumb" material, which absorbs language just as Joseph Beuys's felt absorbs sound.

Beckett's disarticulation of the body awaits its rearticulation with inanimate parts, Gehlen's replacement of the organic with the nonorganic (foreseen by the prosthesis of Krapp's tape machine), at the hands of Thomas Pynchon and even more recently by William Gibson and other cyberpunk novelists. Since we can no longer dismember the gods, we become content to dismember ourselves and each other. But we used to eat the god.

We have seen that repetition in life as well as performance can take on the shape of ritual or addiction. Ritual is the self-conscious maintenance of an integrated relation of self to reality. It is the expression of internalized beliefs that provides a sense of coherence for the self and its community. The attempt to free oneself completely from this internalized structure of belief (in part the heritage of the Enlightenment ideal of individualism) only binds one more completely to the caprices of external change, disintegrating the internal coherence. To maintain a sense of individual continuity, one then becomes trapped in obsessive-compulsive behavior, dependent upon external things or activities, whose intensity varies from habit to addiction.

Beckett writes about addiction, not ritual. What might have *begun* for Krapp as ritual ends as addiction. The obsessive repetition of Krapp's actions changes him from the subject of a ritual to an object or effect of an addiction. What was once a mode of self-conscious behavior becomes the simulation of self-consciousness. The *post hoc ergo propter hoc* nature of both ritual and addiction ("If I don't do it, tomorrow may not come") is differentiated by the fact that addiction takes this argument literally and ritual understands the larger metaphorical

dimensions of such repetition. That is, ritual provides distance as well as a *willed* engagement with transformations.

Modern performance's attraction to repetition, whether it is ritual, routine, habit, or addiction, demonstrates a desire for permanence. The value of repetition is that it sustains the living actions of performance, thoroughly reinscribing the present movement and sounds upon the memory and fearful of the tendency to forget, which is the most dematerializing force of all. When Gertrude Stein asks, "Is it repetition or is it insistence?" she hits the nail on the head. Performance is an "entity" known only in its temporality, attempting through its own use of insistence to certify that it *is* material and present, and not just always passing away. At best, it hopes to create material effects within the lives of the audience.

While both *The Balcony* and *Krapp's Last Tape* demonstrate forms of "bad objectification," if not reification, they also point to something at their core that may be the "cause" (as desired end) of this bad objectification. What resists appropriation by the subjects in both plays is a horizon of unfulfilled desire that is infinitely receding within a *mise-en-abîme*. I could say what resists *comprehension* (especially as something *comprehensive*), but the form this comprehension takes for both Krapp and the clients of the house of illusion is possessive, solely for the nourishment of the selfish ego—a nourishment, however, that consumes the self rather than nourishing it. This core *mise-en-abîme*, so tempting for the narcissistic spirit, cannot be comprehended, nor should it be; yet we must recognize and respect its existence. Paradoxically, its structure in-forms the ground of our being, even while in ways unknown to us, our being in-forms it. To "want it all" is to allow the "all" to both create and destroy you. The search for the numinous that both Artaud and Genet tried to engage in cannot be satisfied or fulfilled by attempts that are hyperconscious rational comprehensions of what we hope is the numinous. It is not summoned or called by us, but we are called by it: it involves watching, listening, and being aware, without desire for complete and masterful possession.[16]

While *The Balcony* and *Krapp's Last Tape* might be seen as progenitors of a postmodern theatrical consciousness ("all is artifice," and the "self" disappears in the abyss of self-consciousness), they are not postmodern precisely because of the *desire* for the absolute that they both evoke—a particularly modernist pursuit. It might be conceded

that at the center of each play resides the postmodern-modern conflict. Postmodernism, despite all of the attention paid to the "libidinal economy" and "desiring machines," is in fact curiously lacking in desire—that is, its desires are ones that are easily and quickly satisfied, while compulsively fed by the culture at large. Postmodern desire is uncannily desireless (in the homeless sense of *unheimlich*) since it always accepts a surface reality for what it is and ignores whatever whole symbolic and material process that surface may point to beyond itself, historically or otherwise. Postmodernism is in fact the reverse of Krapp's method: it is a continual act of forgetting that can't help but remember.

Postmodern theater would be one that doesn't develop character, but also doesn't really invest the actor as a "sign charged with signs"—rather as just a single sign in a cybernetic network of interchangeable signs (evident in the work of both Wilson and Foreman)—the triumph of spectacular "total" theater over theater's traditional locus in the human, both as multivalent sign and as social body.

But this type of theater is but a radicalization of one warring element within modern theater—the theatrical and visual, as opposed to the linguistic and psychological. Herbert Blau has spoken to this very point:

> The denial of character, like the denial of drawing, persists in that antirepresentational ethic of postmodernism which fears more than anything else the premature falling into meaning. On the one hand, it is an extension of the modernist tradition of depersonalization; on the other, it comes from the unsatisfied incessancy of the mirroring self. In either case, it represents the validation of the formal and iconographic, and the diffracted, against the chronographic, the narrative, and the mimetic. (*Take Up the Bodies*, 277)

As we have seen, "character" denies itself through a total merger with the iconographic, as in Genet's play, but it also fragments and dissipates itself in the very process of creating a whole narrative for itself, as we see in Beckett's play.

While one might say that postmodernism is a relativizing structure of thought that attempts to create itself continuously in the dematerialization of whatever object modernism erected to invest its

futurity in, this very movement of objectification-dematerialization is what has always been in the very center of theater practice. Again, in a very precise manner, Blau shows us that the object of theater may be its own dematerializing power:

> *What is the theater but the body's long initiation in the mystery of its vanishing?* On the face of the evidence, inimical to appearances, the actor's most tangible asset is the void. (299)

Art as Object, Art as Definition

The performative body has not been the only site of tension or outright conflict between the immediacy of sensual experience and the incessant deferrals and displacements of signification. Even if through material means, modern painting has had to confront the conceptual nature of vision once Cézanne helped dislodge it from the tradition of perspective. The movement of abstraction toward the most heightened and immediate *sensory* effect upon the viewer was necessarily at the same time an investigation into the *language* of color and form—read along a historical and progressive trajectory—and what it meant for these elements to constitute a "painting." Just as the performative body may try to draw attention to its corporeality while never evading its status as a sign, so painting as it developed—as long as it could call itself painting—had drawn attention to its material nature as *object* while never escaping its status as a *picture;* even so, as a picture it had to contend with its social displacement by photography. Two historical moments—Duchamp's "abandonment" of painting and discovery of the readymade, and the emergence of the "primary objects" of minimal art in the sixties—constitute the breakdown of painting as the definitive and defining center of art production. Neither of these historical moments, however, severed the object from signification, despite some readings of minimalism, but resituated the art object *as* a sign in a field of signs.

The material objectification of painting is like theatricality in theater, pointing to its own manifest structure that produces significance. But once it reaches the point of greatest and most minimal materiality, it reverses as a figure into its ground of signification, and painting as the self-defining center of art becomes only another component of art as self-definition. Even in its most minimal form it becomes an aspect of referential objectification, but on the other side of "picturing"—no longer a microcosmic reproduction, but rather a

signifying element that is a self-conscious part in the syntax of art as it defines itself as both historical and social institution.

In this chapter I survey the tradition of abstraction in painting in its more extreme manifestations, from Malevich, Kandinsky, and Mondrian through abstract expressionism up to its dispersal within sixties minimalism. I intend to show that while Anglo-American conceptualism emerges primarily out of the logic of the minimalist trajectory, it shares the idea of art's basis in linguistic overdetermination that Duchamp advanced. I also examine the contribution of Duchamp and Warhol to the redefining of artistic practice, shifting the emphasis from expressive labor to conceptual investment.

THE ABSTRACT TRADITION: MALEVICH,
KANDINSKY, MONDRIAN

While after Cézanne cubism had set the scene for abstraction, its founders, Picasso and Braque, never became completely abstract painters in the sense of eliminating subject matter drawn from external reality. The painters most look to as the spiritual forebears of later abstractionists were Kasimir Malevich, Wassily Kandinsky, and Piet Mondrian. All three entirely eliminated represented objects from their canvases in order to concentrate on formal properties alone.

The dissolution of the object begun in the Italian futurist exemplifications of the atomic breakdown of matter ended, in 1913, in Malevich's famous black square on a white field. Despite the formal and rational look that the work might have for us today, Malevich was distrustful of interpretation of work that was based in formal and rational considerations. His approach was intuitive and sensual: "To examine a Cubist creation formally is to fail to understand its essence. The world which is understood by sensations is a constant world. The world which consciousness understands as form is not constant" (Malevich, *Essays*, 15).

Although it has been assumed by formalist art critics that the development of abstract painting in this century has been a gradual reductive analysis to its most essential material nature, Malevich claimed that the "materiality" of the painting itself was not a concern, but rather the signification of feeling appealed to through primary forms, a type of Platonism (fig. 3). The forms were a sign system appealing to a nonrational intuition. "The black square on the white

field was the first form in which non-objective feeling came to be expressed. The square = feeling, the white field = the void beyond this feeling" (Chipp, *Theories*, 343). He never designated *which* feeling the square evokes, only that as a primary form on an infinite field, it presents a contained charge of emotional energy. We can see that more direct symbolism is at work when he says, "[I]n the community they have received another significance: the black [square] as the sign of economy, the red one as the signal for revolution, and the white one as pure action" (Malevich, *Essays*, 127). In the case of such wide-open symbolic fields, "[E]volution and revolution have the same aim, which is to arrive at the unity of creation—the formation of signs instead of the repetition of nature" (94).

For all Malevich's revolutionary fervor, he could not consider himself a materialist. He remained devoted, rather, to the dematerializing spiritual value of new works of art, where the forms are given life by artists who create works sui generis, thereby becoming "an indivisible part of God the Creator" (80). His use of the term "non-objectivity" refers to the flow of phenomenal reality, identified with the spiritual, which cannot be captured and tamed, or consumed:

> The "greater significance" of the spiritual consists of the fact that the spiritual does not create for the sake of devouring itself but for its non-objectivity; the materialist, on the other hand, sees the creation of that same matter as the aim of self-devourment—he creates objects for his own appetite. (*Essays*, 210)

While he found no contradiction between what he considered the utilitarian and the spiritual, he spoke out against what he called "the culture of material," even as he spoke for "producing the image through the utilitarian perfection of economic necessity" (126). "Economy," what he called his "fifth measurement" or "fifth dimension," is a libidinal economy, the physical economy of energy at the basis of all movement.

While the conventional value of painting has been determined by its level of expressive labor—as either the torments of van Gogh or the painstaking empirical method of Seurat—the absolute simplicity of Malevich's revolutionary geometric paintings appear to be more a conceptual *fiat lux* than a product of labor. The new basis for art in the creative *act* rather than what he considered to be the repressive nature

of work can be found in his twelfth of eighteen resolutions for art, published in 1919: "To recognize labour to be a left-over from the old world of violence, since the contemporary world stands on creation." The creative speech act, as we will see, constitutes the basis for the conceptual tradition in this century.

Just as he was moving away from the representational toward total abstraction in his colorful, dissonant paintings, Wassily Kandinsky articulated the theoretical underpinnings of his practice in the book *Concerning the Spiritual in Art*. First published in 1911, it became an immediate inspiration for a generation of young painters. There Kandinsky's mystical ideas about color were linked to the Romantic idea of synesthesia, which played a part in Baudelaire's "Correspondences" and Rimbaud's poem "Voyelles." Kandinsky's aspirations for art were toward the condition of music, as the purest form of vibration: "Colour is the keyboard, the eyes are the hammers, the soul is the piano with many strings. The artist is the hand which plays, touching one key or another, to cause vibrations in the soul" (25). Kandinsky constantly referred to the "inner sound" as the fundamental basis for any composition, and called some of his paintings "improvisations," after the musical idea.

This lure of temporal forms, such as music, corresponded with his interest in the spiritual dissolution of matter, similar to Malevich's interest. Both saw science moving away from positivism after the revolutions in physics, and both found it more conducive to the freeing of phenomena from a gross materiality. "When we remember, however, that spiritual experience is quickening, that positive science, the firmest basis of human thought, is tottering, that dissolution of matter is imminent, we have reason to hope that the hour of pure composition is not far away" (47). In his essay in the *Blaue Reiter Almanach* called "On the Question of Form" (1912), he remarked that the privileging of form over "inner content" was no different from pure materialism: "We see that the absolute cannot be sought in the form (materialism). Form is always temporal, i.e., relative, for it is nothing more than the means necessary through which the present revelation makes itself heard" (149). The material world, however, is not the enemy, but rather what we make of it and how we relate to it: *"The world sounds. It is a cosmos of spiritually effective beings. Even dead matter is living spirit"* (173). His ironic reference to "dead matter" rebukes the soulless and amoral rationalizing practices of modernity. If

we examine the material world that provides us with our existence as if it were just an accumulation of "dead matter," what is to prevent us from eventually viewing our own and others' existence in a similar way?

The living spirit, however, is not to be found by concentrating on outward form, but in intuiting inner necessity: "In short, the working of the inner need and the development of art is an ever-advancing expression of the eternal and objective in the terms of the periodic and subjective" (*Concerning the Spiritual*, 34). Thus the inner need is always in the service of the timeless and traditional spirit of art, regardless of the historical context, but whose form can only be created in relation to that context. The "objective" in this case, what is impersonal and eternal, cannot be seen in itself, but only intuited through the apprehension of the subjective, individual form. This timeless ideal of the objective in art, of nonreferential necessity, was appealed to by later artists like Ad Reinhardt, who nonetheless rejected Kandinsky's spiritualism.

For Kandinsky the creation of art was an ascetic task: "The artist is not born to a life of pleasure. He must not live idle; he has a hard work to perform, and one which often proves a cross to be borne" (Overy, *Kandinsky*, 54). The reduction of composition to its simplest and most effective forms does not result from the superior attitude of participation in cosmic creation, as with Malevich, but rather the expressionist (expressive) labor of the spirit.

In Amsterdam in 1917 Piet Mondrian, with Theo van Doesburg, formed de Stijl (the style). De Stijl was the movement of "neoplasticism," a nonobjective art that concentrated on pure uses of line, space, and color (which tended toward the primary colors: red, yellow, and blue). The neoplasticists believed that by eliminating subject matter and concentrating on the three elements mentioned, the "laws of universal harmony" would be found, which would alter not just the shape of art, but society as well. A painting was thought to take on a life of its own once these elements were drawn forth; it freed itself from the personal interest of the artist, while connecting the artist to the objective and timeless essence of art. This idealist art functioned not only as harmonious composition, but as a utopian model for society. Mondrian hoped for an art practice through which all of man's environment would become art and "we will no longer need paintings" (Chipp, *Theories*, 320). In fact, the nature of Mondrian's paintings easily extended them into architectural use. His concern with the aesthetic

dimension of the social environment was as important to him as his focus on paintings.

Like Malevich and Kandinsky, Mondrian saw the world of pure forms to be a world of movement, but one that is contained by the unifying and balancing power of the composition. In plastic art, "[V]itality reveals itself as dynamic continuous movement in equilibrium" (Mondrian, *Plastic Art*, 44). This equilibrium, despite the purity of Mondrian's aesthetic direction, is designed to be read in a moral light. The equilibrium of forces is to be read as what is possible for a harmonious shaping of society. After he shows that all relations in nature are determined by the opposition of two extremes, even his use of line has just such a symbolic value: "Abstract plasticism represents this primordial relation in a precise manner by means of the two positions which form the right angle. This positional relation is the most balanced of all, since it expresses in a perfect harmony the relation between two extremes, and contains all other relations" (*Plastic Art*, 323). After understanding these two axes as representing interiority and exteriority, he even claimed it to be a reconciliation of mind-matter dualism! What is central to his ethical-aesthetic stance is that plastic art should be studied as a model for freedom: "It does not tolerate oppression and can resist it, for art is not bound by material or physical conditions" (38). Alternatively, "[A]rt is the aesthetic establishment of complete life—unity and equilibrium—free from all oppression. For this reason it can reveal the evil of oppression and show the way to combat it" (39). Although it may be debatable that art is free from "material and physical conditions," *human beings* certainly are not. *How* it can show us the way Mondrian never made very clear, unless it was through some form of sympathetic visceral response. That kind of visual and intuitive response was certainly an issue for Mondrian, while he steered clear of a merely conceptual basis in his work:

> The only problem in art is to achieve a balance between the subjective and the objective. But it is of the utmost importance that this problem should be solved in the realm of plastic art—technically, as it were—and not in the realm of thought. The work of art must be "produced," "constructed." One must create as objective as possible a representation of forms and relations. (50)

Conceivably this balance between the subjective and objective is to arise homeopathically, as nonfigurative work "comes from pure intuition, which is at the basis of the subjective-objective dualism" (62). But it must be arrived at through labor, and its meaning resides in its materiality.

Unlike Kandinsky or Malevich, Mondrian did not foresee the dissolution of matter into spirit but rather saw a new relation between them necessary for a new understanding: "In removing completely from the work all objects, 'the world is not separated from the spirit,' but is on the contrary *put into a balanced opposition* with the spirit, since the one and the other are purified. This creates a perfect unity between the two opposites" (60).

What is noteworthy, but problematic, about these three painters is their Platonic conceptions of "pure color" as something that transcends its material basis. Yet, oddly enough, the works of these artists seem to contribute to this idea when they are subject to photographic reproduction. Many experience Mondrian's paintings, for instance, through reproductions in books—or even in the most commodified sense, as print patterns on dresses or designs for shampoo bottles— as "pure" and absolutely *flat*, often matte colors that due to mass reproduction techniques evoke none of the materiality of oil paint. My first experience of Mondrian's actual paintings came as somewhat of a shock when I saw the thickness of the applied paint, which in some cases had cracked over time, giving it the aura of an old, crafted, lacquered item, palpable jewels glowing, encased in black lines. On the other hand, Malevich's paintings seem cruder by contrast to their reproductions, as if quickness of execution—economy of labor as well as means—was necessary to evoke the spiritual.

Malevich had hoped for a revolution whose aim would be the "formation of signs instead of the repetition of nature"; he didn't foresee an epoch founded on and driven by the repetition of signs standing against the formations of nature. Kandinsky's rhythm of form and color aspired to the immateriality of music, and he considered the dissolution of matter imminent as a result of scientific advances, but at the same time claimed that "even dead matter is living spirit." Yet one can say today that through scientific advances and technological means the dissolution of living matter has proceeded apace, but also in the process producing both deadly waste and truly

dead matter that does not decay and become part of the planet's living spirit. Mondrian believed that art was not bound by material or physical conditions, but that its problems were to be solved in the realm of plastic art, not thought; he believed in striking a balance between the subjective and objective—not dissolving their distinction; he saw the world as a world of movement to be contained by the unifying and balancing power of composition: the balance of the material world and spirit. Yet the postwar abstractionists who were his most ardent disciples in technique, such as the concrete painters, could easily reject his spiritual concern for the most literal of aesthetic problem solving.

For their art to function in the utopian way these artists hoped for, it is inevitable or even necessary that their works themselves become reified for them to function for the populace at large. At the same time one danger implicit in the work of abstraction—a continual concern of Kandinsky's—is that it threatens to become mere ornament or decor, thus blocking any possibility of spiritual efficacy. Now the fact that something is "decor" or an aspect of architecture does not preclude a spiritual significance, as, for example, traditional Japanese culture has shown. But we are confronted by the question of the quality of *attention* in a mass-reproduced culture of continual distraction, whose operations have resulted in the artwork's loss of aura— which Benjamin speaks of in his most famous essay, "The Work of Art in the Age of Mechanical Reproduction" (*Illuminations*), understanding aura to mean an effect of the social investment of attention.

All three to a different extent saw themselves as participating in a dematerializing activity, seeing behind the material world one of pure spirit and form that radiates through it. Representation of actual objects of sense must be eliminated in order to facilitate the purest lessons in harmony, and this concerns human behavior as well as artistic form—or rather human behavior motivated by a deeper understanding of artistic form. "Representation" itself, despite what one might think, is not excluded, for Malevich understood his forms as signs with symbolic—if not emblematic, allegorical—value; Mondrian saw in his perpendiculars and colored squares representations of states of balance within human culture. One might say that emptying representation of its content was one way of formally examining the syntactical and rhetorical structures of representation itself: the most minimal explanation of how visual representation represents.[1] In examining these

artists we should recognize that the purest signification they each would desire could not be perceived without purification of the forms that are signs, as well as signs of signification itself (which might also be described as the "feeling" of signification).[2] But these could only be perceived through a material and sensual means that, while having signifying value through its formal and tonal syntax, surpasses the work's explanatory value through its status as an object. This sets in motion a dynamic balance between the spiritual and material, as Mondrian saw it.

MATERIAL TO LITERAL: ABSTRACT EXPRESSIONISM AND MINIMAL ART

One cannot view the New York school—generally known as abstract expressionism—as working entirely out of the conditions set up by formal problems in the evolution of painting. Many of them had, in the thirties, worked for the Works Progress Administration, creating public murals and working for radical causes. They found their radical-ism challenged by the Moscow show trials of 1936 to 1938, when the Soviet Union tried and convicted its major intellectuals, composers, and artists, and then by the Stalin-Hitler pact of 1939. The move away from realism in painting was already under way, however, when Clement Greenberg's essay "Avant-Garde and Kitsch," which ap-peared in *Partisan Review* in 1939, made a decided impact through its distinction between the kitsch of realism, and its popular appeal to fascist movements, whether of the left or right, and abstraction, the form of a libertarian minority.[3] World War II did more to separate the artists from social causes, until the appalling discoveries of the Ger-man concentration camps, the bombs dropped on Hiroshima and Nagasaki, as well as the triumph of the Right in America, creating the repressive atmosphere of the cold war, made it all but impossible to do anything but pursue a private rebellion in isolation.

Barnett Newman had "emphasized that the horror of modern conditions could not be represented or described" (Guilbaut, *How New York Stole*, 113) and therefore the artist had to rely upon the expressive qualities of nonobjective abstraction to avoid falling into sentimentalism. Yet, Adolph Gottlieb and Mark Rothko both denied being nonobjective abstractionists, but rather realists. Gottlieb main-tained that "our obsessive, subterranean and pictographic images are

the expression of the neurosis which is our reality. . . . [I]t is the realism of our time" (Tuchman, *New York School*, 67).

Indeed, in looking at a Gottlieb or a Rothko, one can see a distinct vision of the world outside, as well as the darkness of the expression of their internal states. Gottlieb did a series of paintings called *Blast* that looked like vertical before-and-after pictures of a world exploding. Rothko's squares can become the desolated sea- and landscapes one would expect to view out Beckett's windows in *Endgame*. It must be said as well that de Kooning never abjured external references in his paintings, painting either landscapes or figures. The question of landscape will always appear in any painting that divides its planes horizontally, whether intended by the artist or not. Indeed, *horizontal* comes from the *horizon*: the defining feature of our visual world.[4]

Perhaps this is why Barnett Newman preferred to concentrate on the vertical as disruption of the horizontal plane. His paintings, which increased in size over the years until they were portable murals, generally consisted of a monochromatic field subdivided by one or more vertical lines, or "zips" as he called them. Sometimes these zips were painted in, sometimes they were raw canvas that had been protected by masking tape, sometimes the tape was left on and painted over. Newman's nonobjective works demonstrate both a rational attitude and a desire for a spirituality inspired by Spinoza. He often gave his works titles that gave voice to a desire for an exalted state, an approach to the sublime: *Oneness, Primordial Light, Vir heroicus sublimis, Cathedral*. One famous series of paintings were his black-and-white *Stations of the Cross*. Hardly a Christian, he meant these paintings as allegorical fields of emotion related to the tragic condition of the postwar world. Rather than make "*cathedrals* out of Christ, man, or 'life,' we are making it out of ourselves, out of our own feelings" (Chipp, *Theories*, 553).

The liberation of the truly abstract artist from the constraints of depicting external reality, and the discovery of a world of pure forms that he can participate in, was generally believed to relieve the artist of his individual ego as he submitted to the will of universal forms. Mondrian: "That which distinguishes him from the figurative artist is the fact that in his creations he frees himself from individual sentiments and from particular impressions which he receives from outside, and that he breaks loose from the domination of the individual inclination within him" (*Plastic Art*, 62). Malevich and Kandinsky believed this as

well. Newman's statement indicates a shift away from these universalist drives of the early painters. Newman, as well as other painters of the time, chose the individualist, existentialist position of Kierkegaard over against the impersonal idealist spirit of Hegel. Despite the similarity of abstract works, it is the artist's physical handling of material that always gives it away, that gives it a "signature."

Apollonian in his approach, Newman gathered the spectator into the spaces of his color fields. In the catalog for his one-person show at Betty Parsons Gallery, Newman advised that his huge canvases be looked at "up close," where they would overwhelm the spectator's range of vision. At the same time Newman wanted these paintings to be "entered into," he promoted the idea that the painting should be recognized as a whole, all of a piece, a work that stops at the edge of the stretcher. Donald Judd would later maintain that that's what it does (revealing an antipictorial desire). My own experience of Newman's paintings is quite different, for example, seeing *Cathedra* (1950) in the Stedelijk Museum in Amsterdam, an immensely long rectangle entirely of deep blue with a somewhat ragged white zip a bit to the left of center. Despite the all-over color that would maintain flatness, the stripe creates a number of effects. I get the sense that it goes off the top and bottom of the canvas into infinity. The contrast between the color field and the color or shade of the stripe presents a figure-ground conundrum, so that at one time it appears as a gash through the field, separating it into two similar heavy volumes instead of one; at another time the stripe is a figure against the color ground, sometimes like a rope against the sky presented to you as you fall. A sense of vertical movement also makes the zip seem a scratch on a film shot in darkness. My experience of the zip through the field still elicits for me a pictorial sense, one of gazing through a window onto a portion of a much larger cosmos.

The idea of wholeness in a painting points to a desire for the painting to be an object in itself, and not a picture. A picture has a depth, and one gets the sense that the painting's edge is just a framing device for extracting one part of an entire surrounding visual field. Representational painting traditionally understood itself as this kind of window on the world. Today it is photography that everywhere gives us this sense of arbitrary frames of an entire world. Painting thought it could escape this illusion of looking outward at something that is *not there*, that is only represented as a sign for something that *is*

there, by removing *recognizable* signs. But overlapping forms or colors are enough to maintain a sense of illusion or depth. Even Rothko didn't look far enough to see that to truly eliminate illusion means to eliminate the painting as a picture: "We wish to reassert the picture plane. We are for flat forms because they destroy illusion and reveal truth" (Chipp,*Theories*, 545). This was in 1943. By 1951 Pollock could say, "I want to express my feelings rather than illustrate them," (Chipp, *Theories*, 548), desiring a material trace of bodily experience (in the long run still a sign), rather than a worked-out "picture" *representing* his feelings. If the painting is still a picture of something, even the traces of private emotion, the total elimination of depth was thought to mean the elimination of *any* illusionistic possibility. So there came a push toward flatter and flatter paintings, promoted by Clement Greenberg and practiced by those he called "postpainterly abstractionists," like Helen Frankenthaler, Morris Louis, and Paul Jenkins, who stained raw canvas by pouring pure color over it. In the end of this progression, but still using brushes, Robert Ryman analyzed the flatness of the "picture" in relation to the wall, seeing the wall as the proper ground for the picture the painting as a whole provides, even if it is all-white. Attaching a sheet of canvas, cardboard, or waxed paper to the wall with tape, and then painting over it with paint, so that the brushstrokes spill over onto the wall; when the painting is removed, the spillover is called the "frame." Lucio Fontana will cut a slit into the center of the canvas, Sol LeWitt will draw directly on the wall, and Lawrence Weiner will eventually remove a section of the wall itself, leaving a space there.

All this may seem quite silly in retrospect, and I'm sure some of it was done with humor. But it dramatizes the problem of designating what a particular art form *is*, which is inevitably what anything done in that form *means* it to be. Painters may try to reconcile meaning and being, but suddenly we discover that we have the same problem in art that we do in language—the impossibility of finding the truth of representation without discovering it can only be the truth of a being-in-itself that is *not* the representation of something, but the something *itself*. A word is incapable of doing this without losing its being as a word. The same thing applies to the "essence" of painting that still attempts to prove itself as something separate from sculpture or architecture—that is, as a "picture." The attempt to find the truth of painting-in-itself takes tentative steps away from what I have referred

to as referential objectification to material objectification, a difficult move similar to that found in concrete and sound poetry experiments, which I will discuss in chapter 4.

The moment painting lost figuration it became more and more an aspect of architecture, which was vaguely sensed by abstract artists, who still saw painting as representation, but not really made clear until minimalist incursions into architectural space. From the fifties to the sixties the canvas would take on more and more of an object look while entering the space of the spectator. Rothko would hang his canvases frameless, with paint around the edges of the stretcher. Newman would stretch a canvas six feet high and two inches wide. In Paris, Yves Klein would hang a gallery full of monochromes on supports that projected the paintings away from the wall, as if they were floating. Robert Rauschenberg would create "flatbed" canvases, like *Monogram*, placed flat on the floor with objects atop it. Frank Stella would create paintings on stretchers of various geometric shapes, several inches thick and sometimes with holes in the center, making them seem almost like sculptures for the wall.

An important transitional figure between the abstract expressionists of the forties and fifties and the minimalists of the sixties was Ad Reinhardt. It is perhaps incorrect to connect him entirely with the earlier group because coming in a straight line from the art of Mondrian and Malevich, he eschewed any "expressive" elements in his work at all. From his initial synthetic cubist canvases in the thirties he pared down the surface of the painting to an essential "all-overness," eliminating color contrast, until by the fifties he was doing only monochromatic work. These monochromes—primarily red and blue, until he settled on black as his only color—contained a cruciform, so that the canvas was trisected into nine squares, or sometimes six squares, with a rectangular bar running through the middle. The shadings between the squares are so subtle as to be almost imperceptible. This was especially true of his "black paintings," which from far away look completely black, and which require contemplative time spent in front of the canvas for all the nuance of shadings to appear. From 1956 to 1967, the year of his death, the only paintings he did were shades of black, all of them the "same." Rather than exemplifying the dynamic equilibrium that Mondrian sought, Reinhardt's paintings have a completely static balance, removing them from both movement and temporality. Reinhardt gives the best description of both his painting and his intentions:

A square *(neutral, shapeless)* canvas, five feet wide, five feet high, as high as a man, as wide as a man's outstretched arms *(not large, not small, sizeless)*, trisected *(no composition)*, one horizontal form negating one vertical form *(formless, no top, no bottom, directionless)*, three *(more or less)* dark *(lightless)* no-contrasting *(colorless)* colors, brushwork brushed out to remove brushwork, a matte, flat, free-hand painted surface *(glossless, textureless, non-linear, no hard edge, no soft edge)* which does not reflect its surroundings—a pure, abstract, non-objective, timeless, spaceless, changeless, relationless, disinterested painting—an object that is self-conscious *(no unconsciousness)* ideal, transcendent, aware of no thing but art *(absolutely no anti-art)*. *(Art-as-Art,* 82–83)

The tone of his description displays his usual polemical stance regarding other art. His contribution to the development of abstract art consists of all that he negates as nonessential. As he put it, "Artists-as-artists value themselves for what they have gotten rid of and for what they refuse to do" (63). His notions of "artist-as-artist" and "art-as-art" are examples of his stance as a kind of latter-day Lessing, favoring clear demarcations between the arts. He was not interested in the dadaist or surrealist preoccupation with "art in everyday life," proclaiming more than once that "art is art and life is life." He preached the timelessness of art, maintaining that, in both East and West, "art comes from art only and not from anywhere else" (28). His reading of art history (he had studied with noted art historian Meyer Schapiro, among others) was that art was always seeking its own element above every other consideration. In the seventeenth century it was the separation of fine art from manual art and craft, in the eighteenth century it was the development of "aesthetics," in the nineteenth century it was the "independence" of art from other social considerations, and in the twentieth century it was the desire for the "uncompromising 'purity' of art" (54).

Reinhardt's art-as-art philosophy can be seen as an intermediary stage between the abstract expressionists and the minimalists. His development of a timeless art that he thought touched on the ontological basis for all art ever made was an attempt to transcend ideas of personal expression and get beyond the constricting notion of personal style. His criticism of the abstract expressionists showed his distaste for "hot, loaded, compromised art" that made "a quiet, digni-

fied profession into a rabble-rousing profit-making where 'anything goes,' 'anything can be art,' 'everyone is an artist,' and 'an artist is like everyone else' " (161). Yet his resistance to the market's exploitation of the personal gesture was done in a paradoxical way.

Reinhardt insisted on using traditional materials and techniques that adapted themselves to personal expression (i.e., oil paint, canvas, and brushes) even while he worked diligently at his application of paint to eradicate all brushstrokes. We have seen that the trace of the hand exists in painting to represent, if not external forms, then personal internal gestures. Brushwork is an individual physical habit that focuses expression, even if that movement seeks expressionlessness. Strikingly, his handcrafted production of identical paintings was in an age of mechanical reproduction that eliminated the *need* for such handwork. Andy Warhol photographically capitalized on just this elimination. What is significant about Reinhardt's brushed-out brushwork and its difference from Warhol's techniques is that it so subtly differentiates one shade of black from another that these differences are lost in reproduction, thus maintaining the inappropriability of the material nature of his work by mechanical reproduction, a point scored against the commodified instantaneity of reception. The dependency of the image value on the painting's material nuances prevents it from being reduced to a sign.

Culture has always been governed (and made coherent) by the *act* of reproduction, whether that reproduction is that of behavior, or the depiction of behavior and structures of belief (icons). What we encounter in our own day is simply a greater extension of this dynamic of reproduction, while its control is removed from us by technological and bureaucratic means. This separation of our labor from the necessity of reproduction places us in an indeterminate position vis-à-vis objects, since our freedom from the necessity of reproduction compels us ever to confront the new or to "create" it. In retrospect, and perhaps against his own claims, we might say that Reinhardt's painting was not designed primarily as the production of timeless objects but as a *discipline of the self*.

The creation of paintings is a form of self-fashioning. There is a feedback loop that works between eye, canvas, and hand in the development of the painting.[5] But it also works the other way, as the development of the *artist*, or at least the artist's vision. Nonobjective abstraction keeps the loop more integrated, between eye, work, and hand,

while the reproduction of recognizable objects, whether derived from external reality or conjured up from memory, only complicates the loop, adding the interrupting influence of more conceptual elements. When Hans Hofmann held that "all abstract painting is mystical," and Mondrian spoke of the total balancing of the subjective and objective in the artwork, they were really speaking of the state the artist desires to be in as he/she works. It means what Pollock meant when he said he was *in* his painting, or what Rothko said about not being in command. This is not a purely unconscious state, but more of what the early abstractionists called "intuitive"—a level of awareness that is *in* the present as it is *in* the painting. Unfortunately it is not a state that can be maintained or returned to easily. It is not therefore surprising that artists who had known such moments of exaltation and have had to face drab reality again, sometimes not making it back to those peaks, were alcoholics—Pollock and Rothko, for instance.

Reinhardt is interesting in this regard, as he discovered a literally self-effacing form that he could repeat again and again, becoming something of an anti-Pollock in regard to his brushstrokes. Since he gave up the notion of making better, more radical paintings ("There is nothing less significant in art, nothing more exhausting and immediately exhausted, than 'endless variety' " [*Art-as-Art*, 55]), he didn't need to invest more and more of himself in his work, unlike Rothko, who ended up taking his own life. Considering that Reinhardt painted black paintings for twelve years, it might be wondered why *he* didn't commit suicide. He didn't see his paintings as a reflection of self, but understood them in Kandinsky's sense as simply a subjective expression of the objective, timeless essence of art. It was a practice aimed at equilibrium (homeostasis, if you will), but *not* a concern with death (or life, for that matter). Having traveled through the Orient and steeped himself in Chinese, Japanese, Indian, and Islamic art, he carried away a Buddhistic consciousness (though he never claimed to be one) that valued emptiness, which misguided critics interpreted as nihilism.

Reinhardt had been quoted as saying that he was making "the last paintings anyone can make." As clarification of this statement, when reminded that Malevich made the same claim, he said: "If I were to say that I am making the last paintings, I don't mean that painting is dying. You go back to the beginning all the time anyway. There's the idea that art is one thing, that maybe it doesn't have a beginning or an ending,

and maybe it isn't as historical as one thinks" (Siegel, *Artwords*, 27). Despite his similarity to Kandinsky and Mondrian in thinking that art has a universal essence that the individual artist connects with in making a work, Reinhardt didn't really share their evolutionary view in regard to progress in art—and especially as to its progressive effects on society.

There have been a number of times in the twentieth century when it was claimed by artists that painting was dead: Malevich in 1920 ("There can be no question of painting in Suprematism; painting was done for long ago, and the artist himself is a prejudice of the past" [*Essays*, 127]); Duchamp, who believed the "retinal" had been superseded by the "conceptual"; and conceptualists like Joseph Kosuth, who claimed that all art after Duchamp was conceptual, so therefore painting, as such, was dead. Of course when anyone says that something or other is dead—and this applies to literature and theory as well as art—it's more likely that it is something still too alive for one's own taste or desires. This is part of the drive for the new of which Reinhardt was so skeptical. One can see that all the last paintings, all the monochromatic paintings that occasionally arise—Malevich's *White on White*, Rodchenko's all-red $5 \times 5 = 25$ (1921), Rauschenberg's white paintings (1951), Reinhardt's black paintings, Yves Klein's International Klein Blue paintings (1957), Ellsworth Kelly's primary colors of the fifties, and Robert Ryman's white paintings in the seventies and eighties—while always reminding painting of its outside limits and possible demise, actually form a tradition unto themselves, with individual variations in technique. Whether they meant to or not, these artists have touched upon Reinhardt's timeless sense in art, while some viewed their act as a final one.

We can see that the attempt to get rid of illusion in painting and finally the desire to see painting as an object results in the same inescapable, simultaneous duality implicit in the theatrical body—the body as corpus, the body as sign, each term embedded in the other. Just so we see the painting as object and the painting as picture, the picture as sign. When a painting finds its "truth" as a *picture*, as a picture it can only be an *illusion* if it is to be "true" to "what it is"; apart from that, it has no choice but to be an object instead. In the end, that still doesn't prevent someone from asking, "What does it mean?" The drive toward literality as truth is always confounded by discovering

that its basis is metaphor (an aspect of use, if you will). Truth in this sense can then not be seen as different from illusion—more exactly, it is the most *serviceable* illusion. But we must not lose sight of the specific being, the object character of the material work. It reminds us that we are material beings as well, and our sense of worth depends upon not simply giving that material being up to ideologically driven codes. In the myths of the information society, signs take on the illusion of being the material basis of society (the hyperreal), while material reality itself becomes reduced to a system of signs, which are to be consumed. This consumption is maintained by mechanisms of power and entrenched political-economic philosophies.

The art movements of the sixties that came to be known as minimal and conceptual art can both claim the influence of Ad Reinhardt. He had been acknowledged as a precursor by painter Frank Stella, sculptor Robert Smithson, and conceptualist Joseph Kosuth. In particular, Joseph Kosuth, while shifting the focus of art, like Duchamp, to language, extended ideas of Reinhardt's, expanding the notion of art as art into "art as idea as idea," claiming that "Art is the definition of Art." These artists also followed Reinhardt in his criticism of abstract expressionism's commercialization, his concern with the morality of art, and its resistance to commodification. The incursion of minimal art into the public realm, however, presented problems in seeing the real separation of art from life that Reinhardt wanted, while it was an ambiguity that the minimalists liked to provoke; their objects often appeared to be something other than art. As in Mondrian's time, the form art sometimes took was an analogue to the form social ideals took. Carl Andre created "sculpture" that consisted of bricks or metal plates placed in a line or in a grid on the floor; people were even expected to walk on the plates. He described his work as "atheistic, materialistic, communistic. It's atheistic because it's without transcendent form, without spiritual or intellectual quality. Materialistic because it's made out of its own materials without pretension to other materials. And communistic because the form is equally accessible to all men" (Battcock, *Minimal Art*, 107).

While putting his work into such ideal categories, Andre claimed not to attribute any symbolic value to his work, but saw it as material, pure and simple. This hardheaded attitude was shared by all the minimalists in their quest for absolute literality. As Frank Stella had

said of his shaped black-and-white "pin-stripe" paintings, "[W]hat you see is what you see."

They were not interested in process, but product. Their painted plywood, fiberglass, steel, and Plexiglas constructions all looked like finished products made to order by machines. In 1937, Mondrian had written: "The less obvious the artist's hand the more objective will the work be. This fact leads to a preference for a more or less mechanical execution or to the employment of materials produced by industry" (*Plastic Art*, 61). While this statement presaged the brushed-out brushwork of Ad Reinhardt (and Stella), and the industrial-looking objects of minimalism, it could also have recalled Bauhaus productions, such as a 1922 series of five paintings in porcelain, the composition of which Moholy-Nagy directed over the telephone to the factory superintendent. But Mondrian's statement in the same essay, that "by the unification of architecture, sculpture and painting, a new plastic reality will be created" (63), certainly found its realization in the objects of such artists as Stella, Donald Judd, and Robert Morris. And like Moholy-Nagy, they designed their works (though not necessarily over the phone) to be built by industrial craftsmen. This removal of the labor of the work from the hand of the artist not only provided for a sense of impersonality in the work, but put the work of the artist completely in the preliminary stage of creating a finished *concept* prior to the construction.

The basic form of the movement was the cube, a three-dimensional extension of the modernist grid, best exemplified by Sol LeWitt's pristine permutations of its closed and open interlocking sides. Donald Judd made aluminum boxes that hung in series along the wall like air-conditioning units. Richard Serra balanced heavy steel plates in a square like a house of cards. Robert Morris made white plywood boxes and circular units with lights on the inside. Tony Smith made a black box six by six feet called *Die*. This human-sized product led the formalist critic Michael Fried, who referred to Smith in his 1967 essay "Art and Objecthood" to conclude that Minimalism was an "anthropomorphic" (129) art (a damning phrase for the utterly "objective" artists, but remember the short Reinhardt's "sizeless" man-size painting). Given that it intruded into the space of the spectator and made him self-conscious, it was "theatrical" (135), rather than having the dramatic absorptive power of painting ("Art and Objecthood").

This "self-consciousness" is exactly what the minimalists sought,

"theatrical" or not. What defined the painting for so long was the illusion of a picture plane that convinced the spectator that she didn't exist outside of it, as a viewer in relation to an object. Once this illusion had been shattered, the art object had to consider itself as being figured by another ground—the art space (gallery, museum) that it shared with the spectator.[6]

Although influenced by the phenomenology of Merleau-Ponty and the literary theory of Robbe-Grillet, which concerned itself with the elimination of anthropomorphism in the pure description of surfaces, the minimalists worked out theories of perception of their own through their work. Donald Judd and Robert Morris wrote extensive analyses of the new work. Judd's "criticism" consisted primarily of detailed physical description of an artwork, including dimensions, relation to floor or wall, or other locations in space, color, reflectiveness, and the like. It appeared to be the application of Robbe-Grillet's descriptive style to works that on the whole seemed rather nondescript. Morris was more interested in phenomenological response, describing the conditions in viewing the work, and how the work conditions the viewer. A physical participation of another sort was later to question public and private space, the personal kinesphere in relation to the subject as object. This was the social proxemics body/performance art of Vito Acconci, Chris Burden, and Adrian Piper.

"This displacement of pressures from object to place will prove to be the major contribution of minimalist art." So said Dennis Oppenheim, a minimalist and conceptual artist (qtd. in Karshan, *Conceptual Art*, 30). Or as Carl Andre put it, "[T]he work is not put in a place, it is that place" (qtd. in *Writings of Smithson*, 171). But during the time large-scale minimal objects were carrying on a dialectical relationship with the gallery space, Oppenheim and others were working in quite a different kind of space. These artists went to the desert to work out urges for monumental, uncommodifiable art. Rather than paint landscapes, they created them. Oppenheim created great circles with his motorcycle in the desert; in a semicircular mesa in Nevada, Michael Heizer dug two trenches facing one another, measuring fifteen hundred feet long by fifty feet deep by thirty feet wide, displacing 240,000 tons of earth (*Double Negative*); with earth-moving machinery, Robert Smithson projected his *Spiral Jetty* out into the Great Salt Lake of Utah (fig. 4). The viewer of such art would have to make a special pilgrimage in order to view

these sites in person, while the sites themselves were represented in galleries in New York through detailed description and photo-documentation. This raised the question of where the art was really located—in the sites, or in the information about the sites? If it is the latter, the art can be easily transformed into something predominantly conceptual.

Before he had done his monumental works, Smithson had created a mock-heroic document called *A Tour of the Monuments of Passaic, New Jersey*, in which he took photos of an industrial wasteland, giving aesthetic titles to such features as large pipes pouring effluence into the river, which he called "The Fountain Monument" (perhaps with a nod to Duchamp). This documentation signals the *designation* of a particular site as art, something later taken up by conceptual artists in their "declarations."[7] In his parody of the readymade ruin of Passaic, Smithson asks if "Passaic has replaced Rome as the Eternal City" (*Writings of Smithson*, 56). Like Reinhardt, Smithson didn't agree with the avant-garde idea of time as necessarily progressive; as he was fascinated with geological history, time meant something far more extensive to Smithson, making the glory of human history pale by comparison. Both Smithson and Reinhardt derived some of their ideas of time and art history from George Kubler, whose book *The Shape of Time* appeared in 1962. Kubler maintained that instead of progress in art through the development of changing styles, there were basic forms, called prime objects, "very few and very old, from whose image derived the replica-mass" (29). Prime objects are like prime numbers, in that they both "escape regulation," as no rule is known to govern their appearance, and both resist decomposition (39). These prime objects sound very much like "primary forms," which minimalist objects were often called.

For Smithson, the resistance to commodification meant getting away from the site of commodification, the gallery. Works of art in the neutral space of the gallery "lose their charge," as if experiencing "an aesthetic convalescence." The "warden-curator" oversees its condition, to the point that "Once the work of art is totally neutralized, ineffective, abstracted, safe and politically lobotomized it is ready to be consumed by society" (*Writings of Smithson*, 132).

Despite the way he felt about the gallery system, Smithson did exhibit there what he called his "non-site," or constructed boxes filled with the rocks or soil from one of his earthwork "sites" (fig. 5). As he

put it, "[T]he container is in a sense a fragment itself, something that could be called a three-dimensional map" (90). Smithson's photographic and descriptive documentation thus remained in proximity to more tangible evidence of his material actions, conceived of as a map, but "read" tactilely as much as conceptually.

THE CONCEPTUAL TRADITION

We have seen that already in the case of Malevich that there is a point reached where a particular simple act, placing a black square on a white one, involving a minimum of labor, seems to be enough to summon a work of art into being. This summoning of a work into being, rather than working it out by means of physical skill, was to be the basis of the conceptual tradition in art. In order for it to find its proper role in the redefinition of art, however, it was necessary for it to move beyond the scope of painting altogether. This was the task that Marcel Duchamp set for himself.

Duchamp began this century painting figures in motion, paintings whose style was influenced by cubism, but derived as well from "chronophotography": photographic time-motion studies then being done by Eadweard Muybridge, among others. The prime example of this type of painting was his *Nude Descending a Staircase*, which created a furor at the New York Armory show in 1913. After that he concentrated on studies toward his unfinished magnum opus, *The Bride Stripped Bare by Her Bachelors, Even*, better known as *The Large Glass*. It was a large "window" with upper and lower frames, upon which were painted items like a chocolate grinder, an oculist's chart, a waterwheel on a glider, a reservoir of "love gasoline," pistons, a "desire magneto," and so on. The lower part is the "Bachelor Machine," the upper part the "Bride Machine." It is an arcane allegory of mechanical love, or love reduced to its mechanics. It is also a perpetual motion machine, in that the love is never consummated, although always stimulated. A bachelor will cease being a bachelor if he wins the bride. A bride stands in the pure potentiality of the gap between the state of virginity and being a wife and mother. This idea harks back to an earlier painting, *The Passage from the Virgin to the Bride* of 1912, which Thierry de Duve has meticulously interpreted as Duchamp's "becoming a painter," traversing the cubist field of innovation, and shifting the center of art away from painting at one stroke (more or less from "virgin to bride to bachelor")

(*Pictorial Nominalism*, 41). Duchamp never finished *The Large Glass*, but he signed it in 1923 and ceased to paint altogether. But his concern with time, even if not with perpetual motion, with perpetual potentiality, figured in every work he did, then and thereafter.

That Duchamp had a tremendous impact on art that followed him is a given. The artists he influenced had diverse approaches to art, often at odds with one another. But they all had to deal with his "transvaluation of values" in advocating the primacy of the conceptual over what he termed the purely "retinal" value of abstract painting. After years of work he managed to shift the basis of art's legitimation from the visual to the linguistic. He removed functional products from the reified ground of daily existence, altering their appearance through wordplay, usually in the title, where people look for clues to meaning. Duchamp often "created" these works through a simple speech act: designating them as art. These were what he called his "unassisted readymades"; his "assisted readymades" are two or more elements combined to form a conundrum, along with its title. His first object (1913) was a bicycle wheel on its stanchion inserted upside down into the seat of a stool, an assisted readymade. In the next three years he would make his mark with the unassisted readymades *Bottle Rack* (1914), *In Advance of the Broken Arm* (a snow shovel, 1915), and the infamous *Fountain*, a urinal turned upside down and signed "R. Mutt" (1917) (fig. 6).

Duchamp's position on the conceptual basis of art was in part founded upon his antipathy to "retinal" painting, that is, the progress of painting concerned with its own material effects: abstraction in general. He didn't care for artists who "smelled of turpentine." The sensual qualities of a painting as such held no attraction for him. The only painting he liked was that which had a conceptual basis to it, such as some surrealist painting, but he suspected even André Breton: "[D]eep down he's still really interested in painting in the retinal sense. It's absolutely ridiculous. It has to change; it hasn't always been like this" (Cabanne, *Dialogues*, 43). His reasoning derives from a premodern notion of art: "In fact until the last hundred years all painting had been literary or religious: it had all been at the service of the mind. This characteristic was lost little by little during the last century. The more sensual appeal a painting provided—the more animal it became—the more highly it was regarded" (Duchamp, *Writings*, 125). The pure concern with the senses becomes for Duchamp a

less-than-human enterprise in painting. Though he had started out a painter, Duchamp maintained that the conceptual had always been at the heart of it. "This is the direction in which art should turn: to an intellectual expression, rather than to an animal expression. I am sick of the expression, 'Bête comme un peintre'—'stupid as a painter' " (126). Instead art should have to do with "the gray matter, with our urge for understanding" (136).

Rather than side with the religious in art, Duchamp chose the literary. Some of his works, such as *The Large Glass*, with all its explanatory notes found in *The Green Box*, take on the value of a literary exegesis of a nonhuman courtship ritual, inspired by such sadistic Rube Goldberg linguistic machines as that developed by Raymond Roussel in his novel *Impressions d'Afrique*, that Duchamp knew well. At times the work seems like a script containing layers of motivation and meaning for actors who will never act it out but remain forever frozen in undecidability. While Duchamp chose the literary over the religious, the fetishistic readymades took on a sacred aura after he had released them into the (art) world.

Duchamp saw that the only true response to the purely retinal was in redefining vision in terms of language, which in an artistic sense meant "literature." He saw the move toward literature a move against "physicality." "Dada was an extreme protest against the physical side of painting. It was a metaphysical attitude. It was intimately and consciously involved with 'literature.' It was a sort of nihilism to which I am still very sympathetic. It was a way to get out of a state of mind—to avoid being influenced by one's immediate environment, or by the past" (Duchamp, *Writings*, 125). At the same time, Duchamp's literariness had a kind of material feel to it, as he used extremely concentrated punning structures in his titles and as sentences standing alone, which were published in the Dada journals of that time. *Fresh Widow*, the name of an assisted readymade, was yet another element in the equation of the object: a French window whose panes of glass are all covered with squares of black leather. The short sentence connected to his found objects "instead of describing the object like a title was meant to carry the mind of the spectator towards other regions more verbal" (141).

While the "literarization" of the object served as one means to get beyond the purely visual, Duchamp believed that it is only possible if

one maintains a truly "indifferent" attitude toward the object. As he put in his 1961 "Apropos of Readymades":

> A point which I want very much to establish is that the choice of these "Readymades" was never dictated by esthetic delectation.
> This choice was based on a reaction of visual indifference with at the same time a total absence of good or bad taste. . . . In fact a complete anesthesia. (Duchamp, *Writings*, 141)

It is important in this case to understand that Duchamp's "indifference" is to bear no relation to Kant's "disinterestedness," for Kant had used that term to describe an *aesthetic* state. That state was beyond rational or conceptual justification, being dependent upon "taste." If Duchamp's struggle was with anything, it was a struggle against taste, good or bad (this means that his work does not aim at being tasteless, despite the effect of *Fountain* on the New York crowd, for *tasteless* simply means "bad taste"). Whether a nonaesthetic decision of this kind is really possible, no one has questioned. What is "visual indifference," and how does one arrive at this state in order to make the right choice? Duchamp chose the most banal utilitarian objects he could, as what is most purely "useful" would seem to be the least aesthetic, that is useless. But even this seems based on a certain hypertaste that is antitaste, just as the museum context for his found objects proves them later to be received hyperaesthetically rather than anaesthetically.

Since Duchamp was in some ways a precursor of, as well as a fellow traveler of, Dada, he felt at home with self-contradiction. The phrase "a reaction of visual indifference" may indeed have been said with tongue in cheek (the name of a later, literal illustration of this done in plaster). Self-contradiction was for Duchamp a technique for not repeating himself. While abstract painters might have sought timelessness in universal forms that have always been part of visual experience, Duchamp sought a different kind of timelessness in nonrepeatability. As he put it: "Repeat the same thing long enough and it becomes taste. If you interrupt your work, I mean after you have done it, then it becomes, it stays a thing in itself; but if it is repeated a number of times it becomes taste" (Duchamp, *Writings*, 134). Taste is always temporal; it

is something easily dated, of an age. The surrealists, in their collage terrorism that involved abusing dated nineteenth-century images of bourgeois comfort, sentimentalism, and homiletic virtue, subverted even the solace provided the middle class by nostalgia. The danger of repeating this action, however, may be the danger of contamination, so that surrealism is always at the edge of becoming kitsch itself, especially when seen in a nostalgic light.

This idea of the timeless might have been in the pure moment of unique creation for Duchamp, but its real reference was posterity. One can read the difficulty invested in the levels of meaning in *The Large Glass* as an investment in future decoding, just as James Joyce hoped to keep future critics busy with *Finnegans Wake*.[8] Duchamp had a great distrust of public taste, much less taste in general. He claimed to have had no desire to be famous in his lifetime (even if he was)— preferring the greater honor of taking a unique historical position. In part this involves a desire to be completely free from the demands a contemporary public would make upon his art making. Posterity is what constitutes his "ideal public."

> It is only a way of putting myself in the right position for that ideal public. The danger is in pleasing an immediate public; the immediate public that comes around you and takes you in and accepts you and gives you success and everything. Instead of that, you should wait for fifty years or a hundred years for your true public. That is the only public that interests me. (Duchamp, *Writings*, 133)

This public is in strong contrast to the contemporary public, in Duchamp's opinion. The "posthumous spectator" is superior to the "contemporary spectator, who is worthless in my opinion. His is a minimum value compared to that of posterity, which for example, allows some things to stay in the Louvre" (Cabanne, *Dialogues*, 76). This attitude seems quite in conflict with one who would be called by some an "antiartist"![9]

So Duchamp's well-known modesty may have been a very calculated reserve, designed to pay off in the long term. His celebrated silence was a decision after 1923 to devote himself entirely to playing chess, which he viewed as a sort of art practice in itself. What most people didn't realize is that the entire time he was supposedly retired

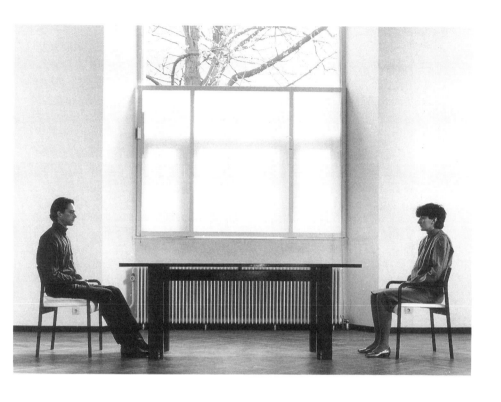

Fig.1. Marina Abramović/Ulay. *Night Sea Crossing*. 1982.
Performance/installation view. Stedelijk Museum, Amsterdam.

Fig. 2. The Judge in Jean Genet's *The Balcony*. Actor's Workshop, San Francisco, 1961. Directed by Herbert Blau. Photograph by Hank Kranzler, courtsey of Herbert Blau.

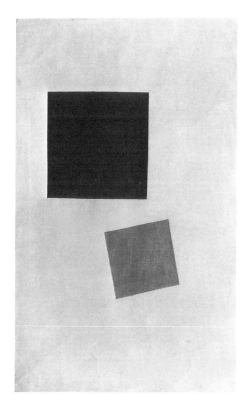

Fig. 3. Kasimir Malevich, *Painterly Realism. Boy with Knapsack—Color Masses in the Fourth Dimension.* (Formerly: *Suprematist Composition: Red Square and Black Square.*) 1915. Oil on canvas, 28" x 17-1/2" (71.1 x 44.5 cm). The Museum of Modern Art, New York.

Fig. 4. Robert Smithson, *Spiral Jetty,* Great Salt Lake, Utah. 1970. Coil 1,500' long and approximately 15' wide. Black rock, salt crystals, earth, red water. Photograph courtesy Gianfranco Gorgoni.

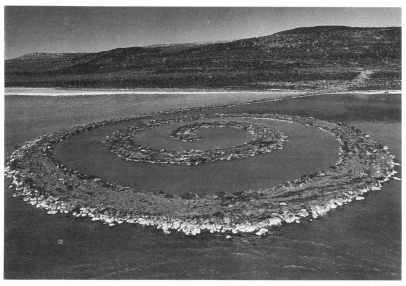

Fig. 5. Robert Smithson, *Non-Site: Line of Wreckage (Bayonne, New Jersey).* 1968. Painted aluminum cage with chunks of busted concrete; 3 photo panels; 1 map panel. Milwaukee Art Museum Purchase, National Endowment for the Arts Matching Funds.

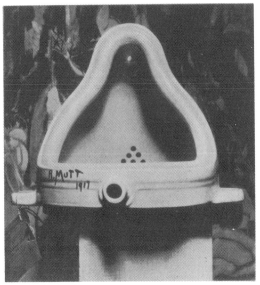

Fig. 6. Marcel Duchamp, *Fountain.* 1917. Photograph by Alfred Stieglitz. Philadelphia Museum of Art: Louise and Walter Arensberg Collection.

Fig. 7. Andy Warhol, *Sixteen Jackies*. 1964. Silkscreen ink on synthetic polymer paint on canvas. Copyright 1993 The Andy Warhol Foundation, Inc.

Fig. 8. Joseph Kosuth, *Clock (One and Five).* 1965. Tate Gallery, London.

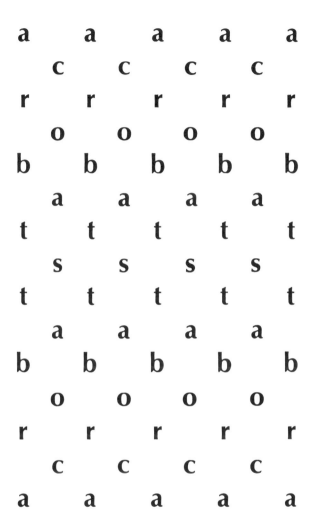

Fig. 9. Ian Hamilton Finlay, "Acrobats." 1964.
Courtesy Ian Hamilton Finlay.

Fig. 10. Eugen Gomringer, "Wind."
Courtesy Eugen Gomringer.

```
film
film
film
film
fi m
f im
fi m
f im
f  m
fl m
f im
f  m
flim
film
flim
film
f lm
f lm
fl m
f lm
fl m
f  m
f lm
fl m
f  m
f lm
f  m
fl m
f lm
fl m
fl m
fl m
fl m
fl m
fl m
flim
film
flim
film
flim
film
flim
f  m
film
f  m
flim
film
flim
film
film
film
film
film
```

Fig. 11. Ernst Jandl, "Film."
1964. Courtesy Luchterhand
Literaturverlag, Hamburg.

```
cinemacinemacinemacinemacinemacinemacinem
acinemacinemacinemacinemacinemacinemacino
macinemacinemacinemacinemacinemacinemacin
emacinemacinemacinemacinemacinemacinemaci
nemacinemacinemacinemacinemacinemacinemac
inemacinemacinemacinemacinemacinemacinema
cinemacinemacinemacinemacinemacinemacinem
cinemacinemacinemacinemacinemacinemacine
macinemacinemacinemacinemacinemacinemacin
emacinemacinemacinemacinemacinemacinemaci
nemacinemacinemacinemacinemacinemacinemac
inemacinemacinemacinemacinemacinemacinema
cinemacinemacinemacinemacinemacinemacinem
acinemacinemacinemacinemacinemacinemacine
macinemacinemacinemacinemacinemacinemacin
emacinemacinemacinemacinemacinemacinemaci
nemacinemacinemacinemacinemacinemacinemac
inemacinemacinemacinemacinemacinemacinema
```

Fig. 12. Ilse and Pierre Garnier, "Cinema." 1965. Courtesy Ilse and
Pierre Garnier.

silencio silencio silencio
silencio silencio silencio
silencio silencio
silencio silencio silencio
silencio silencio silencio

Fig. 13. Eugen Gomringer, "Silencio." Courtesy Eugen Gomringer.

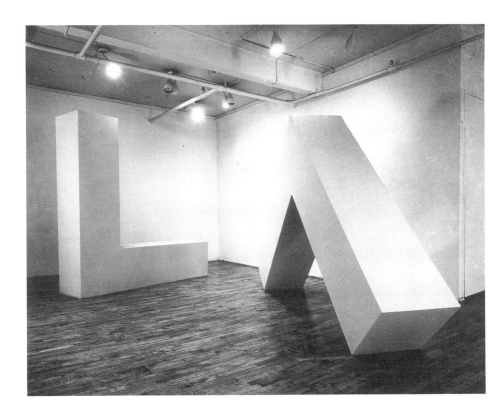

Fig. 14. Robert Morris, *Untitled.* 1965. 8′ x 8′ x 2′ (two pieces).
Photograph by Rudolf Burkhardt, courtesy of Robert Morris.

he worked on various works involving puns, as well as his final work, *Given: 1. The Illuminating Gas, 2. The Waterfall* (*Etants données*), which was assembled in the Philadelphia Museum of Art after Duchamp's death in 1968. This silence added a further mystique to the artist of indifference, who seemed to be able to have an attitude toward art of take it or leave it. Even in a self-consciously self-effacing way Duchamp's ultimate art was himself, as has often been said. But it wasn't even a self as it exists in the present, but a self entirely to be seen historically as a catalyst for changing the meaning of art. In 1964, Joseph Beuys did a performance called *The Silence of Marcel Duchamp is Overrated*. It was a reaction to a situation in which Beuys thought that Duchamp had done so much to devalue art as a practice through his inaction and ethos of nonproduction that younger generations of artists were left with a condition in which no art could be really taken seriously. This may have been true for artists who were still operating (although in some ways conceptually) in a material mode. The conceptual artists of the sixties and seventies, as well as the pop artists of the sixties, did much to provide variations on Duchamp's conceptual themes, even while not necessarily improving on them; in fact, this attempt to go beyond Duchamp, while still following his logic, still persists.

This indifference has also been read as an aversion to a work ethic. As he told Pierre Cabanne, "[D]eep down I'm enormously lazy. I like living, breathing, better than working. I don't think that the work I've done can have any social importance whatsoever in the future. Therefore, if you wish, my art would be that of living: each second, each breath is a work which is inscribed nowhere, which is neither visual nor cerebral. It's a sort of constant euphoria" (Cabanne, *Dialogues*, 72). After what he said above about posterity, the statement about his work having no future social importance smacks of disingenuousness. What we can believe is his attitude toward work. Many of his art objects are less works than acts. By renaming, rather than reworking—even Picasso's' creation of a bull's head out of a bicycle seat and handlebars is more a visual than a conceptual statement— Duchamp introduced a new way of understanding artistic creation. It is a form of *conceptual investment*, which is the designation of something as art that seems to be quite removed from aesthetics or art, while even undermining the visual component by shifting, through the title, the basis from visuality to "literature." Duchamp's preoccupation with posterity demonstrates the long-term nature of his

investment. The rarity of his works does much to increase their value as well, although Duchamp fully understood the publicity value of reproduction; hence his works done in miniature and placed in a traveling museum he called *The Box in a Valise*. While his breaths may have been "inscribed nowhere," his investments were carefully preserved and reproduced in portfolios for the future. (It is significant that some of the early readymades were lost, but were easily replaced, indicating that the "original" is less important as artifact than concept.) What the creation of readymades did for the definition of art was to shift the emphasis from expressive labor to conceptual investment—and investment is nothing else but smart shopping. It is an art based on consumption (with a few improvements perhaps) rather than production. It is an art that transmutes a commodity fetish into a personal fetish, to be "transubstantiated" (Duchamp's word) by the spectator into a valuable work of art, a unique fetish. This transmutation becomes possible simply by naming the work (under the right conditions and with the right name) just as an investment broker would name a stock to be bought. The weight of the investment becomes aesthetically increased by the denegative posture of indifference. The years of silence transferred the mystique of Duchamp's personality to his objects.

In a note in the *Green Box*, instead of referring to *The Large Glass* as a *painting*, he called it a "delay in glass" (Duchamp, *Writings*, 26). The word "delay" demonstrates the conceptual investment in *time* and its gradual increase in interest that was Duchamp's primary aim. It is as if someone told you a joke and you didn't get it at first. What comprised the delay was the time spent figuring it out, staring at its seemingly enigmatic features. Once its secret is revealed, and you can laugh, you can see how the "ordinariness" of the punchline baffled you, until it started resonating with its own suggested otherness. For a wordplay in a punchline to have an effect, the "ordinary" terms have to be displaced by their extraordinary suggestion, so that one view absents itself or is eclipsed by the unsuspected other term. Duchamp is the artist of this unsuspected other term.

But delay could also refer to the idea that the artwork survives in a vital form only as long as the deferral of meaning is maintained. The movement of imagining-naming, or more properly, appropriating-naming, was intended to "derealize" art systems through a direct banalization of the objet d'art by using self-contained, nonart materi-

als. But at the same time it mystified elements of everyday life ("derealizing life") by exalting them as privileged objects of contemplation (despite the "nonaesthetic" nature of their choice). The moment the enigmatic delay, or half-life, of the object ceases is the moment it becomes truly institutionalized as art, the moment when its signification (not merely what it may "mean," but where its possible meaning has had an effect) has been historically determined. But perhaps the real joke, the real punchline, is delivered only *after* such an object has been institutionalized and sacralized. Thus, just like the sacred object Duchamp defaced, his Mona Lisa has itself become a sacred object.

An example of Duchamp's thinking about the art object that takes in its historical nature is his term "the art coefficient." In essence, the art coefficient constitutes the difference between what the artist intended to produce in the work and what was actually realized in the work's completion. As he put it in more exact terms: "[T]he personal 'art coefficient' is like an arithmetical relation between the unexpressed but intended and the unintentionally expressed" (Duchamp, *Writings*, 139). But there is a third term to this art coefficient—that of the spectator. The spectator "refines" the work, like "pure sugar from molasses," but without regard to the other two terms of the coefficient. In the end, "[T]he spectator brings the work in contact with the external world by deciphering and interpreting its inner qualifications and thus adds his contribution to the creative act. This becomes even more obvious when posterity gives its final verdict and sometimes rehabilitates forgotten artists" (139–40). In the end the spectator cashes in on the value of the conceptual investment through his interpretation. The amount of time it takes to come to an interpretation of the work that transcends its epoch only adds to its interest.

Although Duchamp understood that there can be conceptual investment in art that is made through the artist's labor, his coup was to separate the investment from the labor, so that his investment was merely in the *sign* value, as *exchange* value of the work, regardless of labor. This investment in a purer form of signification, created by a glance, is similar to the pure signification of capital, the pure power of equivalence found in money. Duchamp is engaged in a kind of fiscal capitalism of artistic signifiers. This dematerialized form of "productive consumption" will find its peak moment in the work of Andy Warhol, while removing the criticality and resistances enigmatically delayed in Duchamp's work. While Duchamp was engaged in using

manufactured *objects* for his investment, Warhol will move into the purer signification of product images that unite the image with its brand name. Even when the spectator doesn't stop to check the title on a Warhol, the images of Elvis, Marilyn, and Jackie are fully recognizable and identified with their names known through the extensive mechanisms of the culture industry (fig. 7).

Andy Warhol is one American artist whose name can be considered a household word. This may be because his stock-in-trade was household words, or images. He exploited the instantly recognizable icons of commodities and media stars. In late 1962 the consciousness of art world was altered by the exhibition of his soup cans, Coca-Cola bottles, and multiple portraits of Marilyn Monroe, Elvis Presley, and Troy Donahue. His paintings of Campbell's soup cans displayed rows and rows of them, each the same except for the name of their flavors. It was as if he showed us that the spectrum of choice offered by a pluralistic commercial society is based on the slight variations of labels, while they all come out of the same can. This monotony of reproduced variety is emblematic of all of Warhol's work. His work levels all mediated images, personalities, events, and products to the condition of their infinite reproducibility: a flat surface of reproduction. The fact that his studio was called the Factory, and that he said he wanted to be a machine, emphasizes his role in our culture as the nonstop producer of art that mirrors commodification.

Warhol's desire to be a machine should not be construed as the same desire the futurists had expressed. Their desire was to merge the human with the machine so as to blend the force of human will with the force of vehicular momentum. Warhol's desire was to *eliminate* the human element altogether by mechanizing desire and to blend with the impersonality of the mechanical. While this may bear some relation to Duchamp's attitude of indifference toward his artistic choices, there is a basic paradox lurking. Unlike Duchamp, Warhol operates *completely* on the level of taste. While seemingly "bad taste" from the viewpoint of art for art's sake, it is nonetheless taste culled from mass appeal. A similar paradox is that Warhol became a leader in taste by attempting to be a complete conformist to fashion trends. This conformism, this cultivated attitude of the complete fan, consuming media heroes by the minute, was Warhol's way of denying his own personality, of becoming more machinelike. In this way an excess of taste produces the same results as complete indifference. If

everyone is "famous for fifteen minutes," it means that no one stands out from anyone else. If everyone is a star, no one is. In this way movie stars, artists, sports heroes, aristocrats, politicians, art dealers, rock stars, and other celebrities are all modular, interchangeable.

Since taste is temporal, Warhol's work is willfully disconnected from notions of timelessness but attempts to exist entirely in the present (which may be another form of timelessness). More exactly, he lived and worked from moment to moment, always seeking the new in order to capture it before it was gone. Unlike Duchamp, saving himself for posterity, Warhol bet everything on present fame—if not his, then through his constant investment in other people's fame.

This positioning oneself in the present, which also constitutes rejection of history and tradition, is not too difficult to do if you switch the basis or ground of your art from art historical concerns to that of a mass media, which has already been in place for years and is constantly negating the past through its commitment to surveying the present. If history appears at all, it is aesthetically isolated from the present as nostalgia. Warhol has been credited as being a social critic for some of his choices of images (attack dogs at a civil rights march, the electric chair, etc.); if that's the case, he is as critical as the staff who puts together the top stories on the nightly news, which are primarily valued for their mass appeal, rather than historical relevance. This is an idea that has been lost on those influenced by Warhol read through Duchamp, like Haim Steinbach, Jeff Koons, and Richard Prince, whose work operates as if the simple mirroring of reality alone can truly constitute criticism; if anything it enhances the situation it is supposed to criticize. The "realization" that one's work is basically a commodity—presumably an attitude of hardheaded realism that calls art claiming to be anything else escapist—is itself a surrender (though no doubt a well-paying one) to the forces the artist is purportedly criticizing or resisting.

The question of what Warhol is really trying to accomplish in his art may never be answered. He never claimed to be critical. If anything, he claimed to be indulging his artwork in what he enjoyed. As opposed to the comparatively gloomy stance of the abstract expressionists through the war and postwar years, pop art was intent on engaging in the pure pleasure that material prosperity was bringing to America. Some pop artists, it is true, claimed to have an ironic edge to their work, implying criticism of irresponsible consumption.

Warhol was either lacking entirely in irony, or else it was so refined as to be invisible. What the spectator could engage in, however, was an ironic attitude to the work, but that was a choice left up to him or her. The camp that Warhol promoted has now so permeated the culture at large as to have been turned into a kind of kitsch. To underscore this aspect of pop art, the Germans Sigmar Polke and Gerhard Richter called their version of pop "capitalist realism." Warhol had at least one trait in common with Duchamp—he knew how to be silent—in fact, more silent than Duchamp about his art. But it wasn't a silence that indicated an indifferent attitude toward art, it was a silence of pleasurable noninterpretation. While Warhol is participating in the conceptual-investment tradition begun by Duchamp, it is less an investment in unique objects (or more exactly, unique concepts) than a promotion of art that is fully engaged in all aspects of a mediated culture. It is as if Warhol himself is the figure of the art trying to consume the entire ground of his cultural support. *Après moi le déluge.* The concept of art as something effectively separate from its economic ground is thus called into question.

Thus it is possible to say that the definition of art has indeed been altered by Andy Warhol's contribution. But instead of accomplishing that by participating in the internal logic of rationalization in the development of painting, he did it by literally joining forces with social and economic rationalization. Warhol's artistic practice was not negative; it was a positive affirmation of culture as it is at any moment. And it is a total commitment to the reproduction of that culture, which means participating in the creation of mass culture itself. His work can be read, through the unrelenting logic of its repetitive investments in personalities, plus the short attention span that creates that repetition, as a mirror for the American mind. But seen as a body, one witnesses only sameness in "diversity"; in order to be fully invested in what is happening *now*, memory must be consistently erased. Recognition of the sameness, of the surfaces of faces silk-screened in large editions, discloses that the camera can negate the world by replacing it with one of signs, something that Hollywood had been doing for years.

Unlike Duchamp, Warhol never claimed to operate antiaesthetically. If anything, he wanted to make everything art, and to aestheticize the world, which in the long run is the same as total anaestheticization, the creating of a world of distraction and decor.

The center of this world is the self, or more precisely, self-image. But its expressionism is a form of consumerism. The signs we produce are the signs we consume, playing bulimic to art for art's sake's anorexia. The inflationary nature of Warhol's work is produced by continually keeping pace with mass culture in order to mirror it. More exactly, to reproduce it, as it has to be consumed and passed through the artist (even if just as "selection" or "taste").[10] It is the constant (re)production of a world of signs for general consumption. Through repetition compulsion we learn to "live with ourselves." However, complete affirmation of the culture we live in is at the same time the negation of a political self, an artistic self, an ethical self. If this is a form of transcendence, then it is one of giving yourself up to the crowd.

Because of his grids of repeated photographs, his decor of cow wallpaper that anticipates later "installation" work, Warhol carries with him a minimalist sensibility, despite his pictorialism. His twelve-hour movie of the Empire State Building and his nine-hour movie of a sleeping man become almost objectlike in their resistance to a desire for change. His porno flicks eliminate sexual interest. It is what minimal art is accused of being—boring. This boring quality can be construed as another form of timelessness, but one entirely preoccupied with self. Boredom is the flip side of the desire to consume. In Warhol's crowd the speed of fame matched the vacuous time of each member having to exist as "someone." It is not unusual that the drug of choice was amphetamines. Warhol's amoral mechanistic and consumptive attitude permeated those around him and passion seemed like just another "act." Unlike Duchamp, who anthropomorphized machines in his allegory of sexual love, Warhol mechanized sex, making it an impersonal curiosity, creating blank, modular heroes. Superficiality and surface effects are all one is likely to get, as "personality" is all that counts.[11]

These "surface effects" are a concern that also links Warhol with minimalism (or minimalism with Warhol). Gregory Battcock had described it for the minimalists: "They take care to provide just the right *surface*—a *surface* without craft (indeed, without art); in this way rejecting those impulses that claim glory in manual work and nobility in craftsmanship" (*Minimal Art*, 33). A surface without craft, the rejection of work and craftsmanship, may be a rejection of a myth of an individual freedom to act that rings false in the market system. But in obviating that myth through the form of objects, is the minimalist rejecting the

ideal of individuality, or just its promotion as a form of false conscious-
ness? If the former, the art may be contributing to an impersonal collec-
tive ideology, but not necessarily one of socialism. Rather, it works with
the collective mentality produced by marketing and media, the unified
surface of corporate America, and the concomitant depersonaliza-
tion caused by it. If the latter, its practice against assimilation into the
gallery-museum system has either resulted in assimilation as outdoor
public art, or the rejection of its status as such by the public, as in the
notorious case of Richard Serra's *Tilted Arc*.

 A surface without craft or art is machine made, and in the twenti-
eth century the fascination with the machine for its efficiency becomes
a primary source of value. The uselessness of art envies the economic
elegance of pure utility and aspires to that condition. Hopefully in the
long run this will reveal the uselessness of pure utility. No human
action is derived from a condition of pure utility.

While pop art fully entered the process of commodification, minimal
art removed all labels and confronted the spectator with a blank stare.
Barbara Rose, in her essay "A B C Art," delineates the difference: "If
Pop Art is the reflection of our environment, perhaps the art I have
been describing is its antidote, even if it is a hard one to swallow. In its
oversized, awkward, uncompromising, sometimes brutal directness,
and in its refusal to participate, either as entertainment or as whimsi-
cal, ingratiating commodity (being simply too big or too graceless or
too boring to appeal), this new art is surely hard to assimilate with
ease" (Battcock, *Minimal Art*, 297). Whether it is an antidote and not a
reflection may be contested by Robert Smithson's notion that minimal
structures are reflective of urban structures, in particular the blank-
ness of a Philip Johnson office building, which performs "no natural
function, it simply exists between mind and matter, detached from
both, representing neither" (12). In point of fact, it is not intended to
be assimilated.

 The difficulty in naming minimal art, in assigning some linguistic
value or meaning to it, is its finality. It only needs to push its ob-
jecthood a little farther in order to disappear. That usually means
disappearing as the essence of one artistic form and turning into
another. In this sense, Fried's view of minimalism as "theatrical" is
not wrong, insofar as it makes evident the positionality of significa-
tion within the relative and transformative syntax of work-space-

spectator; on the other hand, painting conceals its own theatrical means of absorption.[12]

Conceptual art is implicit in minimal art. The radical break conceptualism makes with material forms is a break instigated by the tendency of those forms to draw attention to themselves as de facto material and nothing else, resisting the tendency of language to interpret the forms. The art challenges criticism to the extent that the words *painting* or *sculpture* became inadequate, and therefore could not be the only bearers of the term *art*. Conceptualism was provoked by the materiality of the work resisting designation into examining *designation itself* as the cultural and critical basis of art. The primary designation to worry about, now that sculpture and painting were irrelevant terms, was *art* itself. Joseph Kosuth had said in his seminal essay "Art after Philosophy" (1969), "Being an artist now means to question the nature of art. If one is questioning the nature of painting, one cannot be questioning the nature of art. . . . Painting is a *kind* of art" (161). Minimalism's strong conceptual basis was designed to confound interpretation. In this sense it is close to Duchamp's notion of the purely retinal, although the whole body and not just the eye, is implicated. What the minimalists showed is that the purely retinal is *in itself* a concept.

While Duchamp's influence upon conceptual artists of the sixties and seventies can be acknowledged, the logic of their development was always there in the dematerializing quest for essence in painting and sculpture. Once the ground of the gallery had been opened up, once sites could be designated as art, it came to be that only the framing mechanism of the artist's speech act (plus appropriate documentation and publication in the right place) could indicate what art was. Pop art participated in this too, but its domain was still primarily a material "artistic" reproduction rather than pure designation. In fact, if language was the frame that created the art, why not make the frame itself the art? The coyness with which some artists influenced by Dada or Duchamp tried to play the game of antiart annoyed minimalists and conceptualists who saw through the denegative aspect of this self-stylization. Donald Judd spoke both against them and for a new opening of the field of possibilities when he said, " 'non-art,' 'anti-art,' 'non-art art,' and 'anti-art art' are useless. If someone says his work is art, it's art" (qtd. in Karshan, *Conceptual Art*, 47).

Kosuth, as well as his British cohorts in the Art and Language

group, could indeed designate the framing mechanism of language as art itself. The naming of an object as art is an understanding of the meaning of art as being entirely predicated on use, rather than essence. One can view Wittgenstein's shift from a picture theory of language to meaning as use, family resemblances, and so on. as paradigmatic for the development of abstract art itself. Put another way, the gestalt of meaning changes as we change focus, from figure to ground.

The "dematerialization of the art object" (Lucy Lippard's term) takes place as the figure disappears into the ground of its legitimation, language. Douglas Huebler spoke for the dematerialized activities of conceptual art when he said: "The world is full of objects, more or less interesting; I do not wish to add any more. I prefer, simply, to state the existence of things in terms of time and/or place" (Meyer, *Conceptual Art*, 137).

How one states the existence of things can be indeterminate depending upon the language that you use, or the possibilities or impossibilities of propositions in terms of how they are stated. Just so does art shift attention from states of affective consciousness to description of intellectual states, from image to language.

My contention that conceptual art marks a shift from a production economy (finding its terminus in the blank industrial constructions of minimalism)[13] to an information economy seems to be born out by exhibitions that were set up as reading rooms by Kosuth, or Morris's *Card File*, which was an index of various statements on subjects related to art (Meyer, *Conceptual Art*, 185). While members of Art and Language originally thought it sufficient that their *writings* about art constituted their art, fellow traveler Kosuth did engage in material gallery works. His early *Protoinvestigations* involved the exhibition, side by side, of an object (such as a hammer or chair), a life-size photograph of the object, and the dictionary definition of the object. While this may appear to be a simple construct, showing the object's relation to the defining power of language, plus its reproduction as a literal sign that points back to the object, things are not so simple. We see these three elements as separate things. The definition is in some sense as much created object as that which it is supposed to define. The display of this work shows that the connection between these three references is that all three are *references*, and not complete in themselves. Meaning as such is predicated on difference, and objecti-

fied by use. A dictionary definition only operates in a metonymical way in relation to other definitions, and it is this looseness in definition that ultimately confounds its tautological relation to any simple object. Kosuth is not so naive as to believe this definition he posits is a closed system. Yet, in constructing this work there seems to be an attempt to put a stop to the metonymic flow to demonstrate a certain quality to the object in itself that allows us to use it meaningfully. This is further problematized in a work that exhibits a clock with the definitions "time," "machination," and "object" (fig. 8). This demonstrates the slippage of meaning when trying to reduce the object clock to any one (or all) of these definitions, though it is related to them all.

The value, or the tension to be found, in the works mentioned above may be that they don't work in themselves as any adequate definition of definition, despite their obviousness. Definition may be the core of Kosuth's concern in art, but definition is governed by context. He was less interested in the definitions of clock, hammer, and chair than he was the definition of art. The real contribution of Kosuth to the development of analysis in art was his description of context and concept in essays like "Art after Philosophy."

Kosuth had declared the demise of philosophy through its usurpation by science. What he saw as the end of philosophy bore the possibility of being the beginning of art, which may be read as similar to modernist claims that art had replaced religion. Duchamp's work offered the possibility for the true emergence of art, as he was the first to challenge the ontological presuppositions of art and brought into question its function (its use). The primacy of the "ontology" of appearance had to shift to the defining agency of the artist.

> This change—one from "appearance" to "conception"—was the beginning of "modern" art and the beginning of conceptual art. All art (after Duchamp) is conceptual (in nature) because art only exists conceptually. ("Art after Philosophy," 162)

From Duchamp on, Kosuth saw the only function of art as one that questioned its own nature, its own meaning. While he might subscribe to Reinhardt's notion of art as art, he added the further critical element of art as a tautology that resists itself, that resists its own reification. This was the reasoning behind the labeling of his art "Art as Idea as Idea":

"Art as idea" was obvious: ideas or concepts as the work itself. But this is a reification—it's using the idea as an object, to function within the prevailing formalist ideology of art. The addition of the second part—"Art as Idea *as Idea*"—intended to suggest that the real creative process, and the radical shift, was in changing the idea of art itself. (Siegel, *Artwords*, 221)

Kosuth effectively increased the stakes for the idea of what is important in the production of art when he said, "[T]he 'value' of particular artists after Duchamp can be weighed according to how much they questioned the nature of art" ("Art after Philosophy," 162). The physical presence of an art object becomes irrelevant to its "art condition"—only its conceptual component that challenges the conventional meaning of art is valuable. The conceptual component is what is part of art's language, a language through which the ideas of art flow from artist to artist. So the function of art operates only within this language: "If we continue our analogy of the forms art takes as being art's *language* one can realize then that a work of art is a kind of *proposition* presented within the context of art as a comment on art" (163). Not only that, but a work of art is an *"analytic* proposition" that provides no information about any "matter of fact" but only says that it is art, that is, "a *definition* of art" (164). In other words, it is a proposition about art in that what was not considered art before now becomes art. But it can only do this by steering clear of the qualifying nature of needs in general: "Art's only claim is for art. Art is the definition of art" (170).

Kosuth's radicality, which is predicated upon negation of all formal, and what he calls "morphological," approaches to art as a *visual* object fails to see the same element in his own art, although its formalism is linguistic rather than visual. What is neglected, and what had been neglected up until then, with the possible exception of Marcel Broodthaers in Belgium and Hans Haacke in the United States, was the defining power of the social context of art. What *really* defines art for all intents and purposes (or sets the limits and conditions for possible definition) is *not* the artist working in a value-free environment, but rather the economic and social powers that provide the material context for art. This means that the material context sets the terms for art to work within it or against it (even while in it). Kosuth eventually took social context into account but still declared the prior-

ity of art, even when considering that context. Art still functioned as a
way of world making, altering the meanings of what we see:

> Our role, as artists, is the development of specialized tools of
> understanding those very mechanisms of "culture," "politics"
> and so on. (They aren't different things, but different faces of the
> same thing.) But to say art is simply "specialized tools of under-
> standing" is already making it too passive, too academic. Art is a
> practice, and insofar as it makes consciousness, it participates in
> making the world. It is for this reason that the politics have to be
> critically seen as within the making process, a process which
> begins here, in our social, cultural and historical location. ("Text/
> Context," 41)

Right here Kosuth seems to be recognizing that the value of effective
conceptual investment in art depends upon *making*, a continual pro-
cess, a recognition of intellectual labor that no longer seems to bear
the Duchampian mark of a superior and indifferent act of choosing or
naming.

All artists that were labeled "conceptual" did not necessarily re-
ject the material basis of art. Robert Barry has said, "We are not really
destroying the object, but just expanding the definition, that's all"
(Meyer, *Conceptual Art*, 36). Robert Smithson, very much involved in
the material world, or the world of material, appeared to make a
distinction between physical material and objects. "Space is the re-
mains, or corpse, of time, it has dimensions. 'Objects' are 'sham
space,' the excrement of thought and language. . . . Objects are phan-
toms of the mind, as false as angels" (*Writings of Smithson*, 96). In
saying this, he recognized that what makes an object an object is an
act of the mind; it is not ontologically given. But his concern was not
solely with what the mind could make: "Occult notions of 'concept'
are in retreat from the physical world. Heaps of private information
reduce art to hermeticism and fatuous metaphysics. Language should
find itself in the physical world, and not end up locked in an idea in
somebody's head. . . . Writing should generate ideas into matter and
not the other way around. Art's development should be dialectical
and not metaphysical" (133). He recognized that purely linguistic con-
ceptual art and its concern with definition was but a form of logical
positivism that finds itself, through its own practice, alienated from

the real world: "[T]he mania for literalness relates to the breakdown in the rational belief in reality" (104). I would want to restate this as "The mania for literalness *provokes* the breakdown of rational belief in reality," as all relations, bodily or linguistic, are at base metaphorical.

Despite even the protests of the more material of the conceptualists and those who carried on with a minimalist ethic, conceptual art in its more dematerialized forms had raised the stakes so high that in the early seventies no respectable artist would still be caught making paintings. In a certain way, conceptualism had indeed been somewhat successful in defeating the expectations and holding at bay the desire of the art market to invest heavily in objects whose value would multiply over time. When the new "violent," "neoexpressionist" paintings started arriving from Germany and Italy in the late seventies, followed by the "new figuration" of Americans like David Salle, Julian Schnabel, and Eric Fischl, the gallery system was overjoyed, and prices soared, just as they had in the late fifties and early sixties. While older artists remarked on this massive form of regression, they ignored the fact that elements that they worked to create were now being combined with older painterly excesses. The conceptual content of the paintings was their performance element.

Although conceptual art seemed to have dissolved materiality and transferred the art to a private and subjective space, even subjective space has a material basis, as the cannier of the conceptualists understood. Conceptuality has a material base, even if only in the body of the artist. At a certain point minimal and conceptual artists began using their own bodies as the object of their art. Dennis Oppenheim's *Parallel Stress* (suspending his body by hands and feet between two high walls, and *Reading for a Second-Degree Burn* (getting a sunburn with a book on his chest, leaving a white "textual inscription"), Terry Fox's *Corner Push* (pushing his body against the corner of a room with all the force he could muster), works of Bruce Nauman, Vito Acconci, and Adrian Piper, all used the body of the artist as the focus of the art.

At the same time the focus of art moved from its location in space to its development in time. It was called "process art," and, while it began with a concentration on certain systems of growth (Haacke's use of condensation, growing grass, hatching chickens), it was extended to the use of the body. The static became kinetic with the introduction of the body as "living sculpture." "Real-time" works

were created, and this phrase is still used as one of the properties of performance art, which began in this way as a form of conceptual art. Laurie Anderson, who began as a sculptor, did a piece on the street in Milan in which she wore (in summer) ice skates embedded in a block of ice. She played her violin in a duet with a taped violin until the ice had melted, and then walked off on the skates.

The artist, in that she creates, is a subject. When the material she is using is her body, she objectifies part of her; when she frames her own process of creating an action, she is objectifying her subjecthood. Conceptual art dissolves the *object* into *subjective* space. Performance art reconstitutes the lost *object* in (as) the *subject itself*.

The dramatic painting that emerged in the late seventies corresponded to a similar objectifying of performance art, so that it lost its experimental process orientation, and instead became a form of theater or nightclub act. Theater itself had moved back away from its more direct audience involvement ethic of the sixties into the proscenium, accentuating distance in the Theater of Images. So painting again took on a role in art, sometimes emotionally hot (Schnabel, Salle, Fischl), sometimes cool (Longo), but offering a blend of idiosyncratic expressionism mixed with a highly developed media consciousness, also complicating the relation of painting to photography, constructed situation to event. This media consciousness would then mingle an earlier pop-conceptual consciousness with critical perspectives on popular and mass culture, derived from the Frankfurt School, Roland Barthes, Walter Benjamin, and Jean Baudrillard (Barbara Kruger, Cindy Sherman, Jenny Holzer, Jack Goldstein, Richard Prince, Louise Lawler, Martha Rosler, and others).

If we stop here and reflect a moment, a kind of historical loop operating between a dematerializing impulse and a materializing impulse presents itself. It is a loop between artist, work, and context (which includes the spectator). Abstraction in painting destroys material representation, creating a shift from painting as picture to painting as object. Once it attains object status, it draws attention to the space it is in as its determining ground. Expanding into that space, it confronts the spectator as figure within that ground. The self-consciousness this creates acts to locate the work within the spectator's consciousness, which then becomes the ground for the concept. Speculation upon the nature of that ground then focuses on the body, and the artist exteriorizes the concept once more through performance. Performance

then aspires once more to the state of an object, whether as painting, video, photography, or other means of self-representation. This loop, which appears as a continual loop of demystification, shows itself to be an alternation between materializing and dematerializing desires: evasion, loss, and the reinstatement of identity as tangible form.

An initial response to the materiality of painting can be seen in Duchamp's suppression of the "retinal": an appropriate criticism of the type of painting that allows society to categorize, valorize, and/or dismiss painters as merely sensual, intuitive lunatics. The method and the degree to which its conceptual alternative is carried out, however, characterize a repression of the body, of the material world, by the intellect. It is a virtual repression of the erotic component in art. This may sound like a misguided judgment, since the *theme* of Duchamp's work seems to rest entirely on the erotic. But it is sex mechanized, made immaterial, placed in the "mind of the beholder," and nowhere else. It is a distancing mechanism that represses or tries to contain truly erotic impulses by turning them into a joke. By doing this sex is put into the service of *control*—Duchamp's voyeurism, most vividly seen in his last work. *Given: 1. The Illuminating Gas, 2. The Waterfall* is a large wooden door framed by brickwork. The spectator is invited to gaze through a peephole in the door, where s/he is confronted by the image of a spread-eagled naked woman, whose head is cut off by the frame, lying in the grass, holding a lamp, with a waterfall in the background. This work thus places the spectator in a very self-conscious position, participating in Duchamp's fetishizing consciousness. If anything, Duchamp is the fetishist par excellence. Erotic impulses, when really acted upon, involve the giving up of personal control to desire—and to the other's desire—real participation with another body. Fetishes are forms of control over the other that resist this truly erotic participation and can be used as elements of mastery through a pose of indifference. Duchamp's aversion to the retinal, to the sensual elements of color, the smell of paint, is evidence of his aversion to sensuality in general, to the influence of other, bodily forms of apprehension.[14] This is why he hated the abstract expressionists so much, and their "animal" nature. Even Duchamp's use of chance and "visual indifference" is a painstaking way of avoiding bodily understanding. This is the major difference between the disembodied form of chance, engaged in by John Cage as well, and the embodied form of automatism, engaged in by André Breton, Max

Ernst, and Jackson Pollock. The former kind of chance is not the ego-ridding kind of play it is made out to be, for whatever occurs is aligned with the artist's personality anyway, and signed as such.

Later conceptual art will do as much (though not in so specific a way) to repress the erotic and advance the notion of intellectual control and power. This can even be seen in minimalism, where the works blankly "confront" the viewer, making him or her self-conscious. Materials used thus may have an ungiving quality, although it must be admitted that the erotic element may still be seen in the gentler uses of earth art (Smithson, Oppenheim, Alice Aycock), in some uses of materials (the use of felt by Morris and Barry Le Va or the poured latex of Lynda Benglis), and in the emergence of body art (in a playful sense with Bruce Nauman, in a darker sense with Vito Acconci). These elements are missing in the work of Art and Language and Joseph Kosuth, who were more concerned with mastering the game of definition.

The divergence within modern art between expressive labor and conceptual investment also plays a part in the notion of embodied and disembodied, materialized and dematerialized art.[15] Art that is constructed is not necessarily devoid of a dematerializing conceptuality. In abstract painting the dematerialization of representation is a move toward the material objectification of the medium. But this is actually a move to another level of representation, which in its own way begins to deobjectify, dematerialize the world. This reflects an aspect of advanced capitalism, which replaces an economy of material production with an information economy—primarily by *displacing* material production to the Third World. This information economy depends upon the intermediary of a service economy to function, just as performance arises when art has been dematerialized into the conceptual space of the art market's consciousness. The body returns, but at the service of a disembodied, semiotized, and thoroughly ideologized "nature," no longer involved, or interested, in the material world that sustains it.

FORM NOT DIFFERENT FROM EMPTINESS

In this chapter I have traced two lines of development. Abstraction wishes to connect itself with nonlinguistic form as the essence of art; conceptualism claims art as a kind of meaning, a type of definition, and it is therefore based in language. In neither case can one emphasis be

truly disconnected from the other. Archibald MacLeish had said that "a poem should not mean / but be," but its being also happens to *be* its meaning. While art in its minimalist and purist spirit has attempted to attain a being without meaning, or transcending meaning, it finds that it cannot escape its function as a sign, whether as a reflection of the cultural context or the personal desires or beliefs of its maker. Just so, no one person lives as pure being, isolated in a solitary existential freedom, despite the heroic loftiness of that aim, but is always at the same time a sign, even if just a sign for that desire that is never fulfilled. Art is a social phenomenon despite all the idiosyncratic impulses toward individual autonomy. As we gain more distance from avant-garde history, we see that all the dadaistic self-contradictory gestures take on a predictable uniformity. At the same time if we look a little closer at art that seems fairly uniform in its expression, little variations in form can create a phenomenal (in both senses of the word) difference in apprehension. The formal intentions of control or lack of control on the part of the artist may play less a part in the spectator's viewing than formerly thought.

While I speak of the unavoidable signification inherent in the object due to its position in a social context, this does not negate its objecthood, resistant to a facile designation as only sign. Those who, after structuralism and poststructuralism, find it easy to establish *writing* as the basic structure of the world and can reduce all things to the state of signs and nothing more show a disrespect for the material world that sustains them on many nonlinguistic levels. A "rational" technological approach to reality whose will to knowledge has treated material reality as dead matter that has been tabulated into a manipulable grid of signs ends up doing the same to human beings. Our inextricable unity with nature always implicates our treatment of it with our treatment of ourselves.

Those who cultivate a respect for human life, for its preciousness and fragility, are less likely to think that a person deserves to be eradicated or repressed simply because of what he or she believes, that is, what that person *represents*. This attitude displays a respect for material (and therefore spiritual) being, not the vagaries and inconstancies of ideological notions of "correctness." Yet a repression of the material being of art, which means a repression of human sensual nature that corresponds empathically with material or with the rest of material reality (including the pleasures and pains of others), is im-

plicit in all theorizing whose end is the *mastery* of all material nature through its consumption by language.

I am not antitheory, certainly, as what I am writing here *is* a theory of sorts. But I am affirming that theory, just like human beings in general, needs to know where it stands in the larger material scheme of things. It has to operate in a dialectical relationship with mute materiality (which can be apprehended in other than linguistic ways) and have respect for that other term. What the "spiritual" *is*, in fact, is that aspect of materiality which resists language; it may be both the inertia and the inexorable mutability of the world (and ourselves) that defies comprehension by language. This aspect shouldn't be ignored or repressed, and we shouldn't pretend that it doesn't exist, for if we do any of these things, we risk losing the ground we stand on. The great advantage of art or literature over theory is that this dual aspect of reality is at their very core. The truest poet is one who knows that language isn't everything. The truest artist knows that while he or she is painting a "picture," or constructing an object, the colors and textures, shapes and lines have an integrity and being to themselves that surpasses simple signification.

That which resists our understanding on the level of meaning invites our participation on the level of being. It is *our* resistances that must break down, not the material object's, in order for the meaning of that being to be "understood."

I have indicated that the making of art is a form of self-fashioning, but the will to knowledge that forms its conceptual component (in abstraction and conceptualism) may be a form of self-deconstruction, creating a predicament not unlike Krapp's in Beckett's play. For instance, the quest of abstract art in this century to reach the limits, and therefore the essence, of painting made painting disappear in the process. In this it shares a condition with a poststructuralist idea of the subject as a decentered self. Perhaps the self is like Heisenberg's electron; it disappears in the energy it takes to locate it. Does this mean, then, that it does not exist? Examine anything closely enough and it will disappear: the public, history, sexuality, even the body itself. But does this examination prove anything but the inadequacy of the mode of examining—to capture something and prove its existence with a literal application of words—seeing it before the mind? Reality can only be apprehended indirectly, through means of reflection, just like an eclipse through a camera obscura.[16] The indirectness of this

approach *itself* resists a literal and direct apprehension. Hence all the confusion attendant upon the objectification of language by structuralism. In time the truths of science may be seen as not very different from poetic truths, that is, if poetry avoids the trap of literalism. The truth of indirection is understood metaphorically against the reified ground of literality, while literality as a figure promises the ability to *grasp* the truth. Metaphorical truth is a qualitative reflection of a value within a particular material reality. Literal truth is founded in a quantitative analysis of material reality. The latter is a confusion of the map with the territory.

The function of nonfunctional art has been to introduce a space of freedom into reality; as it has developed within capitalism, this function is formal, but substanceless. This formal and substanceless drive in modern art, once it has distanced itself from the kind of symbolic value promoted by the early abstractionists, aims at an absolutely literal consciousness. The fear of representation is part of a literalizing mentality: the fear that figuration creates a defining relation to reality, an authoritarian use of false consciousness, too simply read as illusion per se.[17] A symbolizing or metaphorizing consciousness maintains enough of a distance or ambivalent relation to the figurative work (even while maintaining an empathic relation with it) so that the work doesn't have that kind of authority.

Although this fear of representation may result in a misguided notion of language, which through its separation from material objects forms its own artistic order, it has also drawn attention to the integrity of the material world itself that should be seen independently of language's mastery of it. The inability of language to truly master art is part of art's formal but substanceless nature. The main question raised by art in this century is "what is art?" Reinhardt says that the answer is self-evident and part of a long tradition of making of which each individual artist is but a small part: it is "art as art." To Duchamp, as well as to Dada, it is the realm of perfect individual freedom that requires that "art" itself have no meaning, or contain its own negation. To Reinhardt, art is a tautology; to Duchamp, art is a self-contradiction. In both cases we see the formal and substanceless nature of art.

Because of this nature, because of its almost pure sense of being only a method of apprehension, if not cognition, art can only retain its value *as art* in an art-for-art's-sake credo that at the same time mirrors

the attitude of life-for-life's sake. Anything less puts it body and soul at the service of a nonart ideology, and its freedom from ideological predetermination is lost along the way. Art, though it may manifest itself substantially, is a very thin line that walks itself.

The Material Word: Cultural Invention and Intervention

The struggle, in visual art, to separate the conceptual, linguistic elements of a work from its strictly visual and material properties seemed, at least briefly, to have been attained in the history of this century's art culture. A similar struggle within language arts finds a more difficult and more elusive ground to contend with.

There are two models for linguistic representation that obtain in modern poetry. One is a practice of clear description, a common-sense pointing to physical features, mediated by Ezra Pound's use of Flaubert's *le mot juste*—in other words, a positivism aiming at a phenomenology. The other is a concern with structural models of expression, which acknowledge the paucity of direct reference when it comes to a naming of particulars as *content*. Structural models reflect Wittgenstein's early picture theory published in his *Tractatus-Logico-Philosophicus*. Wittgenstein's early theory sought to evade one-to-one correspondences on the level of elements—this word for that thing—but rather posited conventionalized *models of relations* between words that are cognate with physical relations in the world.

The moment this structurally mimetic model is adopted, it seems to take on a life of its own. If one is adept at questioning even the mimetic character of *structure*, it is usual to view the *model* as even more removed than the nominal elemental connections to reality, and begin to see it as a thing-in-itself, as having its *own* reality. Such, in fact, is the development of the structuralist conception of language. And such is the idea that language itself has a materiality, that the most truthful and faithful expression one can have has to do with this materiality of language. What language's materiality exactly *is*, however, has become a matter of utopian fervor and highly skeptical debate.

In the following, I wish to trace these two lines of objectifying

practice: the first impulse of truth-to-description I refer to as *referential objectification*, practiced by imagists, objectivists, and those influenced by them. The second, structural, self-conscious form of production resistant to rhetorical appropriation that eludes the reductions of interpretation I call *material objectification*. This project is developed by both Sound poetry and concrete poetry. Of course, it must be recognized that, like painting and like the body in theater, neither position can exist without traces of its other embedded in its very processes.

A third kind of poetry that understands this dialectical necessity has emerged in the seventies and eighties. "Language poetry" attempts to comprehend both referential and material objectification within one poetic practice. One of its models is Gertrude Stein, who played off the expectations aroused by the referential, material, structural, and musical (rhythmic, tonal, and homonymic) components of language and objectified them, thereby questioning the authority of the idea of simple description.

What should be examined, in regard to the practice of both referential and material objectification, is the writer's purpose for engaging in it in the first place. In the referential sense, it represents the desire to give one's self over to things, to recognize more clearly the material basis of one's existence. In the material sense, it is the desire to alter the shape of existence, to form either an exemplary witness to material formations and formations of consciousness through a miming of the forces of their structuration, or a compulsion to separate consciousness altogether from a mimetic function and to see a new, material, self-identical form take its place in the world. The desire for self-identity in form is a projection of a desire for self-identity in one's subjecthood, resisting all influences of preconceived ideas propagated and enforced by political, economic, and cultural power, whether Foucault's positivities or, for a Marxist, ideology. This desire reflects a highly existential stance, even if not acknowledged as such.

In all the experimental phases of poetry this century, the subjectivity of the poet does not disappear, no matter the motive or practice, but it changes shape, and even disguises itself in multiplicity, in order to remain sovereign, even if only through a unique gesture or style. T. S. Eliot's striving for impersonality through the objective correlative, his veneration of negative capability, and his religiously utopian conception of culture all seem to point to a minimization of self. But if examined more closely, it appears less an elimination of subjectivity

than its hypostatization through and in its cultural products. The "impersonal" aspect in modern practice simply appeared to be the most efficacious resistance and retention of selfhood against a truly depersonalizing interpersonal system of commerce even while it seems imprisoned within that system.

REFERENTIAL OBJECTIFICATION IN MODERN POETRY

T. E. Hulme, one of the major influences on Ezra Pound's invention of *imagisme*, was a cosmopolitan poet well versed in philosophy who participated in the surge of interest in Kant at the turn of the century. For him the objectifying idea of things-in-themselves became a kind of necessary propaedeutic against the self-indulgent alienation of hypersubjective symbolist reverie pervasive at the time, even if it is a problematic idea in philosophical terms.

Wilhelm Worringer was a contemporary German thinker who also had an impact on Hulme's work, as well as on the work of abstract artists such as Kandinsky. Worringer's *Abstraction and Empathy* (1908) pitted "empathetic" art, exemplified by florid Greek realism, against "abstract" art, epitomized by the more "primitive" Egyptian hieratic style. Empathetic art was read as decadent and out of touch with the elemental external forces of life. Abstract art, on the other hand, avoided anthropomorphism and sought an absolute form that would transcend the nature of local environmental and social forces of change. Worringer spoke of primitive abstract art as a refuge; it derives from cultures that either fear nature and feel "an immense spiritual dread of space," or that radically distrust nature and believe it to be an illusion (Isaak, *Ruin of Representation*, 7).

Hulme paraphrased Worringer in his own conceptualizing of abstraction, while not necessarily excluding the Greeks from it:

> The ancients were perfectly aware of the fluidity of the world and of its impermanence; there was the Greek theory that the whole world was a flux. But while they recognized it, they feared it and endeavoured to evade it, to construct things of permanence which would stand fast in this universal flux which frightened them. They had the disease, the passion, for immortality. They wished to construct things which should be proud boasts that they, me, were immortal. . . . Living in a dynamic world, they

wished to create a static fixity where their souls might rest. (Hulme, *Further Speculations*, 70–71)[1]

The dynamic world that Hulme speaks of could just as well have been his own world, in which the rapid changes wrought by technology, the speed of transportation, and the ever-increasing pace of urban life might have left many bewildered souls in their wake. Thus the "static fixity" best characterized by the hieratic sculptures of Gaudier-Brzeska and the smoother sculpture of repose of Constantin Brancusi provided a direction for modernist artists and poets faced not only with the new forms propagated by technological and industrial change,[2] but driven to bold time-transcending gestures by a new understanding of the forces of history that stood behind them. It became necessary to force the artwork out of its contextually style-bound state for it to become an object unto itself. Inasmuch as poetry uses language as a medium, early poetic experiments in the imagist tradition used language to extract an image from the world and verbally hold it before the mind's eye.

Holding it there meant to take it out of time, to allow it to have presence, in the present. A possible source of inspiration for Hulme in this sense was Henri Bergson, who evolved a philosophy of "pure duration," an internal time sense whose continuousness makes it seem ever present. Hulme noted that the difference between prose and poetry was that poetry "arrests the mind." Poetry works against simple propulsion into the future and attempts to hold the mind in a state that resonates within the present.

Pound, although he scorned Bergson and his disciples,[3] similarly developed his image in relation to the moment: an " 'image' is that which presents an intellectual and emotional complex in an *instant* of time. . . . [I]t is the presentation of such a 'complex' *instantaneously* which gives that sense of sudden liberation . . . which we experience in the presence of the greatest works of art" (*Literary Essays*, 4 [emphasis added]). The image thus works to fix the mind, *in the present*, upon a material object, to *sense* it as it were, instead of, as in the case of symbolism, using the symbol to carry one's sentiments off to realms of transcendent meaning.

Pound does not wholly dissociate the image from the symbol but rather redefines the symbol *in terms of* the image. His opposition to the symbol as it had been employed up until then was twofold: against the symbol as metonymic counter with a fixed meaning, and

against mushy abstractionism, a naive transcendentalism that blurs real distinctions. In "A Retrospect" (1918) he says, "Don't use such an expression as *'dim land of peace.'* It dulls the image. It mixes an abstraction with the concrete. It comes from the writer's not realizing that the natural object is always the *adequate* symbol" (*Literary Essays*, 4–5). One can see that the "natural object" is what counts for the image, and that it is always the adequate *symbol*. (*Adequate* is a term that comes into play with Eliot's objective correlative as well). This implies that the poet can use objects without explanatory abstractions within a poem and still elicit a larger meaning than what just the facts suggest. At the same time, for someone not versed in the tradition, a "hawk can still be a hawk," as Pound alluded perhaps to Hamlet's not-handsaw as well as to Yeats's historical gyre.

Pound's experience of Ernest Fenellosa's treatise *The Chinese Written Character as a Medium for Poetry* led him out of the static sense of nonmoving images to a more dynamic sense of a noun-verb convergence in the ideogram. As Fenellosa put it: "A true noun, an isolated thing, does not exist in nature. Things are only the terminal points, or rather the meeting points, of actions, cross-sections cut through actions, snapshots" (10). But Fenellosa wants to make clear that "primitive metaphors do not spring from arbitrary *subjective* processes. They are possible only because they follow objective lines of relations in nature herself. Relations are more real and more important than the things which they relate" (22). Following the "objective lines of relations in nature" is the poetic understanding of reality that Pound, Williams, and, later, Zukofsky, wanted, for different reasons, to include in their practice. The last line in particular stresses that essential meaning is found in the relational *form* of linguistic expression, similar to the logical model of Wittgenstein's early picture theory of language.[4]

The kind of imitation Pound and others of his time were engaged in was a truth to the material of nature, even while the preserves of nature were being rapidly eroded by social and material progress. Pound thought that we should study nature in order to imitate its form-giving power in the creation of our own cultures. The abstractive power of the technological manipulation of nature and the mass reproduction of cultural artifacts, so roundly condemned in *Hugh Selwyn Mauberley*, opposes the balanced creative system of nature. In the Pisan Cantos, Pound admonishes us (and presumably himself) to "Learn of the green world what can be thy place / In

scaled invention or true artistry" (Canto 81). In Canto 27, he cites as a cultural paradigm Venice—"the forest of marble / the stone trees— out of water / —the arbours of stone." The city rhymes its structures with its environment's petrification of submerged trees. Similarly, for Pound, not only the creation of art and architecture must imitate nature, but social behavior as well: "The sages of Han had a saying: / Manners are from the earth and from water / They arise out of hills and streams" (Canto 107).

While Pound will speak of cultural products in terms of their resemblance to natural forms, he will also turn the terms around. Thus bathing nymphs take on an artisanal glow as "Ivory dipping in silver" (Canto 4). "And the waters richer than glass" (Canto 17) presents an oscillation of emphasis around the term "richer." The most beautiful example is "The sky is leaded with elm boughs" (Canto 106). Here there is a transformative power in that the culturally signifying noun (the cohesive element in stained-glass windows) is used as a verb, following Fenellosa's lead, creating a link between human and divine creation. At the same time, read through Worringer, this imitating force is concrete rather than abstract, and in its empathetic identification parts company with the contemporary resistant forces of abstraction.

The dynamics of modern society are such that the human has superseded divine creation, and its own artifacts stand in the way of a clear view of nature. Thus Pound conceived of a present cultural resolution to the problems of modernity only by drawing from past circumstances unlike our own, proposing an archaic organic solution. On the other hand, William Carlos Williams saw the problem as less organic and more mechanical:

> We forget what a poem is: a poem is an organization of materials. As an automobile or kitchen stove is an organization of materials. You have to take words, as Gertrude Stein said we must, to make poems. Poems are mechanical objects made out of words to express a certain thing. (Wagner, *Interviews*, 69)

In his pragmatic way, Williams gives over Pound's hills and streams for a more contemporary consciousness of an environment modified by machines. Thus, given the truth to materials of an urbanized poetry, the creation of a poem is a matter of *construction*, not growth.

Words are the components of such a machine for seeing, as one might call it, thinking of Stein's "arrangement in a system to pointing," pointing to where we should look or read. Both Stein and Williams shared a fascination with the paintings of Cézanne, who was primarily concerned with relating the parts of a work to the whole, to maintain an overall design. Williams noted from this that "the meaning of the poem can be grasped by attention to the design" (Wagner, *Interviews*, 53). Williams accentuates this in his poems by their visual placement, reducing the length of his lines in order to point to, and linger on, each descriptive component:

Between Walls

the back wings
of the

hospital where
nothing

will grow lie
cinders

in which shine
the broken

pieces of a green
bottle

(*Selected Poems*, 84)

The fact that the title is also the first line demonstrates the overall integrity of the composition; beyond this, the walls themselves border the poem's referential contents as a frame would border a painting. But what the poem gains in its visual status it loses in allusive signifying power.

Hulme had said that the "new verse resembles sculpture rather than music; it appeals to the eye rather than the ear" (*Further Speculations*, 75). He maintained that "the art of literature consists exactly in this *passage from the Eye to the Voice*" (86). The voice and phrase submit to the mechanism of sight and its images. While Eliot and Pound were content in their later work to return to more traditional measured verse, Williams kept looking for a passage from the voice to the eye, a

just representation of integral rhythms gleaned from the "American idiom."[5] In this he sought the truth of a basic American cultural experience, a pragmatic approach to reality free from the tradition of European metaphysics.

This truth, this sensorial transfer from experience to expression, is what Louis Zukofsky referred to as "sincerity" in his essay for the objectivist issue of *Poetry* in 1931, "Sincerity and Objectification, with Special Reference to the Work of Charles Reznikoff":

> In sincerity shapes appear concomitants of word combinations, precursors of (if there is continuance) completed sound or structure, melody or form. Writing occurs which is the detail, not mirage, of seeing, of thinking with the things as they exist, and of directing them along a line of melody. (274)

In their different ways, Pound, Williams, Stein, and Zukofsky thought "with the things as they exist. . . . directing them along a line of melody."

But sincerity is also a component of a larger concern for the poem: the poem's own "objectification," its resolution into a structure "to which the mind does not wish to add" (Zukofsky, "Sincerity," 275–76). In addition, the objectification must "convey the totality of perfect rest" (276). Yet the "rested totality" of objectification, the "apprehension satisfied completely as to the appearance of the art form as an object," consists of the "arrangement, into one apprehended unit, of minor units of sincerity—in other words, the resolving of words and their ideation into structure" (274). While Zukofsky praises Reznikoff's poems for their high degree of sincerity, the only contemporary poems that Zukofsky claims represent objectification "to the most constant degree" are those of Ezra Pound, whose "objects are musical shapes" (276). Just so, Zukofsky himself conceived of his epic poem *A* as a musical structure, even including music scores in the final sections. The architectonic structures of Bach's music were initial inspirations for *A*, and perhaps their clear delineations inspired his sense of their "object" status, just as baroque music inspired the idea of architecture as "frozen music."

Zukofsky's idea of sincerity presupposed a clear and direct correspondence between words and things. The clarity of the poem depends upon the clarity of its referential delineations: "[M]ore ob-

jectification cannot be expected from writing than from its subject matter—whatever exists. Still humans live alongside objects, and those interested assume poems are such" (277–78). The poem is a "reassertion of faith that the combined letters—the words—are absolute symbols for objects, states, acts, interrelations, thoughts about them. If not, why use words?" (279).

In this essay of Zukofsky's we witness an intimation, within the referential tradition of imagism-objectivism itself, of the cognitive split between *referential* and *material* objectification. Sincerity forms the referential component (direct treatment of the perceived object) and objectification the material component (the poem itself as object). Zukofsky's own reduction of the object in the poem (which infers the reduction of the subject as well) is to be opened up in projective verse.

Projectivism, as formulated by Charles Olson, is only at odds with objectivism inasmuch as the latter still postulates an external "objective" world, "things" from which we derive our ideas and thoughts. Olson reverses it, not in the sense of denying the reality of material, but in acknowledging that we only know it through the medium of our physical lives and our drives projected into the world; doing this, he problematizes the simple relation of word to thing. This projective practice he designates as "objectism," an objectification that is compelled to represent its relations with both immediate physical world and its history, even while it is always moving away from us. Olson's poetry echoes Heidegger's concern with origins and a lost sense of Being. It shares a desire for a linguistic closeness to things that once seemed to have obtained. Olson invokes etymological explanations as a way of attuning one's self with the environment: the references to the Aryan root for "is" as *as*, "to breathe," and to the Sanscrit *bhu*, "to grow," for "be" are examples of this ("Projective Verse," 389). In this way, a language closer to "origin," because ancient, affirms Olson's own poetics of the breath. The more you know about someone's history, the better able you are to communicate with him or her: the same goes for the ground we walk on, the city or town or world we inhabit.

In Olson as well as Duncan's poetry, and much poetry after them, there is a myth of linguistic origin, in which all language is metaphorical and physical at base. The imperative of this poetry, in resistance to the instrumentalization of language, is the engagement

in an obsessive etymology that finds its own historically paradig-
matic metaphor in geological or historical strata (while its synchronic
metaphor is that of the periplum). While I see a possible necessity
for this practice, it fails to account for the inevitable alterations that
language undergoes through time, and whatever etymological root
one might find, it is not any closer to origin, nor brings us closer to
origin in a material sense, than any contemporary metaphor. Yet it is
itself a transhistorical metaphor whose position might serve a heuris-
tically useful purpose. Unfortunately, there can be a literal-minded-
ness in even the most unpositivistic of poets that latches on to cer-
tain words as if they were secret powers that will return to disrupt or
correct a decadent civilization.

Olson's magnum opus, *The Maximus Poems*, is a massive projection
of Olson's voice into the historical mask of a New England fishing
town, Gloucester, Massachusetts. The name Maximus, while reflecting
the enormous stature and girth of the poet, also creates the illusion of
empire, with Gloucester as one of it nodal points. Olson takes his cues
from the palimpsest of Pound's *Cantos*, only instead of writing a world
history, he localizes elements of world history. Behind the names,
dates, and places are conceptual white spaces, Olson's discontinuities,
forming an unspoken ground to challenge or frustrate the reader. To-
pology is fractured by history and history is segmented into multiple
topologies.

While this fragmentation would seem to also work for the propa-
gation of numerous voices, personae helping to evade subjectivism
by keeping consciousness projected into things, words, and histo-
ries, the strength of the historian's voice and its large-scale anthropo-
morphizing formulations (the obverse of Pound's animism) rings
throughout. Hardly a dispersion of ego into its lifeworld, as Olson
would have wanted it, it becomes the ego's production. "Maximus,
to himself":

It is undone business
I speak of, this morning,
with the sea
stretching out
from my feet

 (*Maximus* [1960], 53)

It is a field work (re)created by the breath, seeing—after Williams's "variable foot" —the voice shaped by the length of expressive moments and the placement of words on the page.

What Olson understood was that despite the poet's concern for the territory, the map is all he can really be accounted for. This urge for a historical as well as topological *visual* model quite often underlies the scattering of words or names across the page, as if they were the faint traces of fault lines. Olson literally expressed this cartographic impulse by his replication of a depths chart of Gloucester harbor at the end of "Letter, May 2, 1959" (*M* [1960], 151).

Olson shared with Williams the desire to express what he saw through a visual mimesis, producing what cannot be as immediately understood through simple description. Such, for Williams, is the word SODA read vertically and surrounded by asterisks in his poem "The Attic Which Is Desire" (*Selected Poems*, 47), replicating a drugstore sign. There is a page in *Paterson* in which the lines are not straight, but seem as if dropped on the page, tilted up and down, jostling each other (137). Olson, too, scattered his lines about, sometimes keeping them straight with each other, but tilting the page (*Maximus* 1983, vols. 1–3, 404), or intersecting phrases at right angles (438), or writing in circles, whether in cursive or type (479, 499).

While it would seem that this visually objectifying urge is designed to secure the feel and gesture of the material that is expressed or indicated, it tends to separate the phrase from its content and instead emphasize the *how* of its expression—a trace of the body's expression. Olson's desire that poetry should work quickly in delivering the poet's experience to the reader can be read in his notion that each perception "must MOVE, INSTANTER, ON ANOTHER" ("Projective Verse," 388). Despite the speed of translation from experience to expression that Olson thought would secure the integrity of the two modes, the translation tends to get slowed down by the body, and the writing body replaces what initiated the experience. In that the poetry involves an evasion of this factor, there is no recollection in tranquility in Olson's poems. It is a far cry as well from Zukofsky's idea of "repose" in the adequately objectified poem.

This urge for immediacy, founded in a distrust of phonetic language's adequacy for description, is also to be seen in the simultaneity of the futurists and Stein's continuous present. The possibility of

immediacy should be read as a prerequisite for authenticity, which is best approximated by something close to being self-identical, map *and* territory at once. The visualizing urge in poetry that emerged in the fifties, the most radical objectification yet of the desire to merge form and content (surpassing even Olson/Creeley's "form as never more than an extension of content") became known as concrete poetry. In order to understand more explicitly this poetry's origins, we have to return to the turn of the last century.

MATERIAL OBJECTIFICATION IN MODERN POETRY

Concrete Poetry

I don't know if Rudolf Arnheim had Mallarmé in mind when, in writing about "The Visual Aspects of Concrete Poetry," he maintained that the art of concrete poetry is one of replacing the *message* with the *memento*, thinking of the lapidary art of gravestones and memorials (100–101). In his essay, "The Book: A Spiritual Instrument," Mallarmé expresses this idea explicitly: "The foldings of a book, in comparison with the large-sized, open newspaper, have an almost religious significance. But an even greater significance lies in their thickness when they are piled together; for then they form a tomb in miniature for our souls" (*Selected Prose*, 25).

The book thus wages a tragically modernist battle for permanence against the instant degradability of news, printed on the somewhat slower degradability of newsprint. But next to the speed of new communication media, the book's only permanence is that of an epitaph. In the coming years, did the avant-garde use of newsprint, whether in the slowly eroding collages of Picasso, or in Tristan Tzara's cut-up chance poems, send a mocking note back to the Master? (see Poggi, "Mallarmé"). Mallarmé's battle of the book with the newspaper was a battle against the commodification of language. Picasso and Tzara's appropriation of that selfsame commodified form was an ironic speeding up of mass language's entropic trajectory, its instant consumability. We will discover that the concrete-poetry movement that Mallarmé helped to inspire would expand the resistant objecthood of the poem beyond the book, even into the commercial sphere which he loathed.

The preservation of the book's integrity called for the creation of a

literary work whose essential elements demanded a very material ground, which was the book itself. Its sense was to become dependent upon how it is read within the framework of a book's pages, the rectangular canvas (a dyptich unified), across which Mallarmé "drew" swaths of lines, in varieties of shapes and sizes, from the upper left of the verso to the lower right of the recto.

Mallarmé attempted to do many things at once in *Un Coup de dés*. On the one hand, he was creating a movement of words scattered across the page that visually suggested both a ship being tossed back and forth between stormy waves and a throw of dice, a random dispersion of meaning. We are to read in negative the black words against the pure white of the page as white stars against the black of the sky, their configuration forming a constellation, a structure imposed on the stars by human imagination. Just so, out of the seeming random scattering of words across the page we create our own configurations of meaning and reference.

All of these effects seem purely visual, but Mallarmé wanted to create *Un Coup de dés* as an evocation of musical form. We are to understand it as a score—words in larger type calling for a loud voice, words in smaller type a more quiet voice, perhaps italicized words using more intensity, and finally, noting the white space as the space of silence. This rhythmic cueing by means of placement on the page was to be taken up by Pound, Williams, Olson, and others. At the same time, the movement on the page that echoes the ocean movements announced by the words presages the tautological technique of Apollinaire's *Calligrammes*. As music, it evokes less Debussy's misty impressionism of *L'Après-midi d'un faune* than it does the later pointillism of Webern.

But the poem is more evocative, in the sense of both Debussy's and Webern's music, than it is visually tautological. "To *name* an object is largely to destroy poetic enjoyment, which comes from gradual divination. The ideal is to *suggest* the object" (*Selected Prose*, 21). This suggestiveness involves the constant subversion of a positivistic reality, conjuring "hidden identities through a kind of equivalence which will gnaw and reduce physical reality, and always strive for a central state of purity"(103). Thus the constellations of *Un Coup de dés* contain always unfinished, always becoming nodes of meaning that would like to make nonsense of literal readings.

Music or lapidary inscription? Can it be both? Always changing, shifting reference, or fixing the words physically forever on the page?

It is a sharply delineating moment of music and visual sense, but it is also the moment of their combining. Wagnerian in its desired scope, Platonically ideal, but with a Cartesian doubt lurking behind it, over the century it has served as a paradigm for both the fluid, Heraclitean school of modern Sound poets, and the static, Eleatic school of modern concrete poets.[6]

With one difference: as both concrete and Sound poetry movements evolved, they moved from symbolic modes of expression to literal ones. The sounds (compounded by their very pictorial scores) invoked by Marinetti and his futurist friends were imitations of natural or industrial sounds; sounds invoked by Hugo Ball at the Cabaret Voltaire hoped to imitate a latent form of an ancient language of ritual. But the sounds promoted by the later Dada experiments of Hausmann and Schwitters, as well as those of the lettrists in France, or the Four Horsemen in Canada, or John Cage in America, were all to be *literal* (therefore unique) sonic manifestations of the body. (It must be said, however, that for such as the lettrists and the Russian futurist practitioners of *zaum*, this literal body-centered language was supposed to attain universal symbolic value as well.)

While *Un Coup de dés* and Aragon's "Suicide" have symbolic, enigmatic auras, even early visual poems like Apollinaire's *Calligrammes* tended to be literal messages (while retaining symbolic verbal content), yet curiously detaining our gaze. It is most likely, *pace* Arnheim, that most concrete poetry is a striving to be *both* message and memento, both sign *and* object.

The score aspect of the visual text has always tied together the concrete and Sound poetry movements, with poets quite often practicing both. In Mallarmé's case, it is a radical spatialization of the conventional line break. But what is true of Mallarmé's poem as well as Pound's *Cantos* and Williams's poems, is that the score is less understandable or realizable sonically than visually or ideationally.[7] Where it does have an impact in both visual and aural spheres is in repetitive texts, such as those of Gertrude Stein. Concrete poets like the Austrian Gerhard Rühm have shown how to draw that line more finely, as in his poem

leafleafleafleafleafleafleafleaflea

(Russell, *Avant-Garde*, 147)

which connotes a shifting verbal *and* visual figure-ground of flea and leaf, as well as the movement of the flea across the leaf.

As we will see in the case of Sound poetry, concrete poetry has a dual impulse—to be absolutely transparent in signification, yet to be unique and opaque in its objecthood. The latter, individualistic, objectifying function typifies a personalized anticommodity stance tending toward anarchic, highly libidinalized forms of resistance to rational systems, which are blamed for the degradation of contemporary existence. The former semiotic ideal finds its home in the very rationalized system the anarchistic objectifying impulse decries. This distinction can be clarified for us if we view the rationalistic concrete poetry that developed in postwar West Germany against the post-Dada tradition of individual contrarationalism that was stimulated by the movement in France known as lettrism.

While the lettrism of the fifties claimed to be an international poetry movement, it remained a parochial Parisian phenomenon. What *was* an international phenomenon was the concrete-poetry movement, which resulted in a number of major anthologies, edited by Emmett Williams, Mary Ellen Solt, Hansjörg Mayer, Eugene Wildman, and others. This movement included poets from Japan, Germany, Austria, Italy, Portugal, Spain, Holland, Belgium, Sweden, England, France, America, and Brazil.

In the following, I wish to examine how the visual art of concrete poetry and the sonic art of sound poetry either work toward the establishment of a positive attempt at the *invention* of a universal system of communication, stimulated by the period of reconstruction following World War II, or the *intervention* of individualized embodied languages in the bureaucratic workings of a rapidly growing, rhetorically and semiotically overdetermined environment.

Liselotte Gumpel has defined two senses of the word *concrete* as it applies to the poetry of the postwar divided Germanies: in the German Democratic Republic it refers to a poetry aspiring to social realism, whose exemplary writer was Gottfried Benn; in the Federal Republic, its meaning is the one that it has generally come to have in the West, that of a predominantly visual form that aims at an (almost) instantaneously perceived, mutually reinforcing union of lexical and pictorial elements that make of the poem an object in its own right. My own

distinctions of referential objectification (as applied to imagist and objectivist schools of poetry) and material objectification (as applied to sound, concrete, and Language poetry) are basically in line with Gumpel's idea, even while I deny that these distinctions are absolute, each type containing to a certain degree elements of the other.

Gumpel has recognized that ideological forces endemic to the societies on both sides of the Berlin Wall can be counted as influential in the development of these two differently understood "concrete" poetries. Thus, in the fifties, while East Germany spoke the language of socialist realism, West Germany spoke the language of "capitalist realism," or advertising. Gumpel connects the truly "logo"-centric nature of advertising with the communicative ideals of western concretism as it developed in the fifties: "The word ["Coca-Cola"] becomes something like a sensational 'figure' for the drink; it juts out and lends impact as a linguistic form to the thing signified. Thus, curiously enough, the word, and not just the taste of the drink, contributes to the popularity of this commodity as its material form fosters consumer appeal. The western concrete poem trades on linguistic design in a similar manner, even if the appeal is meant to be esthetic instead of publicity-oriented" (*Concrete Poetry*, 10–11).

The poet who did most to connect the practice of advertising and industrial design to concrete poetry was Eugen Gomringer, a Bolivian-born German living in Switzerland. Influenced by the "concrete painters" of Zurich, such as Max Bill and Paul Lohse, as well as by Bauhaus social ideals, Gomringer (who had been Bill's secretary) claimed to have invented the term concrete poetry in 1955 in Ulm, with Decio Pignatari, one of the visually experimental Brazilian Noigandres group.[8] Ulm was the postwar home of the Bauhaus, reestablished by Bill as the Hochschule für Gestaltung, and the relation of Bauhaus design to social-engineering attempts is well documented. Its former nominally socialistic philosophy found itself able to adapt to a predominantly capitalistic one during reconstruction and the start of the cold war.

Thus, Gomringer, looking back to the early days in his 1976 essay "Poetry as a Means for the Structuring of a Social Environment," could laud posters, brochures, and advertisements as "weapons in the struggle of free enterprise" that "yielded a measure of aesthetic sense gratis" (230–31). He saw the poet as someone who could now be "an important, if not leading, member of this new team—a team

whose creative efforts were all in some respect or other concerned with verbal communication" (233). In order to do this, the poet had to leave his position on the margins of society, abandon his tragic role, his attitude of genius, and enter instead into the "enlightened, elemental constructive world of the rational creative builders" (234).

In a series of statements published in a special concrete poetry issue of *Hispanic Arts* in 1968, Gomringer proposed that poetry could now have an "organic function" in society, one related less to literature and more to "architecture, painting, sculpture, and industrial design." The almost literal sense of the term *concrete* is made clear when he avers that "the visible form of concrete poetry is identical to its structure, as is the case with architecture" ("Concrete Poetry," 67)—that is, if you think form should follow function. Even as late as 1976, Gomringer thought of concrete poetry as "singular, self-contained forms . . . in a way comparable to single-family dwellings; I have always perceived the essential value of a poem and that of a sketch for a single-family house to be equal" ("Poetry as Means," 237–38). We could jump from here to Corbusier's notion of a house as a "machine to live in" to Williams's notion of a poem as a machine for meaning. Consider that concrete poetry arrived in Europe at a time of reconstruction. What was most important was a communicability that would enable everyone to build from the ashes, and to modernize their dwelling at the same time.

There is a referential ideal implicit in Gomringer's idea of concrete poetry, one that is as univocal and direct as possible. The concrete poem as "functional object" ("Poem as Functional Object," 69) should, on the one hand, be as universal and readable as possible: "The resulting poems should be, if possible, as easily understood as signs in airports and traffic signs" (70).

On the other hand, it was his desire that the concrete poem should have an existence unto itself and not be pure reference. Borrowing from Mallarmé (who would no doubt be alarmed by Gomringer's poetics), he calls his poems "constellations," whose basic unit is the word. These units are then placed in a nonlinear configuration or "cluster," thus forming "a reality in itself, and not a poem about something or other" ("From Line to Constellation," 67). If meaning wasn't being transmitted referentially, it was communicating analogically, using metaphors grounded in the visual (proxemic) structure rather than the grammatical.

There was a tendency among concrete poets like Gomringer to

propose that revolutions in poetic form were reflections of social re-
form. Gomringer was challenged by Ekkehardt Jürgens on the as-
sumption that giving up a poem reflects the democratic breakdown of
social hierarchy. Jürgens calls this a form of naïve realism, which is
especially uncalled for when concrete poetry itself tends to be an
"elitist" form. As Gumpel puts it: "Esoterism and 'engagement'
hardly go together, and the asyntactism of a constellation is certainly
not conducive to generating a thematic Weltanschauung" (*Concrete
Poetry*, 49).

Despite this seeming irreconcilability between modernist opacity
and purity and the desire for a consumer-oriented transparency of
meaning, Gomringer and his comrades from São Paulo were only
too ready to recognize writers like Mallarmé, Pound, Joyce, cum-
mings, Apollinaire, as well as futurists and dadaists, as forerunners
of their more publically oriented endeavors. In their "Pilot Plan for
Concrete Poetry" the Noigandres group, which included Pignatari,
Augusto de Campos, and Haroldo de Campos, listed just these po-
ets as precursors in the development of the ideogram, a "space-time
structure instead of mere linear-temporistical development." This led
to their own use of a "phonetical system (digits) and analogical syn-
tax, [creating] a specific linguistical area—'*verbivocovisual*'—which
shares the advantages of nonverbal communication, without giving
up the word's virtualities." They refer to this as a "metacommuni-
cation" that reveals, or, in more contemporary usage, *lays bare* the
structure of the communication along with what it is to *signify*. This
is an example of what the group called "total responsibility before
language. Thorough realism. Against a poetry of expression, subjec-
tive and hedonistic." If there is an aesthetic, it is purely cerebral: "To
create precise problems and to solve them in terms of sensible lan-
guage" ("Pilot Plan for Concrete Poetry," 72).

Behind this spartan relationship to language lurks an almost Cal-
vinist rationality, even though the Joycean "verbivocovisual" itself has
a hedonistic, synesthetic ring to it. No subjective expression is al-
lowed within the universal language. "A general art of the word. The
poem-product: useful object." Gomringer, as if narrating at a futurist
fair had said, "Concrete poetry is founded upon the contemporary
scientific-technical view of the world and will come into its own in the
synthetic-rationalistic world of tomorrow" ("Concrete Poetry," 68).

This is a poetry that worships science, especially a behavioral

science. It is a design school language and an attempt at a non-metaphysical *writing*. Concrete poetry, as defined by Gomringer and Noigandres, in its functionally chaste state of being, aspires to a mathematical purity of comprehension. In this sense it differs from advertising, which *is* a suggestive "poetry of expression, subjective and hedonistic," even if directed at the masses. Concrete poetry is as much a measure as it is a message. It is a belief in knowing what one can say, and how to control its reception. Thus it is a personal measure that eventually allies itself with economic power.

Yet for many relatively powerless poets the rational play of concrete poetry seemed to offer a way out of the emotional and existential turmoil of postwar consciousness. As Ian Hamilton Finlay, the Scottish concretist, put it: "I should say—however hard I would find it to justify this in theory—that 'concrete' by its very limitations offers a tangible image of goodness and sanity; it is very far from the now-fashionable poetry of anguish and self. . . . It is a model, or order, even if set in a space which is full of doubt" ("Letter to Pierre Garnier," 84).

Finlay's own poems are paragons of repose and sanity. This may have to do, in part, with how he works them into the context of human habitation. He inscribes words into marble benches, stone planters, concrete walkways, the pediments of buildings, sundials and small monuments, creating gardens of verbal contemplation.[9] Even such a busily moving poem as his "Acrobats" from 1964 (fig. 9) is also a highly balanced structure, a contained kinesis. Like his other work, it is meant for a social space: "Properly, the poem should be constructed of cut-out letters, to occupy not a page, but an entire wall above a children's playground" (Williams, *Anthology*, n.p.). The pluridirectionality of this poem was anticipated ten years earlier by Gomringer's "Wind" (fig. 10; Solt, *Concrete Poetry*, 93), which reveals the fact that any wind is defined by its direction. By compelling the reader to move his or her eye back and forth across the poetic object, the poem aspires toward the movement of film; like the text, film is bound to a rectilinear plane but is also moving (us) within it. Literal examples of this "projective" parallel are Ernst Jandl's "Film" (fig. 11) and Ilse and Pierre Garnier's "Cinema" (fig. 12), in which the positioning of the repeated word "cinema" creates the illusion of light rays in a theater. From this example in particular, it is not hard to conclude that concrete poetry shared the desire for a psychokinetic response in the viewer with its contemporary, op art.[10]

Finally, a more stable, but evocative "constellation" that points to the entire gestalt of understanding, whether verbal or visual, is Gomringer's "Silencio" (fig. 13), whose center of silence, a Mallarméan whiteness, is foregrounded by the repeated word that defines it both literally and "figuratively." While based on the same principle of whiteness = silence, this is a *reversal* of the figure-ground schema of *Un Coup de dés*; the silence of the latter poem forms a virtually unbordered and infinite ground for the words that break its surface, while Gomringer's silence is carefully and rationally contained by its defining terms.

What is remarkable about concrete poetry is its almost instantaneous birth throughout the globe, with not much evidence of initial communication between artists (with the exception of Gomringer and the Brazilians). The fact that concrete poetry was a global phenomenon, however, is not surprising. Its basis in rationality is a response to the war hysteria that preceded it. Its eschewal of "human nature" is a fear of a basically corrupt and demonic, despotic power. In Germany, especially, this rationalist movement conceived of itself as, if not liberation from, resistance to mystical, biological, and nature-based prejudice. Of course, what it reveals at the same time is the emerging new international rational base—a monolithic culture guided by the scientific-technological support of multinational industry and trade. It is in this instance of international science taking over where nationalism left off, promising a glowing future, that the idea of the end of ideology took hold. This is explicitly, though somewhat contradictorily, stated by the French inventor of *spatialisme*, Pierre Garnier: "Man today is no longer determined by his environment, his nationality, his social class, but by the images he receives, by the objects which surround him, by the universe" (Solt, *Concrete Poetry*, 33). As we know, this supposed end was to be called into question in the sixties by various liberation groups concerned with the complicity of science with war industries.[11]

Due to its reductive and highly ludic nature, Gomringer was worried lest concrete poetry be seen as a separate, perhaps arcane, "genus of poetry." He was insistent that it "should not develop into a form of poetry set apart from the main tradition." He was concerned about it being construed as "merely playful," that is, it shouldn't promote a "facetious kind of poetry. Concrete poetry has nothing to do with comic books" (Solt, *Concrete Poetry*, 10). If his desire was for a

universal poetry—that is, with an immediate comprehension by all people—it was less a mass- market attempt to make contact with all levels of understanding in society and more an Arnoldian didacticism hoping to raise the general cultural level.

One reason that concrete poetry didn't take hold as a continuing *poetry* movement is that it offered very little for critics and other institutional purveyors of interpretation to work with. On the other hand, perhaps this *failure* of concrete poetry to find itself assuming the only respectable position for *poetry* in the contemporary world (as Gomringer would have had it) is a sign of its real success in other ways. It is a form of communication and visual experience that cannot be contained by the conventional notion of poetry. Indeed its stretching of the term made it go so far past the generic boundaries of what everyone thought poetry should be (definitely not part of Pound's dance-music-poetry rule),[12] that it found itself better acclimated to the visual-art world, from where it had taken many of its cues. Far from being merely an esoteric and isolated phenomenon, the effects of the practices and doctrines of concrete poetry can still be experienced today in visual art—in all its postmodern, neo-conceptual, semiotic, "commodified" senses.

In fact, the influence of concrete poetry was so pervasive in the sixties that conceptual artists had to distance *their* use of language from that of concretists, even though both displayed words on gallery walls. It's not hard to believe that concrete poetry had some effect on artists such as Ed Ruscha—how far are his one-word paintings from Aram Saroyan's one-word poems? Or Lawrence Weiner, who tends to put one or more nonsemantically connected words on bare walls, pediments, and other architectural sites (a trait he shares with concretist Finlay). The argument the conceptualists used against being called concretists involved the *conceptually* referential, nonobject status of their words. An example I can take from Les Levine, from a 1982 issue of the British *Art Journal*, is the following phrase placed in the middle of a page:

LEARN TO READ

While its meaning might seem transparent at first glance, it raises the question: Who is this addressed to? It is directed at those who evidently can't read, yet they would have to be able to read the phrase to

know that it is directing a message to them. Thus, for those who can read, it is an unnecessary message, while to those who can't, it is nothing but meaningless marks on the wall.

Can we call this concrete or conceptual? It is certainly not concrete, because not understandable, to the person to whom it is directed. And it is certainly not concrete to those of us who can read it, because to really understand its meaning we have to *imagine* not being able to read it, which removes us from the immediacy of the words themselves. Thus language-oriented conceptual art is not interested in language artworks as things-in-themselves, but rather as indicators of the social context of artistic signification. As Siegfried Schmidt put it, "In concrete poetry, there is the debate between the poet and the designer; in conceptual art there is the philosopher pitted against the artist who continues to produce a product" ("Perspectives," 115). Thus the crucial distinction in the latter debate between a producer and a critical theoretician is not there in the former debate, which is between the ideas of two producers with different means of production.

It is true that words have been used in visual art since Picasso's cubist collages and are found in various ways in the work of Marinetti, Boccioni, Max Ernst, Kurt Schwitters, John Heartfield, René Magritte, Stuart Davis, Marcel Broodthaers, Arakawa, to name a few. Some concrete poets actually did work on a large visual-art scale, such as Ferdinand Kriwet, with his *Poem-Paintings* and his *Publit (Public Literature)* (Solt, *Concrete Poetry*, 20). The word-works of more recent postmodern artists show a concrete-oriented level of deadpan (ironic?) literalism, seen in the "Truism" lists of Jenny Holzer, the "ads" of Barbara Kruger and the most recent word superimpositions in neon and marble of Bruce Nauman (such as the words *Envy* and *Hope*). I don't mean to say that concrete poetry has had a direct influence on these artists, but rather that in the emerging scene of pop appropriation and imitation of the rationalized urban landscape of the fifties, concrete poetry helped to draw attention to the new roles language was playing and the new media it was used in, which affect our sense of meaning in the world. While concrete poetry was modernist in that it regarded its products as things-in-themselves and as nonmimetic, it like other modernist art participated in mimesis, even if unconsciously. It did not do this in a content-oriented sense, but rather in an Aristotelian process-oriented

sense (imitating the actions not of nature, but of culture). Its mimetic object was not a natural system, but the rhetorically and visually oriented processes of the continuously changing urban landscape of representation.

In this sense, even *words* were not considered necessary for visual "poetry." In 1964, Decio Pignatari developed the "semiotic poem," which could use any kind of semiotic code or diagram (Solt, *Concrete Poetry*, 15). Postmodern artists such as Matt Mullican and A. R. Penck are exemplary in this practice. Even the contribution of graffiti artists who entered from beyond the pale of modernist art should be considered in this light. Their appropriation and employment of mass-cultural icons (cartoon characters, logos) are indeed "semiotic"—see especially the paintings of Ronnie Cutrone, Kenny Scharf, and the more personally stylized works of Keith Haring and Jean-Michel Basquiat. Nevertheless, what actual graffiti attempts, against the grain of the *impersonal* communicative ideal of most concrete poetry, is to establish its *subjectivity*, first of all, over against impersonal systems of commodified communications. While graffiti materializes an individual resistance to impersonal mass communications systems, it does this through adopting that very system's practice of packaging the self as personal style—as personal mythology that derives its images from mass-cultural mythologies—just like any commodity.[13] The personal, by becoming "political" in this way, only ends up joining the one-dimensional world of commodified "personality" in general, especially when its appropriations become reappropriated by the art market and media.

Concrete poetry can only approximate being a thing-in-itself by being overly self-reflexive in a visual way. No more than painting can it lose its referential function, along with the connotations aroused by its visual form. Nor can concrete poetry become merely self-identical and still somehow be language. Even so, despite the poem's unified and instantaneous nature, which seems to predispose it for instant consumability, there can be such an *over*emphasis on the literal that the word becomes enigmatic and objectlike, at once transparent and opaque. At the same time, what makes us pay critical attention to it is its institutional ground—if it appears in an anthology, art museum, or gallery rather than in street signs, advertisements, or vanity license plates.

SOUND POETRY

> We all secretly venerate the ideal of a language which in the last
> analysis would deliver us from language by delivering us to things.
> —Merleau-Ponty, *The Prose of the World*

While Merleau-Ponty seems to be speaking most directly to those
poetic phenomenologists called imagists and objectivists, and indeed
seems to point to Williams's "No ideas but in things," he points as far
as Charles Olson, who, in his modest way, says that "ONE PERCEPTION
MUST IMMEDIATELY AND DIRECTLY LEAD TO A FURTHER PERCEPTION,"
and each perception "must MOVE, INSTANTER, ON ANOTHER" ("Projec-
tive Verse," 388). Olson figures the speed of translation gets us closer
to the (experience of) things we speak about. Those poets who have
been most concerned with instantaneous perception of something not
re-presented, but instead spontaneously *pres*ented in a performative
way, creating an embodied event that was a "thing itself," have been
sound poets. These poets take seriously Olson's tracing from "the
HEAD, by way of the EAR, to the SYLLABLE / the HEART, by way of the
BREATH, to the LINE" (390), without concerning themselves with the
concomitant symbolic content.

Sound poetry, as a desire for an immediate and self-identical
manifestation, considers itself a "language of presence." Behind the
quest for this language of presence lie certain assumptions, some or
all of which are shared by the sound poetries of Italian futurism,
dadaism, and Russian futurism.

First of all, behind this language of presence is the tacit assump-
tion that it is the original, Adamic tongue, an *Ursprache* that names an
object or being in its essence, which means the signifier is one with
the signified and their relationship is not arbitrarily or conventionally
fixed. Second, because of the primal nature of this language, it can be
construed as a universal tongue, whose true nature arises primarily
from exclamation and emotional intonations that are assumed to be
universally human. Third, this emotive, intonational language is seen
as being more true for the human condition than signifying language
because its expression is that of the body, active and reactive, not
distracted by any cognitive split; thus Sound poetry is an authentic
objectification of the subject. And finally, this language should be
incantatory, summoning forth the power of presence within every

fiber and organ and nerve of the human being, uniting the spiritual with the physical, tapping into dormant and primally creative energies, and emanating outward to connect with the listener. It is a sounding of one's human space and the establishing of a resonating field, creating a harmonious sub- or prelinguistic communication between poet and auditor.

There have been various ways in which avant-garde poets have attacked the problem of reducing the indeterminacies of signifying language and bringing forth all the power and clarity of the immediate experience of sounds or words.

F. T. Marinetti, in his invention of "words in freedom" (*parole in libertà*), relied heavily on onomatopoeia. In poems like "Zang-Tumb-Tumb" he imitated the sounds he heard during the bombardment of Adrianople, and in his "script," like Mallarmé implied the relative intensities of the sounds through size of type, and their simultaneity and directionality through their physical placement on the page.

From a quite different political orientation dadaism combatted the instrumental language of modernity it associated with the political and technological catastrophe of World War I. From its "balcony" in Zurich it poured forth self-indulgent nonsense, obscenities, "primitive" chants designed to exorcise the spirit of self-indulgent complacent bourgeois authority.

> gadji beri bimba
> glandridi, lauli lonni cadori
> gadjama bim beri glassala
> glandridi glassala tuffm i zimbrabim
> blassa galassasa tuffm i mimbrabim
> (Kostelanetz, *Text-Sound Texts*, 18)

So chanted Hugo Ball in his impossible cardboard bishop's suit at the Cabaret Voltaire in 1916. He reached back to a childhood religious experience to empower him in his physically and psychologically stagestruck position. The language had external force without meaning coupled with an intensely personal self-affection. But the externally destructive nature of Dada could not be supported by its internal lack of meaning. For Ball, this route to inner freedom was schizophrenic: "Spit out words: the dreary, lame, empty language of men in society. Simulate gray modesty or madness. But inwardly be in a state of tension.

Reach an incomprehensible, unconquerable sphere" (*Flight out of Time*, 76). This solitary fortress in which one seeks an inner presence, this incomprehensible sphere, can be a prison as well, though its purpose may be to free one from the constraints of language in society. This struggle, this tension, finally led Ball into a state of monastic silence.

The dadaists' attraction for the speech of "primitive" peoples (one example is Tristan Tzara's *poèmes nègres*) is indicative of the desire for a language that is older and in a harmonious relationship with its environment, that is more concrete and more directly in touch with reality than the languages of Western societies. Admittedly this European primitive attitude was to a large extent a fantasy perhaps connected with the rage for American jazz, rather than a direct knowledge of non-Western cultures. Nonetheless it represented a desire for origin that was free of the repressive historical overlays of rationalized existence.

At the same time both the Italian futurist and dadaist use of the simultaneous text approximated the music of the period and its conflicting inner rhythms, from futurist Luigi Russolo's mechanical imitations of industrial sounds to Stravinsky's *Rite of Spring* (1913). It was a virtual pandemonium, as Milton had coined it, rebels noisily reigning in a bourgeois hell. But what of the *successful* revolutionaries?

The Russians were asking, At what point are words first perceived for what they might mean? They decided: at the level of the phoneme. As for the meaning as determined by the surrounding emotional field, whose relation to lexical meaning takes the form of a rhetorical figure-ground, the ground can be understood as *intonation*, the predication of any spoken communication—best demonstrated by Khlebnikov's phonemic poem "Invocation by Laughter." It *shapes* the lexical like clay. Sometimes the effect is resonant (when words and emotions are aligned: in anger, desire, sadness, etc.) and sometimes dissonant (when words and emotions are misaligned to somewhat self-consciously create effects: irony, sarcasm, mockery). The best liars are conscious of this and are masters at controlling the figure-ground relationship.

In the face of what has become a predominantly written and imprinted society, it seems sensible and natural that Sound poets turn to the idea of intonation as a common emotive ground from which springs individuated meaning. This development of a nonrational intonational language contains the possibility of cutting across linguistic boundaries and becoming a universal language, based on the common-

ality of the most basic prelingual human expression. This is the path the Russian futurists took, conscious of the birth pains of the Soviet Union as a consolidation of a host of different ethnic groups and tongues. The poets Alexander Kruchenyk and Velamir Khlebnikov attempted to create a "trans-rational" language, otherwise known as *zaum*. "*Zaum* is a universal art, though its origin and initial character may be national. For example: hurrah, euhoe, and so on. Transrational works may result in a worldwide poetic language which is born organically, and not artificially like Esperanto" (Markov, *Russian Futurism*, 345–46). This sentiment was still echoed in the late seventies by the Austrian Sound poet Gerhard Rühm: "The musical gestus of linguistic expression mediates itself in its emotional dimension so intensively that it is even possible to communicate through a nonverbal language between two people who do not originally speak the same language." The question then arises—would a nonverbal, intonational language be less ambiguous in its meaning than a verbal language? Rühm goes on: "[T]he more emotional the information and expression which wants to be mediated, the more unmistakable its meaning" ("Auditive Text," 12).[14] This indicates that the language of presence can only operate on the level of strong emotion if it is to be discerned or experienced unambiguously. Can there be any hope of finding *nuance* here, below the level of thought?

The irony of developing an unambiguous emotive language is that it attempts to do on a nonverbal level what logical positivists were trying to do on a verbal level—the difference, of course, being that it is "born organically and not artificially," and therefore seen as more in touch with what is basically and cross-culturally human. This "organic"—a word that Gomringer also used—language is still being sought, indicating that Sound poets may not really be the clarifiers of human expression through the pursuit of pure, affective meaning, but rather problematizers of the possibility that meaning can be pure or singular at all, although this may certainly not be their intention. And Sound poetry that is politically engaged likes to create problems, as we shall see.

LETTRISM

In the years immediately following World War II, an interart movement that worked from a basis in Sound poetry was begun in Paris by a

young Rumanian emigré, Isidore Isou (Jean-Isidore Goldstein). The aim of the lettrist movement was to intervene in and reestablish every art form—from music to painting to architecture—through the agency of the human voice and the atomization of language down to its very letters and syllables. Isou saw a need for a refurbished avant-garde, given the superannuated condition that both Dada and surrealism were in, no longer offering spirited resistance to the complacency of bourgeois ideology, becoming drawn instead into the world of fashion itself.

Isou rather vainly saw himself as the sole inheritor of the avant-garde tradition in poetry (of which he remarked only the French), being at the end of a line that included Hugo, Baudelaire, Rimbaud, Mallarmé, Apollinaire, and Tzara. To him this line represented the gradual breakdown of poetic language into smaller and smaller units, ending with Tzara's Sound poems—a historical cycle he called "chiseling," which is to be followed, after Isou's penultimate chiseling, by a new "amplic" cycle, which he also identified with the pre-Romantic era. Isou thought that his own breakdown of language into both letters and syllables had a potential for revolutionizing painting (through what lettrists called "hypergraphism," a kind of crudely fabricated cross between phonetic writing, gestural painting, and hieroglyphics), music (as the music of the body's own intonations, cries, percussive qualities, etc.), and even architecture (recalling Schwitters's collage house, the Merzbau).

Isou himself wrote volumes of theory about what lettrism could be and accomplish, but very little poetry himself. His megalomaniacal and dictatorial manner—the sole decider of who should be in the movement, how it should conduct itself, and how to get back at "traitors"—eventually made him an embarrassment and a major source of irritation to many who were first stimulated by his rhetorical forcefulness. For this reason perhaps, very little is mentioned in major texts on concrete poetry or Sound poetry about lettrism itself, and next to nothing about Isou.[15]

Another reason may have been that Isou's vision was essentially backward looking, and that in an age when a revolution in typography contained visual possibilities, and audio recording held sonic possibilities for linguistic experimentation, Isou clung to a calligraphic graphism and a purely live, choral approach to Sound poetry. Some Sound poets once in contact with, but disaffected by

lettrism, such as Henri Chopin, Bernard Heidsieck, and François Dufrêne (whose *crirythmes* were largely influenced by Artaud), went on to open up new areas for vocally based experiments in the recording studio, around the same time Pierre Schaffer was making the first *musique concrète* recordings. Other sound poets such as Jean-Louis Brau and Gil Wolman tended to retain a forcefully anarchistic nontechnological "body-sound art," a tradition maintained by Jean-Paul Curtay.

In mentioning Brau and Wolman, it is necessary to speak of the other, more impactful *political* influence that lettrism had. Isou, in his grandiose but myopic way, considered the movement as international in the possible applications of its total vision. As Chopin had noted, however, it was international only in Isou's mind, and remained a parochial Parisian phenomenon (Foster, 64). Brau, Wolman, and Guy Debord, the left wing of the lettrists, first broke with Isou in 1952 to form *their* idea of the Lettrist International, which in 1957 became the Situationist International. The aims of the SI were anarchistic, anti-work, and for the continual subversion of commodified and spectacularized existence. These ideas achieved their most coherent theoretical form in Debord's 1967 book *The Society of the Spectacle*.

But some lettrist practices were retained in modified form—hypergraphism became applied directly to already existing advertisements, comic books, and posters, in actions labeled *détournements*, turning the ideological sign system of the culture against itself, with the human figures found in these forms revealing the truth about their own ideological construction and reflecting on future possibilities for subversion. In fact, comic books, given their cheap and easy qualities for distribution, became a primary means for propagating situationist thought. Perhaps this was what the would-be social engineer Gomringer was reacting to when he said, "Concrete poetry has nothing to do with comic books." What strikes one as immediately absurd in this practice, but what also made it effective in gaining attention, is seeing simple characters from romance comics speaking the language of Marxist theory, using terms like "reification" and "commodification." *Détournement* as a rewriting of existing billboards and the use of graffiti as a critical practice had major impact in the events of May 1968 in Paris during the student riots. Later these methods would be picked up by British punk, with *détournement* applied not only to words and images, but to clothing styles as

well.[16] Today we see *détournement* operating in the visual art of ideological critique of Barbara Kruger and Hans Haacke.[17]

I've seem to come far afield from the specific practices of sound poetry per se and have circled back to concretism, but within avant-garde history it is difficult to separate out the elements of visual poetry from their sonic forms of experimentation, even as they seem to be operating in their purest states. Thus lettrist sound poetry is conjoined to hypergraphism, just as dadaist sound poetry is conjoined to collagist experimentation even to the point of architecture (e.g., Kurt Schwitters's Merzbau).

Further, within the historical movements of concretism and sound poetry there is a conflict between social *intervention*, as a subversion of bourgeois ideology—from dadaists to situationists—and social *invention*, the implicit idealism in both sound poetry and concrete poetry as universal languages—from the *zaum* of the Russian futurists to Gomringer's "functional object." This conflict can occur even within the same movement. It is not unusual for the antiaesthetic subversions of one group to become the basis for the aesthetic social ideals of another (or vice versa), whether it is Dada's transformation into surrealism's formalized psychic practices, or Dada's proximity even to future Bauhaus experimentation, or in the opposite sense, Isou's quasi-aesthetiç lettrism becoming an antiaesthetically political situationism, eventually commodified as punk.[18] It appears to me, however, that concrete poetry is much more readily assimilable to corporate ends and more commodifiable than Sound poetry, in that Sound poetry has a peculiarly corporeal character to it, at least before it is transformed through technological means.[19] In these terms, we can recall that the hieratic signs that Genet constructed in *The Balcony*, in their illusion of an eminently visible authority that conceives of itself as self-contained yet universal in scope, are not that different than concrete poems as Gomringer conceived them. Similarly, the desire to speak one's most authentic self and at the same time coincide with that speech in a transparent and full presence connects Krapp's dilemma with that of the sound poet, who realizes that the distancing factor of real verbal articulation will always prevent self-coincidence and must be sacrificed.

This then is the basic split within sound poetry: one side works toward the ideal of individual freedom from all restraints—even

linguistic—the freedom to construct one's own language, resulting in hermeticism and solipsism, a closing off of the world; the other side is the movement toward a universal emotive language that can only operate at the expense of subtlety of thought. It may be motivated by a search for political unification or solidarity, but not at the expense of individual will. "Plurality in unity" reaches its most conflicted and impossible state within these particular artistic expressions of desire. The excluded middle of these two extremes—something whose emphasis would promote coherence but if unexamined might disguise ideological conformity as clarity—is the grammatical and syntactical structure of language. The objectification of this structure can be found in the work of Gertrude Stein, while its exemplification designed for our critique constitutes the work of the Language poets.

Gertrude Stein and the Objectification of Linguistic Structure

The design that emerges from the voice and rhythmically seduces the eye is the design that Gertrude Stein chose to represent as the workings of (her) consciousness. The major questions she raised in the working out of this design were, What is the relation of seeing to hearing, sound to meaning, speech to thought, memory to perception, and finally, the relation of all these aspects to a unified self within the field of language?

What she understood is how the changing uses of sentences, paragraphs, phrases, and word choice demonstrate the culturally habit-bound nature of human consciousness in its understanding of reality. But what her writing also reflects is the momentary, atemporal state of mind of the writer as well, within the confines of her historical position. Her way out of her history-bound situation consists of manipulating her current language so that it would be difficult to situate in time, all the while creating a "continuous present."

In doing this, Stein makes no distinction between the more "objective" nature of grammar and "subjective" use of semantics. Her grammar *is* semantics. William James, in the "Stream of Consciousness" chapter of his *Psychology*, puts it this way: "We ought to say a feeling of *and*, a feeling of *if*, a feeling of *but*, and a feeling of *by*, quite

as readily as we say a feeling of *blue*, or a feeling of *cold*" (162). Stein will address these considerations of identity within time by examining "the feeling of" the part of speech, the sentence, the paragraph, the phrase, and the punctuation mark.

Randa Dubnick has drawn attention to Stein's two "obscure" writing styles: "identity" writing and "entity" writing. Stein's prose identity writing is a swirling movement of description that eschews nouns but privileges verbs and verb forms and pronouns over names, to establish as general a study of human personality as possible. The monumental *The Making of Americans* is the primary example of this style. Stein labels this identity writing because its primary concern is description of the hard-to-pin-down characteristics of human beings. This style cannot help but involve memory, as the form is processual, pointing to the progression of people's lives. It involves naming only by the use of sentences composed of simple and very general words, whose meanings are made more subtle through the insistent reformations of the sentence and within the sentence:

> Many having resisting being have it in them all their living when they are beginning and then on to their ending have it to have suspicion always naturally in them and this is a natural thing for them to have in them because they having resisting being have it in them to be knowing that always some one is doing attacking. (Stein, *Selected Writings*, 313)

The second obscure style is entity writing, or Stein's poetry, first exemplified by *Tender Buttons*. Its focus is synchronic. Stein has switched from processual identification of characters through verbs, their nominalizations, and pronomial forms to the static perception of entities through the process of naming, with nouns predominating. As she put it, "Poetry is doing nothing but using losing refusing and pleasing and betraying and caressing nouns" (qtd. in Dubnick, *Structure of Obscurity*, 138). Stein is not concerned with things per se or an sich, but rather with the *names* of things, and drawing attention to their own "thingness" (this goes for states of being and mind as well as objects). Their separation from identifiable associations render them opaque (as do the "words as things" of Freud's *Interpretation of Dreams*). Entity writing focuses wholly on the present scene as still

life, as opposed to identity writing, which is more cinematic, ever moving, even if slowly. Entity writing:

SALAD DRESSING AND AN ARTICHOKE

It was please it was please carriage cup in an ice-cream, in an ice-cream it was too bended bended with scissors and all this time. A whole is inside a part, a part does go away, a hole is red leaf. No choice was where there was and a second and a second. (Stein, *Selected Writings*, 496)

A sound-oriented, semantic expectation is defeated when we read, after "ice-cream," the word "bended" when the word blended should be the apparent choice. That "A whole is inside a part" evinces not only her continually present monadism, but Cezanne's sense of overall design. It would seem that in comprehending the sense of the poem, there was no choice where there was a choice, and even a second choice would not matter in settling on any definitive interpretation of the poem's sense; this allows it to remain secure in its objecthood.

Part of the opposition of identity to entity in Stein's thinking is that entity writing is unself-conscious; since memory is not involved, one is not thrown back upon one's memory for understanding, and therefore being conscious of one's thought processes. Instead the reader is to exist selflessly in the present and ineffable presence of language and things (a Mallarméan ideal as well). "The one thing one gradually comes to find out is that one has no identity that is when one is in the act of doing anything. Identity is recognition, you know who you are because you and others remember anything about yourself essentially you are not that when you are doing anything" (*Writings and Lectures*, 149). Existing in the present, entirely engaged with objects, frees the self of its burden of memory-inspired self-consciousness and therefore relieves it of identity.

Of course, Gertrude Stein's own identity is inextricably invested in both of these styles of writing. Furthermore, one could hardly say that she was a poet whose self-image was a burden to her. Even so, given her approach to the representation of consciousness, as well as her resistance to rewriting texts, she was true to the moment, whether it was a moment of seeing, writing, or speaking.

LANGUAGE POETRY

Gertrude Stein's writing, both as theory and practice, especially as it appears in *Tender Buttons*, has served as a primary source of inspiration for a group of poets seeking to break new ground in the seventies. Called Language poets because of their development in and around the poetics journal $L=A=N=G=U=A=G=E$, they followed Stein's lead in drawing attention to the formal and "material" structures of language itself. While most of the poets were located in the San Francisco Bay area, like Barrett Watten, Bob Perelman, Lyn Hejinian, Steve Benson, Michael Palmer, Rae Armantrout, Carla Harryman, and Ron Silliman, others resided in the New York area, like Charles Bernstein and Bruce Andrews, who were the editors of $L=A=N=G=U=A=G=E$. Most of their works have been self-published through small presses, such as Lyn Hejinian's Tuumba Press. Two major anthologies of Language poetry have been published: *"Language" Poetries, an Anthology* edited by Douglas Messerli, and *In the American Tree*, edited by Ron Silliman (hereafter cited as *IAT*).[20]

Other tutelary spirits for these poets have been Pound, Olson, Robert Creeley, John Ashbery, Zukofsky, George Oppen, and Williams, whose influence is read in the parodic title of Silliman's anthology—taken from a poem by Kit Robinson—after Williams's *In the American Grain*.

The critical writing and the poetic writing of the Language poets share certain common features. In terms of style, the poets tend to write in sentence fragments, even in their essays, as if always simply *pointing* to something, *naming* a phenomenon—which is what Gertrude Stein claimed for her own "arrangement in a system to pointing." On the other hand, many of the fragments found in the poetry tend to be circumlocutions around a nonexistent point, since they are seldom "finished" before they are displaced by the next phrase, whose alien sense shifts the expectation aroused by the phrase before.

Language poetry can be every bit as allusive as high modernist texts. It often points to modernist texts and practices themselves. Three such references are found close together in Barrett Watten's "Real Estate": "The invulnerable sentences verge on prophetic fatigue: 'What are you thinking about? Nothing!' Friction between buildings evokes celestial play: 'a man cut in half by a window' " (*IAT*, 38). The references to sentences made by Hugo Ball, T. S. Eliot, and

André Breton comprehend three different modernist practices, those of anarchistic Sound poetry, a nihilistic symbolism, and the restructuring of appearance to sever one's habitual ties to a reality already constructed for us. Yet Eliot's sense of "difficulty" is relative to Ball's "invulnerable sentences" and to Breton's enigmatic objects of wakeful dreaming. All are involved with the objectification of language, and while the lexical sense may be out of immediate reach, the objectification creates in its stead an experience, not an understanding. Understanding may come later, as it does with dreams, signs, and zeitgeists we encounter or absorb. Although I use the word *reference* here, one of the objectifying, enigmatizing strategies of Language poetry is to undermine the idea that any use of *reference itself* is unproblematically clear, a transparent medium for understanding the world it may signify, instead of an ideologically motivated construct— what Ron Silliman calls "the optical illusion of reality in capitalist thought" (*LB*, 63).

Other allusions are to poets such as Williams, Oppen, and Zukofsky. But one of the most frequent references, understandable given their theorizing about language, is to Ludwig Wittgenstein. Thus in Barrett Watten's "Relay": "But you can never get the glass out of the bottle" (Messerli, *"Language" Poetries*, 141). This responds to Wittgenstein's "What is your aim in philosophy?—To shew the fly the way out of the fly-bottle,"(*Philosophical Investigations*, 309). Carla Harryman also tweaks Wittgenstein when she says: "*I was delighted when I managed to deprive those bewitched lines of meaning*" (*IAT*, 171). This refers to Wittgenstein's famous "Philosophy is a battle against the bewitchment of our intelligence by means of language" (*Philosophical Investigations*, 109). Harryman indicates that it is "meaning" that is a spell cast over words, and once they are freed of meaning, they are once again "themselves."[21]

Throughout all the works of these poets there is a liberal dose of self-reflexive sentences: sentences about grammatical conditioning, pronouns as escape hatches or traps, the distance of language from what it seems to signify, or the phenomenological condition of the writer as he/she is writing.

This referential self-consciousness is especially true of the split between words and objects: "Words/Blame objects for lack of effect" (Bob Perelman, *IAT*, 72). "Recognition dissolves the object" (Tom Mandel, *IAT*, 214). "The voice spreads out, fighting with circles. The object

in descriptive writing is to disappear" (Barrett Watten, *IAT*, 28), and "Art instead of being an object made by one person is a process set in motion by a group of people" (30). "This special mode of address is used to captivate inanimate objects, in our sanctuary. We look at our things because they have our respect" (Carla Harryman, *IAT*, 162). "The subject relieves the object of its knowledge" (Alan Bernheimer, *IAT*, 182).

In all of these examples one can sense the worry about the denigration of the object by the subject's language—words blame objects, recognition dissolves objects, "The object in descriptive writing is to disappear" (is the object of descriptive writing that the *writer* or the *object* disappear?), "The subject relieves the object of its knowledge" ("relieves" strikes me as a euphemism for something more violent). The one statement here that isn't worried about the status of objects is Watten's idea of art as process set in motion rather than the production of an object by one person. But this is less the desire to evade objects than it is to thwart their investment by a singular subjectivity.

What is to take the place of subjectivity is the self-reflexive condition of language itself as it is being written, its "self-manifestation," and it is difficult to find a poem that doesn't engage this idea in some way. This is often done by literalizing figures of speech that deal with writing but are implicated in physical action. An extension of "materializing" parts of speech in this way occurs in Carla Harryman's "Possession":

> "I don't intend," he said, "to imitate poetry but to be imitated by it.
> "I live in a fabrication near something I have never said before I can't see my doctor and when he . . . I do see him he pelts me syntactically. My assignation burns toward abstraction. Because imperatives never blow over, get on your feet! Stumbling through this padded interstice, my body has limits. Yours doesn't compare notes." (*IAT*, 160)

This ironic literalizing of rhetorical and linguistic terms negates their force while seeming to embody it. As the body of the Language poet is engaged in an obsessive comparison of notes, the comparison is going on between a series of decentered selves, a strategy of avoiding the "reified" self or "voice" of ideologically bound academic poetry.

Steve Benson: "I can hear myself, my voice that is, in the / distance. Which of us is answering back?" or

It's
not the last thing I do to change the sentence
in the middle—my mind is so stubborn I couldn't
tell you I changed it. It resolutely refuses
to be challenged and I refuse to believe it.

(*IAT*, 197).

Michael Davidson: "Let us meditate upon the I necessary or adjacent to identity, the one the two could get along the better without" (*IAT*, 207). It is striking that what might have begun in surrealism as the relinquishment of the conscious self to unconscious writing in order to produce for the subject the greatest freedom from external forces, in Language poetry ends up being a battling of various internal(ized) and constructed selves to prevent the eventual authority of any one of them from manifesting itself. This is understood as writing's own, or language's own, production of the self through the process of writing, and the evasion of a reified subjectivity by systems of reified "reference." These market systems have produced such reification through the emphasis upon the authenticity, the true self of the "voiced" poet, usually associated with academic, confessional, or "organic" types of poetry.

Language poets claim to have no investment in a "true self," but neither would they claim to be indifferent to their readers, who they believe should actively engage in the writing process through reading their difficult, indeterminate, attention-shifting poems. Since their readers have for years been other poets in the group, the communication is hardly indifferent or one-way. At the same time, inasmuch as it becomes an esoteric movement, there are few internal incentives to avoid self-indulgent and affected gestures in the writing.

The theory, or theories, behind Language poetry may at first glance seem incoherent, primarily because though considered by many to be a movement, it consists, like most movements, of individuals with individual practices. As such, these individuals have different perspectives on what is involved in writing, and a part of their practice as well is discussing these varying perspectives with each other. So anyone who tries to generalize about a theory behind the writing does so at the risk of having such generalizations stoutly denied by certain

members of the group.[22] Yet I believe it is possible, after reading through many of their individual essays, that there are some beliefs held in common, or in majority, by the more theoretically inclined writers. The following may adumbrate the particular desires that these stances represent, whether it is possible to achieve them or not.

For Language poets, one can find a general belief in

1. A heteroglossic "self" constructed by language, but also creating itself through the act of writing, and found only there

2. All writing as enactment, "speech act," self-constitutive, a parallel structure with material processes, a physicalized thinking

3. "Language as language"—all language essentially refers only to itself. Text as signified rather than signifier

4. The "fetishism" of the referential function of language in society, and its remedy through the human act of writing that is either "nonreferential" or whose referential functioning is constantly called into question and/or subverted. This practice is to be a form of ideology critique

5. The inherent one-dimensional surface of the written page. Eschewal of any notion of psychological subjective depth in poetic meaning, which will express a unified voice that values one sentiment or idea over another in a teleology of the poem. Alan Davies: "All, or mostly surface. The subject has disappeared behind the words only to emerge in front, or inside them" (LB, 34). Instead, a multivoiced, all-over, nonhierarchical "democracy" of sense, a banalization of the profound, a making profound of the banal, primarily to demonstrate how language structures function socially and ideologically

The multivoiced problematizing of self in the poem is not new— it is the dramatistic element that Pound and Eliot both used, one to avoid personality, the other to identify with history. But what we could call the dramatistic or performative element in Language poetry is the adoption of speech-act theory to their practices. Thus it would appear that part of the Language poets' practice is to merge the constative and the performative functions of language (in other words, all *description* becomes a kind of *prescription*). This is similar to, although more blatant than, Husserl's sense of intention in any act of consciousness, even while it lacks the sense of a transcendental ego.

Perhaps it is closer to Merleau-Ponty's idea that "Consciousness is being towards the thing through the intermediary of the body" (*Phenomenology of Perception*, 138–39). The idea of body should be extended to the "writing body," in this case; this reminds one of Olson's practice as well.

Given the emphasis on *process*, it is difficult to get a true sense of the effects of Language poetry by merely quoting short sections. One must instead read it in quantity (as it is often written), to "stretch out" with it, in order to get a larger sense of its intended engagement with the reader. Such is the case with Ron Silliman's book-length works *Ketjak* and *Tjanting*, and Lyn Hejinian's *My Life*. It is true that many shorter attempts that one can read in the anthologies try for the pithiness of epigrammatic wit, but they often fall flat as stoned pseudoprofundities.

Silliman, who appears to be the most quoted representative of these writing practices, himself engages in an all-overness that seems at once stream-of-consciousness and extremely self-conscious design. His book *Ketjak* is built up around the progressions of the Fibonacci series, beginning with one line in the first paragraph, two the next, three the next, five the next, and so on. In his next book, *Tjanting*, he develops various permutations over the course of the work. The first paragraph starts with a repetition that grows and negates itself: "not this," "not not this," "not not not-this," "not not not-not this," and so on. Or, "Of about to within which what," "of about under to within which what without," "of about under to within which of what without into by." In a more immediately comprehensible descriptive sense he develops this series: "Last week I wrote 'that muscles in my palm so sore from halving the rump roast I cld barely grip the pen' "; "Last week I wrote 'the muscle at thumb's root so taut from carving that beef I thought it wld cramp' "; "Last week I wrote 'I can barely grip this pen' "; "I cld barely write 'Last week I gripped this pen.' "[23] These permutations are interspersed among a great variety of invoked references that require a wide range of intertextual competency, between high art and theory and mass culture.

Many lines of Silliman's would have been set apart by other poets as climaxes or emphasized phrases, a nice series of alliteration or assonance. In the process of equalizing them all, however, he feels free to play indiscriminately, allowing the *reader* as well to pick out moments or phrases that suit his or her own projected understanding.

Reading *Tjanting* is quite enjoyable in that I can read as much as I want, put it down, then pick it up again later without the feeling of missing something; there is no need to remember a narrative or logical continuum. Repetitions are of course reassuring, but experiencing someone else's shifts between internal monologue, the act of writing, the writer's bodily perception of the space around him, and so forth— at the same time the writing making one aware of one's own space of consciousness—has its charms. Yet for all the pleasurable mobility of Silliman's phenomenological and ahistorical sense of being-here-now, a direct sensual contact with linguistically materialized, random (access) memory, it is also a bit disheartening to realize that this is exactly how the media operates in its own self-legitimating way. It is an abolishment of the continuity (or the possibility of continuity) of personal history, and therefore the negation of the conditions for personal action (which depends upon a future possibility predicated upon a past understanding). In the long run, in front of the television, dropping the remote control from your hand, you have to wonder whether this obsessive desire to constantly shift channels or attention, this distraction from yourself, is really a fear of an integral, continuous experience of living that cannot be borne: an immense responsibility for an impossibly coherent production different from distraction. As should be clear to many by now, a personal sense of freedom in terms of directed attention or commitment is not enhanced by simply increasing the possible number of choices of distraction.

One could say that Language poets are poststructuralists who refuse to give up the materiality of their bodily lives or the world, in exchange for a mere signifying system based on difference. In fact, there is an underlying, old (but not necessarily irrelevant) desire to, if not identify words with things, then include words *as* things in a world of things, rather than simply reduce the material world to an intertextuality of immaterial floating signifiers. Zukofsky's idea of "thinking with things" still has a bearing upon the practice of writing, as does the ghost of Wittgenstein's early picture theory of language. There *is* an intertextual world here, but it has physical ramifications. Still, there are times when the world does become lost in the universe of self-conscious discourse, and it is only the occasional moments of *attention* that bring us back to reality. What is being recapitulated within Language poetry is the battle between phenomenology and structuralism. Outside of that, it tends to become a self-defeating

critique of ideology. Despite these factors, one does not have to read the poetry as simply illustrations or exemplifications of these theories, and perhaps it is better for the reader if they are not read that way. The formal attributes of the construction of any language are considered by these poets to be informed by an ideological construction of consciousness, and self-consciousness about that "always already" construction presupposes itself as political. George Hartley has in this way shown the influence of Althusser on the Marxists in the group. In a utopian sense, form in language then becomes an analogue to social formations. We have encountered this before "concretely" with Gomringer.

While the effectiveness of this use of form as political homology is doubtful, it can at least point us to the historical desires of avant-garde production. We see that the so-called end of ideology began contemporaneously with an abstractionism (sometimes called "concrete") that attempted to abolish it by evading content. Minimalism in painting and sculpture eliminates a hierarchy of (aesthetic) value. How does one do this in language?

The "all-overness" sought by minimal painting or minimal objects depends upon absolute homogeneity of surface (monochromes, grids, etc.), while the "all-overness" that the Language poets seek often depends upon absolute *heterogeneity* of surface material (phrases that have no organic connection, non sequiturs, etc.). The modern paradigm of radical homogeneity (or "purity") has come under attack by postmodern critique as totalitarian, while the radical heterogeneity of postmodernism is to be understood as a utopian pluralism. But in their absolute forms, what is the real difference between them? If it is possible to extend this to a *real* political scene, this demonstrates the usual situation of slippage between forms of anarchism and fascism. The entropic barrage of references that through their nonrelation to other references seek to minimize their own status *as* reference may be the prerequisite for an adequately comprehensible experience of the Language poem. But in a certain sense, the "objecthood" of language itself depends upon a condition of expectation for referential meaning. This expectation is frustrated, in the hopes that the word or phrase will reveal itself as sonic or visual substance, as a thing. In other words the expectation of reference forms the ground for a non- or antireferential figuration of language.

The problem with the all-overness involved in the homogeneous

surface-phrasing is that some phrases will inevitably stand out among others. Whether this is a matter of the inherent quality certain phrases have over others, or the projective mind-set of the reader at any moment, is indeterminate, although it is hopefully the latter. The aphoristic compulsion in much Language poetry is in some sense both the *source* of the fragmentary consciousness in the composition and the *resistance* of the individual phrase to its status as just another linguistic element in the poem. It is the revenge of the referent lying hidden among the foliage of incomplete referents. This resistance, which can be found *in potentio* in any of the scattered referential and pseudoreferential phrases, is what *contributes*, in fact, to the heterogeneous sense of all-overness.

Language poetry's desires lie somewhere between the objectivists' referential objectification and Stein's material objectification. For all its eschewal of reference, it is a desire to give a sense of things in the world at the same time as it gives us a sense of words as things. At its worst, Language poetry is didactic, if not pedantic, wrapped up more in lexicons (literalism) than in the world. Language is seen as the intertextual escape route from ego and so reflects poststructuralism as much as anything. Pronomial shifters are used to evade the persistence of an authorial or directing voice. Sometimes, in the commitment to this evasion, the language has a sense of being out of control, the seduction of the sound of certain phrases being too much to resist, like bad puns. Sometimes it is more "just keep talking until you say something profound," (for all the surface-only talk), not unlike the poetry of the Beats.

What Language poetry can offer us, whether we end up liking any particular poem or not, is a realization of the amount of freedom we have in using language in more ways than we assume we know, as well as recognizing the sensual, emotional tone of phrases in their various roles; anything that will serve to effectively commingle emotion and thought can only be commendable. As much as we might think that new ways of speaking affect how we feel, new ways of feeling also affect how we speak, and these latter ways need to be addressed.

Implicit in the poets' work is the idea that a truer sense of our relation to things, especially in that they are mediated by language, is better comprehended by an actively physical and affective relation to language as constituted by its material elements (words, sentences,

etc.) than by using it as a supposedly transparent medium. This can only be accomplished by using language in as plastic a way as possible, as a painter uses paint or a sculptor marble, clay, or steel.[24] This is then an "artifactualization of language" emerging as the reverse of conceptual art's "literalization of art." In terms of a liberating sense of distinctive personal involvement in the construction of texts, as opposed to feeling that one is inevitably and always only rechewing the cud of previous ideological formations, this is all to the good.

But the striving for a truth to materials in language cannot be understood in the same way as truth to paint, wood, plastic, steel, fat, felt, human flesh, or even tones from a guitar, piano, or brake drum. The term *material signifier* so often understood as the primary medium of Language poetry seems a contradiction in terms, whereby language is reduced to an objective status by its physical utterance or as marks on a page. Given that language has been effectively separated from things as a meaning structure by semiotic and structuralist theory, there has to be *something* in its nature still understood as bearing a connection to the physical world, even if it is its own material formation. For those poets interested in political economy, writing's structure or design becomes a homology for *base* in the old determining base-superstructure formation.

Language poetry is concerned with the physical determinants of consciousness and the indeterminations of describing them. Evoked and denied, placed in mediating positions, these indeterminations present a flux, a panning of the lens over a landscape of voices. The poetry strives to form a new social formation out of the lacunae of those voices, out of the unheard.

Those poets involved in ideology critique want to confound the transparency of the referent, or more exactly, its *literal* status in direct relation to the thing. They objectify language as a material signifier in order to resist its reification as unanalyzed literal referent. Their attacks on other forms of poetry, poetry that one might assume acknowledges the difference between the literal and the metaphorical bases of language, are attacks on the supposed clarity and direction of the poet's unified voice. But since Language poetry is still a poetic, productive practice, even if it purports to be analytical critique as well, it does not (or cannot) effectively *trace back* any usage to its particular ideological roots—a ruthless examination Lukács would have preferred—but can only *exemplify* or point out its ideological *status*. By engaging in critical

or theoretical discourse, as they so often do, Language poets participate in the very process of referencing they decry as reified or
commodified (in fact *reification, commodity, capitalism, history* are *all*
reifications). There is some realization of this, however, for the poetic
practice inevitably finds its way into their essays and vice versa: a
reciprocal contamination of critique and positive practice, although
some would claim they are the same thing.

As to the political nature of this poetry, what is political lies not so
much in the form or content of the poems themselves as it does in the
communicative interactions of the poets in their "talks"; that is, in the
way they have mobilized or stabilized themselves as a community. In
this regard at least they are truer to their political ideals than the
utopian movements of the European avant-garde, who, despite their
communistic fervor, always ended up with an autocratic system,
headed by such as Breton, Isou, or Debord. If there is then a desirable
form to be emulated by others as a political project, it is this system of
mutual autocritique, rather than the antireferential poetic practice itself, even though it forms the basis of this particular community.

The problem that lies in their exemplary poetic technique is not
so much its constant recognition of its ideological nature, as its failure
to specify benign from malignant *uses* of ideology for any social organization. That linguistic form is itself a signification is a parallel to the
discovery that painting could not escape an ideologically signifying
status by becoming "pure form." On the other hand, to persist in
pursuing this disruption of form itself as a key to evading ideological
determination is as solipsistic and impotent *politically* as sound poetry
or concrete poetry was. The political must not be read, as it so often is
in postmodern discourse, as simply individual subversions or challenges of ideology (even though this plays a *part* in political practice),
but necessarily, as the root *polis* implies, a collective and social effort
by willing subjects sharing an ideal or project toward a communicative goal of solidarity. By the same token, the political nature of the
Language poetry community, while it appears to function effectively
in its own context due to a shared practice, may not necessarily provide the best paradigm for any other community.[25]

While in their talks Language poets do not speak in the same way
they write their poems, what is established instead is a *dialectic* between
production and reception, that helps shape the material, if not easily
translatable, nature of their work as a resistant form. Despite evasions

of the unified subject, the formulation of enigmatic linguistic structures or poetic objects—even if seen as primarily processual, they are objects in their "material" status—is still a method of preserving oneself as a (relatively) sovereign subject in a largely desubjectifying and dehumanizing world. The only subject being evaded is the reified, commodified, and therefore depersonalized subject. The subject is liable to these forces only if it does not resist them through a self-fashioned objectification that confounds *hegemonic* ideological appropriation. The strategy of impersonalized shifting of voice and the collagist technique of multiplied and contradictory "I's" within a work is still a strategy of the subject, even if one of constant disguise.

This strategy was adopted because of the relative ease with which any unified "voice" in confessional or deep-image poetry had been appropriated and mystified, relegating the poet to the metaphysical margins of society. If one takes this personally heteroglossic strategy seriously enough and far enough in practice, however, it actually eliminates any chance of political efficacy since it has dissolved the subject into voices talking only to themselves. This, in effect, is what the capitalist media *itself* promotes, through its tremendous reduction of experience to a variety of representations at odds with one another. Inasmuch as the media operate only on a unilaterally representational, not truly communicational, level, they undermine the possibility for ethical action. Ethical action, as has been pointed out by Alasdair MacIntyre and Paul Ricoeur, depends upon a personal sense of continuity and coherence, or in other words, a narrative integrity.[26] What constitutes narrative versus nonnarrative is another matter, for even fragmented poetic discourse may carry a narrative along within its highly overdetermined, condensed fragments. As Pound has shown, through a difficult attempt at comprehending history, an entire life might be rendered as a vortex, a dynamic allegory condensed into a symbol.

Beyond this, any truly political writing is an instrumental writing. Anti–instrumental writing is actually *anti*political writing (anarchism is an antipolitics like schizoanalysis is an antipsychiatry, and both do more to challenge politics and psychiatry than critique or dispel them).

Writing in an ethical sense is an exemplary writing, even if it is exemplary of failure. All good artworks fail to communicate everything; they contain secrets of which we know little. Learning anything from them is the revelation of secrets bought by trust, and perhaps

the establishment of that trust is more important than what can be learned. Every skeptical subversion of trust in meaning structures expects trust in its own, even if it claims a position that denies structure. But it would appear that the more tangible and "material" the work, whether in a referential or material sense, the more it should secure a sense of trust from the viewer or reader.

Chapter 5

Form, Attitude, and Material Conditions

I began this study with an enigmatic object, "Suicide," by Louis Aragon, that despite its mute content presents an alarming image to those who believe in the liberating, life-affirming power of literature and the written language. The poem presents us with one possible result of fetishizing language, especially as a wholly ideal and independent structure cut off from, and cutting us off from, our material needs and desires. We see this independent status in the rows of letters, the alphabetic *order* as something "natural" and complete unto itself. After his surrealist adventure Aragon himself felt it necessary to reconnect language to some kind of effective material action, and in his case did it through a commitment to socialist realist prose. His attempt at this reconnection through an entrenched ideological structure took him perhaps just as far from materiality, if not farther, than surrealist poetry.

We may recognize this turn to realism as an artistic mistake, as putting an ideological straitjacket on modes of expression necessary for a new era. On the other hand, a mistake that the avant-garde has consistently made in its experimentation is conflating the nature of formal innovations that go against the grain of conventional aesthetic forms with politically or socially critical acts. In the long run, these formal innovations have had no trouble, with modifications, of being assimilated into an ever-more-widely-developing hegemonic culture. The shock of the new, so dear to modernist aesthetics in its desire to *épater les bourgeois*, is a fundamental operational aspect of capitalism itself: the shock values of the fashion system conjoined with technological progress in the standard of living: central features of a free-market ideology. This describes one of the "cultural contradictions of capitalism" that Daniel Bell has pointed out (*Cultural Contradictions*). It is a shift in emphasis from a Calvinist ethic of material gain coupled

with outward austerity for the sake of internal spiritual "wealth" (an idea of work as a value in itself), to the hedonistic, self-conscious outward show of conspicuous consumption: the former phenomenon analyzed by Weber and the latter by Veblen.

Unfortunately, many artists, anxious on the one hand to be innovative, and on the other hand remaining needful of instruction from those avant-garde paradigms of disruption that by now form a reassuring tradition, still believe that any new instances of formal disruption are models of efficacious social or political action. The critical support structure of contemporary culture within academia still operates in this way as well. A good portion of postmodernist critical theory functions according to the formal examples of avant-garde theories, only now applied *tout court* to social, political, and discursive models. Thus poststructuralism can promote indeterminacy or libidinal flow in the world of discursive meaning as essentially liberatory, often drawing from dadaistic or surrealist sources; Jean-François Lyotard can work from an implicit (but occasionally credited) model first developed by John Cage that finds salvation in "just gaming"; and a pragmatic pluralism operates out of the application of a collage aesthetic to the social realm. Perhaps I am mistaken in giving the artist a privileged position in this sense, since the shift in the social ground itself has helped give rise to these developments in the first place; yet it is the artist who has transposed them into resistant form.

One cannot deny the fact that the forms of social structures we inherit and live within contribute to our sense of formal continuity (or lack of), which in turn is part of imaginative production or even resistant behaviors. But it is unclear *how* those formal models of experience that artists or critics produce can be translated from the artistic realm into efficacious models for social interaction. Yet I feel it necessary to defend the notion of artistic activity as possible model for understanding cognitive and attitudinal relations with the world. The committed artist engages in such activity because, first, the process of artistic production offers moments of emotional liberation from all the exterior forces that determine one's behavior and perception of things; secondly, as the artist is aware when he or she assumes the role of a spectator of other art, there are moments of emotional liberation that are evoked by the reception of important artworks. But as emotion or physical feeling is just one end of a spectrum, at whose other end can be the most articulate kind of discursivity, this sense of

liberation points to the desire for its formal articulation, so that such possibility of liberation can be repeated. But if the framework for this possibility becomes *too* formalized, in the hope that it can be repeated exactly, it will fail when placed against the ground of a new spatial, social, or temporal context—not only fail in its repetition of experience, but with the distinct possibility of evoking a response opposite to that expected. Theater can offer a demonstration of this, in the sense that an attempt at an exactly repeated successful production of *Mother Courage*, say, can fall prey to the very cathartic reification that Brecht wanted a perpetually critical consciousness to reduce, if not eliminate.

In terms of nonreplication, then, form in an artistic or critical sense has been largely replaced by another term—*practice*. This isn't to imply that practice doesn't have a form, merely that it is seen in a more adaptive, pragmatic light—its form of resistance is at the same time a learning to adapt. The fundamental question here is one of proportion, and proportion appropriate to circumstance. That is, if one is simply and adamantly opposed to all change and defends oneself in a rigid form, one will only be run over by the forces of change. At the same time, if one completely adapts to every element of change in society, one will lose one's sense of being, and in the process lose not only freedom but the ability to think independently, sympathetically, and imaginatively. Ethical action consists of a balancing between these two states, being able to shift more to one side or the other according to context. It is analogous to the shifting center of the martial artist and, ironically, what Kleist found so appealing about the marionette. Effective practice takes upon itself a form whose proportions are particular to circumstance.

But we shouldn't find ourselves getting too nominalistically contextual and relative about all this, for the context is never so particular that there isn't a relevant history brought to bear upon the situation, perhaps determining the form of a practice of which local onlookers are quite unaware. This also means we should beware those kinds of historical relativists who will tell us that past particular events are incomprehensible to the meaning of our situation. We should never trade in temporal qualifications for spatial certitudes. By this I don't mean we are even limited by *recent* history; ancient history is often quite meaningful when we need to articulate visions of reality similar yet alternative to our own, or to demonstrate just how old a apparently new

problem can be. As Robert Smithson's work demonstrates, even geological history that exceeds human history has something to tell us about our material, environmental conditions.[1]

If the form of a practice takes on certain characteristics congruent with one's behavior over time, despite the differences in context, then one *can* say with assurance that this practice, even if engaged in producing art—but more to the point, *conditioned* by producing it in a particular way—will have a social effect. That is, forms of artistic practice will produce, consciously or not, a form of self-fashioning. So that even while Ad Reinhardt may have been opposed to using art in a polemical, didactic, socially engaged way, his own consistent practice would have conditioned in some way or other his personal approaches to the world and other people.

Yet it is difficult to see, for instance, what actual or possible effects that the textual *forms* Language poetry take can produce upon the reader in a social or political sense. This is not very useful as analogy, any more than Mondrian's idea that the intersection of vertical and horizontal lines adequately represent the meeting of spiritual and material, or body and mind. As a discursive *practice* developed among a number of different writers, the context of which includes meetings, talks, and readings designed to preserve differences even in an overall continuity of vision (but also established by difference from other, more traditional or institutional practices), one could say that an actual social, if not political, effect is being wrought by the forms of the practice.

This is why Joseph Beuys's motto became "Every person an artist!" He understood the nature of artists' responses to particular social conditions, and the possibility that the behavior of anyone who wishes to truly change those conditions must be predicated upon an (inter)active artistic relation to the world, not just an "aesthetic" reception of it—too often a mere blend of taste and status-conscious behavior. It doesn't mean that everyone becomes an artist in the Warholian fifteen-minute-personality sense. It means that people develop in their lives a strong relationship to their own material conditions—and material in a stronger than Marxist sense: actually an interactive love of the material world. The relative selflessness of the artist at work in relation to the truth of her materials must be a prerequisite for a society that is not based solely on self-interest, and somehow the elite idea of art must be expanded to include all manner of occupations and

behaviors, even while never doing away with people whose roles are primarily involved in the creation of "pure" artworks.

FORM AND IDEOLOGY

Formalism is always criticized for not taking into account social and political contexts, as if it were somehow blind to them (even while at times this may be the case). But perhaps it can be argued on the side of formalism that such is not its job. That job can be handled very well by ideology critique, which may even use the fruits of formalist labor for its own purposes of analysis (as I am doing here). In a certain sense it's a matter of scale and focus—like accusing microbiology of not taking into account findings of cultural anthropology. Ideological criticism, in spite of its "all is political" attitude (often concealing very personal needs under that heading, such as self-satisfaction and social approbation for "political correctness") cannot account for all the elements of personal stylistic variation without a distortion of ideological reasoning, which needs to operate on a more generalized scale. This is not to excuse formalist criticism for its own myopic hubris. Yet the formalist attempt at locating objective interpersonal criteria of value based on a sense of wholeness (not to be confused with oneness or sameness) is not something to disparage necessarily; indeed it can work toward something that is cross-culturally "ideological." That is, it generally aims at a sense of balance as a foundation for aesthetic as well as ethical action. This ideal of balance has been true as much for Confucius as for Aristotle, North American Indians as for East Indians, Stoics as for eighteenth-century *philosophes*. Where the sense of balance has differed has been in context as well as scope: we can see today, noting the global repercussions of local acts, how immensely the scope of one's involvement in balance has increased. The formalist project in art has been, in part, an attempt to liberate art from the tyranny of local taste—as unanalyzable or solely structured around political and economic considerations—and to produce a kind of universal standard through the formulation of problems in design and bodily relation to material, for instance. It is obvious, however, that this "standard," while working toward cross-cultural understanding, must be a flexible one—not simply wishful projection, but conducive to, and derived from, active communication—reconsidered within each ideological context.

A work of art is not inherently ideological in any pure sense. What is ideological is the use put to it by its interpreter—including the artist. By the same measure its interpretation may be ideological to some yet utopian to others.[2] Thus a work of indeterminacy by John Cage may be liberating to someone bound by a determinist ideology. For someone else it may represent a more irresponsible nature, an example of the individualistic extremes of American ideology—the Thoreauist "leave well enough alone" side (or, as the bumper sticker of the eighties put it, Shit Happens). This means that what is ideological in the work is to be found (or created) in the interpretation— actually the meeting ground of *two* ideologies: the author's and the reader's.[3]

I can offer the following characteristics of the work of one era as both ideological and utopian: as characteristic of, and responsive to that era's overall ethos. Charles Olson's poetic reductions to breath and syllable are roughly contemporaneous with Isou's reduction of poetry to letters and syllables. This atomization is a part of the desire to rebuild all of social and cultural reality with artistically reworked fragments. Olson's concern with the original materiality of small words was an etymological appeal to the enormous scale of history (and geography) typified by the term *Indo-European*. The appeal of fragmentation was expressed by Isou as "Destruction of WORDS for LETTERS . . . / Each poet will integrate everything into Everything / Everything must be revealed by letters" ("Manifesto," 72). The Lettrist International, even after its break with Isou, developed from Isou's predominantly aesthetic ideas the concept of unitary urbanism, whereby the fragments of a revolutionary critical consciousness directed at urban culture should be developed into a larger holistic vision. In a similar vein Mark Rothko had said: "The familiar identity of things has to be pulverized in order to destroy the finite associations with which our society increasingly enshrouds every aspect of our environment" (Chipp, *Theories*, 549).

The idea of shattering reality at that time—the fifties—seems, in a sense, the desire to finish the job that World War II had begun, and to destroy the remnants of *les anciens régimes* wherever they may be found, everywhere seeming to reinstate themselves, even if with altered countenance. At the same time, the expansive sense of relief and the desire to grow in an America topologically untouched by the tragic devastation of war contributed to a unprecedented sense of

freedom from at least internalized constraints. In this regard, one should examine how it is the "field" opens up in poetry in the fifties, along with visual art's increase of scale (Newman, Rothko), followed by the larger contextualizing practice of minimalism.

Art must fit the needs of its situation, as a form of (sometimes excessive) counterbalance to the excesses of that situation. Pound, Stein, and Nietzsche have variously made the point that the committed artist doesn't care what his or her age wants, but what it needs. And yet what one age needs, the next age will demand. Although I have made the point that the cult of the new that is shared by both the avant-garde and capitalism seems to be driven primarily by market mechanisms, to leave it at that may be too cynical. We must also understand that, outside of any economic system of manipulated desire, larger changes are always in effect. Demographic shifts, international and internecine conflict, liberalization as well as reactionary shutdowns, shifting paradigms within the scientific-technological sphere, ecological disasters, the rise of religious fundamentalism, or the demise of philosophical and political systems all play a part in the need for change, the need for a new vision of our material circumstances.

Because of this, old paradigms of artistic consciousness may no longer be applicable. Artists in the fifties and sixties who created works that appeared nonhierarchical in their elements, indeterminate in terms of directing meaning, and thus open-ended, so that the viewer/auditor/reader could participate in the creation of whatever meaning they wished to see there, often intended this form (or lack of) to operate as a paradigm for a truly free, democratic system of communication. It is more likely, however, that rather than operating toward a consensual structure of communication (not the same as consensus), as a democratic politics attempts, it appeals to a laissez-faire anarchism of thought, with no importance given to common interpretation whatsoever.

Here the historical context has to be taken into account. These forms emerged in a situation determined by two things: affluence and the cold war. On the one hand, this artistic approach was operating in reaction to the dead hand of authoritarianism that still held to the primacy of the work ethic, playing by the rules and climbing to the top, a dedication to a hierarchical structure of meaning against the subversive power of communism. On the other hand,

what contradicted the work ethic on its very ground was the wealth of the new consumer society, and the relative security in which everyone could engage openly in interactive games, and where the biggest enemy was boredom.

Yet it seems that by now the desirability of the open over the closed, the indeterminate over the overdetermined, and process over product have become unanalyzed doxa on the part of theorists, critics, and artists. There is thus no dialectic operating between these terms at all, but rather a Manichaean split in value. It is possible that the radically indeterminate open forms may actually tend to close themselves off from the possibilities of interpretation. Even the Chinese box levels of (un)reality in *The Balcony* seem as much to fatalistically close in on themselves as open up to the reality of the audience. It is actually drawing the audience into its own trap. Besides, the debate over closed versus open texts after the skeptical space created by deconstruction's radical hermeneutics seems a useless one. After all, what does this method of reading indicate but that there is no such thing as a closed text? (The penultimate polysemic example of this is Barthes's reading of Balzac in *S/Z*.) On the other hand, what must be shown is that there is no such thing as a radically open text either, especially given the nature of the hermeneutic circle. This is not to deny differences of degree between forms that seem more open and more closed than others.

Is an entirely processual, indeterminate, and "open" form of artistic (anti)politics needed to address the problems we all hold in common today, but aren't sure how to act on? We no longer live in a culture of abundance. Given the way multinationals, and we as obsessive consumers, are busy depleting resources and destroying the basis for our existence, would a "let be" policy be best? Given the rapid decline of the economy and the creation of a massive underclass, wouldn't "just gaming" appear as an incredibly bourgeois, if not aristocratic, indifference to suffering?

We should understand that while dissemination, freeplay, and indeterminate games of chance have quite effectively and importantly revealed to us how the standard categories in the world are breaking down—whether political, aesthetic, ethnic, national, or economic—and breaking up into new identities within what will have to be understood as a global pluralism, it does not necessarily mean it is an appropriate state of mind to maintain at every level. We are discover-

ing that ecologically, at least, we live in a closed (even if continually changing) system, and to try to carry on as if it is a system open to all manner of playful expenditure at the expense of rather fragile material balances is pure folly. The number of choices we can make is being drastically reduced. The ground of legitimation for new modes of behavior or creativity may quite literally be the ground we exist upon. What we may be experiencing in the "infinite" discursive freeplay of poststructuralist theory is the last fling of an avant-garde whose sense of being, while initially something other, ends up as only the constant subversion of what it sees (and sometimes helps construct) as authoritarian and conformist ideologies. On the other hand, the immaterial playground of language still offers for those addicted to the liberation of pure self-affirmation (in the disguise of subjectlessness)[4] a space distinct from rapidly growing material contingencies. But the party will soon be over.

The dubious value of deconstruction's notion of (interpretive) freedom is in line with the often equally dubious American notion of freedom: maximum freedom of choice. That idea of freedom is derived from the ideology of abundance behind the imagination-exploiting market strategies of laissez-faire capitalism. Thus the maximum freedom of interpretive choice in a world of indeterminacy creates the sense of an incredible arena of freeplay. The only thing that isn't assured is the impossibility of boredom created by this very open field—something the situationist critique of the spectacle emphasizes. Unlimited options are always limited by our attention span, our sense of continuity—in other words, our sense of being, which despite all attempts at such exteriorized consumerist distraction from our existential predicament, will now and again break through in the form of silence, emptiness, inexplicability, frailty, anxiety.

Of course what is lacking in this idea of freedom—which because of this lack rapidly turns into freedom's internalized opposite, addiction—is the idea of self-mastery. Paradoxically, addiction itself is a misguided attempt at self-mastery, derived from the very desire to consistently repeat an *externally* induced experience that initially created a sense of well-being. *Internal* self-mastery, of course, is the Eastern (but also early Greek and Stoic)[5] concept of freedom. The control of the outside world means nothing for one's sense of being if one cannot control one's own nature. The body performance (endurance) art of Abramović and Ulay, Linda Montano, Tehching Hsieh, Joseph

Beuys, Stuart Brisley, Chris Burden, and others exemplifies this idea in often extreme ways. The manual repetition involved in the productions of visual artists, such as Ad Reinhardt, Frank Stella, and Sol LeWitt may also be considered as a form of mental self-discipline.

On the other side, the control of the outside world can become an excuse for lack of self-control and may even turn into a disastrous projection of this lack of self-control (as we see ecologically, or in the uncontrolled death trips of rock stars). Unfortunately, and despite Freud's reservations about the notion of releasing oneself from the "repression" of self-control, the influence of psychoanalysis or psychotherapy, in a broad and vulgar sense, has spread the gospel of releasing self-inhibition as a means of realizing one's authentically free self. But one cannot do this without reaping the consequences, either socially, or in a personally physical sense. Thus a false dialectic is set up between expression of desire (which is largely socially produced, even while socially prohibited) and its repression (for the good of the community), and one side merely perpetuates or exacerbates the anxious expression of the other.[6]

Art as a form of cognition, and as a paradigm for ethical relations to the material world, will soon find it necessary to move beyond the paradigms of Duchamp, Cage, and Warhol as they have been handed down to us—necessary as they might have seemed in their time—if it is to play a part in the material world's survival or regeneration, materially and spiritually, or rather, materially, therefore spiritually.

The question of form in art as a method of redirecting consciousness, and in a revolutionary sense, social consciousness, is a complicated one. On the one hand, I have been critical of the consistent mistake of making simple arguments for directing social and political consciousness through an isomorphism of artistic/aesthetic forms and utopian social forms. This is true whether of harmonious Bauhaus designs; Mondrian's perpendiculars; Malevich's color symbolism; abstract expressionism's visceral impact; minimalism's creation of spectator self-consciousness; Cage's indeterminate participatory ethic; Brecht's alienation effect; Artaud's cruelty; concrete, sound, and lettrist poetry's atomistic "universalism"; Language poetry's "material signifier" and disruption of reference or semantic hierarchy; and on and on. This isomorphic reasoning is incomplete as is. Part of the reason for its incomplete character is that all these forms only operate as such within the privileged space of art. The idea of their being

instrumentally efficacious outside of art through the influence of their exemplary forms upon the operations of social structures falls prey to what Whitehead called "the fallacy of misplaced concreteness" (*Process and Reality*, 10). Even the frustration experienced by antiformal artists who wish to disrupt art into a process that will be undefinable or unfetishizable—"more like life"—comes about because they are still operating within art, or their work is defined over against the ground of art—and art, above all, is a formal mode of perception. At the same time, ideology as well as its critique, and behavior in all its manifestations, have formally defined characteristics; otherwise they would be wholly unidentifiable, and not worth thinking about, if perceivable at all.

Yet, if this idea of formal transference from one realm to another is really a mistake, what accounts for the persistence of the belief? Perhaps it persists because on the level of the individual artist's *experience* of the material of her world, and the ethical/aesthetic (or anti-ethical/antiaesthetic) stance developed through the *act* of creation (or creative destruction), a sense of freedom obtains (yet one not opposed to an understanding of necessity), whether the act seems disengaged and conceptual or expressively worked through: leaning on the power of the word or the power of the deed. The artist then desires that the reception of the work recapitulate this engagement in the viewer, who will go on to reproduce that sense in his or her own way.

While reticent about making any political claims for art itself, I must ask: how is it, and *is* it, possible for the formal investigations of art to have a real effect on personal attitude toward the material world—that is, as it consists of both people and things? If indeed such a thing is possible (that is, a change of consciousness), only then one might be able to consider its effects in a larger political sense. Thus the question truly begins as a materially aesthetic-ethical question. To say that political ideology is at the root of all ethics is only an evasion, for the Marxist and the capitalist relations to the (nonhuman) material world have always been fundamentally the same, led by technocratic and utilitarian ideals.

If one rejects the argument of the latent translation of the experience of creation to reception and concentrates solely on the "objective" effects of the artwork's formal properties, difficulties arise. A simple one-to-one correspondence based upon a picture theory understanding of the relation of the material form of art and the social forms

of its context is inadequate. As I have mentioned, however, it may often be the case that the very forms that avant-garde art promotes as a resistance to capitalist structures are the very forms those structures take, or are beginning to assume, so the prescriptive nature of artworks may in fact be unacknowledged or unconscious description. As Franco Moretti puts it: " 'Open' texts contradict and subvert organicist beliefs, there is no doubt about this; but it remains to be seen whether in the past century the hegemonic frame of mind has not in fact abandoned organicism, and replaced it with openness and irony" ("Spell of Indecision," 28). If one works within a reformist consciousness (as, say, the Bauhaus), this is not something to be overly concerned with, as it might very well demonstrate a progressive movement even within capitalism itself. But if one operates with a revolutionary consciousness, which views such assimilation as a form of repressive desublimation that must be entirely overthrown, it presents a difficult dilemma for the activist artist. The inadequacy of the picture theory, however, is its static nature, as well as its lack of dialectical leeway. *What* is a projection or reflection of *what?*

The shift from object to dynamic interactions, from stasis to kinesis, from singular typifying gesture to performative indeterminacy, from product to process, can be read philosophically and linguistically in the light of Wittgenstein's shift from a picture theory of language to one of use, family resemblance, and language games. That is, it is a shift from the determinacy of spatial description to the relative indeterminacy of temporal and mutual interactions. The conception of language games, with an emphasis placed upon meaning as *use* might be more beneficial in many ways, and in fact provide a dialectical approach within any social and historical gestalt, without denying the nondiscursive material basis of that gestalt, which should align us to a greater degree with our environmental responses and responsibilities. For all this, the former theory, the ghost of that material basis, the former "object" status of the theory or artwork is still contained within the latter "deobjectifying" practice and actually forms its ground, even if negatively. Just so, the objectifying practices of both phenomenology and structuralism constitute the framework for the deobjectifying practice of deconstruction and poststructuralism, forming a symbiotic, if not parasitical, relationship between the two.

Obviously, the fact that I have concentrated on the material nature of each of the three arts I have covered—visual art, performance,

and poetry—even while demonstrating their bondedness to significa-tion, means that I have some investment in the idea that form *can* affect and direct consciousness in some way. I hesitate to make too much of a theoretical case for this, or to point the way out too clearly—merely gesturing toward a possible shift in attitude toward materiality—because of the tendency for the theoretical to eradicate this path in its very urgency to clear it for us. I have indicated that there is no form that in and of itself can maintain a universal status as liberatory or life affirming outside of its context. The purpose of the figure-ground heuristic was to demonstrate that certain eras, or even certain areas, demand a particular kind of form to balance the exces-sive properties of their cultures, whether it is a repressive, overly ordered environment calling for indeterminacy and freeplay, or a cha-otic (though not for that reason necessarily unrepressive) desub-stantialized situation filled with internal strife calling for a sense of order and material security. The fact that both types of artistic form might exist within the same era might not be as contradictory as one thinks, given the often mercurial nature of circumstances within con-temporary life.

THE SUBJECT AND ITS SENSE OF BEING

Within modernism, the enigmatic nature of the pure object of art is but the manifestation of the artist's desire to exist forthrightly and coherently and yet retain a private essence, inaccessible to interpretation—that is, appropriation. The reduction of the private sphere in the twentieth century and its assimilation by the public realm has been documented and discussed by many. Richard Sennett speaks of it in regard to the loss of "masks," or "the actor without a role," in interpersonal relations, the loss of a civility that protects the privacy of the individual (*Fall of Public Man*, 267).

The dissolution of privacy is at the same time the dissolution of the notion of authenticity. This may be in part because contemporary verbal communication between people, between personal bodily un-derstanding of experiences, carries with it doubt about the adequate or true nature of the means of communicating that material experi-ence. In other words, conceptual investment that is only communica-tive in an abstract way or that cannot evoke that physicality, that lacks the component of what is personally and bodily understood in a

singular and empathic way, cannot help but fall prey to inauthenticity. And given that conceptual investment believes itself (as the linguistic or semiotic basis of consciousness) to be the only basis for experiencing or comprehending reality, it tends to proclaim everything as inauthentic. This philosophy's only difference from Platonism is a disbelief in ideal models, even while it rather cynically trades in them.

The advent of conceptual investment in art coincided with the questioning of subjective agency as a substantial force in society or culture. The existential era was the apogee of the subjective and the end point of expressive labor as an adequate basis for art. As the phenomenon in its purity succumbed to semiotics, in all its indeterminate and context-bound structuration, so the subject found itself another sign among signs, whether in the novels of Robbe-Grillet, Butor, Burroughs, Pynchon, Barth, and Barthelme or in pop art, absurdist theater, or field poetics. Where once Simmel saw the object passing out of the subject and back into it again (subject-object-subject), Sartre saw it the other way around—the subject as the median point for objective forces (object-subject-object).[7] This reflects Marx's description of the relation commodity-money-commodity as one reversed by capitalism to money-commodity-money. The object, within modernism the projected refuge of the subject, now becomes the source of the subject's demise, as it enters into *la système des objets*. In the era of conceptual investment, even the object is no longer the same. It is reduced to a sign, in the same way Pound viewed symbols in the last century as reduced to mere counters. In that every signified becomes just another signifier, the signified, whether subject or object, loses its substantiality in the process.

The drive toward objectification, or the self-identity of the art object—which is the striving for the absolute unity of form and content—far from engaging in the antimimetic drive it claims to be doing, actually operates mimetically one level higher, but in such a way that that mimesis is not immediately apparent. It becomes more apparent, however, as time passes and we can see these attempts historically. The mimesis implicated in abstraction is not one of external *content* represented in the artwork, but is rather a structural or formal mimesis of the *predicament of the subject* in a world that threatens its subjective status, a kind of metamimesis. Paradoxically, the subject can preserve its own status only by the preservation of the object that forms its

defining ground, the nature of the particular subject-object split acting as a prerequisite for articulable consciousness.

In this sense the defensive posture of Mallarmé's symbolism in its withdrawal from the real world into an enigmatic one and the defensive posture of minimalism in its literality are not too different (even while contexts and effects are). Maurice Berger has pointed to the significance of the scale of Robert Morris's sculptures (fig. 14): "[T]he body was the ultimate target of their phenomenology. For Morris, the new sculpture was not so much a metaphor for the figure as it was a parallel existence, sharing the perceptual response a viewer would have toward the human body" (*Labyrinths*, 50). Within what would seem to be a counterexample, Robbe-Grillet (an influence on Morris), in his attack on Sartre's humanist prose as too "anthropomorphic," viewed the task of the writer as being "to record the separation between an object and myself, the distances pertaining to the object itself (its *exterior* distances, that is, its measurements), and the distances between objects; to insist, further on the fact that these are *only distances* (and not heart-rending separations)" ("Dehumanizing Nature," 377). Yet, as is evident to anyone familiar with his novels, the very distances carefully delineated in his prose are always revealing the human character that *seems* to be missing; this is because all forms of measurement and scale can only be developed and understood in relation to the human body and its externalized desires: what could be more anthropomorphic than that?

I must make clear that my acceptance of a subject-object split within aesthetic contemplation does not mean I am on the side of a disengaged reason whose contemplative distance is the basis for deciding what *instrumental* use to make of the object. Rather than a simple projection of desires (or needs) onto the object, as in the latter case, one must find within aesthetic contemplation of the object the way in which the object situates the spectator, auditor, reader within *its* world—so that, paradoxically, the art object is granted "subjecthood." As Peter Sloterdijk views it, "Artists and eroticists live under the impression that the things want something from them rather than that they want something from the things, and that it is the things that entangle them in the adventure of experience" (*Critique of Cynical Reason*, 360).[8] Unfortunately, too often the desire to break down the distinction between subject and object,

the understandable desire for wholeness, comes from the subject and results in the appropriation and consumption of the object by the subject. The latter's ideal of nondifferentiation masks a wish to be omnipotent. One must consider, rather, how to give oneself to the nonsubjective world as object.

At the same time, one must be wary of the claims of artists that their practice is an always adequate means of escaping the bonds of ego (whether they are Duchamp, Olson, Pollock, Cage, Warhol, or Grotowski). Any intentional attempt to escape ego only embeds one more inextricably in it. This is something that has been obvious to Eastern spiritual disciplines for centuries, especially Buddhism, which rejected the most extreme egoistic antiegoistic asceticism of Hinduism, understood even in the religions of the West as "spiritual pride." Beyond this, the dismissal by critics of intuitive, extrarational practices as "mysticism" only illustrates the limited understanding of thinking bound by grammar (as some Language poets suspect), or (lest those poets feel too satisfied) even that bound by the instrumental "subversion" of grammar, the structure of whose practice is still determined by its enemy. In other words, rationalism's dismissal of other ways of knowing and their quite adequate methods of directing one's ethical and material life is a denial of any experience that cannot be contained by the ego, even while in its own intertextual idealism rationalism seems to deny the ego. This includes the postmodern anti-Enlightenment that appears to be anti-rationalist.

The notions of responsibility and reform are predicated upon the separability of act from actor. To identify an artist's work entirely with the artist denies the artist the freedom of her acts. On the other hand, to deny the artist agency, by calling her merely the "instance writing," as Roland Barthes did in "The Death of the Author" (*Image-Music-Text*, 145), is to also deny the artist freedom by removing all responsibility from her acts. In this sense, the desire for absolute identification of subject and object—or elimination of either or both—can lead to the evasion of personal responsibility within the social or natural world.

In my examination of modernist objects, I don't mean to imply that the artistic intention is necessarily always one of giving oneself to the object. The drive to create objects that displayed their objecthood was oftentimes not so much to create an impersonal and therefore collective and communicable plane of ideas, but rather a drive to

reveal the subject as the master of form, a unique way of speaking based on what one's perception selects from the world. Stein's continuous present can as much be read as an extension of subjective control over all of reality as the unself-conscious engagement of being in the present. Since it excludes change, progress, or history, it excludes the social as what is outside the infinite *durée* of the inner self, to invoke Bergson. The personal use of history by Pound is a similar case.

It is in the act of artistic creation, however, that the two modes of contemplation—rational and object oriented (situational)—actually come into dialogue. One should never assume, because of the often virulent antagonism of artists to instrumental reason, that instrumental reason plays no role in the creation of the artwork. Rather, it functions symbiotically with the artist's "situational" contemplation in the creation of the work. It is true that the balance of roles varies, so that reason may be given priority in some cases (in the classicism of Mondrian, Newman, Sol LeWitt, the later Eliot, the later Brecht, the later Beckett, concrete poets), or the priority of the object's subjecthood—its material truth—may come to the fore (the romanticism of the surrealists, the abstract expressionists, Artaud, Grotowski, Sound and Language poets).

The subject-object split, demonstrating to artists and philosophers the seemingly irredeemable nature of the individual's alienation from the world, is not necessarily a problem if one shifts one's attention and asks what might be its possible *value*, if allowed to be what it is, or on the other hand, asks what would happen to consciousness if it *were* overcome. The desire to overcome this split even within oneself, as I demonstrated in my discussion of *Krapp's Last Tape*, and the absolute ferocity with which, because of continual frustration, it is undertaken, becomes in effect a death drive, creating material and bodily degradation in the quest for absolute integration of consciousness and memory, the transparent unity of thought and its origins so painfully sought by Artaud. This illustrates the voracious consumption of the object by the subject.

On the other hand, as I hoped to show in my discussion of Genet's *The Balcony*, the will to absolute objectification of the subject, which is an externalization—a projection of the subject into the preserve of its own creation, its own object—is a desire at once for personal glory (immortality) and personal inaccessibility—the impossibility for

others' appropriating one's self through interpretation or critical acts. This also ends up involving the death drive, since it is only the dead who are (personally) inaccessible and immortal.[9] The created object resonates in the overwhelming silence of these two qualities.

One can say that art participates to a lesser degree in both of these drives. I have concentrated on the latter, more modernist form of inaccessibility, from the monuments of Mallarmé to the primary objects of minimalism to the publicly displayed privacy of body artists and the "private languages" of sound poets and Language poets. Nevertheless, Krapp's obsession strikes me as the reigning contemporary paradigm, pointing to the drive toward all-inclusiveness within both poststructuralist theory and postmodern culture, inaugurated by conceptualism, whose continual recontextualization of the object dissolves it into language, and the regime of information.

Demystification

The shift from expressive labor to conceptual investment is but another level of *demystification*, a drive to see things as they are, seeing through not only determinant rhetorical contexts, but also through the naturalism of forms; the demystification of the latter leads right back into rhetoric. A sometimes fierce dialectical confrontation of rhetoric with its physical basis can be located in the theater.

The labor-intensive nature of naturalistic acting à la Stanislavsky constitutes the expressive-labor side of theater. The conceptual-investment side of acting begins with Brecht, whom one would suspect is devoted to labor, if anything, but whose formulations for a critical art form can only be approached from a reflective and conceptualizing standpoint. Grotowski, inasmuch as he was influenced by Stanislavsky and Artaud, is *hyper*naturalistic, at the end point of expressive labor, pushing it into the conceptually invested territory of the problematically authentic. After such instances as the Living Theater's use of real junkies in Jack Gelber's *The Connection*, conceptual investment is further developed in the life-art problematizing of early performance art, or eventually becoming codified in the highly stylized signifying practices of Wilson's Theatre of Images (an autistic young man as determining force in composition) and the Wooster Group (the cast tripping on LSD and formalizing that experience on tape and in rehearsal).

Conceptual investment in theater consists in drastically separating the constituent elements of theater: its artifice (Brecht) from its experiential nature (Artaud)—both sides having an influence on performance art that radically theatricalizes "real life," as Spalding Gray does with his own biography, or else radically realizes a formal construction of life, as was the case when Tehching Hsieh and Linda Montano were bound together at the waist by a length of rope for a year without touching each other. Both performances are forms of demystification: one through public confession, the other through the discipline of constant mutual surveillance.

As to the radical unveiling and self-conscious use of artifice, epitomized by *Verfremdungseffekt:* are the conceptions of Brecht's theater still appropriate for the needs of today? What becomes of a demystifying technique if that technique becomes mystifying in itself? When does demystification simply become obsessively regressive within the politics of representation (or the representation of politics), and lose sight of the material necessities of other forms of human involvement?[10] Every demystifying practice carries with it its own mystifying technique. The more regressive the mystification by rhetoric becomes, the more violence is needed to bring everything back to the level of corpo-reality, as it would seem from the work of Brecht's heir, Heiner Müller, especially his *Hamletmachine:* "When she walks through your bedrooms carrying butcher knives you'll know the truth" (58). Violence in this sense emerges less from the fight for basic bodily needs, and self-determination in dealing with those needs. It emerges, instead, from a stultifying deanimating despondency created by a passive, if not masochistic, relation to a spectacularly administered reality (to conflate Debord and Adorno) that instigates a loss of the sense of being. Violence becomes the reaction of the body to a system of immaterial stimulation, and to the perpetually unfulfillable desires created by it. Anything that *simply* encourages new ways of watching that reality, even "critically," does nothing to materially alleviate the situation, and may even encourage its growth. What is needed is the creation of an alternative to the reception of ephemeralities altogether, a redirection of focus toward the more gradual movement of material conditions around us.

Kant considered the basis of ethics as seeing human beings as ends in themselves. When the material means in art are understood as ends in themselves, artifice is not taken for granted by the artist as

an adequate rhetorical or semiotic expression of other aims (moral, religious, nationalistic) but is exposed for what it is. Yet in the process of self-discovery it either disappears or (more likely) is pushed farther back into a larger field of artifice. For performance, this raises the question, how can one demystify the body? Demystification as a materialist tool always means an appeal to some kind of nominalist thesis of historical or social contingency, leading to how such-and-such or so-and-so was "constructed." While the body might *seem* to be only "a body" or "bodies," the more particular the body is that is "constructed," the more difficult it is to describe it in toto; *as a defined quantity* it tends to disappear, once it is examined at length. Likewise, there comes a point in the materialist demystifying of human nature and its constituents (creativity, will, imagination) where it would seem to do away with altogether the very subject of its project—human beings and their liberation.

While the adoption of a hermeneutics of suspicion may be a necessary development in the formation of a political and (sometimes) performative efficacy, one should also note the deletorious effects that a complete adoption of this attitude might entail. An obsession with continual demystification produces a desiccation of the spirit that can lead only to a cynical evasiveness of life. In a hopeful fashion, forms of this evasiveness are sometimes called "strategies of resistance." But they may also tend to resist, or at least deny, the life within, which has fewer qualms about affirming illusions or realizing them in various ways. Demystification of the body's knowledge of the material world can end up a mystification of the mind's inadequacies, especially when the implicit comparison is between a theoretician and a practicing artist, or practicing farmer or carpenter, for that matter.

On the other hand, the belief in the truthfulness or clarity of perception of the physical world by the poet has been a particularly American assumption, integrally related to a kind of pragmatism, a desire for a freedom from ideology, getting down to where the "real folks" live. It is no attempt at a value-free phenomenology, but rather an attempt at adducing values from "things" in the course of following a phenomenological method. A hermeneutics of credence, not suspicion. If the uncritical logic of this ideal is carried too far, it finds it easy to accommodate itself to the forces of reaction, the spell of ideology-laden common sense and the spell of narrative.

In modernism the narrative logic of the story or the "event" de-

picted in painting or performance was forcibly displaced by the synchronic technique of collage, the effect of simultaneity. The emphasis on simultaneity displaces any notion of cause and effect, and therefore of any continuity that can constitute an ethic (in the sense that Ricoeur and MacIntyre speak of). The emphasis on the new and the displacement of the old through the forgetfulness bred by constantly elicited and partially fulfilled desires has dismantled a historical consciousness that allows for effectiveness and integrity in producing a groundwork for personal ethics. The continuity sought in producing perdurable objects that resist change may represent a desire for personal continuity (sometimes in the guise of an amoralism), but as long as the object remains disconnected—defamiliarized—from its ground, whether historical or social, it succumbs to the commodifying processes that sweep up everything unrooted in their path. While collages seem much more like objects than stories do, one must recognize any narrative as an object as well. Particular stories can take on a talismanic quality for people in time of need—allegorical reassurance whose shape or glow alters within the light of whatever particular context it is invoked, but which retains its core, repeatable—because never wholly consumable—value. Such was the nature of Scripture to a former age, but we in this secular age have our own Scriptures as well to fall back upon, whether we call them Literature, Philosophy, or Theory. But when we reduce the world to a structure of occurrence governed by this talisman, instead of being unveiled or revealed by it, we have fetishism.

REIFICATION AND FETISHISM

First of all, what is the relation of the fetish to reification? Any idea can be reified (indeed *must* be reified to be useful). Reification of an idea is inevitable if we give it a name. Thus all concepts, such as history, technology, material, society, language, even reification itself, are reified the moment they are used. They have to be, otherwise the very structure of communication of these ideas breaks down under endless regressions of contextualization, generally unaccomplishable due to language's arbitrary relation to things.

So reification per se is not the problem. The problem is our loss of control over its almost independent development, even while it seems to be serving us (like technology itself). Reification must be put

into balance with its material, specific, concrete other. Strangely enough, it appears to take a symbolic process to do this. But the symbolic process must hold itself aloof from mere instrumental use as well—it must tap into unconscious comprehensions as well as point to a transcendent capability (i.e., unconstrained by specific conditions). It must have a trace of an enigma at its core, even while it may be clear (for instance, as allegory) from the outside. It must involve a "system of pointing," and for this it must show us how to see things, even a slight movement against the underbrush. To accomplish all this, "The poem must resist the intelligence / Almost successfully," as Wallace Stevens put it ("Man Carrying Thing").

Where an idea moves from a merely reified state to a fetish is the point where the thinker or artist forgets its provisional status as a useful heuristic or guide in understanding something. Instead, the idea or concept is hypostasized to the point of assuming that all things must necessarily relate to *it*, rather than the other way around. The concept may not even have to be that clearly delimited for it to be fetishized—it could be History or it could be Writing.

Fetishization of concepts may be an inevitable and perhaps necessary horizon for the possibility of use in a limited reified sense, even while it must be avoided. In this regard, it is interesting that experiences that seem to take us beyond language, or language's ability to properly circumscribe or define those experiences, are generally dismissed as fetishistic and mystical, and unworthy of intellectual contemplation, since they *resist* such reified contemplation. At the same time, this is what thinkers are constantly (even if unconsciously) trying to do, even while proclaiming their prisoner status in the *mise-en-abîme* of language. The hypnotic fascination with one's own entrapment by language is indeed the fetishized and mystical one, taking "signs for wonders." Thomas Merton pointed out that even St. John of the Cross counted his mystical experiences—whether of immense dread or rapture—as nothing, as *blockages* to the way to wisdom (*Zen*, 77). In a Western rational sense fetishization of concepts is indeed such a form of blockage. Even art, as most conscious artists know, as a historically hypostasized concept can prevent important future work and understanding from being realized. This is why Kosuth insisted that important art is that which alters the definition of art, even while perhaps fetishizing the concept of art-as-definition.

When human beings had a more cohesive and integrated relation-

ship with the landscape, much of what one would call thinking oper-
ated through ritualistic gestures that were a form of conversation with
the physical world. In other words, thinking was a form of bodily
activity within the world and within human society as part of that
world. What we (in an anthropological sense) call "fetishism" is in fact
a locus of thought, a leading idea, eidos, in material form. The irony
of the notion of the fetishization of an idea or concept—taking as
materially real something "essentially" abstract and immaterial—is
found in the developmental sense that that immaterial idea once *had
its origin* in a material "fetish." In this sense, Williams's line: "Say it:
no ideas but in things" resonates clearly within the material field of
thought, a field through which I should now like to lead the reader.

NOTES TOWARD AN ECOLOGY OF REPRESENTATION

I would like to tentatively describe what I have written so far as "notes
toward an ecology of representation." It is no doubt obvious that my
inspiration for this phrase is the title of Gregory Bateson's collection of
essays, *Steps to an Ecology of Mind*. The inspiration, however, is more
than just in terms of his title. I have drawn my notion of the artist's
cybernetic loop with the work from a conception of Bateson's. His
idea of "mind" operates, not as a self-deluding projection "into" dead
matter that works for the benefit of human ideas and desires by being
mechanically operated upon, but incorporates matter *and* human
thought into a symbiotic whole of which humans are only a part. As
he put it,

> [A]s you arrogate all mind to yourself, you will see the world
> around you as mindless and therefore not entitled to moral or
> ethical consideration. The environment will seem to be yours to
> exploit. Your survival unit will be you and your folks or conspecif-
> ics against the environment of other social units, other races and
> the brutes and vegetables.
>
> If this is your estimate of your relation to nature *and you have an
> advanced technology*, your likelihood of survival will be that of a
> snowball in hell. (404)

The "survival unit" of which he speaks is derived from a mistaken
Darwinian notion that this unit consists of either the "breeding

individual or the family line or the sub-species or some similar homogeneous set of conspecifics" isolated from the overall life of its environment (451). Bateson, on the other hand, maintains that "the unit of survival is *organism* plus *environment*" (483). The separation of culture from nature, the belief that nature is only brute matter to be manipulated for the benefit of the human transcendence of material necessity, as much a cornerstone of classical Marxist thinking as it is of liberal utilitarianism, is a profoundly anthropocentric blindness.[11] Bateson goes on to say that organism plus environment *"turns out to be identical with the unit of mind"* (483).

Bateson identifies certain stages as the identification with, and separation of, human thought from the mind field of the environment. He understands the metaphoric application of the system of natural processes to human society as "totemism"; the human being "took that empathy as a guide for his own social organization and his own theories of his own psychology" (484).[12] Next, the process was reversed and aspects of self were applied to the natural world: "This was 'animism,' extending the notion of personality or mind to mountains, rivers, forests, and such things" (485). But the development of gods, which separated the notion of mind from the natural world, instead of letting it operate immanently, was the beginning of a war between humans and the very ground of their existence, in a never-ending striving to transcend the material. I could even take Bateson a step farther in this development, and designate the advent of a hypostasization of human reason as both telos and causal principle (especially after Descartes) as an introjected monotheism. Thus, it didn't matter if man appeared to have killed God, because although Nietzsche exclaimed: who can take his place? who can blot out the horizon? this introjected arrogance may indeed, in the end, blot out the horizon in a very literal way, perhaps starting with the ozone layer.

While I may seem to be making enormous leaps, going from the relatively humble position of producing or viewing/reading/hearing works of art to a global situation, it is clear that even the global situation emerges from an extension of local attitudes of people to their material contexts, and the objects (or commodities they have become) that inhabit those sites. In this sense, it is interesting that both artists and poets of the fifties—the abstract expressionists and the "open field" poets—were fixated on *materia prima* (paint, color, syllables, breath) and at the same time the function of myth. It seems

a desire for a return to an animistic universe, which was prevented at the time by an eminently rational, existential state of despair.

It is of note that the "antihumanist," "antianthropological" thrust of poststructuralism, which calls into question the status of the subject of "man," hasn't been taken up in the service of ecology. That is, if "man" is displaced as the privileged subject, why isn't he seen *within* the material world of nature of which he is a constituent part? He has been displaced, rather, by "language," an aspect of technology that anthropomorphically appears to refuse the ground of its own manifestation, whether as the human body or in relation to things, and believes in its origin in itself, whether as the "body-without-organs" or without parents of Artaud, or the "always already" mythology of Derrida. The demystification of man has resulted in the mystification of language, discourse, ideology, writing. To even mention the term *resistance* is to postulate a self, a willing self. The phrase "language resisting itself" doesn't make any sense. Resistance needs bodies in space, interacting. We can clearly see the anthropomorphization of language that results from the antianthropological critique of humanism.

It is perhaps not too extreme to say that where once the silent material world formed the ground against which we examined the figures of language corresponding to, or shaped by, that ground, we now see the material world as a figure shaped entirely by the ground of language, usually designated as ideology. Yet we couldn't have the latter figure-ground relationship if the former were not also possible and inherent even in our speech about the latter, no matter how it is denied.

If the nature of my historical exegesis seems at times overly schematic, that is because it attempts to fly high over our historical circumstances, not only to see where we've come from, but to get an idea of where we may be going, and what we may need to consider there. I have probably done disservice to various artists in not considering all the complexities of their works that require separate study, but I am concerned primarily with the alignment or misalignment of overall intentions and formal effects with certain historical trends, which oftentimes betray them. This betrayal should not be read as something insidious underlying what appear to be ethically necessary and committed intentions, but rather as the consequence of pushing those intentions too far and being too absolute about them.[13]

In this sense, I am not a modernist, seeking an ideal purity that

unites form and content within whatever medium I use. I have shown the contradictions inherent in this pursuit: concrete poetry, in pursuing a purification of its essence as written or visual language, ceased to be poetry and became a species of visual art. Sound poetry that pushed beyond an "absent" language of signification to essentialize itself as the body's pure intonation, rhythm, and so on, ceased to be poetry and became music. In like manner, any art that pushes itself into a merely conceptual state ceases to *be* art and instead becomes content to be a theory *about* art, made painfully obvious in the statements of some artists who love to claim that *anything* they invest in—that is, anything they can merely claim (or buy) for their purposes—language or lifestyle—is nothing other than art.

On the other hand, one must be careful in assuming that there are no absolutes operating within postmodernism itself. In fact, I often think of the predominant ethos of postmodernism as one of absolute relativism, taking its cues from the idea that the only thing one can be sure of is difference, without any sort of grounded evaluative discrimination between objects of difference being possible. This is essentially the literalization of reality—the assumption that all of our relations with the material world should be based wholly upon an understanding of the differential structure of language. This strategy effectively ephemeralizes the material world, discounting the necessity of developing a phenomenal understanding and affection. It is not possible in this manner to, as Wendell Berry puts it, "stand for what I stand on." The subversion of the so-called fetishization of reference—which somehow erroneously believes that words can stand for things, allowing us to act with, for, upon things—is a misplaced idealism, fetishizing language itself. While it is difficult to perceive people producing language in the way they produce furniture, tools, or visual art, this doesn't mean they are only conduits for some supersensible, intertextual being rendering the nonauthor only an "instance writing." That strikes me only as a kind of ironically extreme response to the overly individualized and romantically atomistic notion of an existential artist, deriving everything out of his own "authentic" being.[14]

It is true that the dematerialization of representation that Malevich, Kandinsky, and Mondrian were engaged in sought subjectively to transcend the material limits of habitual patterns of cognition; but it did this through a purification of the material nature of painting. Thus

the spiritual was really sought—no matter what they thought—*not* in a transcendence of *material*, but a transcendence of conventionalized *representation*, through a focused concentration on material, formal effects. Given the social meanings inevitably affixed to even the simplest of forms (whether you see them as culturally specific, or universal archetypes), representation is not completely overcome by a purification of material means, *although its relation to material nature is brought into focus through this process.* In theater, the desires of Artaud and Grotowski to locate the epicenter of bodily desire, thought, and action brought into focus the perpetual and unstoppable decay of these very qualities, as so clearly manifested in the works of Genet and Beckett: a decay ironically wrought by the necessity of a dematerializing representation for the purpose of objectified self-understanding.

The attempted materialization of the *word*, of language, presents a more complex problem, in that a word is only a word inasmuch as it is a representation. It is true that we can recognize a sound spoken by someone, or a pattern of marks on a page, whether phonetic or ideographic, as a possible word. But a comprehension of its material nature, seemingly attainable only when its meaning is not understood, involves inflections—whether musical or pictorial—that consign it to a *possible* meaning. For all that, its true power for us as an instrumentalizing, communicating, and therefore responsible species can only come through its referential role—ambiguously, allusively metaphorical or literal—even while its material essence will forever elude us. I believe that the desire for poets—whether sound, concrete, or Language poets—to distinguish and elaborate the material nature of language is on the whole a most worthy desire, if we view it as a parallel to that same materializing project in visual and theater arts. Yet it misconceives the nature of language, whose staying power is less in the purely enigmatic (similar to the silence implicit in Genet's and Mallarmé's tomb building) or the voracious appetite of literal comprehension (Krapp's predicament) than it is in an understanding of an often fragile, yet enduring allusiveness that balances the metaphorical with the literal, the local with the global, the contemporary with the historical, the material with the ideal, and even the true with the false.

We must understand our present dilemma in relation to the reigning idealism of signification: seeming to wholly determine our lives, while remaining at base indeterminate and value free. I am not one to dismiss idealism in itself, as so many who proclaim themselves to be

materialists often do. These materialists, in fact, spend most of their time in an ideal framework that provides continuity between various historically specific material contexts. My very notion of material as resistant to signification can be labeled metaphysical. These labels don't concern me, in that I am not trying to prove the absolute consistency of a theory within an often inconsistent and contextually relative discursive universe. In fact, it is the persistence of the drive toward absolute consistency, theoretically motivated, that can lead toward rhetorical excesses that point us away from the world, rather than toward it. Idealism and materialism are two sides of the same coin when it comes to participating in social and material life. What should matter to us is *how* they interact and how their interaction affects our participation in life, rather than the necessity of purging elements of one from the other. Language is idealistic in nature, but it has definite material effects. The material world, in that it can have an aesthetic (and as I believe, ethical) effect upon us, therefore directing our attitudes, itself communicates to us through an ideal medium of signification. While admitting that the purifying impulse within modernism is inadequate to our needs, politically, aesthetically, and ethically, I hope to have shown that even this trajectory has luminously revealed to us the value of understanding the relationship between the human universe of signification and its ground in the larger universe of material, a material world greater than our instrumental, discursive, and literalizing attempts to comprehend it.

Notes

1. If one wants to use the term *postindustrial* in any real sense, then it doesn't matter whether or not the majority of human beings can be separated from the mechanical processes of industry (through robotic processes, etc.). It doesn't alter the fact that society is still built upon an industrial framework—in fact it becomes even more evident. The ephemera of information systems is still dependent upon hardware, which is manufactured industrially (and can be a source of pollution), automobile production is still increasing, and so on. Shifting industrial manufacturing to sweatshops in Third World countries has effectively concealed from us the actual displaced costs of human labor—not replaced by robots—that give us the illusion of living in an industry-free culture: in effect exacerbating the "naturalizing" effects of commodity fetishism.

Finally, it is clear from the effects of the decimation of the rain forest, the pollution of our waterways and atmosphere, and the growing hole in the ozone layer that we can in no way consider ourselves in a postindustrial situation.

2. If one accepts Lyotard's notion of "incommensurable discourses" (*The Postmodern Condition, The Differend*), which I do not in any absolute sense, then it's clear that acceptance of the other cannot be based on understanding.

3. I find a recent book by Paul Mann, *The Theory-Death of the Avant-Garde*—which is a thoroughgoing, if not ruthless, analysis and critique of the avant-garde's self-definition and function in society—to be more congruent, despite its pessimism, with what I am attempting here.

CHAPTER 1

1. These parallels can be read as variants of the historical cultural parallels Fredric Jameson makes with Ernest Mandel's three stages of capitalism: market capitalism, monopoly capitalism, and multinational capitalism corresponding with romanticism, modernism, and postmodernism. See "Postmodernism," 78.

2. I realize that the term *imagination* is out of favor among those who see it as a Romantic form of subjective agency. One might attempt to replace it with the more acceptable psychoanalytical sense of "desire," or—especially favorable to the Stevens quote—"pleasure principle," or even with the

Lacanian function of the Imaginary, while recognizing that in all of these senses imagination lacks any synthesizing intellectual agency.

3. For an account of how technological innovation disrupted and revolutionized human behavior, consciousness, and culture at the turn of the century, see Stephen Kern, *Culture of Time*. See also Marshall Berman, *All That Is Solid*. For how technological/economic development altered cultural formations entering the postmodern era see David Harvey, *The Condition of Postmodernity*.

4. While it is unnecessary to accept Ellul's "demonic force" in its literal sense, one might understand it as demonic by default—that is, the notion of all progress as dependent solely on technological innovation is almost universally accepted within late capitalist culture, and it achieves its force from lack of any substantive critique on the part of the populace. For a criticism of Ellul's view, see Winner, *Autonomous Technology*.

5. Ross, *Failure of Modernism*; and Gablik, *Has Modernism Failed?*

6. It is important here to call into question the presupposition that the proletariat's working conditions are conducive to contemplation: anyone who has ever operated a machine or done piecework in a factory knows that the opposite is the case. The very mechanization of movement required is enough to *prevent* thought from occurring, and fatigue after a day's work prevents reflection as well. Continual attention to tasks in order to prevent mistakes, sometimes injurious or even fatal ones, also preempts any kind of thought larger than what's necessarily at hand. Despite Lukács's bureaucrat being reified "body and soul," if it is likely anywhere that reflection upon one's conditions can take place, it is within bureaucratic office work, where interruption or slowdown of repetitive labor presents no physical danger, and where slow periods in general, while they compel makework under the eye of the boss, allow for reflection when the boss is elsewhere. One only need look at a contemporary of Lukács—Kafka—to recognize such reflection.

7. One of the most concise descriptions of ideology I've seen is that of "a forced perspective"; see Blau, *Audience*, 338.

8. Thanks to Anthony Kubiak for this amendment to Baudrillard's concept.

9. Paul de Man: "Literature involves the voiding, rather than the affirmation, of aesthetic categories. One of the consequences of this is that, whereas we have traditionally been accustomed to reading literature by analogy with the plastic arts and with music, we now have to recognize the necessity of a non-perceptual, linguistic moment in painting and music, and learn to *read* pictures rather than to *imagine* meaning" (*Resistance to Theory*, 10).

10. "In addition, chance is not only a striking form of injustice, of gratuitous and undeserved favor, but is also a mockery of work, of patient and persevering labor, of saving, of willingly sacrificing for the future—in sum, a mockery of all the virtues needed in a world dedicated to the accumulation of wealth. As a result, legislative efforts tend naturally to restrain the scope and influence of chance. Of the various principles of play, regulated competition is the only one that can be transposed as such to the domain of action and prove

efficacious, if not irreplaceable" (Caillois, *Man, Play, and Games*, 157). What Caillois wasn't prescient enough to realize is how games of chance could actually be appropriated and used legislatively to stimulate state and local economies and to keep the attitudes of citizens in an ever hopeful and expectant state.

11. By "autonomous art" I do not simply mean an art for art's sake that appears to separate itself entirely from its social milieu. While the historical avant-gardes—as well as postmodern critical art—have practiced an engaged art that denies a separation from its social basis, its very criticality depends upon an attitude of *conceptual* autonomy from that context, and its aim tends toward the liberation of the subject from the ideological determinations of that context.

12. "Art will live on only as long as it has the power to resist society. If it refuses to objectify itself, it becomes a commodity" (Adorno, *Aesthetic Theory*, 321).

13. "In art the primacy of the object, understood as the potential freedom of life from domination, manifests itself in the freedom from objects" (Adorno, *Aesthetic Theory*, 366–67).

14. Aesthetics as a "sensuous parallel of logic" was developed by A. C. Baumgartner just prior to Kant's formulations. For Baumgartner, it operated according to the geometrical method of proofs, theorems, and corollaries. The rules were cognitive and sought perfection. (Francis X. J. Coleman, *Harmony of Reason*, 18).

15. Kitsch has shifted within some types of postmodern discourse from Clement Greenberg's term of opprobrium to an almost valorized populist sense (Jeff Koons's work capitalizes on just this reversal). But I have to concur somewhat with Greenberg's distrust of its ideological nature (especially as it was evident in 1939), noting that "populism" is not antithetical to authoritarian impulse. Milan Kundera corroborates this distrust in his novel *The Unbearable Lightness of Being* by seeing kitsch as "the absence of shit": "It follows, then, that the aesthetic ideal of the categorical agreement with being is a world in which shit is denied and everyone acts as though it did not exist. . . . [K]itsch is the absolute denial of shit, in both the literal and figurative senses of the word; kitsch excludes everything from its purview which is essentially unacceptable in human existence" (248). Further, he remarks: "In the realm of totalitarian kitsch, all answers are given in advance and preclude any questions. It follows, then, that the true opponent of totalitarian kitsch is the person who asks questions" (254).

Kitsch *that is recognized as such* (rather than as a cute or beautiful object), if it is not rejected by the viewer, has already passed over into *camp*, the ironic framework for the viewer's perception of kitsch. Camp in this sense is only possible inasmuch as—through irony—there is an awareness of the kitsch object's ideological status as an idealized alibi for the less-than-ideal realities of its cultural origins. Camp in this sense would appear to function critically by holding both ideal and real together in comic tension. On the other hand, as I mention here, the proliferation of camp—and camp is one of those things

that proliferate easily—can soon lose its critical distance, and the fetishized camp object becomes in fact a new form of kitsch, a noncritical defense mechanism or escape for its collector.

16. Beat poetry had an ambivalent relation to modern society, in the spectrum of response from Ginsberg's condemnation of the industrial world as Moloch to Kerouac's celebration of city life and the romance of the American automobile.

17. "[I]t is a fact that *those individuals who have the capacity to accept the separateness of objects are those who have a distinct, at least in part, beloved sense of self.* If one can be a loving parent to oneself, one can more easily accept the separateness of objects. This is a momentous step in psychic development" (Modell, *Object Love and Reality*, 59).

18. I realize that there are variations and degrees of actual critical articulation between different artists who work in this mode. Often the criticality has to be injected wholesale by congenial critics who go to great lengths to prove it—for the work of Jeff Koons and Haim Steinbach, for instance, and to a lesser degree for Richard Prince; while for Jenny Holzer and Barbara Kruger, who use the forms of commodity information systems, the content—the message—can be fairly blunt politically, while its form can render it ambiguous. Cindy Sherman's work is more complex and stands somewhere both critically and formally between these extremes.

19. A few of these artists have relied upon Baudrillard's theory of the simulacrum to legitimate their "commodities" as "theoretical objects" (that is, art). It is ironic that Baudrillard himself has repudiated these attempts to utilize his theory in the service of art, which, following his line of thinking, has no legitimate existence anymore, at least not one with a critical function. As he put it to an expectant crowd at the Whitney Museum, "I cannot get involved in explaining this new art of simulation. . . . In the world of simulation there is no object. There is a misunderstanding in taking me as a reference for this work" (qtd. in Mann, *Theory-Death*, 140).

20. At the same time, it is of utmost importance to recognize the political danger inherent in the self-conscious production of wonder through spectacular means. The wonder I refer to is not the wonder at the power of human accomplishment, but the wonder at the larger world of existence of which human accomplishments are but a part.

21. In his *Groundwork of the Metaphysic of Morals*, Kant stipulates as part of the explanation of the categorical imperative that human beings must, in an ethical sense, be understood as ends in themselves, and not as means. He does not extend this to nonhuman life: "Beings whose existence depends, not on our will, but on nature, have none the less, if they are non-rational beings, only a relative value as means and are consequently called *things*" (96). If, however, we were to understand the degree to which human activities are implicated in the entire system of life on this planet (and it in human life), it might be necessary to begin to see forms of nonhuman life or material as ends in themselves as well. Of course, the idea of ethics founded in understanding even human beings as ends in themselves is a transcendental notion and goes

against the grain of the more "materialist" philosophy implicit in "greatest good" utilitarianism and Marxism. An example of extreme utilitarianism within theater is Brecht's "learning play" *The Measures Taken*, which condemns individual instances of compassion as being destructive of the ultimate ends of revolution, whose means must necessarily be at times cruel and inhumane. Of course the question of context here is of utmost importance in addressing these questions, but it does not necessarily mean that the extremism of the revolutionary context logically denies any importance to Kant's argument, as no doubt Gandhi or Martin Luther King would have pointed out.

CHAPTER 2

1. One might say that the materialization of a theatrical script in performance is also and at the same time its dematerialization as a literary artifact.

2. For an influential view of the critical relation of performance to theater, see Josette Féral's "Performance and Theatricality."

3. The distinction between the nineteenth-century tableau and Brecht's gestus should be obvious, however, as the former is designed to unify an audience behind a particular ideologically motivated representation, while the latter intends to present a contradictory image that disrupts the audience's emotional link to the action in order to stimulate critical analysis.

4. Eliot himself, from the voices in *The Waste Land* through his verse plays, sought to develop a truly embodied sense of the *literary*, rather than accommodating the literary to the dramatic needs of the modern theater. These attempts did less to dispel or mend the dissociation of sensibility than to summon forth the melancholy ghosts it created.

5. What will be quickly recognized here is that my concentration on the body as "object," an examination of its phenomenological reduction, does not take into account the question of gender. This question is not omitted because I dismiss it as unimportant, but because I cannot discuss it here with the attention it deserves. There is a wealth of feminist writings on the objectification of the female body, starting with Laura Mulvey's "Visual Pleasure and Narrative Cinema" (1975), and later taken up extensively by film theorists such as Teresa de Lauretis, Tania Modleski, and Annette Kuhn. It has been addressed in art (Kate Linker, Mary Kelly, Victor Burgin), photography (Abigail Solomon-Godeau, John Berger), and theater and performance (Sue-Ellen Case, Jill Dolan, Elin Diamond). What I intend to show here, in a larger sense, is that the body *as the signifying object of performance* does not embody essential or universal attributes, except as those attributes are socially constructed. This is true for male as well as female bodies, though we should recognize that *how* any particular objectification takes place is what is really at stake within a patriarchal system, not *the fact that* objectification is taking place, which seems to me to be an undeniable aspect of cognition (or desire).

6. On the other hand, "Wanting to see it on the surface, no cover up, is the aesthetic counterpart of political demystification. The same attitude occurs

in the psychology of behavior when we prefer people who are 'up front' and 'all there,' although in the theater that is something of a problem as it is not in the strictly graphic arts" (Blau, *Take Up the Bodies*, 12–13).

7. After Derrida, presence as a concept in theater has become highly suspect, if not conceived of as being authoritarian, where before it had been highly valued in a performer. It is interesting that while Derrida's critique of presence as basis for legitimation in the phonocentric/logocentric tradition in effect *denies the very possibility* for what he usually qualifies as "full" presence or "pure" presence (or pure self-presence), critics like Philip Auslander or Elinor Fuchs seem to substantiate presence as a force of authority to be deconstructed in theater experiments like that of the Wooster Group. To be fair, Fuchs's analysis of presence acknowledges its dependence upon absence, while Auslander more or less reduces the concept to the mystified one of charisma. Fuchs sees the issue primarily in terms of the actor's concealing the constructedness of the written script through "spontaneous" oration, linking the notion of theatrical authority with a phonocentric illusion. While at face value this seems plausible when confined to naturalism, it also seems to belittle the intelligence of the spectator: what spectator would fully believe a finely crafted text to be spontaneous speech—or care if it is or not? Obviously in theater there is a continual denegation going on, connected with Coleridge's "suspension of disbelief," in which the spectator can be simultaneously caught up in the performance, the dialogue, and at the same time be appreciative of the writing. One question to ask is what happens to the specific *pleasure* that theater affords if presence is to be evaded, eliminated, or deconstructed; even Brecht knew that continuous alienation precludes entertainment, which he valued even for didactic reasons. See Auslander, *Presence and Resistance*, 30, and Fuchs, "Presence."

8. While this is more or less a description of the early plays of Richard Foreman, he himself has indicated—given his commitment to Stein's notion of a continual present—that he's not primarily concerned with the audience's remembering the details of what happened in the play.

9. I have not mentioned ceremonies, but ceremonies are less repetitions than unique events for the participants. Ceremonies are events that initiate a new order of rituals. Of course it depends upon one's role in the ceremony: a wedding ceremony is less an event for the minister than it is a ritual act.

10. Many interpretations of *The Balcony* assume, within the structure of the play, the reality of the deaths of Chantal and Arthur the pimp (killed by a stray bullet). This interpretation follows the contrast created between the "fake" dead body required for the Mausoleum Studio and the "real" dead Arthur they are unexpectedly delivered. Yet, given the openness of the ending created by Madame Irma's lines to the audience, it is possible that even the deaths of Chantal and Arthur, *as well as the revolution itself,* are illusions created to further objectify, if not apotheosize, the positions of the powers within the Grand Balcony. After all, it is evident within the "real" world of politics that the presence of an external enemy (fabricated or not) enhances the internal support of those in power. In the final section Irma asks the

Envoy whether what they heard were real shots, to which he replies, "Someone dreaming, madame."

11. For another examination of a mausoleum state consciousness, focused on the postwar Soviet Union, see Komar and Melamid, "In Search of Religion."

12. The role of women as witnesses in Genet's world would seem to reverse the objectifying gaze of the male spectator, giving that power to the woman. But it is *given* to the woman in the spirit of both masochism and narcissism. Here Freud's contention that women are more narcissistic than men seems confounded. The woman's gaze may be construed as the gaze of the mother: the mother as nurturer and accuser at once. In a strictly Freudian sense, the Judge, who licks the thief's shoes, demonstrates the behavior of a fetishist, who would return the phallus to the mother, hence returning to her her authority. And appropriately enough for the play, Freud designates the kleptomaniac as the female counterpart to the male fetishist.

13. "In modern theatre stage-roles undermined, in fact, everyday-life roles, declaring the latter 'inauthentic.' From this viewpoint, it is the *mundane* world that is false, illusory, the home of the *persona*, and theatre that is real, the world of the *individual*, and by its very existence representing a standing critique of the hypocrisy of all social structure which shape human beings, often by psychical and even physical mutilation . . . in the image of abstract social status-roles" (Turner, *From Ritual to Theatre*, 116).

14. Michel Foucault, in speaking of the classical episteme, comes close to describing Krapp's method:

> [R]elations between beings are indeed to be conceived in the form of order and measurement, but with this fundamental imbalance, that it is always possible to reduce problems of measurement to problems of order. So that the relation of all knowledge to the mathesis is posited as the possibility of establishing an ordered succession between two things, even non-measurable ones. (*Order of Things*, 57)

Are the stages of Krapp's life on tape truly "measurable," one to another? It is evident that although Krapp's drinking might have remained constant, its effects on him become more evident as he ages, as does his relation to women and the world in general. But this points also to the relativism of these comparisons: against what standard are these stages being measured?

15. Bergson can give us an idea of why Krapp's project is doomed to fail. He argues against the sense that life is a "continually rolling up, like that of a thread on a ball." Instead it is

> actually . . . neither an unrolling nor a rolling up, for these two similes evoke the idea of lines and surfaces whose parts are homogeneous and superposable on one another. Now, there are no two identical moments in the life of the same conscious being. Take the simplest sensation, suppose it constant, absorb in it the entire personality: the consciousness

which will accompany this sensation cannot remain identical with itself for two consecutive moments, because the second moment always contains, over and above the first, the memory that the first has bequeathed to it. A consciousness which could experience two identical moments would be a consciousness without memory. It would die and be born again continually. In what other way could one represent unconsciousness? ("Duration," 727)

The theaters of both Gertrude Stein and Richard Foreman aim at a consciousness that dies and is born again continually. They can only attempt to do this through the incessant subversion of the audience's memory. More to the point of Krapp's own system, Bergson writes,

Memory . . . is not a faculty of putting away recollections in a drawer; there is not even, properly speaking, a faculty, for a faculty works intermittently when it will or when it can, whilst the piling up of the past upon the past goes on without relaxation. In reality, the past is preserved by itself, automatically. In its entirety, probably, it follows us at every instant; all that we have felt, thought and willed from our earliest infancy is there, leaning over the present which is about to join it, pressing against the portals of consciousness that would fain leave it outside. ("Duration," 725)

16. This unpossessable aspect of performance that compels one's attention within the present moment is something affirmed by both Josette Féral, who believes that the demystifying potential of performance dies once it is frozen on video ("Performance and Theatricality," 173), and Peggy Phelan, who conceives of the "unmarked," disappearing nature of performance as its real political potential, evading the appropriative movements of hegemonic power. See her *Unmarked*.

CHAPTER 3

1. For a detailed analysis along these lines on Malevich's *Painterly Realism* (formerly *Red Square and Black Square*) (fig. 3), see Altieri, "Representation."
2. For the same issue as it applies to poetry, see the section on Gertrude Stein in chapter 4.
3. See note 15 on kitsch in chapter 1.
4. In the commercial graphic art world, an illustration layout placed vertically is called a "portrait" and horizontally a "landscape." This designation based on positioning, regardless of content, verifies the painting as picture even if only according to canvas shape, no matter how minimal the content.
5. For the consequences attendant upon a more material sense of the actual production of paintings for art history, see Bryson, *Vision and Painting*.

6. For a more detailed analysis of this shift from the two-term—spectator and painting—"absorption" by painting, as Fried sees it, to "theatricalization" through the minimalist emphasis on three terms—spectator, work, and exhibit space—see my essay linking this to the perceptual relativism in Harold Pinter's drama in the seventies: "Pinter and the Ethos of Minimalism." I owe this reading of minimal art to Rosalind Krauss's discussion of Robert Morris's work in her *Passages in Modern Sculpture*, 267.

7. Perhaps the rise of documentation in art is a reflection of television's increasing documentation of everyday events and pseudoevents. Consider the fact that if the art spectator is confronted with the photograph of an earthwork (say, Heizer's *Double Negative*) and the photograph documenting an event that will never occur again (a Happening), if the spectator never finds the opportunity to visit the site of the earthwork, the "substance" of the two photographs as information, one of an object, the other an event, is virtually the same. Documentation of theatrical and other performance works thus "objectifies" and freezes the event for history, even while, as every performer knows, often creating something very different from the event itself. Documentation can even be of something that never really "happened" as it appeared in the photograph, as in Yves Klein's famous "leap into the void," which shows him diving from a second-story window over a quiet street, or Rudolf Schwarzkögler's faked documentation of the amputation of his penis, an "event" for which one still finds credulous references.

8. The Glass's complex encoding has led critics to interpret it physiologically, archetypally, and alchemically. For the last two (respectively) see Octavio Paz, *Marcel Duchamp*, and Jack Burnham's *Great Western Salt Works*.

9. For a remarkable indication of Duchamp's skills at manipulating public reception of his work while remaining (necessarily) invisible in the process, see Thierry de Duve's essay on the submission of *Fountain* to the first Society of Independent Artists exhibition in 1917, "Given the Richard Mutt Case."

10. In the fifties the Italian artist Piero Manzoni had literalized this by canning his own waste products and selling it as "Artist's Shit."

11. Some have gone so far as to say that Warhol created the "celebrity," whose only talent is that for being seen.

12. See my remarks on theatricality and dramatic absorption in chapter 2.

13. The "industrial base" of minimalism already almost nostalgically marks the end of an era, especially in its more masculine guises (Andre, Serra). It anticipates plant closings and transfer of industry to other nations. There is a temptation to view the scandal surrounding the allegation that Carl Andre murdered his artist wife Ana Mendieta, who was Mexican, as the encapsulation of the conflicted feelings of white male working-class Americans who feel their own power being transferred to and usurped by "feminine" Third World societies.

14. De Duve in *Pictorial Nominalism* suggests envy and resentment in the young Duchamp regarding the success of the cubist painters in developing the legacy they received from Cézanne.

15. Not all artists who engage in the constructing of an art object would appreciate my use of the adjective *expressive*, as for some it is less an expression of self than an active connection with the material world outside the self, forming a dialectical mode of creation; this is indicated by the adage "truth to materials." Yet the form of self-fashioning that occurs with the formation of objects can indicate a kind of mutual "expression" for the sake of the *spectator*.

16. I am not insensible to Marx's use of the camera obscura as a metaphor for the operations of ideology. But ideology in any sense is impossible to evade as a perspective, even, and especially, as the perspective by which an ideology from which one is alienated can be critiqued. Marx's own turning of Hegel on his head is not unlike the reversals of the camera obscura. (Yet Hegel on his head is still Hegel). See Paul Ricoeur's extrapolation of Karl Mannheim's paradox of ideology critique in *Lectures on Ideology and Utopia*.

17. for a magisterial historical overview and analysis of the fear of representation as it culminates in various types of iconoclasm, see David Freedberg, *The Power of Images*.

CHAPTER 4

1. If one examines the part of Worringer's text that Hulme is using, a shift in emphasis can be seen:

Tormented by the entangled inter-relationship and flux of the phenomena of the outer world, such peoples were dominated by an immense need for tranquility. The happiness they sought from art did not consist in the possibility of projecting themselves into the things of the outer world, of enjoying themselves in them, but in the possibility of taking the individual things of the external world out of its [*sic*] natural context, out of the unending flux of being to purify it of all its dependence upon life, i.e., of everything about it that was arbitrary, to render it necessary and irrefragable, to approximate it to its *absolute* use. (Qtd. in Isaak, *Ruin of Representation*, 7)

Worringer makes it clear that the art he describes did not involve projection of personality into things, but rather the freezing and freeing of an object from the blur of experience, of being able to make the *object* pure and stable, if not immortal. Hulme adds that the Greeks sought immortality in their constructions, and this involves projection: "Living in a dynamic world they wished to create a static fixity where their souls might rest."

2. The new machine-age sculpture in the second decade of this century

represented a violent turning away from the sculpture of Rodin, the best example of empathetic art.

3. Ironically, Bergson's diagram of the system of perception and memory found in *Matter and Memory* is an inverted cone, its tip, perception, skating across the plane of reality, while the cone above is the shape of memory. It is, in fact, the shape of a vortex, the symbol that Pound used after his shift away from the more static image.

4. Later on, concrete poets will rely on this relationalism, evidenced by their liberal use of quotes from the *Tractatus*.

5. Although Williams never explained in detail what he meant by this practice, it has usually been read in terms of "breath" (especially by the projectivist and "open field" poets of the fifties), similar to the terms set by *vers librist* John Gould Fletcher: "Each line of a poem, however many or few its stresses, represents a single breath, and therefore a single perception" (qtd. in Coffman, *Imagism,* 101). Henry Sayre argues that Williams used a "variable foot" in a *visual* and arbitrary way; as opposed to considering the voice at all, it creates a mechanism of *appearance:* "In essence the overall effect of the poem's *visual pattern of repetition* that his shape establishes makes each line, over the whole poem, *seem* a 'single beat'—that is, a single move of the eye, and thus a single visual unit equal to the other units (or lines) of the poem" (Sayre, *Visual Text of Williams,* 88).

6. This conflict of symbols runs through Pound's *Cantos* as well: the inorganic and organic, concrete and the fluid meet in "stone eyes looking seaward." It is an ovidian sense of flourishing growth and change bounded by the agelessness of art, whether poetry or architecture, "the house of smooth stone".

7. In Williams's case, this is astutely examined in Henry Sayre's *Visual Text of Williams.*

8. This group is named after an anecdote in Pound's Canto 20, in which Pound goes off to old Lévy, a translator of Arnaut Daniel, the Provençal poet, asking about the meaning of the word *noigandres.* The old man tells him that for an entire six months, every night when he went to bed he asked himself, "Noigandres, eh, *noigandres,* / Now what the DEFFIL can that mean!"

9. A contemporary inversion of Finlay's figures of repose is found in Jenny Holzer's "benches"—also marble seats, but inscribed with text describing the bodily anxiety of possible violence. For an overview of Finlay's work, see Prudence Carlson's "The Garden on the Hill."

10. In years previous to the creation of these poems, the lettrists were avid avant-garde filmmakers, "chiseling away" at the social construction of viewing and being "led" by pictures, incorporating words and word sounds against fields of black and white.

11. In its ideological allegiance to free enterprise, one can compare Gomringer's concretism to the institutional use of nonrepresentational painting in West Germany in the fifties as a promotion of Western individualism during the cold war. See Jost Hermand, "Modernism Restored," and Serge Guilbaut's *How New York Stole the Idea of Modern Art.*

12. "[M]usic begins to atrophy when it departs too far from the dance . . . poetry begins to atrophy when it gets too far from music" (*ABC of Reading*, 14).

13. In examining the use of "appropriation" from Dada to graffiti to simulation art, one should think of it as an historical shift in meaning of an older, less urban-bound term, "imitation." Premodern works of art that drew upon pastoral imagery for its content could believe that, in imitating nature, whatever was there could be taken for human use without cost, especially for something as innocuous as visual or literary representation. Within the urban environment, what could be "taken" in order to imitate in this manner? As long as markets stayed small, objects, such as the ones appropriated by Duchamp, retained their anonymity. Today, however, much of our mediated environment is *owned and signed* by its owners. Thus, any attempt at imitation necessarily becomes appropriation of these banal images of everyday life. (In a musical sense, this system of recognizable property has been problematized by rap groups that use digital samplers to appropriate sounds from other recordings and work them into a rhythm loop.) For an insightful essay on the relation of graffiti to commodity relations and property, see Susan Stewart, "*Ceci Tuera Cela.*"

14. I thank Hubert Klocker for his translation.

15. My information about lettrism comes from the following sources: (1) a somewhat romantic view of it as a youth-oriented, politically subversive movement can be found in Greil Marcus's *Lipstick Traces;* (2) a special issue of *Visible Language* 18, no. 3 (summer 1983) edited by Stephen C. Foster, concerned with lettrism's artistic uses of language, both visually and orally. Of special historical interest in this issue are the viewpoints expressed by sound poet Henri Chopin in an interview on "The Limitations of Lettrisme"; (3) Stewart Home, *The Assault on Culture;* (4) Ken Knabb, ed. *Situationist International Anthology;* (5) Raoul Vaneigem, *Revolution in Everyday Life.*"

16. For more on this see Dick Hebdige, *Subculture.*

17. For a comparison of the relation of art to political life from the standpoint of situationists and artists of the American "happening," see my essay "The Spectacle of the Anti-Spectacle."

18. A revealing anecdote about the contrasting, but sometimes approximate, positions of intervention and invention is the following: the Danish painter Asger Jorn, one of the founders of the Situationist International, formerly of the COBRA group (COpenhagen, BRussels, and Amsterdam), had approached Max Bill in 1953, after hearing about Bill's "new Bauhaus" in Ulm. Jorn wanted to collaborate in its development but was rejected by Bill, whose geometric, rational painting was a far cry from Jorn's primitive, tachist style. Jorn then decided to form his own movement (with Italian "nuclearist" painter Enrico Baj) called the Mouvement International pour un Bauhaus Imaginiste (MIBI). This movement was subsumed in the formation of the Situationist International in 1957. See Guy Atkins, *Asger Jorn* 29.

19. As the question arises of addressing the point where the "purely" visual nature of concrete poetry forsakes the lexical altogether and becomes

visual art, so too the question arises as to when the most basic sonic elements of language cease functioning as language and become music. This is especially true in the case of those Sound poets whose practice takes place mostly in the powerful sound-manipulating atmosphere of the recording studio. This is also the case for works created by composers such as John Cage, which contain a wide variety of intonational possibilities, but which function less as imitations or approximations of sub-, pre-, or metalinguistic communications and more for their musical sound values, as in pieces composed for Cathy Berberian and Joan LaBarbara.

20. Included in these books are not only the more easily identified younger members of the movement, but older poets that provided inspiration for them—Jackson Mac Low, Hannah Weiner, Clark Coolidge, and Bernadette Mayer, who was the teacher of some of them at St. Mark's Church Poetry Project in New York in the early seventies. A collection of selected essays from the journal L=A=N=G=U=A=G=E, called The L=A=N=G=U=A=G=E Book, edited by Andrews and Bernstein, came out in 1982 (hereafter cited as LB). Poetics Journal, the other major theoretical instrument, edited by Lyn Hejinian and Barrett Watten, is still publishing. Other sources for these poetics are volumes 6–7 of Hills, called Talks, edited by Bob Perelman, as well as various issues of Boundary 2. My remarks here relate primarily to the emergent years of the movement; critical positions held by some members have no doubt shifted since them.

21. Rather than poetry, Wittgenstein saw the use of a continuously dialectical philosophy as a way of freeing ourselves from the continuous mystifications of language. The difference is that Wittgenstein wouldn't refer to "ideology" as the mystifier, as do the Language poets. What is most interesting about the Wittgenstein quote, however, is that its ambiguous construction presents a double bind for those who are "constructed" as well as "constructing" in language. "By means of" we take to refer to the bewitching of our intelligence by language, but it could also be read that language is the means by which we battle this bewitchment; this is true even in the German: "Die Philosophie is ein Kampf gegen die Verhexung unsres Verstandes durch die Mittel unserer Sprache," (Philosophical Investigations, 47).

22. The self-protective nature of this denial of aesthetic continuity is obvious and understandable. The establishment of a community of these writers was necessary, first, to promote all of their writings as individuals—easier if done as a group—and secondly, to protect their writings from being evaluated, accepted, or dismissed on the basis of their adherence to an emergent overall aesthetic (protecting individuality). The extent to which those critics who are promoting Language poetry wish to avoid offending this plurality-in-unity is illustrated by the habit of Michael Greer, who in his essay "Ideology and Theory in Recent Experimental Writing," puts scare quotes around his every mention of the term Language poetry. This effect of avoiding the movement's titular "reification" doesn't work in any case, after one has got habituated to the title's constant use, quotes or not.

23. Silliman's use of permutated sentences (changing the order of the

nouns so that they develop different syntactical relations) calls to mind the more austere, but no less obsessive, permutations found in the kinetic concrete poetry of Emmett Williams from the sixties. Other permutational precedents might be found in the poetry of Helmut Heissenbüttel and Peter Handke. Of course, Gertrude Stein's work is a primary influence.

24. This is an attitude held in common with concrete and sound poetry. But while those two poetries believe they are dealing with language's *prima materia*, that is, its purest sounds and visual signals, Language poetry problematizes the erroneous and reductive nature of this by demonstrating the necessity of including grammatical and syntactical structures as the basis of any understanding or real experience of what language is. This is even further developed by the shift in emphasis from the (Russian futurist) idea of the "word as such" to Silliman's "new sentence" (see "From *The New Sentence*" in *IAT*), perhaps following the insight provided by philosophers of language that the minimal unit of communication is not the word but the sentence, even if it is contextually implied in a one-word signal. Thus Wittgenstein's meditation on a construction worker's expression "Slab!" could involve, by context, the implied sentence "Bring me that slab!" (*Philosophical Investigations*, 19).

25. One thing that puzzles me in this politicization of (referential) language, or maybe I should say its absolute permeation by an omnipresent ideology, is that the resistant practice that these poets are engaged in is often referred to (mostly by Silliman) as "class struggle." (Silliman: "The social function of the language arts, especially the poem, place them in an important position to carry the class struggle *for* consciousness to the level of consciousness" [*LB*, 131]). This term or its context is never explained anywhere, even by Hartley in his otherwise comprehensive explanation of the Althusserian Marxist roots of Language poetics. Since the term *proletarian* is never used, I can only assume that Language poets must constitute a class unto themselves, as I doubt that many proletarians would know what to do with their poetry or their critique. Even if the term is used in a metaphorical sense, it is never clear what it refers to even metaphorically.

In a like manner, the use of the word "fetish," as in "referential fetish," or "narrative fetish" (Silliman, *LB*, 131), is unanalyzed. Is a fetish a symbol, or is it a thing-in-itself? Is it a symbol that one *thinks* is a thing-in-itself? What is its use value? If these distinctions are not made clear, one could ask, as did Jackson Mac Low, "What could be more of a fetish or more alienated than slices of language stripped of reference?" (Perloff, *Dance of the Intellect*, 233).

26. See MacIntyre's *After Virtue*, especially pages 172–73, and Ricoeur's "Human Being." Of course no continuous sense of self can depend only on its own experience outside of a social involvement and interaction, which in turn depends upon a communicated coherency.

CHAPTER 5

1. Much postmodern reading of history reverses the traditional reading of present circumstances in the light of historical precedents and instead

reads the "postmodern condition" *into* events in history, projecting contemporary values into contexts that most likely would not have comprehended them. See Richard Levin's "Poetics of Bardicide."

2. In this, I draw upon the distinction that Paul Ricoeur makes between ideology, as a rationalization of any current system, and utopian thinking, as a form of challenge to that rationalization. See his *Lectures on Ideology and Utopia*.

3. For a good example of an artist influenced by Cage, but having second thoughts about the social implications of his philosophy as a whole, see Yvonne Rainer's "Looking Myself in the Mouth." The essay displays a shift from an investment in the "egoless" philosophy of the composer-with-the-sunny-disposition to the "subjectless" theories of Barthes and Foucault.

4. While Eliot stated that only those with personality would know what it means to want to escape from it, I must add that only those who can afford unthreatened subjectivity are those who feel at ease in "ridding" themselves of it.

5. For more on this in Greek culture, see Foucault's *The Use of Pleasure*.

6. The Buddhist response is the letting go of desire, but that's another, long story.

7. Simmel: "Our relationship to the world may be represented as an arc that passes from the subject to the object, incorporates the object and returns to the subject" (*The Philosophy of Money*, 205).

Sartre:

> I cannot describe here the true dialectic of the subjective and the objective. One would have to demonstrate the joint necessity of "the internalization of the external" and the "externalization of the internal." *Praxis*, indeed, is a passage from objective to objective through internalization. The project as the subjective surpassing of objectivity toward objectivity, and stretched between the objective conditions of the environment and the objective structures of the field of possibles, represents *in itself* the moving unity of subjectivity and objectivity, those cardinal determinants of activity. The subject appears then as a necessary moment in the objective process. (*Search for a Method*, 97)

While this begins to sound like Barthes's idea of the writer as simply the "instance writing," Sartre uses another term to reconnect the instance to its human source: "Only the project, as a mediation between two moments of objectivity, can account for history; that is, for human *creativity*" (99).

8. Sloterdijk addresses a significant type of resistance to this notion:

> Precedence of the objects would mean to be forced to live with a power *over* us, and because we, quasi-automatically, identify everything that is above us with that which oppresses us, from the viewpoint of this unenlightened enlightenment, there can be, on the contrary, only a stance of polemical distance. Nevertheless, there is another kind of precedence

that is not based on subjugation: The precedence the object enjoys in sympathetic understanding does not demand that we reconcile ourselves to an inferiority and an alienated position. Its prototype is love. The ability to concede the object a precedence would be tantamount to the ability to live *and* let live (instead of live and let die), and indeed as an ultimate consequence, also to die and let live (instead of following the impulse to pull everything down into death with us). (*Critique of Cynical Reason,* 360)

9. "Art partakes of reconciliation only because it is deadly, which is why it continues to be enslaved by myth. This is the Egyptian quality that characterizes all art. Wanting to immortalize the transitory—life—art in fact kills it" (Adorno, *Aesthetic Theory,* 194). I must take some exception to Adorno's conception of this type of death drive as characterizing all art. This is true neither of certain forms of process art or performance in general. It is necessary to contrast this idea with Sloterdijk's "live and let live." Yet the desire to find "true" Being often results in the attempt to halt *Becoming,* by which Being is rendered less determinate. This then is transformed into the desire for homeostasis, in the Freudian sense, and actually the desire for death, the *antithesis* of Being (therefore its ground).

10. Witness the 1988 presidential campaign, in which the major issue covered by the media was the way each candidate was representing himself and the other candidate in their personal attitudes toward pressing problems, to the detriment of any substantive discussion of how to deal with them. While the media appeared to be operating in a "demystifying" way toward the semiotic strategies of the campaigns, voter turnout was the lowest in decades. The campaign of 1992 differed in that the self-serving media was chastened by what appeared to be the demystifying tactics of Ross Perot, while the Republican convention floundered in its obsession with imaging the phantasm of universal moral values.

11. Recent years, however, have seen the rise of a "red and green politics," which attempt to rethink Marxist theory in the light of ecological concerns. Journals such as *Capitalism, Nature, Socialism* are committed to this task.

12. It may be significant in this regard that W. J. T. Mitchell, in his book on ideology and iconoclasm, *Iconology,* posits the idea of the totem as the "sort of image [that] might fill the blank space our culture creates between aesthetic objects and idols. . . . Totems are not idols or fetishes, not objects of worship, but 'companionable forms' (to use Coleridge's phrase) which the viewer may converse with, cajole, bully, or cast aside. They are, in Sir James Frazer's words, 'an imaginary brotherhood established on a footing of perfect equality between a group of people on the one side and a group of things on the other side' " (114).

13. If I am skeptical of the pretensions of twentieth-century avant-garde art in its various attempts to alter social consciousness through form, and if I indicate that these works often end up in line with, rather than opposed to, the form hegemonic culture (eventually) takes—for good or ill—I by no

means wish to take the superior historical position and say it should have been done another way. This is one illusion of belated consciousness, to which one must reply: it couldn't have. But at the same time it is essential not to be blind to the form that pretension takes now, if one still maintains a desire for a way to effect a change in attitude. ("Consciousness," a word of the sixties, by the eighties has seemed to have shrunk to "attitude"—although not necessarily in a bad way, for the former word is internal and overly self-concerned, while the latter claims a bodily disposition toward the outside world, even if less self-aware.)

Indeed, as I hope to have shown, there is a historical shift (if not development) in attitude regarding materiality and signification. This shift has occurred not only in art, but across the social and cultural board. The artists who hope to challenge any contemporary ideology should recognize their implication in its logic, while recognizing that to change the logic's *content* is not enough—one must change (the orientation of) the logical system itself, which usually means having some kind of alternative in mind. Indeed it would appear that this is a question that feminist art and theory has had to confront all along. But it is also necessary, in any art that considers itself to be political, for the work to be self-critical at the same time it implicates the system at large. It is possible to call this self-criticism ironic or tragic consciousness, and often, as in Beckett, it is both. Work in which the artist is not consciously concerned with any self-critical elements, work that seems merely "other-directed," will contain the seeds of the destruction of its own critical position.

14. While I put "authentic" in quotes, I do not mean to disparage its applicability to my argument, only the distortions wrought by its often inappropriate use. It is not the solitary human being that should be understood as the authentic or inauthentic source for anything. Obviously the notion of inauthenticity turns on a relational axis—what might be an inauthentic practice in one context may be quite authentic in another. Authenticity refers not to selves per se, but selves in relation.

Bibliography

Adorno, Theodor. *Aesthetic Theory*. Trans. C. Lenhardt. Ed. Gretel Adorno and Rolf Tiedemann. London: Routledge and Kegan Paul, 1984.
———. *Minima Moralia: Reflections from Damaged Life*. Trans. F. N. Jephcott. London: Verso, 1974.
Altieri, Charles. "Representation, Representativeness, and 'Non-Representational' Art." In *Perspectives on Perception, Philosophy, Art, and Literature*, ed. Mary Ann Caws, 1–28. New York: Peter Lang, 1989.
Andrews, Bruce, and Charles Bernstein, eds. *The* L=A=N=G=U=A=G=E *Book*. Carbondale: Southern Illinois University Press, 1984.
Apollinaire, Guillaume. *Calligrammes*. Paris: Gallimard, 1967.
Aristotle. *Ethics*. Trans. D. P. Chase. London: J. M. Dent, New York: E. P. Dutton, 1937.
Arnheim, Rudolph. "Visual Aspects of Concrete Poetry." In *Literary Criticism and Psychology*, ed. Joseph P. Strelka, 91–109. University Park: Pennsylvania State University Press, 1976.
Artaud, Antonin. *The Theatre and Its Double*. Trans. Mary Caroline Richards. New York: Grove Press, 1958.
Atkins, Guy. *Asger Jorn, The Crucial Years, 1954–1964*. New York: Wittenborn, 1977.
Auslander, Philip. *Presence and Resistance: Postmodernism and Cultural Politics in Contemporary American Performance*. Ann Arbor: University of Michigan Press, 1992.
Ball, Hugo. *Flight out of Time: A Dada Diary*. Trans. Ann Raimes. New York: Viking, 1973.
Barthes, Roland. *Image-Music-Text*. Trans. Stephen Heath. New York: Hill and Wang, 1977.
———. *S/Z*. Trans. Richard Miller. New York: Hill and Wang, 1974.
Bateson, Gregory. *Steps to an Ecology of Mind*. New York: Ballantine, 1972.
Battcock, Gregory, ed. *Minimal Art: A Critical Anthology*. New York: Dutton, 1968.
Baudrillard, Jean. *Les Strategies fatales*. Paris: Bernard Grasset, 1983.
———. *Toward a Critique of the Political Economy of the Sign*. Trans. Charles Levin. St. Louis, MO: Telos Press, 1981.
Beckett, Samuel. *The Collected Shorter Plays of Samuel Beckett*. New York: Grove Press, 1984.
———. *Proust*. New York: Grove Press, 1931.

Bell, Daniel. *The Cultural Contradictions of Capitalism.* New York: Harper and Row, 1978.

Benjamin, Walter. *Illuminations.* Ed. Hannah Arendt. Trans. Harry Zohn. New York: Schocken, 1978.

———. *Reflections.* Trans. Edmund Jephcott. Ed. Peter Demetz. New York: Harcourt Brace Jovanovich, 1978.

Berger, Maurice. *Labyrinths: Robert Morris, Minimalism, and the 1960s.* New York: Harper and Row, 1990.

Bergson, Henri. "Duration." In *The Modern Tradition,* ed. Richard Ellmann and Charles Feidelson, Jr., 723–30. New York: Oxford University Press, 1965.

———. *Matter and Memory.* Trans. Nancy Margaret Paul and W. Scott Palmer. New York: Macmillan, 1950.

Berman, Marshall. *All That Is Solid Melts into Air.* New York: Viking-Penguin, 1988.

Blau, Herbert. *The Audience.* Baltimore: Johns Hopkins University Press, 1990.

———. *Take Up the Bodies: Theater at the Vanishing Point.* Urbana: University of Illinois Press, 1982.

Brecht, Bertolt. *Brecht on Theatre.* Trans. and ed. John Willett. New York: Hill and Wang, 1964.

Bryson, Norman. *Vision and Painting: The Logic of the Gaze.* London: Macmillan, 1983.

Buettner, Stewart. *American Art Theory 1945–1970.* Ann Arbor: UMI Research Press, 1981.

Burnham, Jack. *Great Western Salt Works: Essays on the Meaning of Post-Formalist Art.* New York: George Braziller, 1974.

Burns, Elizabeth. *Theatricality: A Study of Convention in the Theatre and in Social Life.* London: Longman, 1972.

Cabanne, Pierre. *Dialogues with Marcel Duchamp.* Trans. Ron Padgett. New York: Viking, 1971.

Cage, John. *M: Writings '67–'72.* Middletown, CT: Wesleyan University Press, 1973.

Caillois, Roger. *Man, Play, and Games.* Trans. Meyer Barash. New York: Free Press, 1961.

Carlson, Marvin. *Theories of the Theatre: A Historical and Critical Survey, from the Greeks to the Present.* Ithaca, NY: Cornell University Press, 1984.

Carlson, Prudence. "The Garden on the Hill." *Arts* 64, no. 7 (February 1990): 38–53.

Chipp, Herschel B., ed. *Theories of Modern Art.* Berkeley and Los Angeles: University of California Press, 1971.

Coe, Richard N., ed. *The Theater of Jean Genet: A Casebook.* New York: Grove Press, 1970.

Coffman, Stanley K. *Imagism: A Chapter for the History of Modern Poetry.* Norman: University of Oklahoma Press, 1951.

Coleman, Francis X. J. *The Harmony of Reason: A Study in Kant's Aesthetics.* Pittsburgh: University of Pittsburgh Press, 1974.

Craig, Gordon. *Craig on Theatre*. Ed. J. Michael Walton. London: Methuen, 1983.

Debord, Guy. *The Society of the Spectacle*. Detroit: Black and Red, 1983.

de Duve, Thierry, ed. *The Definitively Unfinished Marcel Duchamp*. Cambridge: MIT Press, 1991.

———. *Pictorial Nominalism: On Marcel Duchamp's Passage from Painting to the Readymade*. Trans. Dana Polan with author. Minneapolis: University of Minnesota Press, 1991.

de Man, Paul. *The Resistance to Theory*. Minneapolis: University of Minnesota Press, 1986.

Derrida, Jacques. "Différance." In *Speech and Phenomena and Other Essays on Husserl's Theory of Signs*, trans. David B. Allison. Chicago: Northwestern University Press, 1973.

———. *Of Grammatology*. Trans. Gayatri Chakravorty Spivak. Baltimore: Johns Hopkins University Press, 1976.

Diamond, Elin. "Brechtian Theory/Feminist Theory: Toward a Gestic Feminist Criticism." *Drama Review* 32, no. 1, (spring 1988): 82–94.

Dubnick, Randa. *The Structure of Obscurity: Gertrude Stein, Language and Cubism*. Chicago, University of Illinois Press, 1984.

Duchamp, Marcel. *The Writings of Marcel Duchamp*. Ed. Michel Sanouillet and Elmer Peterson. New York: Da Capo Press, 1973.

Eliot, T. S. *Selected Essays, 1917–1932*. New York: Harcourt Brace, 1932.

Ellul, Jacques. *The Technological Society*. Trans. Joachim Neugroschel. New York: Continuum Books, 1980.

Erickson, Jon. "Pinter and the Ethos of Minimalism." In *Pinter at Sixty*, ed. Katherine Burkman and John Gibbs, 100–107. Bloomington: Indiana University Press, 1993.

———. "The Spectacle of the Anti-Spectacle: Happenings and the Situationist International." *Discourse* 14, no. 2 (spring 1992): 36–58.

Fenellosa, Ernest. *The Chinese Written Character as a Medium for Poetry*. San Francisco: City Lights, 1936.

Féral, Josette. "Performance and Theatricality: The Subject Demystified." *Modern Drama* 25, no. 1 (March 1982): 170–81.

Finlay, Ian Hamilton. "Letter to Pierre Garnier, September 17th, 1963." *Hispanic Arts* 1, nos. 3–4 (winter–spring 1968), 84.

Foster, Stephen C., ed. *Visible Language*, special issue on lettrisme, 17, no. 3 (summer 1983).

Foucault, Michel. *Language, Counter-Memory, Practice*. Trans. Donald F. Bouchard and Sherry Simon. Ithaca, NY: Cornell University Press, 1977.

———. *The Order of Things: An Archaeology of the Human Sciences*. New York: Vintage, 1973.

———. *The Use of Pleasure. Vol. 2 of The History of Sexuality*. Trans. Robert Hurley. New York: Vintage, 1986.

Freedberg, David. *The Power of Images: Studies in the History and Theory of Response*. Chicago: University of Chicago Press, 1989.

Fried, Michael. "Art and Objecthood." In *Minimal Art: A Critical Anthology*, ed. Gregory Battcock, 116–47. New York: E. P. Dutton, 1968.

Freud, Sigmund. *Beyond the Pleasure Principle*. Trans. James Strachey. New York: Norton, 1961.

———. *The Ego and the Id*. Trans. Joan Riviere. New York: Norton, 1960.

———. "Fetishism." In *The Standard Edition of the Complete Psychological Works of Sigmund Freud*, trans. James Strachey. Vol. 21. London: Hogarth Press, 1961.

———. "The Interpretation of Dreams." In *Basic Writings of Sigmund Freud*, trans. A. A. Brill. New York: Modern Library, 1938.

Fuchs, Elinor. "Presence and the Revenge of Writing: Rethinking Theatre after Derrida." *Performing Arts Journal* 9, nos. 2–3 (1985): 163–73.

Gablik, Suzi. *Has Modernism Failed?* London: Thames and Hudson, 1984.

Gehlen, Arnold. *Man in the Age of Technology*. Trans. Patricia Lipscomb. New York: Columbia University Press, 1980.

Genet, Jean. *The Balcony*. Trans. Bernard Frechtman. New York: Grove Press, 1966.

Gomringer, Eugen. "Concrete Poetry." *Hispanic Arts* 1, nos. 3–4 (winter–spring 1968): 67–68.

———. "From Line to Constellation." *Hispanic Arts* 1, nos. 3–4 (winter–Spring, 1968): 67.

———. "The Poem as Functional Object." *Hispanic Arts* 1, nos. 3–4 (winter–spring, 1968): 69–70.

———. "Poetry as a Means for the Structuring of the Social Environment." Trans. Mark E. Cory. *Visible Language* 10, no. 3 (summer 1976): 227–41.

Greer, Michael. "Ideology and Theory in Recent Experimental Writing, or The Naming of 'Language Poetry.' " *Boundary 2* 16, nos. 2–3 (winter–spring 1989): 335–55.

Grotowski, Jerzy. *Towards a Poor Theatre*. New York: Clarion, 1968.

Guilbaut, Serge. *How New York Stole the Idea of Modern Art*. Trans. Arthur Goldhammer. Chicago: University of Chicago Press, 1983.

Gumpel, Liselotte. *"Concrete" Poetry from East and West Germany: The Language of Exemplarism and Experimentalism*. New Haven, CT: Yale University Press, 1976.

Habermas, Jürgen. *Theory of Communicative Action*. Trans. Thomas McCarthy. Vol. 1. Boston: Beacon Press, 1981.

Hartley, George. *Textual Politics and the Language Poets*. Bloomington: Indiana University Press, 1989.

Harvey, David. *The Condition of Postmodernity*. London: Basil Blackwell, 1989.

Havel, Václav, et al. *The Power of the Powerless: Citizens against the State in Central-Eastern Europe*. Ed. John Keane. London: Hutchinson, 1985.

Hebdige, Dick. *Subculture: The Meaning of Style*. London: Methuen, 1979.

Heidegger, Martin. "The Question Concerning Technology," trans. William Lovitt. In *Basic Writings*, ed. David Farrell Krell. New York: Harper and Row, 1976.

Hejinian, Lyn. *My Life*. San Francisco: Burning Deck, 1980.

Hermand, Jost. "Modernism Restored: West German Painting in the 1950s." *New German Critique* 32 (spring–summer 1984): 23–41.

Home, Stewart. *The Assault on Culture: Utopian Currents from Lettrisme to Class War*. London: Aporia Press, 1988.

Hulme, T. E. *Further Speculations*. Ed. Sam Hynes. Minneapolis: University of Minnesota Press, 1955.

Isaak, Jo Anna. *The Ruin of Representation in Modernist Art and Texts*. Ann Arbor: UMI Research Press, 1986.

Isou, Isidore. "Manifesto." *Visible Language* 17, no. 3 (summer 1983): 70–75.

James, William. *Psychology*. Cleveland: Fine Editions Press, 1948.

Jameson, Fredric. "Postmodernism, or The Cultural Logic of Late Capitalism." *New Left Review* 146 (July–August 1984): 53–92.

———. "Reification and Utopia in Mass Culture." *Social Text* 1, no. 1 (winter 1979): 130–48.

Kandinsky, Wassily. *Concerning the Spiritual in Art*. Trans. M. T. H. Sadler. New York: Dover, 1977.

Kandinsky, Wassily, and Franz Marc, eds. *The Blaue Reiter Almanac*. Documentary edition ed. Klaus Lankheit. New York: Viking, 1974.

Kant, Immanuel. "Critique of Judgement." In *Philosophical Writings*, ed. Ernst Behler; trans. J. C. Meredith. New York: Continuum, 1986.

———. *Groundwork of the Metaphysic of Morals*. Trans. H. J. Patton. New York: Harper and Row, 1956.

Karshan, Donald, ed. *Conceptual Art and Conceptual Aspects, April 10 to August 25, 1970*. Exhibition catalog. The New York Cultural Center.

Kayman, Martin A. *The Modernism of Ezra Pound: The Science of Poetry*. London: Macmillan, 1986.

Kern, Stephen. *The Culture of Time and Space, 1880–1918*. Cambridge: Harvard University Press, 1983.

Kierkegaard, Søren. *Repetition: An Essay in Experimental Psychology*. Trans. Walter Lowrie. Princeton, NJ: Princeton University Press, 1946.

Kirby, E. T., ed. *Total Theatre*. New York: Dutton, 1969.

Kleist, Heinrich von. *An Abyss Deep Enough*. Trans. and ed. Philip B. Miller. New York: Dutton, 1982.

Knabb, Ken, ed. *Situationist International Anthology*. Berkeley: Bureau of Public Secrets, 1981.

Komar, Vitaly, and Alexander Melamid. "In Search of Religion." *Artforum* 18, no. 9 (1980): 36–44.

Kostelanetz, Richard. *Text-Sound Texts*. New York: William Morrow, 1980.

Kosuth, Joseph. "Art after Philosophy." In *Conceptual Art*, ed. Ursula Meyer, 152–71. New York: Dutton, 1972.

———. "Text/Context, 1978/79." In *The Making of Meaning (Bedeutung von Bedeutung)*. Stuttgart: Staatsgalerie Stuttgart, 1981.

Krauss, Rosalind. *Passages in Modern Sculpture*. Cambridge: MIT Press, 1981.

Kubler, George. *The Shape of Time: Remarks on the History of Things*. New Haven and London: Yale University Press, 1962.

Kundera, Milan. *The Unbearable Lightness of Being.* Trans. Michael Henry Heim. New York: Harper and Row, 1984.

Lacan, Jacques. *Ecrits: A Selection.* Trans. Alan Sheridan. New York: W. W. Norton, 1977.

Lakoff, George, and Mark Johnson. *Metaphors We Live By.* Chicago: University of Chicago Press, 1980.

Levenson, Michael. *A Genealogy of Modernism.* London: Cambridge University Press, 1987.

Levin, Richard. "The Poetics and Politics of Bardicide." *PMLA* 105, no. 3 (May 1990): 491–504.

Levine, Les. "Learn to Read." *Art Journal* 42, no. 2 (summer 1982): 131.

Lippard, Lucy R. *Ad Reinhardt.* New York: Harry Abrams, 1981.

———. *Six Years: The Dematerialization of the Art Object from 1966 to 1972.* New York: Praeger, 1973.

Lukács, Georg. *History and Class Consciousness.* Trans. Rodney Livingstone. Cambridge: MIT Press, 1968.

Lyotard, Jean-François. *The Differend.* Trans. Georges Van Den Abeele. Minneapolis: University of Minnesota Press, 1988

———. *Just Gaming.* Trans. Wlad Godzich and Brian Massumi. Minneapolis: University of Minnesota Press, 1985.

———. *The Postmodern Condition: A Report on Knowledge.* Trans. Geoff Bennington and Brian Massumi. Minneapolis: University of Minnesota Press, 1984.

MacIntyre, Alasdair. *After Virtue.* Notre Dame, IN: Notre Dame University Press, 1981.

Maier, Charles S. "The Politics of Time: Changing Paradigms of Collective Time and Private Time in the Modern Era." In *Changing Boundaries of the Political,* ed. Charles S. Maier, 151–75. Cambridge: Cambridge University Press, 1987.

Malevich, Kasimir. *Essays on Art.* Trans. Xenia Glowacki-Prus and Arnold McMillin. Ed. Troels Andersen. Vol. 1. Copenhagen: Borgen, 1968.

Mallarmé, Stéphane. *Igitur, Divigations, Un coup de dés.* Paris: Gallimard, 1976.

———. *Selected Prose Poems, Essays, & Letters.* Ed. Bradford Cook. Baltimore: Johns Hopkins University Press, 1956.

Mann, Paul. *The Theory-Death of the Avant-Garde.* Bloomington: Indiana University Press, 1991.

Marcus, Greil. *Lipstick Traces: A Secret History of the Twentieth Century.* Cambridge: Harvard University Press, 1989.

Marinetti, F. T. "Destruction of Syntax—Imagination Without Strings—Words-in-Freedom." In *Futurist Manifestos,* ed. Umbro Apollonio, 95–106. New York: Viking, 1973.

Markov, Vladimir. *Russian Futurism: A History.* Berkeley and Los Angeles: University of California Press, 1968.

Marx, Karl. *Das Kapital.* Trans. Serge L. Levitsky. Chicago: Henry Regnery, 1970.

Materer, Timothy. *Vortex, Pound, Eliot, and Lewis.* Ithaca, NY: Cornell University Press, 1979.

Mayer, Hansjörg. *Edition Hansjörg Mayer*. Exhibition catalog, Haags Gemeeutemuseum, 5 October to 24 November, 1968.

McEvilley, Thomas. "I Think, Therefore I Art." *Artforum* 23, no. 10 (summer 1985): 74–84.

Meisel, Martin. *Realizations: Narrative, Pictorial, and Theatrical Arts in Nineteenth-Century England*. Princeton, NJ: Princeton University Press, 1983.

Merleau-Ponty, Maurice. *The Phenomenology of Perception*. Trans. Colin Smith. New York: Humanities Press, 1962.

———. *The Prose of the World*. Trans. John O'Neill. Ed. Claude Lefort. Evanston, IL: Northwestern University Press, 1973.

Merton, Thomas. *Zen and the Birds of Appetite*. New York: New Directions, 1968.

Messerli, Douglas, ed. *"Language" Poetries: An Anthology*. New York: New Directions, 1987.

Meyer, Ursula, ed. *Conceptual Art*. New York: Dutton, 1972.

Meyerhold, Vsevolod. *Meyerhold on Theatre*. Trans. and ed. Edward Braun. New York: Hill and Wang, 1969.

Mitchell, W. J. T. *Iconology: Image, Text, Ideology*. Chicago: University of Chicago Press, 1986.

Modell, Arnold H. *Object Love and Reality: An Introduction to a Psychoanalytic Theory of Object Relations*. New York: International Universities Press, 1968.

Mondrian, Piet. *Plastic Art and Pure Plastic Art, 1937, and Other Essays, 1941–1943*. New York: Wittenborn Schultz, 1947.

Moretti, Franco. "The Spell of Indecision." *New Left Review* 164 (July–August 1987): 27–33.

Müller, Heiner. *Hamletmachine and Other Texts for the Stage*. Trans. and ed. Carl Weber. New York: Performing Arts Journal Publications, 1984.

Mulvey, Laura. "Visual Pleasure and Narrative Cinema." In *Art after Modernism: Rethinking Representation*, ed. Brian Wallis, 361–73. Boston: David Godine, 1984.

Nietzsche, Friedrich. *Basic Writings of Nietzsche*. Trans. and ed. Walter Kaufmann. New York: Modern Library, 1968.

———. *The Birth of Tragedy and the Genealogy of Morals*. Trans. Francis Golffing. New York: Anchor Books, 1956.

———. *Philosophy and Truth: Selections from Nietzsche's Notebooks of the Early 1870's*. Trans. and ed. Daniel Breazeale. Atlantic Highlands, New Jersey: Humanities Press, 1979.

Noigandres Group. "Pilot Plan for Concrete Poetry." *Hispanic Arts* 1, nos. 3–4 (winter–spring 1968): 71–72.

Olson, Charles. *The Maximus Poems*. Vol. 1. New York: Jargon/Corinth Books, 1960.

———. *The Maximus Poems*. Ed. George F. Butterick. Berkeley and Los Angeles: University of California Press, 1983.

———. "Projective Verse." In *The New American Poetry*, ed. Donald Allen, 386–97. New York: Grove Press, 1960.

Overy, Paul. *Kandinsky: The Language of the Eye*. New York: Praeger, 1969.

Paz, Octavio. *Marcel Duchamp: Appearance Stripped Bare*. Trans. Rachel Philips and Donald Gardner. New York: Viking, 1978.

Perelman, Bob, ed. *Talks*. Special issue of *Hills* 6–7 (spring 1980).

Perloff, Marjorie. *The Dance of the Intellect: Studies in the Poetry of the Pound Tradition*. Cambridge: Cambridge University Press, 1985.

Phelan, Peggy. *Unmarked: The Politics of Performance*. London: Routledge, 1993.

Poggi, Christine. "Mallarmé, Picasso, and the Newspaper as Commodity." *Yale Journal of Criticism* 1, no. 1 (fall 1987): 133–51.

Pound, Ezra. *ABC of Reading*. New York: New Directions, 1934.

———. *The Cantos of Ezra Pound*. New York: New Directions, 1971.

———. *Gaudier-Brzeska: A Memoir*. New York: New Directions, 1970.

———. *The Literary Essays of Ezra Pound*. Ed. T. S. Eliot. New York: New Directions, 1955.

Rainer, Yvonne. "Looking Myself in the Mouth." *October* 9 (1981): 65–76.

Reinhardt, Ad. *Art-as-Art: The Selected Writings of Ad Reinhardt*. Ed. Barbara Rose. New York: Viking, 1975.

Ricoeur, Paul. "The Human Being as the Subject Matter of Philosophy." *Philosophy and Social Criticism* 14, no. 2 (1989): 203–15.

———. *Lectures on Ideology and Utopia*. Ed. George H. Taylor. New York: Columbia University Press, 1986.

Robbe-Grillet, Alain. "Dehumanizing Nature." In *The Modern Tradition*, ed. Richard Ellmann and Charles Feidelson, Jr., 361–78. New York: Oxford University Press, 1965.

Ross, Andrew. *The Failure of Modernism*. New York: Columbia University Press, 1986.

Rühm, Gerhard. "Auditive Texte." In *Kontextsound*, ed. Michael Gibbs, 12. Amsterdam: Kontexts Publications, 1977.

Russell, Charles, ed. *The Avant-Garde Today: An International Anthology*. Urbana: University of Illinois Press, 1981.

Sanouillet, Michel, ed. *Francis Picabia et "391."* Vol. 2. Paris: Eric Losfeld, 1966.

Sartre, Jean-Paul. *Being and Nothingness*. Trans. Hazel E. Barnes. New York: Citadel Press, 1968.

———. "The Face." In *Essays in Phenomenology*, ed. Maurice Natanson. The Hague: Martinus Nijhoff, 1966.

———. *Sartre on Theatre*. Trans. Frank Jellinek. New York: Pantheon, 1976.

———. *Search for a Method*. Trans. Hazel E. Barnes. New York: Vintage, 1968

Sayre, Henry M. *The Object of Performance: The American Avant-Garde since 1970*. Chicago: University of Chicago Press, 1989.

———. *The Visual Text of William Carlos Williams*. Urbana: University of Illinois Press, 1983.

Schmidt, Siegfried. "Perspectives on the Development of a Post-Concrete Poetry." *Poetics Today* 3, no. 3 (1982): 101–36.

Sennett, Richard. *The Fall of Public Man*. New York: Knopf, 1977.

Siegel, Jeanne. *Artwords: Discourse on the 60s and 70s*. Ann Arbor: UMI Research Press, 1985.

Silliman, Ron. *Ketjak*. Berkeley: This Press, 1978.
————. *Tjanting*. Berkeley: The Figures, 1981.
————. ed. *In the American Tree*. Orono, ME: National Poetry Foundation, 1986.
Simmel, Georg. *The Philosophy of Money*. Trans. Tom Bottomore and David Frisby. London: Routledge and Kegan Paul, 1978.
Sloterdijk, Peter. *Critique of Cynical Reason*. Trans. Michael Eldred. Minneapolis: University of Minnesota Press, 1987.
Smithson, Robert. *The Writings of Robert Smithson*. Ed. Nancy Holt. New York: New York University Press, 1979.
Solt, Mary Ellen, ed. *Concrete Poetry: A World View*. Bloomington: Indiana University Press, 1969.
States, Bert O. *Great Reckonings in Little Rooms: On the Phenomenology of Theater*. Berkeley and Los Angeles: University of California Press, 1985.
Stein, Gertrude. *Gertrude Stein, Writings and Lectures 1909–1945*. Ed. Patricia Meyerowitz. Baltimore: Penguin Books, 1967.
————. *Selected Writings of Gertrude Stein*. Ed. Carl Van Vechten. New York: Vintage, 1962.
Stevens, Wallace. *Collected Poems*. New York: Vintage, 1961.
————. *The Necessary Angel: Essays on Reality and the Imagination*. New York: Vintage, 1951.
Stewart, Susan. "*Ceci Tuera Cela*: Graffiti as Crime and Art." In *Life after Postmodernism: Essays on Value and Culture*, ed. John Fekete, 161–80. New York: St. Martin's Press, 1987.
Strindberg, August. *Selected Plays*. Trans. Evert Sprinchorn. Minneapolis: University of Minnesota Press, 1986.
Szondi, Peter. *Theory of the Modern Drama*. Trans. Michael Hays. Minneapolis: University of Minnesota Press, 1987.
Tisdall, Caroline. *Joseph Beuys*. London: Thames and Hudson, 1979.
Tuchman, Maurice, ed. *New York School: The First Generation*. Greenwich, CT: New York Graphic Society, 1965.
Turner, Victor. *From Ritual to Theatre: The Human Seriousness of Play*. New York: Performing Arts Journal Publications, 1982.
Vaneigem, Raoul. *The Revolution of Everyday Life*. Trans. Donald Nicholson-Smith. London: Left Bank Books, 1983.
Wagner, Linda Welshimer, ed. *Interviews with William Carlos Williams*. New York: New Directions, 1976.
Watten, Barrett. *Total Syntax*. Carbondale: Southern Illinois University Press, 1985.
Weber, Max. *From Max Weber*. Trans. and ed. H. H. Gerth and C. Wright Mills. New York: Oxford University Press, 1981.
Whitehead, Alfred North. *Process and Reality*. New York: Free Press, 1969.
Wildman, Eugene, ed. *Chicago Review Anthology of Concrete Poetry*. Chicago: Swallow Press, 1967.
Wiles, Timothy. *The Theater Event: Modern Theories of Performance*. Chicago: University of Chicago Press, 1980.

Williams, Emmett. *Anthology of Concrete Poetry*. New York: Something Else
 Press, 1967.
Williams, William Carlos. *Paterson*. New York: New Directions, 1963.
————. *Selected Poems*. New York: New Directions, 1969.
Winner, Langdon. *Autonomous Technology: Technics-out-of-Control as a Theme in
 Political Thought*. Cambridge: MIT Press, 1977.
Wittgenstein, Ludwig. *Philosophical Investigations*. Trans. G. E. M. Anscombe.
 Oxford: Basil Blackwell, 1963.
————. *Tractatus Logico-Philosophicus*. Trans. D. F. Pears and B. F. McGuinness.
 London: Routledge and Kegan Paul, 1961.
Worringer, Wilhelm. *Abstraction and Empathy: A Contribution to the Psychology of
 Style*. New York: International Universities Press, 1953.
Zukofsky, Louis. *A*. Berkeley and Los Angeles: University of California Press,
 1978.
————. "Sincerity and Objectification, with Special Reference to the Work of
 Charles Reznikoff." *Poetry* 37, no. 5 (February 1931): 272–89.

Index